THE ALLEGORY
OF LOVE

Oxford University Press, Amen House, London E.C.4

GLASGOW NEW YORK TORONTO MELBOURNE WELLINGTON
BOMBAY CALCUTTA MADRAS KARACHI KUALA LUMPUR
CAPE TOWN IBADAN NAIROBI ACCRA

THE ALLEGORY
OF LOVE

A STUDY IN
MEDIEVAL TRADITION

BY

C. S. LEWIS, M.A.

FELLOW OF MAGDALEN COLLEGE
OXFORD

Multa renascentur quae jam cecidere, cadentque
Quae nunc sunt in honore.

OXFORD UNIVERSITY PRESS

FIRST PUBLISHED 1936
REPRINTED 1938 (WITH CORRECTIONS)
1943, 1946, 1948, 1951, 1953, 1959

TO
OWEN BARFIELD
WISEST AND BEST
OF MY
UNOFFICIAL
TEACHERS

PREFACE

IT is to be hoped that the purpose of this book is sufficiently explained in the text, and the preface need therefore be occupied with nothing but thanks where thanks, so far as I can recall, are due. But I cannot promise to remember all my debts, and I am well aware, like the philosopher, that 'if I had succeeded in owing more, I might then perhaps have gained more of a claim to be original'.

Of unambiguous debts my first is naturally to the Delegates of the Clarendon Press and to the skilled and patient anonymities who serve them; then to Dom André Wilmart, O.S.B., for careful criticisms of the first two chapters; to Professor C. C. J. Webb for his helpful interest in the second; to the Medieval Society of Manchester University (and specially to Professor Vinaver) for their kind hearing and useful discussion of the third; to Dr. C. T. Onions for subjecting my attempts at Middle English verse to that best criticism in which all distinction between the literary and the linguistic is resolved; and to Dr. Abercrombie, for all that is not erroneous in the Appendix on *Danger*. The first chapter was read and commented upon by Mr. B. Macfarlane and Professor Tolkien so long ago that they have probably forgotten the labour, but I do not therefore forget the kindness.

Thus far my task is easy; but behind these unmistakable creditors I detect a far larger circle of those who have helped me, directly or indirectly, when neither they nor I supposed that any such matter was toward. There seems to be hardly any one among my acquaintance from whom I have not learned. The greatest of these debts—that which I owe to my father for the inestimable benefit of a childhood passed mostly alone in a house full of books— is now beyond repayment; and among the rest I can only select. To have lived on the same college staircase with Professor J. A. Smith is in itself a liberal education. The

untiring intellect of Mr. H. Dyson of Reading, and the selfless use which he makes of it, are at once spur and bridle to all his friends. The work of Dr. Janet Spens has encouraged me to say more boldly what I saw in Spenser and to see what I had not seen before. Above all, the friend to whom I have dedicated the book, has taught me not to patronize the past, and has trained me to see the present as itself a 'period'. I desire for myself no higher function than to be one of the instruments whereby his theory and practice in such matters may become more widely effective.

I have tried to acknowledge the assistance of previous writers wherever I was aware of it. I hope it will not be supposed that I am either ignorant or contemptuous of all the celebrated books I do not mention. In writing my last chapter I have regretted that the particular point of view from which I was approaching Spenser did not allow me to make much use of the labours of Professor Renwick and Mr. B. E. C. Davis, or even of Professor de Sélincourt's noble preface. Such knowledge as I have of Latin poetry would have been more easily and pleasurably acquired if Mr. Raby's great works had reached me earlier. But when all is said, doubtless I have still failed to mention many giants on whose shoulders I have stood at one time or another. Facts and inferences and even turns of expression find a lodging in a man's mind, he scarcely remembers how; and of all writers I make least claim to be αὐτοδίδακτος.

C. S. L.

CONTENTS

I. COURTLY LOVE

I

THE allegorical love poetry of the Middle Ages is apt
to repel the modern reader both by its form and by
its matter. The form, which is that of a struggle between
personified abstractions, can hardly be expected to appeal
to an age which holds that 'art means what it says' or even
that art is meaningless—for it is essential to this form that
the literal narrative and the *significacio* should be separ-
able. As for the matter, what have we to do with these
medieval lovers—'servants' or 'prisoners' they called them-
selves—who seem to be always weeping and always on their
knees before ladies of inflexible cruelty? The popular
erotic literature of our own day tends rather to sheikhs
and 'Salvage Men' and marriage by capture, while that
which is in favour with our intellectuals recommends
either frank animalism or the free companionship of the
sexes. In every way, if we have not outgrown, we have
at least grown away from, the *Romance of the Rose*. The
study of this whole tradition may seem, at first sight, to
be but one more example of that itch for 'revival', that
refusal to leave any corpse ungalvanized, which is among
the more distressing accidents of scholarship. But such
a view would be superficial. Humanity does not pass
through phases as a train passes through stations: being
alive, it has the privilege of always moving yet never
leaving anything behind. Whatever we have been, in some
sort we are still. Neither the form nor the sentiment of
this old poetry has passed away without leaving indelible
traces on our minds. We shall understand our present,
and perhaps even our future, the better if we can succeed,
by an effort of the historical imagination, in reconstructing
that long-lost state of mind for which the allegorical love
poem was a natural mode of expression. But we shall not

B

be able to do so unless we begin by carrying our attention back to a period long before that poetry was born. In this and the following chapter, I shall trace in turn the rise both of the sentiment called 'Courtly Love' and of the allegorical method. The discussion will seem, no doubt, to carry us far from our main subject: but it cannot be avoided.

Every one has heard of courtly love, and every one knows that it appears quite suddenly at the end of the eleventh century in Languedoc. The characteristics of the Troubadour poetry have been repeatedly described.[1] With the form, which is lyrical, and the style, which is sophisticated and often 'aureate' or deliberately enigmatic, we need not concern ourselves. The sentiment, of course, is love, but love of a highly specialized sort, whose characteristics may be enumerated as Humility, Courtesy, Adultery, and the Religion of Love. The lover is always abject. Obedience to his lady's lightest wish, however whimsical, and silent acquiescence in her rebukes, however unjust, are the only virtues he dares to claim. There is a service of love closely modelled on the service which a feudal vassal owes to his lord. The lover is the lady's 'man'. He addresses her as *midons*, which etymologically represents not 'my lady' but 'my lord'.[2] The whole attitude has been rightly described as 'a feudalisation of love'.[3] This solemn amatory ritual is felt to be part and parcel of the courtly life. It is possible only to those who are, in the old sense of the word, polite. It thus becomes, from one point of view the flower, from another the seed, of all those noble usages which distinguish the gentle from the vilein: only the courteous can love, but it is love that makes them courteous. Yet this love, though neither playful nor licentious in its expression, is always what the nineteenth century called 'dishonourable' love. The poet normally addresses

[1] See Fauriel, *Histoire de la Poésie provençale*, 1846; E. Gorra, *Origini etc. della Poesia Amorosa di Provenza* (*Rendiconti del Istituto Lombardo*, &c. II. xliii.14, xlv. 3), 1910–12; Jeanroy, *La Poésie lyrique des Troubadours*, 1934.

[2] Jeanroy, op. cit., tom. i, p. 91 n.

[3] Wechssler, *Das Kulturproblem des Minnesangs*, 1909, Bnd. I, p. 177.

another man's wife, and the situation is so carelessly accepted that he seldom concerns himself much with her husband: his real enemy is the rival.[1] But if he is ethically careless, he is no light-hearted gallant: his love is represented as a despairing and tragical emotion—or almost despairing, for he is saved from complete wanhope by his faith in the God of Love who never betrays his faithful worshippers and who can subjugate the cruellest beauties.[2]

The characteristics of this sentiment, and its systematic coherence throughout the love poetry of the Troubadours as a whole, are so striking that they easily lead to a fatal misunderstanding. We are tempted to treat 'courtly love' as a mere episode in literary history—an episode that we have finished with as we have finished with the peculiarities of Skaldic verse or Euphuistic prose. In fact, however, an unmistakable continuity connects the Provençal love song with the love poetry of the later Middle Ages, and thence, through Petrarch and many others, with that of the present day. If the thing at first escapes our notice, this is because we are so familiar with the erotic tradition of modern Europe that we mistake it for something natural and universal and therefore do not inquire into its origins. It seems to us natural that love should be the commonest theme of serious imaginative literature: but a glance at classical antiquity or at the Dark Ages at once shows us that what we took for 'nature' is really a special state of affairs, which will probably have an end, and which certainly had a beginning in eleventh-century Provence. It seems—or it seemed to us till lately—a natural thing that love (under certain conditions) should be regarded as a noble and ennobling passion: it is only if we imagine ourselves trying to explain this doctrine to Aristotle, Virgil, St. Paul, or the author of *Beowulf*, that we become aware how far from natural it is. Even our code of etiquette, with its rule that women always have precedence,

[1] Jeanroy, op. cit., tom. ii, pp. 109–13.
[2] Ibid., p. 97.

is a legacy from courtly love, and is felt to be far from natural in modern Japan or India. Many of the features of this sentiment, as it was known to the Troubadours, have indeed disappeared; but this must not blind us to the fact that the most momentous and the most revolutionary elements in it have made the background of European literature for eight hundred years. French poets, in the eleventh century, discovered or invented, or were the first to express, that romantic species of passion which English poets were still writing about in the nineteenth. They effected a change which has left no corner of our ethics, our imagination, or our daily life untouched, and they erected impassable barriers between us and the classical past or the Oriental present. Compared with this revolution the Renaissance is a mere ripple on the surface of literature.

There can be no mistake about the novelty of romantic love: our only difficulty is to imagine in all its bareness the mental world that existed before its coming—to wipe out of our minds, for a moment, nearly all that makes the food both of modern sentimentality and modern cynicism. We must conceive a world emptied of that ideal of 'happiness' —a happiness grounded on successful romantic love— which still supplies the motive of our popular fiction. In ancient literature love seldom rises above the levels of merry sensuality or domestic comfort, except to be treated as a tragic madness, an ἄτη which plunges otherwise sane people (usually women) into crime and disgrace. Such is the love of Medea, of Phaedra, of Dido; and such the love from which maidens pray that the gods may protect them.[1] At the other end of the scale we find the comfort and utility of a good wife acknowledged: Odysseus loves Penelope as he loves the rest of his home and possessions, and Aristotle rather grudgingly admits that the conjugal relation may now and then rise to the same level as the virtuous friendship between good men.[2] But this has plainly very little

[1] Euripides, *Medea*, 630; *Hippolytus*, 529.
[2] Aristotle, *Ethics*, 1162 A. εἴη δ' ἂν καὶ δι' ἀρετήν.

to do with 'love' in the modern or medieval sense; and if
we turn to ancient love-poetry proper, we shall be even
more disappointed. We shall find the poets loud in their
praises of love, no doubt,

τίς Δε βίος, τί Δε τερπνὸν ἄτερ χρυσῆς 'ΑφροΔίτης;

'What is life without love, tra-la-la?' as the later song has
it. But this is no more to be taken seriously than the
countless panegyrics both ancient and modern on the all-
consoling virtues of the bottle. If Catullus and Propertius
vary the strain with cries of rage and misery, this is not
so much because they are romantics as because they are
exhibitionists. In their anger or their suffering they care
not who knows the pass to which love has brought them.
They are in the grip of the ἄτη. They do not expect their
obsession to be regarded as a noble sorrow—they have no
'silks and fine array'.

Plato will not be reckoned an exception by those who
have read him with care. In the *Symposium*, no doubt, we
find the conception of a ladder whereby the soul may
ascend from human love to divine. But this is a ladder
in the strictest sense; you reach the higher rungs by leaving
the lower ones behind. The original object of human love
—who, incidentally, is not a woman—has simply fallen out
of sight before the soul arrives at the spiritual object. The
very first step upwards would have made a courtly lover
blush, since it consists in passing on from the worship of
the beloved's beauty to that of the same beauty in others.
Those who call themselves Platonists at the Renaissance
may imagine a love which reaches the divine without aban-
doning the human and becomes spiritual while remaining
also carnal; but they do not find this in Plato. If they
read it into him, this is because they are living, like our-
selves, in the tradition which began in the eleventh
century.

Perhaps the most characteristic of the ancient writers on
love, and certainly the most influential in the Middle
Ages, is Ovid. In the piping times of the early empire—

when Julia was still unbanished and the dark figure of
Tiberius had not yet crossed the stage—Ovid sat down to
compose for the amusement of a society which well under-
stood him an ironically didactic poem on the art of seduc-
tion. The very design of his *Art of Love* presupposes an
audience to whom love is one of the minor peccadilloes of
life, and the joke consists in treating it seriously—in writ-
ing a treatise, with rules and examples *en règle* for the nice
conduct of illicit loves. It is funny, as the ritual solemnity
of old gentlemen over their wine is funny. Food, drink,
and sex are the oldest jokes in the world; and one familiar
form of the joke is to be very serious about them. From
this attitude the whole tone of the *Ars Amatoria* flows.
In the first place Ovid naturally introduces the god Amor
with an affectation of religious awe—just as he would have
introduced Bacchus if he had written an ironic *Art of
Getting Drunk*. Love thus becomes a great and jealous
god, his service an arduous *militia*: offend him who dares,
Ovid is his trembling captive. In the second place, being
thus mockingly serious about the appetite, he is of neces-
sity mockingly serious about the woman. The real objects
of Ovid's 'love', no doubt, he would have ordered out of
the room before the serious conversation about books, or
politics, or family affairs began. The moralist may treat
them seriously, but the man of the world (such as Ovid)
certainly does not. But inside the convention of the poem
they are the 'demnition charmers', the mistresses of his
fancy and the arbitresses of his fate. They rule him with
a rod of iron, lead him a slave's life. As a result we find
this sort of advice addressed to the 'prentice lover:

> Go early ere th' appointed hour to meet
> The fair, and long await her in the street.
> Through shouldering crowds on all her errands run,
> Though graver business wait the while undone.
> If she commands your presence on her way
> Home from the ball to lackey her, obey!
> Or if from rural scenes she bids you, 'Come',
> Drive if you can, if not, then walk, to Rome,

And let nor Dog-star heats nor drifted load
Of whitening snows deter you from the road.
Cowards, fly hence! Our general, Love, disdains
Your lukewarm service in his long campaigns.[1]

No one who has caught the spirit of the author will mis-
understand this. The conduct which Ovid recommends
is felt to be shameful and absurd, and that is precisely why
he recommends it—partly as a comic confession of the
depths to which this ridiculous appetite may bring a man,
and partly as a lesson in the art of fooling to the top of her
bent the last baggage who has caught your fancy. The
whole passage should be taken in conjunction with his
other piece of advice—'Don't visit her on her birthday:
it costs too much.'[2] But it will also be noticed—and this
is a pretty instance of the vast change which occurred
during the Middle Ages—that the very same conduct
which Ovid ironically recommends could be recommended
seriously by the courtly tradition. To leap up on errands,
to go through heat or cold, at the bidding of one's lady,
or even of any lady, would seem but honourable and
natural to a gentleman of the thirteenth or even of the
seventeenth century; and most of us have gone shopping
in the twentieth with ladies who showed no sign of regard-
ing the tradition as a dead letter. The contrast inevitably
raises in our minds a question as to how far the whole tone
of medieval love poetry can be explained by the formula,
'Ovid misunderstood'; and though we see at once that

[1] *Ars Amatoria*, ii. 223:

Iussus adesse foro, iussa maturius hora
　　Fac semper venias, nec nisi serus abi.
Occurras aliquo, tibi dixerit; omnia differ,
　　Curre, nec inceptum turba moretur iter.
Nocte domum repetens epulis perfuncta redibit—
　　Tunc quoque pro servo, si vocat illa, veni.
Rure eris et dicet, Venias: Amor odit inertes!
　　Si rota defuerit, tu pede carpe viam,
Nec grave te tempus sitiensve Canicula tardet,
　　Nec via per iactas candida facta nives.
Militiae species Amor est: discedite segnes!
　　Non sunt haec timidis signa tuenda viris.

[2] *Ars Amatoria*, i. 403, et seq.; cf. 417 et seq.

this is no solution—for if it were granted, we should still have to ask why the Middle Ages misunderstood him so consistently—yet the thought is a good one to keep in mind as we proceed.[1]

The fall of the old civilization and the coming of Christianity did not result in any deepening or idealizing of the conception of love. The fact is important, because it refutes two theories which trace the great change in our sentiments respectively to the Germanic temperament and to the Christian religion—especially to the cult of the Blessed Virgin. The latter view touches on a real and very complex relationship; but as its true nature will become apparent in what follows, I will here content myself with a brief and dogmatic statement. That Christianity in a very general sense, by its insistence on compassion and on the sanctity of the human body, had a tendency to soften or abash the more extreme brutalities and flippancies of the ancient world in all departments of human life, and therefore also in sexual matters, may be taken as obvious. But there is no evidence that the quasi-religious tone of medieval love poetry has been transferred from the worship of the Blessed Virgin: it is just as likely—it is even more likely—that the colouring of certain hymns to the Virgin has been borrowed from the love poetry.[2] Nor is it true in any unequivocal sense that the medieval church encouraged reverence for women at all: while it is a ludicrous error (as we shall presently see) to suppose that she regarded sexual passion, under any conditions or after any possible process of refinement, as a noble emotion. The other theory turns on a supposedly innate characteristic in the Germanic races, noted by Tacitus.[3] But what Tacitus describes is a primitive awe of women as uncanny and probably prophetic beings, which is as remote from our comprehension as the primitive reverence for lunacy or the primitive horror of twins; and because it is thus re-

[1] See p. 43.
[2] See Jeanroy in the *Histoire de la langue et de la littérature française*, 1896, tom. i, p. 372 n.; also Wechssler, op. cit., Bnd. I, cap. xviii. [3] *Germania*, viii. 2.

mote, we cannot judge how probably it might have developed into the medieval *Frauendienst*, the service of ladies. What is certain is that where a Germanic race reached its maturity untouched by the Latin spirit, as in Iceland, we find nothing at all like courtly love. The position of women in the Sagas is, indeed, higher than that which they enjoy in classical literature; but it is based on a purely commonsensible and unemphasized respect for the courage or prudence which some women, like some men, happen to possess. The Norsemen, in fact, treat their women not primarily as women but as people. It is an attitude which may lead in the fullness of time to an equal franchise or a Married Women's Property Act, but it has very little to do with romantic love. The final answer to both theories, however, lies in the fact that the Christian and Germanic period had existed for several centuries before the new feeling appeared. 'Love', in our sense of the word, is as absent from the literature of the Dark Ages as from that of classical antiquity. Their favourite stories were not, like ours, stories of how a man married, or failed to marry, a woman. They preferred to hear how a holy man went to heaven or how a brave man went to battle. We are mistaken if we think that the poet in the Song of Roland shows restraint in disposing so briefly of Alde, Roland's betrothed.[1] Rather by bringing her in at all, he is doing the opposite: he is expatiating, filling up chinks, dragging in for our delectation the most marginal interests after those of primary importance have had their due. Roland does not think about Alde on the battle-field: he thinks of his praise in pleasant France.[2] The figure of the betrothed is shadowy compared with that of the friend, Oliver. The deepest of worldly emotions in this period is the love of man for man, the mutual love of warriors who die together fighting against odds, and the affection between vassal and lord. We shall never understand this last, if we think of it in the light of our own moderated and impersonal loyalties. We must

[1] *Chanson de Roland*, 3705 et seq. [2] Ibid. 1054.

not think of officers drinking the king's health: we must think rather of a small boy's feeling for some hero in the sixth form. There is no harm in the analogy, for the good vassal is to the good citizen very much as a boy is to a man. He cannot rise to the great abstraction of a *res publica*. He loves and reverences only what he can touch and see; but he loves it with an intensity which our tradition is loath to allow except to sexual love. Hence to the old vassal in the English poem, parted from his lord,

> þynceþ him on mode þæt he his monndryhten
> Clyppe and cysse and on cneo lecge
> Honda ond heafod, swa he hwilum ær
> On geardagum giefstoles breac . . .

The feeling is more passionate and less ideal than our patriotism. It rises more easily to heroic prodigality of service, and it also breaks more easily and turns into hatred: hence feudal history is full of great loyalties and great treacheries. Germanic and Celtic legend, no doubt, had bequeathed to the barbarians some stories of tragic love between man and woman—love 'star-crossed' and closely analogous to that of Dido or Phaedra. But the theme claims no pre-eminence, and when it is treated the interest turns at least as much on the resulting male tragedy, the disturbance of vassalage or sworn brotherhood, as on the female influence which produced it. Ovid, too, was known to the learned; and there was a plentiful literature on sexual irregularities for the use of confessors. Of romance, of reverence for women, of the idealizing imagination exercised about sex, there is hardly a hint. The centre of gravity is elsewhere— in the hopes and fears of religion, or in the clean and happy fidelities of the feudal hall. But, as we have seen, these male affections—though wholly free from the taint that hangs about 'friendship' in the ancient world—were themselves lover-like; in their intensity, their wilful exclusion of other values, and their uncertainty, they provided an exercise of the spirit not wholly unlike that which later ages have found in 'love'. The fact is, of course, significant.

Like the formula 'Ovid misunderstood', it is inadequate
to explain the appearance of the new sentiment; but it
goes far to explain why that sentiment, having appeared,
should make haste to become a 'feudalization' of love. What
is new usually wins its way by disguising itself as the old.

The new thing itself, I do not pretend to explain. Real
changes in human sentiment are very rare—there are per-
haps three or four on record—but I believe that they
occur, and that this is one of them. I am not sure that
they have 'causes', if by a cause we mean something which
would wholly account for the new state of affairs, and so
explain away what seemed its novelty. It is, at any rate,
certain that the efforts of scholars have so far failed to find
an origin for the content of Provençal love poetry. Celtic,
Byzantine, and even Arabic influence have been suspected;
but it has not been made clear that these, if granted, could
account for the results we see. A more promising theory
attempts to trace the whole thing to Ovid;[1] but this view
—apart from the inadequacy which I suggested above—
finds itself faced with the fatal difficulty that the evidence
points to a much stronger Ovidian influence in the north
of France than in the south. Something can be extracted
from a study of the social conditions in which the new
poetry arose, but not so much as we might hope. We know
that the crusading armies thought the Provençals milk-
sops,[2] but this will seem relevant only to a very hardened
enemy of *Frauendienst*. We know that this period in the
south of France had witnessed what seemed to contem-
poraries a signal degeneracy from the simplicity of ancient
manners and an alarming increase of luxury.[3] But what
age, what land, by the same testimony, has not? Much
more important is the fact that landless knighthood—
knighthood without a place in the territorial hierarchy of

[1] By W. Schrötter, *Ovid und die Troubadours*, 1908: severely reviewed in
Romania, xxxviii.

[2] Radulfus Cadomensis *Gesta Tancredi*, 61, *ne verum taceam minus bellicosi*;
also the proverb *Franci ad bella, Provinciales ad victualia*. (*Recueil des Historiens
des Croisades*, Acad. des Inscriptions, tom. iii, p. 651.)

[3] Jeanroy, op. cit., tom. i, pp. 83 et seq.

feudalism—seems to have been possible in Provence.[1] The
unattached knight, as we meet him in the romances, re-
spectable only by his own valour, amiable only by his own
courtesy, predestined lover of other mens' wives, was
therefore a reality; but this does not explain why he loved
in such a new way. If courtly love necessitates adultery,
adultery hardly necessitates courtly love. We come much
nearer to the secret if we can accept the picture of a
typical Provençal court drawn many years ago by an
English writer,[2] and since approved by the greatest living
authority on the subject. We must picture a castle which
is a little island of comparative leisure and luxury, and
therefore at least of possible refinement, in a barbarous
country-side. There are many men in it, and very few
women—the lady, and her damsels. Around these throng
the whole male *meiny*, the inferior nobles, the landless
knights, the squires, and the pages—haughty creatures
enough in relation to the peasantry beyond the walls, but
feudally inferior to the lady as to her lord—her 'men' as
feudal language had it. Whatever 'courtesy' is in the place
flows from her: all female charm from her and her damsels.
There is no question of marriage for most of the court.
All these circumstances together come very near to being
a 'cause'; but they do not explain why very similar con-
ditions elsewhere had to wait for Provençal example before
they produced like results. Some part of the mystery re-
mains inviolate.

But if we abandon the attempt to explain the new
feeling, we can at least explain—indeed we have partly
explained already—the peculiar form which it first took;
the four marks of Humility, Courtesy, Adultery, and the
Religion of Love. To account for the humility we need no
more than has already been said. Before the coming of
courtly love the relation of vassal and lord, in all its in-
tensity and warmth, already existed; it was a mould into
which romantic passion would almost certainly be poured.

[1] Fauriel, op. cit., tom. i, pp. 515 et seq.
[2] 'Vernon Lee', *Euphorion*, vol. ii, pp. 136 et seq.

And if the beloved were also the feudal superior the thing becomes entirely natural and inevitable. The emphasis on courtesy results from the same conditions. It is in courts that the new feeling arises: the lady, by her social and feudal position, is already the arbitress of manners and the scourge of 'villany' even before she is loved. The association of love with adultery—an association which has lasted in continental literature down to our own times—has deeper causes. In part, it can be explained by the picture we have already drawn; but there is much more to be said about it than this. Two things prevented the men of that age from connecting their ideal of romantic and passionate love with marriage.

The first is, of course, the actual practice of feudal society. Marriages had nothing to do with love, and no 'nonsense' about marriage was tolerated.[1] All matches were matches of interest, and, worse still, of an interest that was continually changing. When the alliance which had answered would answer no longer, the husband's object was to get rid of the lady as quickly as possible. Marriages were frequently dissolved. The same woman who was the lady and 'the dearest dread' of her vassals was often little better than a piece of property to her husband. He was master in his own house. So far from being a natural channel for the new kind of love, marriage was rather the drab background against which that love stood out in all the contrast of its new tenderness and delicacy. The situation is indeed a very simple one, and not peculiar to the Middle Ages. Any idealization of sexual love, in a society where marriage is purely utilitarian, must begin by being an idealization of adultery.

The second factor is the medieval theory of marriage—what may be called, by a convenient modern barbarism, the 'sexology' of the medieval church. A nineteenth-century Englishman felt that the same passion—romantic love—could be either virtuous or vicious according as it

[1] See Fauriel, op. cit., tom. i, pp. 497 et seq. Cf. the wooing scene in Chrétien's *Erec* quoted below.

was directed towards marriage or not. But according to the medieval view passionate love itself was wicked, and did not cease to be wicked if the object of it were your wife. If a man had once yielded to this emotion he had no choice between 'guilty' and 'innocent' love before him: he had only the choice, either of repentance, or else of different forms of guilt.

This subject will delay us for a little, partly because it introduces us to the true relations between courtly love and Christianity, and partly because it has been much misrepresented in the past. From some accounts we should conclude that medieval Christianity was a kind of Manicheeism seasoned with prurience; from others, that it was a sort of carnival in which all the happier aspects of Paganism took part, after being baptized and yet losing none of their jollity. Neither picture is very faithful. The views of medieval churchmen on the sexual act within marriage (there is no question, of course, about the act outside marriage) are all limited by two complementary agreements. On the one hand, nobody ever asserted that the act was intrinsically sinful. On the other hand, all were agreed that some evil element was present in every concrete instance of this act since the Fall. It was in the effort to determine the precise nature of this concomitant evil that learning and ingenuity were expended. Gregory, at the end of the sixth century, was perfectly clear on this question: for him the act is innocent but the desire is morally evil. If we object to the conception of an intrinsically wicked impulse towards an intrinsically innocent action, he replies by the example of a righteous rebuke delivered in anger. What we say may be exactly what we ought to have said; but the emotion which is the efficient cause of our saying it, is morally bad.[1] But the concrete sexual act, that is, the act *plus* its unavoidable efficient cause, remains guilty. When we come down to the later

[1] Gregory to Augustine *apud* Bede, *Eccles. Hist.* I, xxvii (p. 57 in Plumer's ed.). The authenticity of this letter has been questioned; but my argument does not depend on it.

Middle Ages this view is modified. Hugo of St. Victor agrees with Gregory in thinking the carnal desire an evil. But he does not think that this makes the concrete act guilty, provided it is 'excused' by the good ends of marriage, such as offspring.[1] He goes out of his way to combat the rigorous view that a marriage caused by *beauty* is no marriage: Jacob, as he reminds us, married Rachel for her beauty.[2] On the other hand, he is clear that if we had remained in the state of innocence we should have generated *sine carnis incentivo*. He differs from Gregory by considering not only the desire but the pleasure. The latter he thinks evil, but not morally evil: it is, he says, not a sin but the punishment of a sin, and thus arrives at the baffling conception of a punishment which consists in a morally innocent pleasure.[3] Peter Lombard was much more coherent. He located the evil in the desire and said that it was not a moral evil, but a punishment for the Fall.[4] Thus the act, though not free from evil, may be free from moral evil or sin, but only if it is 'excused by the good ends of marriage'. He quotes with approval from a supposedly Pythagorean source a sentence which is all-important for the historian of courtly love—*omnis ardentior amator propriae uxoris adulter est*, passionate love of a man's own wife is adultery.[5] Albertus Magnus takes a much more genial view. He sweeps away the idea that the pleasure is evil or a result of the Fall: on the contrary, pleasure would have been greater if we had remained in Paradise. The real trouble about fallen man is not the strength of his pleasures but the weakness of his reason: unfallen man could have enjoyed any degree of pleasure without losing sight, for a moment, of the First Good.[6]

[1] Hugo of St. Victor, *Sententiarum Summa*, Tract. VII, cap. 2. (The traditional attribution of this work need not, for our purpose, be questioned.)

[2] Ibid. cap. 1.

[3] Ibid. cap. 3.

[4] Pet Lomb. *Sententiarum*, IV, Dist xxxi, *Quod non omnis*.

[5] Ibid.; *De excusatione coitus*. For the real identity of Sextus (or Xystus) Pithagoricus, see Ueberweg, *Hist. of Philosophy*, vol. i, p. 222: *Catholic Encyclopedia*, s.v. Sixtus II, &c.

[6] Alb. Magnus *In Pet. Lomb. Sentent.* iv, Dist. xxvi, Art 7.

The desire, as we now know it, is an evil, a punishment for the Fall, but not a sin.[1] The conjugal act may therefore be not only innocent but meritorious, if it has the right causes—desire of offspring, payment of the marriage debt, and the like. But if desire comes first ('first' in what sense I am not quite sure) it remains a mortal sin.[2] Thomas Aquinas, whose thought is always so firm and clear in itself, is a baffling figure for our present purpose. He seems always to take away with one hand what he holds out to us with the other. Thus he has learned from Aristotle that marriage is a species of *amicitia*.[3] On the other hand, he proves that sexual life would have existed without the Fall by the argument that God would not have given Adam a woman as a 'help' except for this purpose; for any other, a man would obviously have been so much more satisfactory.[4] He is aware that affection between the parties concerned increases sexual pleasure, and that union even among the beasts implies a certain kindliness—*suavem amicitiam*—and thus seems to come to the verge of the modern conception of love. But the very passage in which he does so is his explanation of the law against incest: he is arguing that unions between close kinsfolk are bad precisely because kinsfolk have mutual affection, and such affection would increase pleasure.[5] His general view deepens and subtilizes that of Albertus. The evil in the sexual act is neither the desire nor the pleasure, but the submergence of the rational faculty which accompanies them: and this submergence, again, is not a sin, though it is an evil, a result of the Fall.[6]

It will be seen that the medieval theory finds room for innocent sexuality: what it does not find room for is

1 Alb. Magnus *In Pet. Lomb. Sentent.* iv. Dist. xxvi, Art 9, Responsio.
2 Ibid., Art 11.
3 *Contra Gentiles*, iii. 123, 124.
4 *Sum. Theol. Prima Pars Quaest.* xcviii, Art 2.
5 *Contra Gentiles*, iii. 125. (The beasts come in 123.)
6 *Sum. Theol. Prima Secundae*, xxxiv, Art. 1. The foregoing account confines itself to medieval authorities: a full explanation of the scholastic view would of course begin with its Dominical, Pauline, Augustinian, and Aristotelian sources.

passion, whether romantic or otherwise. It might almost be said that it denies to passion the indulgence which it reluctantly accords to appetite. In its Thomist form the theory acquits the carnal desire and the carnal pleasure, and finds the evil in the *ligamentum rationis*, the suspension of intellectual activity. This is almost the opposite of the view, implicit in so much romantic love poetry, that it is precisely passion which purifies; and the scholastic picture of unfallen sexuality—a picture of physical pleasure at the maximum and emotional disturbance at the minimum— may suggest to us something much less like the purity of Adam in Paradise than the cold sensuality of Tiberius in Capri. It must be stated at once that this is entirely un-just to the scholastics. They are not talking about the same kind of passion as the romantics. The one party means merely an animal intoxication; the other believes, whether rightly or wrongly, in a 'passion' which works a chemical change upon appetite and affection and turns them into a thing different from either. About 'passion' in this sense Thomas Aquinas has naturally nothing to say —as he has nothing to say about the steam-engine. He had not heard of it. It was only coming into existence in his time, and finding its first expression in the poetry of courtly love.

The distinction I have just made is a fine one, even as we make it centuries after the event with all the later expressions of romantic passion in mind. Naturally it could not be made at the time. The general impression left on the medieval mind by its official teachers was that all love—at least all such passionate and exalted devotion as a courtly poet thought worthy of the name—was more or less wicked. And this impression, combining with the nature of feudal marriage as I have already described it, produced in the poets a certain wilfulness, a readiness to emphasize rather than to conceal the antagonism between their amatory and their religious ideals. Thus if the Church tells them that the ardent lover even of his own wife is in mortal sin, they presently reply with the rule

that true love is impossible in marriage. If the Church says that the sexual act can be 'excused' only by the desire for offspring, then it becomes the mark of a true lover, like Chauntecleer, that he served Venus

> More for delyt than world to multiplye.[1]

This cleavage between Church and court, or, in Professor Vinaver's fine phrase, between Carbonek and Camelot, which will become more apparent as we proceed, is the most striking feature of medieval sentiment.

Finally we come to the fourth mark of courtly love—its love religion of the god Amor. This is partly, as we have seen, an inheritance from Ovid. In part it is due to that same law of transference which determined that all the emotion stored in the vassal's relation to his *seigneur* should attach itself to the new kind of love: the forms of religious emotion would naturally tend to get into the love poetry, for the same reason. But in part (and this is, perhaps, the most important reason of the three) this erotic religion arises as a rival or a parody of the real religion and emphasizes the antagonism of the two ideals. The quasi-religious tone is not necessarily strongest in the most serious love poetry. A twelfth-century *jeu-d'esprit* called the *Concilium in Monte Romarici* is here illuminating. It purports to describe a chapter of the nuns at Remiremont, held in spring time, at which the agenda were of a curious nature—*De solo negotio Amoris tractatum est*—and whence all men save a sprinkling of *honesti clerici* were excluded. The proceedings began like this:

> When the virgin senate all
> Had filled the benches of the hall,
> Doctor Ovid's Rule instead
> Of the evangelists was read.
> The reader of that gospel gay
> Was Sister Eva, who (they say)
> Understands the practick part
> Of the Amatory Art—

[1] *Cant. Tales*, B 4535.

> She it was convoked them all,
> Little sisters, sisters tall.
> Sweetly they began to raise
> Songs in Love's melodious praise. . . .[1]

The service being ended, a *Cardinalis domina* arose in their midst and thus announced her business:

> Love, the god of every lover,
> Sent me hither to discover
> All your life and conversation
> And conduct a Visitation.[2]

In obedience to the she-cardinal, a number of the sisters (two of whom are named) made public confession of their principles and practice in the matter of love. It soon became apparent that the convent was divided into two distinct parties, whereof the one had been scrupulous to admit to their favours no lover who was not a clerk (*clericus*), while the other, with equal pedantry, had reserved their kindness exclusively for knights (*militares*). The reader, who has doubtless grasped what kind of author we are dealing with, will not be surprised to learn that the *Cardinalis domina* pronounces emphatically in favour of the clerk as the only proper lover for a nun, and urges the heretical party to repentance. The curses denounced upon them in case of obstinacy or relapse are very exhilarating:

> In reward of their impiety,
> Terror, Travail, Grief, Anxiety,

[1] *Zeitschrift für deutsches Alterthum*, vii, pp. 150 et seq., lines 24–32:
> Intromissis omnibus Virginum agminibus
> Lecta sunt in medium Quasi evangelium
> Precepta Ovidii Doctoris egregii.
> Lectrix tam propitii Fuit evangelii
> Eva de Danubrio Potens in officio
> Artis amatoriae (Ut affirmant aliae)
> Convocavit singulas Magnas atque parvulas.
> Cantus modulamina Et amoris carmina
> Cantaverunt pariter.

[2] Ibid., lines 51 et seq.:
> Amor deus omnium Quotquot sunt amantium
> Me misit vos visere Et vitam inquirere.

Fear and Discord, Strife and Gloom,
Still attend them as their doom!
Let all those who in their blindness
Upon laymen waste their kindness
Be a scorn and execration
To the clerks of every nation,
And let clerks at every meeting
Pass them by without a greeting! . . .
To which malediction we
Say AMEN, so may it be![1]

The whole poem illustrates the influence of Ovid, and
the religion of love, very well; but it is by no means an
instance of 'Ovid misunderstood'. The worship of the god
Amor had been a mock-religion in Ovid's *Art of Love*. The
French poet has taken over this conception of an erotic
religion with a full understanding of its flippancy, and
proceeded to elaborate the joke in terms of the only re-
ligion he knows—medieval Christianity. The result is a
close and impudent parody of the practices of the Church,
in which Ovid becomes a *doctor egregius* and the *Ars Ama-
toria* a gospel, erotic heterodoxy and orthodoxy are dis-
tinguished, and the god of Love is equipped with cardinals
and exercises the power of excommunication. The Ovi-
dian tradition, operated upon by the medieval taste for
humorous blasphemy, is apparently quite sufficient to pro-
duce a love religion, and even in a sense a Christianized
love religion, without any aid from the new seriousness
of romantic passion. As against any theory which would
derive medieval *Frauendienst* from Christianity and the
worship of the Blessed Virgin, we must insist that the love
religion often begins as a parody of the real religion.[2] This

[1] Ibid., vii, pp. 160, 166, lines 216 et seq.:

 Maneat Confusio, Terror et Constricio,
 Labor, Infelicitas, Dolor et Anxietas,
 Timor et Tristitia, Bellum et Discordia, . . .
 Omnibus horribiles Et abhominabiles
 Semper sitis clericis Que favetis laicis.
 Nemo vobis etiam, Ave dicat obviam
 (Ad confirmacionem Omnes dicimus Amen!)

[2] For a discussion of its possible connexions with the mystical theology of

does not mean that it may not soon become something
more serious than a parody, nor even that it may not, as
in Dante, find a *modus vivendi* with Christianity and pro-
duce a noble fusion of sexual and religious experience.
But it does mean that we must be prepared for a cer-
tain ambiguity in all those poems where the attitude of
the lover to his lady or to Love looks at first sight most
like the attitude of the worshipper to the Blessed Virgin
or to God. The distance between the 'lord of terrible
aspect' in the *Vita Nuova* and the god of lovers in the
Council of Remiremont is a measure of the tradition's width
and complexity. Dante is as serious as a man can be; the
French poet is not serious at all. We must be prepared to
find other authors dotted about in every sort of inter-
mediate position between these two extremes. And this
is not all. The variations are not only between jest and
earnest; for the love religion can become more serious
without becoming reconciled to the real religion. Where
it is not a parody of the Church it may be, in a sense, her
rival—a temporary escape, a truancy from the ardours of
a religion that was believed into the delights of a religion
that was merely imagined. To describe it as the revenge
of Paganism on her conqueror would be to exaggerate;
but to think of it as a direct colouring of human passions
by religious emotion would be a far graver error. It is as
if some lover's metaphor when he said 'Here is my heaven'
in a moment of passionate abandonment were taken up
and expanded into a system. Even while he speaks he
knows that 'here' is not his real heaven; and yet it is a de-
lightful audacity to develop the idea a little further. If
you go on to add to that lover's 'heaven' its natural acces-
sories, a god and saints and a list of commandments, and
if you picture the lover praying, sinning, repenting, and
finally admitted to bliss, you will find yourself in the pre-
carious dream-world of medieval love poetry. An exten-
sion of religion, an escape from religion, a rival religion—

St. Bernard, see E. Gilson, *La Théologie Mystique de St. Bernard* (Paris 1934),
Appendix IV.

Frauendienst may be any of these, or any combination of them. It may even be the open enemy of religion—as when Aucassin roundly declares that he would rather follow all the sweet ladies and goodly knights to hell than go without them to heaven. The ideal lady of the old love poems is not what the earliest scholars took her to be. The more religiously she is addressed, the more irreligious the poem usually is.

> I'm no the Queen o' Heavn, Thomas;
> I never carried my head sae hee,
> For I am but a lady gay
> Come out to hunt in my follee.

Before we proceed to examine two important expressions of courtly love, I must put the reader on his guard against a necessary abstraction in my treatment of the subject. I have spoken hitherto as if men first became conscious of a new emotion and then invented a new kind of poetry to express it: as if the Troubadour poetry were necessarily 'sincere' in the crudely biographical sense of the word: as if convention played no part in literary history. My excuse for this procedure must be that a full consideration of such problems belongs rather to the theory of literature in general than to the history of one kind of poem: if we admit them, our narrative will be interrupted in every chapter by almost metaphysical digressions. For our purpose it is enough to point out that life and letters are inextricably intermixed. If the feeling came first a literary convention would soon arise to express it: if the convention came first it would soon teach those who practised it a new feeling. It does not much matter what view we hold provided we avoid that fatal dichotomy which makes every poem either an autobiographical document or a 'literary exercise'—as if any poem worth writing were either the one or the other. We may be quite sure that the poetry which initiated all over Europe so great a change of heart was not a 'mere' convention: we can be quite as sure that it was not a transcript of fact. It was poetry.

Before the close of the twelfth century we find the

Provençal conception of love spreading out in two direc-
tions from the land of its birth. One stream flows down
into Italy and, through the poets of the Dolce Stil
Nuovo, goes to swell the great sea of the Divine Comedy;
and there, at least, the quarrel between Christianity and
the love religion was made up. Another stream found its
way northward to mingle with the Ovidian tradition
which already existed there, and so to produce the French
poetry of the twelfth century. To that poetry we must
now turn.

II

Chrétien de Troyes is its greatest representative. His
Lancelot is the flower of the courtly tradition in France,
as it was in its early maturity. And yet this poet is not
wholly the product of the new conceptions: when he
began to write he seems scarcely to have accepted them.[1]
We must conceive him as a poet of the same type with
Dryden: one of those rare men of genius who can trim
their sails to every breeze of novelty without forfeiting
their poetic rank. He was among the first to welcome the
Arthurian stories; and to him, as much as to any single
writer, we owe the colouring with which the 'matter of
Britain' has come down to us. He was among the first (in
northern France) to choose love as the central theme of a
serious poem: such a poem he wrote in his *Erec*, even
before he had undergone the influence of the fully de-
veloped Provençal formula. And when that influence
reached him, he was not only the first, but perhaps the
greatest, exponent of it to his fellow countrymen; and,
combining this element with the Arthurian legend, he
stamped upon men's minds indelibly the conception of
Arthur's court as the home *par excellence* of true and noble
love. What was theory for his own age had been practice
for the knights of Britain. For it is interesting to notice

[1] G. Paris, *Le Conte de la Charette* (*Romania*, xii). On the degree to which the
new sentiment appears in the Romances of *Eneas* and *Troie*, and the influence
which these works may have had on Chrétien, see Gustave Cohen, *Chrétien de
Troyes et son œuvre*, 1931, pp. 38–73 et passim.

that he places his ideal in the past. For him already 'the age of chivalry is dead'.[1] It always was: let no one think the worse of it on that account. These phantom periods for which the historian searches in vain—the Rome and Greece that the Middle Ages believed in, the British past of Malory and Spenser, the Middle Age itself as it was conceived by the romantic revival—all these have their place in a history more momentous than that which commonly bears the name.

An appreciation of Chrétien's work as a whole would here be out of place. That he has claims on our attention, far beyond the restricted purpose for which I cite him now, must surely be admitted. It is his fate to appear constantly in literary history as the specimen of a tendency. He has deserved better. And the tragedy of the thing is that he himself was never really subdued to that tendency. It is very doubtful whether he was ever dazzled by the tradition of romantic adultery. There are protests in *Cligés* which seem to come from the heart.[2] He tells us in the opening lines of *Lancelot* that he wrote it at the command of the Countess of Champagne,[3] and that she furnished him with both the story and the treatment. What does this mean? I am probably not the first reader who has seen in the fantastic labours which Lancelot undergoes at the bidding of the Queen, a symbol of the poet's own genius bent to tasks unworthy of it by the whim of a fashionable woman. However this may be, there is assuredly something in Chrétien beyond the reach of all

[1] *Yvain*, 17 and 5394. The unrivalled position of Arthur's court as the home of courtesy becomes so fixed in later romantic tradition that it is acknowledged to have surpassed that of Charlemagne even by the partisans of the 'matter of France'. Cf. Boiardo, *Orlando Innamorato*, ii. xviii, stanzas 1 and 2: 'Fu gloriosa Bretagna la grande Una stagion' ... 'Re Carlo in Franza poi tenne gran corte, Ma a quella prima non fu somigliante ... Perche tenne ad amor chiuse le porte E sol si dette a le battaglie sante, Non fu di quel valore o quella stima Qual fu quell'altra.'

[2] *Cligés*, 3145–154, 5259–62. (But Foerster treats the second passage as an interpolation.)

[3] *Lancelot*, 26: *Matiere et san l'an done et livre La contesse.* v. G. Paris, op. cit., p. 523: also, the admirable tenth chapter of Vinaver's *Tristan et Iseut dans l'œuvre de Malory*, 1925.

changes of taste. After so many centuries, it needs no historical incantation to bring to life such lines as

> A! wher was so gret beautee maked?
> —God wroughte hir with His hond al naked,[1]

nor to appreciate the superb narrative power in the opening of the *Lancelot*. How irresistible is that cryptic knight who comes and goes we know not whence or whither, and lures the reader to follow as certainly as he lured the Queen and Kay. How nobly the poem of *Yvain* approaches to the romantic ideal of a labyrinthine tale in which the thread is never lost, and multiplicity does no more than illustrate an underlying singleness. For our present purpose, however, we must give Chrétien short shrift. What is of interest to us is that versatility which enables us to trace, in the distance between *Erec* and *Lancelot*, the extent of the emotional revolution which was taking place in his audience.

In *Erec*—almost certainly an early work[2]—the later rules of love and courtesy are outraged at every turn. It is indeed a love story; but it is a story of married love. The hero has married the heroine before the main action of the poem begins. This, in itself, is an irregularity; but the method of his wooing is worse. *Erec* sees *Enide* in her father's house, and falls in love with her. There are no passages of love between them: no humility on his part, no cruelty on hers. Indeed it is not clear that they converse at all. When he comes to the house, the maiden, at her father's command, leads his horse to stable and grooms it with her own hands. Later, when they are seated, the father and the guest talk of her in her presence as if she were a child or an animal. *Erec* asks her in marriage, and the father consents.[3] It does not seem to occur to the lover that the lady's will could be a relevant factor in this arrangement. We are given to understand that she is pleased, but only a passive role is expected of her, or indeed

[1] *Yvain*, 1497: 'Don fust si granz biautez venue? Ja la fist Deus de sa main nue.'
[2] For the probable chronology, see Cohen, op. cit., p. 87.
[3] *Erec*, 450–665.

allowed to her. The whole scene, however true it may be
to the marriage practices of the time, is strangely archaic
compared with the new ideals of love. We are back in a
world where women are merely the mute objects of gift
or barter, not only in the eyes of their fathers, but even
in the eyes of their lovers. When we pass on to the main
story, this lack of 'courtesy' is even more striking. The
tale of *Erec*'s behaviour to his wife will be familiar to
every one from Tennyson's *Geraint and Enid*. Chrétien
renders it more credible by following a version in which
the plot does not turn wholly on the absurd device of a
soliloquy overheard,[1] and in which the husband has subtler
and truer motives for his anger than Tennyson can give
him. But this does not alter the inherent brutality of the
theme. The story belongs to the same general type as that
of Griselda—the story of wifely patience triumphing over
ordeals imposed by the irresponsible cruelty of a husband
—and, as such, it cannot possibly reconcile itself with even
the most moderate ideal of courtesy. But Erec does not
confine his discourtesy within the limits of the ordeal.
Just as he had allowed Enide to groom his horse for him
before their marriage, so, in their journeyings, he lets her
watch and hold the horse all night, while he himself sleeps
at ease beneath the cloak which she has taken from her own
back to cover him.[2]

When we turn to the *Lancelot* all this is changed. The
Chrétien of *Lancelot* is first and foremost the Chrétien who
has translated Ovid's *Art of Love*,[3] and who lives at the
court of my lady of Champagne—herself an ultimate
authority on all questions of courtly love. As against the
married life of Erec and Enide we have the secret love of
Lancelot and Guinevere. The story turns mainly on the
Queen's captivity in the mysterious land of Gorre, where
those that are native can go both in and out but strangers
can only go in,[4] and on her rescue thence by Lancelot. It

[1] A soliloquy *is* overheard in Chrétien, but it is the resulting conversation which
matters (*Erec*, 2515–83).
[2] *Erec*, 3095–102. [3] *Cligés*, 2, 3. [4] *Lancelot*, 1919 et seq.

is one of Chrétien's misfortunes that the dark and tremendous suggestions of the Celtic myth that lurks in the background of his story should so far (for a modern reader) overshadow the love and adventure of the foreground. He has, however, no conception of this. We think of the Middle Ages playing with the scattered fragments of classical antiquity, and failing to understand them, as when, by an intolerable degradation, they make Virgil a magician. But indeed they have dealt as roughly with the fragments of the barbarian past, and understood them as little: they have destroyed more magic than they ever invented. Lancelot sets out to find the Queen and almost at once loses his horse. In this predicament he is met by a dwarf driving a tumbril. To his questions, the dwarf—surly like all his race—replies, 'Get in, and I will bring you where you shall have news of the Queen'. The knight hesitates for a moment before mounting the cart of shame and thus appearing as a common criminal; a moment later he obeys.[1] He is driven through streets where the rabble cry out upon him and ask what he has done and whether he is to be flayed or hanged. He is brought to a castle where he is shown a bed that he must not lie in because he is a knight disgraced. He comes to the bridge that crosses into the land of Gorre—the sword-bridge, made of a single blade of steel—and is warned that the high enterprise of crossing it is not for one so dishonoured as he. 'Remember your ride on the cart', says the keeper of the bridge. Even his friends acknowledge that he will never be rid of the disgrace.[2] When he has crossed the bridge, wounded in hands, knees, and feet, he comes at last into the presence of the Queen. She will not speak to him. An old king, moved with pity, presses on her the merits of his service. Her reply, and the scene that follows, deserve to be quoted in full:

> 'Sire, alle his tyme is spilt for noght,
> For sooth to seyn he hath at me
> No thankes wonnen ne no gree'.

[1] Ibid. 364 et seq. [2] Ibid. 2620 et seq.

> Lancelot sory chere maketh
> Yet lyk a lovere al he taketh
> In meknesse and seyth humblely,
> 'Dame, I am greved certeinly;
> Yet, for the cause of your chiding,
> I dar nat asken for no thing'
> Greet pleynte tho to make him liste
> If that the Quene wolde hit liste,
> But to encrese his were and wo,
> She yeveth him no wordes mo.
> Into a bour she paceth nouthe,
> And evere as ferforth as he couthe
> This Lancelot with eyen two
> Hir folwed and with herte also.[1]

It is only later that he learns the cause of all this cruelty. The Queen has heard of his momentary hesitation in stepping on to the tumbril, and this lukewarmness in the service of love has been held by her sufficient to annihilate all the merit of his subsequent labours and humiliations. Even when he is forgiven, his trials are not yet at an end. The tournament at the close of the poem gives Guinevere another opportunity of exercising her power. When he has already entered the lists, in disguise, and all, as usual, is going down before him, she sends him a message ordering him to do his poorest. Lancelot obediently lets himself be unhorsed by the next knight that comes against him, and

[1] *Lancelot*, 3975–89:

> 'Sire, voir, mal l'a anploiié—
> Ja par moi ne fera noiié
> Que je ne l'an fai point de gre.'
> Ez vos Lancelot trespansé,
> Si li respont mout humblemant
> A maniere de fin amant:
> 'Dame, certes, ce poise moi,
> Ne je n'os demander par quoi.'
> Lanceloz mout se demantast
> Se la reïne l'ecoutast;
> Mes par lui grever et confondre
> Ne li viaut un seul mot respondre,
> Ainz est an une chanbre antree;
> E Lanceloz jusqu'a l'antree
> Des iauz et del cuer la convoie'.

then takes to his heels, feigning terror of every combatant
that passes near him. The herald mocks him for a coward
and the whole field takes up the laugh against him: the
Queen looks on delighted. Next morning the same com-
mand is repeated, and he answers, 'My thanks to her, if
she will so'. This time, however, the restriction is with-
drawn before the fighting actually begins.[1]

The submission which Lancelot shows in his actions is
accompanied, on the subjective side, by a feeling that
deliberately apes religious devotion. Although his love is
by no means supersensual and is indeed carnally rewarded
in this very poem, he is represented as treating Guinevere
with saintly, if not divine, honours. When he comes before
the bed where she lies he kneels and adores her: as Chré-
tien explicitly tells us, there is no *corseynt* in whom he has
greater faith. When he leaves her chamber he makes a
genuflexion as if he were before a shrine.[2] The irreligion
of the religion of love could hardly go further. Yet
Chrétien—whether he is completely unconscious of the
paradox, or whether he wishes, clumsily enough, to make
some amends for these revolting passages—represents his
Lancelot as a pious man and goes out of his way to show
him dismounting when he passes a church, and entering
to make his prayer; by which, according to Chrétien, he
proves both his courtesy and wisdom.[3]

Chrétien de Troyes, judged by modern standards, is on
the whole an objective poet. The adventures still occupy
the greater part of his stories. By the standard of his own
times, on the other hand, he must have appeared strikingly
subjective. The space devoted to action that goes forward
only in the souls of his characters was probably beyond all
medieval precedent.[4] He was one of the first explorers
of the human heart, and is therefore rightly to be num-
bered among the fathers of the novel of sentiment. But

[1] Ibid. 5641 et seq.
[2] Ibid. 4670–1 ('Car an nul cors saint ne croit tant') and 4734 et seq.
[3] Ibid. 1852 et seq.
[4] But cf. the admirable conversation between Amata and Lavinia quoted from
the *Eneas* by Cohen, op. cit., pp. 44 et seq.

these psychological passages have usually one characteristic which throws special light on the subject of this book. Chrétien can hardly turn to the inner world without, at the same time, turning to allegory. No doubt the Provençals here served him as a model; no doubt both the poet and his audience loved the method for its own sake, and found it clever and refined. Yet it would not surprise us if Chrétien found some difficulty in conceiving the inner world on any other terms. It is as if the insensible could not yet knock at the doors of the poetic consciousness without transforming itself into the likeness of the sensible: as if men could not easily grasp the reality of moods and emotions without turning them into shadowy *persons*. Allegory, besides being many other things, is the subjectivism of an objective age. When Lancelot hesitates before mounting the cart, Chrétien represents his indecision as a debate between *Reason* which forbids, and *Love* which urges him on.[1] A later poet would have told us directly—though not, after all, without metaphor—what Lancelot was feeling: an earlier poet would not have attempted such a scene at all. In another place Lancelot is asked by a lady for the head of a knight whom he has just disabled. The knight begs for mercy, and two duties within the chivalrous code are thus brought into collision. The resulting state of Lancelot's mind becomes for Chrétien a debate between Largesse and Pitë. Each fears defeat and between them they hold him a prisoner.[2] Again, in *Yvain*, where Gawain and the hero, who are fast friends, meet without recognition and fight, the contrast between their amicable intentions and their hostile acts is worked up into a very elaborate allegory of Love and Hate—Hate looking from the windows, Hate mounting into the saddle, while Love (here used in its larger sense), who shares the same house, is upbraided for skulking in an inner room and not coming to the rescue.[3] This certainly seems frigid to a modern reader, and does not rise as naturally from the

[1] *Lancelot*, 369–81.
[2] Ibid. 2844–61. [3] *Yvain*, 6001 et seq.

context as those which I have quoted from the *Lancelot*.
Yet we should beware of supposing too hastily that the poet
is merely being clever. It is quite possible that the house
with many rooms where Love can be lost in the back-
ground, while Hate holds the hall and the courtyard,
may have come to Chrétien as a real revelation of the
workings of circumstance to produce such various actions
from the emotions of a single heart. We have to worm our
way very cautiously into the minds of these old writers:
an *a priori* assumption as to what can, and what can not,
be the expression of real imaginative experience is the
worst possible guide. The allegory of the Body and the
Heart[1]—also from *Yvain*—is an interesting example. That
Chrétien has borrowed it from Provence does not in the
least alter the fact that it is for him an expression—perhaps
the only possible expression—of something well and truly
imagined. But he has not yet learned the art of dropping
such tools when they have done their work. The glitter
of the weapon takes his fancy when the thrust has already
been given, and here we may feel almost confident that
what begins as live allegory dies into mere virtuosity in
the course of the next ten lines. The more commonplace,
and reiterated, allegory of Death in *Cligés* will recur to
the memory of any of its readers.[2]

The figure of Love personified himself is almost equally
connected with the subject of the 'love-religion' and with
that of allegory. The references to his archery in *Cligés*[3]
belong to a familiar type, and might come out of any
classical love-poet. The idea of Love as an avenging god,
coming to trouble the peace of those who have hitherto
scorned his power, belongs also to the Latin tradition, but
it is more serious for Chrétien than for Ovid. The repen-
tance of those who had been fancy free, and their self-
surrender to a new deity, are touched with a quasi-religious
emotion. Alexander, in *Cligés*, after a brief resistance,

[1] Ibid., 2639 et seq. The Provençal parallels are mentioned by J. Morawski,
Romania, liii, p. 187 n.

[2] *Cligés*, 5855 et passim.　　　　　　[3] Ibid. 460, 770.

confesses that love chastens him thus in order to instruct him. 'Let him do with me as he will, for I am his.' Soredamors, in the same poem, acknowledges that Love has humbled her pride by force, and doubts whether such extorted service will find favour.[1] In the same spirit Yvain determines to offer no resistance to his passion: not only to resist love, but even to yield unwillingly, is an act of treason against the god. Those who have thus sinned against him deserve no happiness.[2] In *Lancelot* the same doctrine is carried further. It is only the noblest hearts which Love deigns to enslave, and a man should prize himself the more if he is selected for such service. We find also the conception of lovers as the members of an *order* of Love, modelled upon the orders of religion: of an *art* of Love, as in Ovid; and of a *court* of Love, with solemn customs and usages, modelled upon the feudal courts of the period.[3] It will be seen that no final distinction is possible between the erotic religion, the erotic allegory, and the erotic mythology.

<div align="center">III</div>

In Chrétien de Troyes we see the developed theory of love put into action in the course of stories. His teaching takes the form of example rather than precept, and, to do him justice, the purely narrative interest is never for long subordinated to the didactic. Having thus studied the new ideal in the ὕλη, embodied and partly concealed in story, we naturally look next for a professedly theoretical work on the same subject, wherewith to finish off our sketch. Such a work is ready for us in the *De Arte Honeste Amandi* of Andreas Capellanus[4] (André the chaplain). It was probably written early in the thirteenth century, and is in Latin prose. The style is agreeable and easy, though the author's favourite *cursus* often makes his sentences end like hexameters in a way strange to classical ears.

The *De Arte* takes the form of methodical instruction

[1] *Cligés*, 682, 941. [2] *Yvain*, 1444. [3] *Cligés*, 3865; *Yvain*, 16.
[4] Ed. Trojel (Hauniae, 1892). For chronology *v.* G. Paris, op. cit.

in the art of love-making given by the Chaplain to a certain
Walter; but after a very few definitions and preliminary
considerations the author proceeds to illustrate his subject
by a series of ideal dialogues, adapted for the use of lovers
in various social positions. We are shown by specimen
conversations how a man who is *nobilis* ought to approach
a woman who is *nobilior*, or how a *plebeius* should woo a
plebeia; even how a *plebeius* ought to woo a *nobilis* or a *nobi-*
lior. It thus comes about that during the greater part of
his work Andreas is not speaking in his own person, and
that he uses, through these imaginary mouthpieces, the
most different kinds of argument. This would present us
with a serious difficulty if it were our object to give an
account of the author's mind; but it is less serious if we
wish to study (what is very much more interesting) the
characteristics of the theory of love as it existed in the
general mind of the period. The occurrence of a given
opinion in these imaginary dialogues does not tell us what
Andreas thought; but it is tolerably good evidence that
such an opinion was part of the body of floating ideas on
the subject. We can hardly suppose that he would hold
up, for the imitation of his pupil, speeches containing
arguments and ideas which were not 'correct' by the
standard of the best courtly tradition. I cannot promise
that I shall not fall into such convenient expressions as
'Andreas says'; but all these are to be understood under
the *caveat* given above.

The definition of love on the first page of this work rules
out at once the kind of love that is called 'Platonic'.[1] The
aim of love, for Andreas, is actual fruition, and its source
is visible beauty: so much so, that the blind are declared
incapable of love, or, at least, of entering upon love after
they have become blind.[2] On the other hand, love is not
sensuality. The sensual man—the man who suffers from

[1] The distinction made in *De Arte Honeste Amandi*, i. 69 (Trojel's edition, p.
182) between *purus amor* and *mixtus*, leaves *purus amor* far from Platonic. Besides,
the Lady rejects it as absurd (ibid., p. 184).
[2] Ibid. i. 5 (p. 12 in Trojel's edition).

abundantia voluptatis—is disqualified from participating in it.[1] It may even be claimed that love is a 'kind of chastity', in virtue of its severe standard of fidelity to a single object.[2] The lover must not hope to succeed, except with a foolish lady, by his *formae venustas*, but by his eloquence, and, above all, by his *morum probitas*. The latter implies no mean or one-sided conception of character. The lover must be truthful and modest, a good Catholic, clean in his speech, hospitable, and ready to return good for evil. He must be courageous in war (unless he is a clerk) and generous of his gifts. He must at all times be courteous. Though devoted in a special sense to one lady, he must be ready to perform *ministeria et obsequia* for all.[3] With such a conception of the lover's qualifications, it is not surprising that Andreas should return again and again to the power of love for good. 'It is agreed among all men that there is no good thing in the world, and no courtesy, which is not derived from love as from its fountain.'[4] It is 'the fountain and origin of all good things'; without it 'all usages of courtesy would be unknown to man'.[5] The lady is allowed free choice in her acceptance or rejection of a lover in order that she may reward the merit of the best: she must not abuse this power in order to gratify her own fancies. By admitting a worthy lover to her favours she does well. Only women who are 'enlisted in the soldiery of love' are praised among men. Even a young unmarried woman should have a lover. It is true that her husband, when she marries, is bound to discover it, but if he is a wise man he will know that a woman who had not followed the 'commands of love' would necessarily have less *probitas*.[6] In fine, all that is *in saeculo bonum*, all that is good in this present world, depends solely upon love. And yet, if the author's ideal of the *probitas* demanded in a lover goes far to explain this praise of love, we must yet remember that that

[1] *De Arte Honeste Amandi*, i. 5 (p. 13).
[2] Ibid. i. 4 'amor reddit hominem castitatis quasi virtute decoratum' (p. 10).
[3] Ibid. ii. 1 (p. 241). [4] Ibid. i. 6 A (p. 28).
[5] Ibid. i. 6 D (p. 81). [6] Ibid. i. 6 G (p. 181).

ideal has its clearly defined limits. Courtesy demands that
the lover should serve all *ladies*, not all *women*. Nothing
could mark more plainly the negative side of this courtly
tradition than the short chapter in which Andreas ex-
plains that if you are so unfortunate as to fall in love with
a peasant woman, you may, *si locum inveneris opportunum*,
make use of *modica coactio*. It is hardly possible otherwise,
he adds, to overcome the *rigor* of these creatures.[1]

As the source of all worldly goodness, love must be
thought of as a state of mind; but the rules which Andreas
lays down for its conduct remind us that it is also an art.
The elaboration of the art has now become so subtle
as to lead to hard cases which demand an expert solu-
tion; and he bases his judgements on the decisions
given by certain noble ladies to whom such problems
have been referred. The whole of his curious chapter
De variis iudiciis amoris is filled with them. Some of
these problems arise concerning the limits of obedience.
A lover has been commanded by his lady to cease to serve
her. Later, hearing her defamed, he speaks in her defence.
Is he then guilty of disobedience? The Countess of Cham-
pagne ruled that he was not: the lady's command, being
wrong in the first instance, has no binding force.[2] What
is the courtly law in the case of two lovers who find out
that they are related within the degrees which would have
forbidden their union by marriage? They must part at
once. The table of kindred and affinity which applies to
marriage applies also to loving *par amours*.[3] Rulings are
given as to the presents which a lady may receive without
being condemned as mercenary. The duty of secrecy in
love—one of the legacies of this code to modern society—
is strongly enforced, and the vice of detraction is blamed.[4]
But perhaps no rule is made clearer than that which ex-
cludes love from the marriage relation. 'Dicimus et stabi-

[1] Ibid. i. 11 (p. 236). Cf. the very close parallel in Malory, iii. 3: 'she told the
King and Merlin that when she was a maid and went to milk kine, there met
with her a stern knight, and *half by force*, etc.'

[2] Ibid. ii. 7 (pp. 271–3).

[3] Ibid. ii. 7 (p. 279).

[4] Ibid. i. 6 c (p. 65).

lito tenore firmamus amorem non posse suas inter duos iugales extendere vires.'¹ The disabling influence of marriage extends even after marriage has been dissolved: love between those who were formerly married to each other and are now divorced is pronounced by the lady of Champagne to be *nefandus*. And yet there are passages which suggest that the chivalrous code, however anti-matrimonial in principle, has already done something to soften the old harshness of the relations between husband and wife. Andreas finds it necessary to recognize the possibility of *maritalis affectio* and to prove at some length that it is different from *Amor*.² The proof is very illuminating. Conjugal affection cannot be 'love' because there is in it an element of duty or necessity: a wife, in loving her husband, is not exercising her free choice in the reward of merit, and her love therefore cannot increase his *probitas*. There are minor reasons too—conjugal love is not furtive, and jealousy, which is of the essence of true love, is merely a pest in marriage. But it is the first reason which puts this 'theory of adultery' before us in its most sympathetic, and therefore in its truest, light. The love which is to be the source of all that is beautiful in life and manners must be the reward freely given by the lady, and only our superiors can reward. But a wife is not a superior.³ As the wife of another, above all as the wife of a great lord, she may be queen of beauty and of love, the distributor of favours, the inspiration of all knightly virtues, and the bridle of 'villany';⁴ but as your own wife, for whom you have bargained with her father, she sinks at once from lady

¹ *De Arte Honeste Amandi*, i. 6ꜰ (p. 153). ² Ibid., pp. 141 et seq.

³ Even where a love affair, conducted hitherto on the courtly model, ends in marriage, later medieval feeling regards this as completely reversing the previous relations of the lovers; cf. *Amadis of Gaul* (Southey's translation 1872, vol. iii, pp. 258, 259, bk. iv, c. 29). 'O lady, with what services can I requite you, that by your consent our loves are now made known? Oriana answered, It is now, Sir, no longer time that you should proffer such courtesies, or that I should receive them. I am now to follow and observe your will with that obedience which wife owes to husband.'

⁴ Cf. Chaucer, *Compleynt of Mars*, 41: 'She brydeleth him in her manere With nothing but with scourging of her chere'.

into mere woman. How can a woman, whose duty is to obey you, be the *midons* whose grace is the goal of all striving and whose displeasure is the restraining influence upon all uncourtly vices? You may love her in a sense; but that is not love, says Andreas, any more than the love of father and son is *amicitia*.[1] We must not suppose that the rules of love are most frivolous when they are most opposed to marriage. The more serious they are, the more they are opposed. As I have said before, where marriage does not depend upon the free will of the married, any theory which takes love for a noble form of experience must be a theory of adultery.

To the love religion, or rather to the love mythology, Andreas makes interesting contributions. In the *Council of Remiremont* we have seen the god Amor already provided with a gospel, cardinals, visitations, and the power to curse his heretical subjects. Andreas goes far to complete his parallelism with the God of real religion. In one of the imaginary conversations a lady pleads to be excused on the ground that she does not reciprocate her lover's feelings, and there's an end of the matter. 'At that rate', retorts the lover, 'a sinner might plead to be excused on the ground that God had not given him grace.' 'On the other hand', says the lady, 'just as all our works without charity cannot merit eternal bliss, so it will be unavailing to serve Love *non ex cordis affectione*.'[2] All that was left was to attribute to Love the divine power of reward and punishment after death, and this is actually done. The story which Andreas tells on this subject is one of the freshest passages of his work.[3] Looking forward from it, we can foresee a well-known tale in Boccaccio, Gower, and Dryden: looking backward, we perhaps come into touch again with the buried stratum of barbarian mythology. It begins, as a good story should, with a young man lost in a forest.

[1] *De Arte Honeste Amandi*, p. 142.
[2] Ibid. i. 6 ε (p. 123).
[3] Ibid. i. 6 ᴅ², pp. 91–108. The parallels are collected by W. Neilson in *Romania*, xxix: he regards that found in the *Lai du Trot* as slightly earlier than Andreas's version.

His horse had wandered while he slept, and as he searches for it he sees three companies go by. In the first, led by a lovely knight, rode ladies, richly horsed and each attended by a lover on foot. In the second, there were ladies surrounded by such a crowd and tumult of contending servitors that they wished for nothing but to be out of the noise. But the third company rode bareback on wretched nags *macilentos valde et graviter trottantes*, unattended, clothed in rags, and covered with the dust of those that went before. As might be expected, the first party consists of ladies who in their life on earth served love wisely; the second, of those who gave their kindness to all that asked it; and the third *omnium mulierum miserrimae*, of those implacable beauties who were deaf to every lover's prayer. The mortal follows this procession through the woods, until he is brought into a strange country. There stood the thrones of the king and queen of Love beneath the shadow of a tree that bears all kinds of fruit; and beside them rose a fountain as sweet as nectar, from which innumerable rivulets overflowed and watered the surrounding glades, winding their way in every direction among the couches which were there prepared for the true lovers who rode in the first company. But beyond and around this pleasant place, which is called *Amoenitas*, lay the realm of *Humiditas*. The streams from the central fountain had turned icy cold before they reached this second country, and there, collecting in the low ground, formed a great swamp, cold beneath, and treeless, but glaring under a fierce sun. Here was the appointed place for the ladies of the second company. Those of the third were confined in the outermost circle of all, the burning desert of *Siccitas*, and seated upon bundles of sharp thorn which the tormentors kept in continual agitation beneath them. Lest anything should be lacking to this extraordinary parody or reflection of the Christian afterworld, the story ends with a remarkable scene in which the mortal visitor is brought before the throne, presented with a list of the commandments of Love, and told to report on earth this

vision which has been allowed him in order that it may
lead to the 'salvation' of many ladies (*sit multarum domi-
narum salutis occasio*).[1] The second story which he tells is
less theological; and though it also ends with the com-
mandments of love, they are won, together with the Hawk
of Victory, from Arthur's court and not from the next
world.[2] Elsewhere, as usual, there are things that lie on
the borderland between allegory and mythology. Such
passages, however audacious they may appear, are clearly
flights of fancy, far removed, indeed, from the comedy of
the *Council*, but equally far removed from anything that
could be regarded as a serious 'religion of love'. Andreas
is at his gravest not here but in those places, which I re-
ferred to above, where he dwells upon the power of love
to call forth all knightly and courtly excellences: love
which makes beautiful the *horridus* and *incultus*,[3] which
advances the most lowly born to true nobility, and
humbles the proud. If this is not a religion, it is, at any
rate, a system of ethics. Of its relation with the other,
the Christian, system, Andreas tells us a good deal. As
against the author of the *Council*, he states plainly that
nuns ought not to be the servants of Love—and ends the
passage with a comic account of his own experiences which
is not one of his most chivalrous passages.[4] With *Clerici*,
on the other hand, the case is different. They are only
men, after all, conceived in sin like the rest, and indeed
more exposed than others to temptation *propter otia multa
et abundantiam ciborum*. Indeed, it is very doubtful
whether God seriously meant them to be more chaste
than the laity. It is teaching, not practice, that counts.
Did not Christ say '*secundum opera illorum nolite facere?*'[5]

[1] *De Arte Honeste Amandi*, i. 6 D[2], p. 105: 'Nostra tibi sunt concessa videre
magnalia ut per te nostra valeat ignorantibus revelari et ut tua praesens visio
sit multarum dominarum salutis occasio.'

[2] Ibid. ii. 8 (pp. 295–312).

[3] Ibid. i. 4 (p. 9). [4] Ibid. i. 8 (p. 222).

[5] Ibid. i. 7 (p. 221), i. 6 G (pp. 186–8). He interprets the passage from the Gospel
as meaning 'Credendum est dictis clericorum quasi legatorum Dei, sed quia
carnis tentationi sicut homines ceteri supponuntur, eorum non inspiciatis opera
si eos contigerit aliquo deviare'.

He is anxious to point out that the code of love agrees with
'natural morality'. 'Incestuous' and 'damnable' unions are
equally forbidden by both.¹ He includes ordinary piety
and a reverence for the saints among the virtues without
which no man is qualified to be a lover. Heresy in the
knight justifies a lady in withdrawing her favour from him.
'And yet', he says, in a very significant passage, 'some
people are so extremely foolish as to imagine that they
recommend themselves to women by showing contempt
for the Church.'² We have a sudden glimpse of a party
who had grasped the fundamental incompatibility between
Frauendienst and religion, who delighted to emphasize it
by a freedom (probably crude enough) of the tongue; and
of another party, to which Andreas belongs, who want
nothing less than emphasis. That may be the meaning,
too, of the piety which Chrétien ascribes to Lancelot—
an object-lesson for the ribald left wing of the courtly
world. Yet while Andreas thus wishes to christianize his
love theory as far as possible, he has no real reconciliation.
His nearest approach to one is a tentative suggestion on
the lines of Pope; 'Can that offend great Nature's God
which Nature's self inspires?'—on which we can have no
better comment than the words of the lady, in the same
conversation, a few lines later, *sed divinarum rerum ad
praesens disputatione omissa* . . . 'Leaving the religious side
of the question out for a moment'—and then she turns to
the real point.³

For the truth is that the rift between the two worlds
is irremediable. Andreas repeatedly recognizes this.
'Amorem exhibere est graviter offendere deum.'⁴ Marriage
offers no compromise. It is a mistake to suppose that the
vehemens amator can escape *sine crimine* by the impro-
priety (from the courtly point of view) of loving his own

¹ *De Arte Honeste Amandi* i. 2 (p. 7) 'Quidquid natura negat amor erubescit
amplecti.' Also ii. 7, Jud. 7 (p. 279).
² Ibid. i. 6 c (p. 68).
³ Ibid. i. 6 ɢ (p. 162): 'Credo tamen in amore Deum graviter offendi non posse;
nam quod natura cogente perficitur facili potest expiatione mundari'. And p. 164.
⁴ Ibid., p. 159.

wife. Such a man is *in propria uxore adulter*. His sin is
heavier than that of the unmarried lover, for he has abused
the sacrament of marriage.[1] And that is precisely why the
whole world of courtesy exists only by 'leaving the reli-
gious side of the question out for a moment'. Once bring
that in, as the lover argues in the same passage, and you
must give up, not only loving *par amours*, but the whole
world as well.[2] As if this were not sufficiently clear,
Andreas has a surprise for the modern reader at the begin-
ning of the last book. Having written two books on the
art of love, he suddenly breaks off and begins anew: 'You
must read all this, my dear Walter, not as though you
sought thence to embrace the life of lovers, but that being
refreshed by its doctrine and having well learned how to
provoke the minds of women to love, you may yet abstain
from such provocation, and thus merit a greater reward.'
All that has gone before, we are given to understand, has
been written in order that Walter, like Guyon, may see,
and know, and yet abstain. 'No man through any good
deeds can please God so long as he serves in the service of
Love.' 'Quum igitur omnia sequantur ex amore nefanda'
. . . and the rest of the book is a palinode.[3]

What are we to make of this *volte-face*? That the
Chaplain's love-lore is pure joking, or that his religion is
rank hypocrisy? Neither the one nor the other. It is more
probable that he meant what he said when he told us that
love was the source of everything *in saeculo bonum*, and it is
our fault if we are apt to forget the limitation—*in saeculo*.
It is significant that we cannot even translate it 'worldly'
good. 'Worldliness' in modern, or at least in Victorian,
language does not really refer to the values of this world
(*hoc saeculum*) as contrasted with the values of eternity:

[1] Ibid. i. 6 F (p. 147).

[2] Ibid. i. 6 G (p. 161 et seq.): 'Nec obstare potest quod Deum in amore narratis
offendi, quia cunctis liquido constare videtur quod Deo servire summum bonum
ac peculiare censetur; sed qui Domino contendunt perfecte servire eius prorsus
debent obsequio mancipari et iuxta Pauli sententiam nullo saeculari debent adim-
pleri negotio. Ergo, si servire Deo tantum vultis eligere, mundana vos oportet
cuncta relinquere.' [3] Ibid. iii. 1 (pp. 314 et seq.).

it merely contrasts, inside a single world, what is con-
sidered baser—as avarice, personal ambition, and the like—
with what is considered nobler, as conjugal love, learning,
public service. But when Andreas talks of the *bonum in
saeculo* he means what he says. He means the really good
things, in a human sense, as contrasted with the really bad
things: courage and courtesy and generosity, as against
baseness. But, rising like a sheer cliff above and behind
this humane or secular scale of values, he has another which
is not to be reconciled with it, another by whose standard
there is very little to choose between the 'worldly' good
and the 'worldly' bad. That very element of parodied or,
at least, of imitated religion which we find in the courtly
code, and which looks so blasphemous, is rather an expres-
sion of the divorce between the two.[1] They are so com-
pletely two that analogies naturally arise between them:
hence comes a strange reduplication of experience. It is
a kind of proportion sum. Love is, *in saeculo*, as God is,
in eternity. *Cordis affectio* is to the acts of love as charity
is to good works. But of course there is for Andreas, in a
cool hour, no doubt as to which of the two worlds is the
real one, and in this he is typical of the Middle Ages.
When *Frauendienst* succeeds in fusing with religion, as in
Dante, unity is restored to the mind, and love can be
treated with a solemnity that is whole-hearted. But where
it is not so fused, it can never, under the shadow of its
tremendous rival, be more than a temporary truancy. It
may be solemn, but its solemnity is only for the moment.
It may be touching, but it never forgets that there are
sorrows and dangers before which those of love must be

[1] The double standard of values, with a worldly *good* equally distinct from mere
'worldliness' on the one hand, and from heavenly good on the other, which is indeed
the origin of the idea of the *gentleman*, survived, of course, almost to our own times.
In Wyatt's *Defence* ('I grant I do not profess chastity, but yet I use not abomina-
tion') it has almost the air of the distinction between an Honours School and a
Pass School. It is significant that the final abandonment of the double standard
in Victorian times (with the consequent attempt to include the whole of morality
in the character of the *gentleman*) was the prelude to the *gentleman*'s disappearance
as an ideal; the very name being now, I understand, itself ungenteel and given
over to ironical uses. *Suos patitur manes.*

ready, when the moment comes, to give way. Even Ovid had furnished them with a model by writing a *Remedium Amoris* to set against the *Ars Amatoria*:[1] they had added reasons of their own for following the precedent. The authors are all going to repent when the book is over. The Chaplain's palinode does not stand alone. In the last stanzas of the book of Troilus, in the harsher recantation that closes the life and work of Chaucer as a whole, in the noble close of Malory, it is the same. We hear the bell clang; and the children, suddenly hushed and grave, and a little frightened, troop back to their master.

[1] It is perhaps worth noting that in one manuscript the rubric of Andreas's Third Book runs *Incipit liber remedii seu derelinquendi amorem* (Trojel, p. 313 n. 1).

ADDITIONAL NOTE to *p.* 8

In all questions of literary origin and influence the principle *quidquid recipitur recipitur ad modum recipientis* must be constantly remembered. I have endeavoured to point out above that 'Ovid misunderstood' explains nothing till we have accounted for a consistent misunderstanding in a particular direction. For the same reason I have said nothing of *Aeneid IV*, and other places in ancient poetry, which are sometimes mentioned in discussions of Courtly Love. The story of Dido provides much material that can be used, and was used, in courtly love poetry, *after* Courtly Love has come into existence: but till then, it will be read for what it is—a tragic and exemplary story of ancient love. To think otherwise is as if we should call classical tragedy the cause of the Romantic Movement because Browning and Swinburne, after Romantic poetry has arisen, can use classical tragedy for romantic purposes.

II. ALLEGORY

'Veramente li teologi questo senso prendono altrimenti che li poeti.' DANTE.

I

IN the last chapter we traced the growth of the sentiment of courtly love down to a point at which that sentiment was already beginning to express itself by means of allegory. It now remains to consider independently the history of the allegorical method, and for this purpose we must return to classical antiquity. In our new inquiry, however, there is no question of finding and no possibility of imagining, the *ultimate* origins. Allegory, in some sense, belongs not to medieval man but to man, or even to mind, in general. It is of the very nature of thought and language to represent what is immaterial in picturable terms. What is good or happy has always been high like the heavens and bright like the sun. Evil and misery were deep and dark from the first. Pain is black in Homer, and goodness is a middle point for Alfred no less than for Aristotle.[1] To ask how these married pairs of sensibles and insensibles first came together would be great folly; the real question is how they ever came apart, and to answer that question is beyond the province of the mere historian.[2] Our task is less ambitious. We have to inquire how something always latent in human speech becomes, in addition, explicit in the structure of whole poems; and how poems of that kind come to enjoy an unusual popularity in the Middle Ages.

It is possible to limit our scope even farther. This fundamental equivalence between the immaterial and the material may be used by the mind in two ways, and we need here be concerned with only one of them. On the one hand you can start with an immaterial fact, such as

[1] *Medemnesse*; cf. Goth. *midjis*, Skrt. *madbyas*. For the presence of both senses ('middling' and 'good') in OE., *v.* Bosworth and Toller, s.v. *Medume*.

[2] See O. Barfield's *Poetic Diction* (1928).

the passions which you actually experience, and can then
invent *visibilia* to express them. If you are hesitating
between an angry retort and a soft answer, you can express
your state of mind by inventing a person called *Ira* with
a torch and letting her contend with another invented
person called *Patientia*. This is allegory, and it is with
this alone that we have to deal. But there is another way
of using the equivalence, which is almost the opposite of
allegory, and which I would call sacramentalism or sym-
bolism. If our passions, being immaterial, can be copied
by material inventions, then it is possible that our material
world in its turn is the copy of an invisible world. As the
god Amor and his figurative garden are to the actual
passions of men, so perhaps we ourselves and our 'real'
world are to something else. The attempt to read that
something else through its sensible imitations, to see the
archtype in the copy, is what I mean by symbolism or
sacramentalism. It is, in fine, 'the philosophy of Hermes
that this visible world is but a picture of the invisible,
wherein, as in a portrait, things are not truly but in equi-
vocal shapes, as they counterfeit some real substance in
that invisible fabrick'. The difference between the two
can hardly be exaggerated. The allegorist leaves the given
—his own passions—to talk of that which is confessedly
less real, which is a fiction. The symbolist leaves the given
to find that which is more real. To put the difference in
another way, for the symbolist it is we who are the allegory.
We are the 'frigid personifications'; the heavens above us
are the 'shadowy abstractions'; the world which we mis-
take for reality is the flat outline of that which elsewhere
veritably is in all the round of its unimaginable dimensions.

The distinction is important because the two things,
though closely intertwined, have different histories and
different values for literature. Symbolism comes to us
from Greece. It makes its first effective appearance in
European thought with the dialogues of Plato. The Sun
is the copy of the Good. Time is the moving image of
eternity. All visible things exist just in so far as they

succeed in imitating the Forms. Neither the lack of manuscripts nor the poverty of Greek scholarship prevented the Middle Ages from absorbing this doctrine. It is not my business here to trace in detail the lines of its descent; and perhaps it would be idle to look for particular sources. The diffused Platonism, or Neoplatonism—if there is a difference—of Augustine, of the pseudo-Dionysius, of Macrobius, of the divine popularizer Boethius, provided the very atmosphere in which the new world awoke. How thoroughly the spirit of symbolism was absorbed by full-grown medieval thought may be seen in the writings of Hugo of St. Victor. For Hugo, the material element in the Christian ritual is no mere concession to our sensuous weakness and has nothing arbitrary about it. On the contrary there are three conditions necessary for any sacrament, and of these three the positive ordinance of God is only the second.[1] The first is the pre-existing *similitudo* between the material element and the spiritual reality. Water, *ex naturali qualitate*, was an image of the grace of the Holy Ghost even before the sacrament of baptism was ordained. *Quod videtur in imagine sacramentum est.* On the literary side the chief monuments of the symbolical idea, in the Middle Ages, are the *Bestiaries*; and I should distrust the judgement of the critic who was unaware of their strange poetry, or who did not feel it to be wholly different in kind from that of the allegories. But of course the poetry of symbolism does not find its greatest expression in the Middle Ages at all, but rather in the time of the romantics; and this, again, is significant of the profound difference that separates it from allegory.

I labour the antithesis because ardent but uncorrected lovers of medieval poetry are easily tempted to forget it. Not unnaturally they prefer symbol to allegory; and when an allegory pleases them, they are therefore anxious to

[1] Hugo of St. Victor, *De Sacramentis Fidei*, lib. i, pars ix, c. ii: 'Habet autem omnis aqua ex naturali qualitate similitudinem quamdam cum gratia Spiritus Sancti . . . et ex hac ingenita qualitate omnis aqua spiritalem gratiam repraesentare habuit, priusquam etiam illam ex superaddita institutione significavit' (Migne, tom. clxxvi, p. 318).

pretend that it is not allegory but symbol. It seems chilling to be told that *Amor* in the *Vita Nuova* is only a personification; we would willingly believe that Dante, like a modern romantic, feels himself to be reaching after some transcendental reality which the forms of discursive thought cannot contain. It is quite certain, however, that Dante feels nothing of the kind; and to put an end to such misconceptions once and for all, we had better turn to Dante's own words. They will have the added advantage of giving us our first clue to the history of allegory.

'You may be surprised', says Dante, 'that I speak of love as if it were a thing that could exist by itself; and not only as if it were an intelligent substance, but even as if it were a corporeal substance. Now this, according to the truth, is false. For love has not, like a substance, an existence of its own, but is only an accident occurring *in* a substance.'[1] However the personification is to be defended, it is clear that Dante has no thought of pretending that it is more than a personification. It is, as he says himself a moment later, *figura o colore rettorico*, a piece of technique, a weapon in the armoury of ῥητορική. As such it is naturally defended by an appeal to literary precedent. In Latin poetry, he observes, 'many accidents speak as if they were substances and men'; and that would be for Dante a sufficient defence if he did not find it necessary—such was the formalism of the age—to prove at some length that riming in the vernacular (*dire per rima*) did really correspond to versifying in Latin (*dire per versi*), and that the rimer might therefore justly claim all those licences which were already conceded to the versifier. He must not, however, use them arbitrarily; he must have a reason, and it must even be 'the sort of reason that could be explained in prose'. 'It would be a great disgrace', Dante adds, 'to a man, if he should rime matters under figure and rhetorical colouring,

[1] Dante, *Vita Nuova*, xxv. 'Potrebbe qui dubitare persona ... di ciò che io dico d'Amore come se fosse una cosa per sè, e non solamente sustanzia intelligente, ma sì come fosse sustanzia corporale; la quale cosa, secondo la veritate, è falsa; che Amore non è per sè sì come sustanzia, ma è uno accidente in sustanzia.'

and then, when he was asked, could not strip off that
vesture and show the true sense.'[1]

The great allegorist's firm thinking leaves no room for
misunderstanding. There is nothing 'mystical' or mys-
terious about medieval allegory; the poets know quite
clearly what they are about and are well aware that the
figures which they present to us are fictions. Symbolism
is a mode of thought, but allegory is a mode of expression.
It belongs to the form of poetry, more than to its content,
and it is learned from the practice of the ancients. If
Dante is right—and he almost certainly is—we must begin
the history of allegory with the personifications in classical
Latin poetry.[2]

II

The function of personification has been laid down by
Johnson. '*Fame* tells a tale or *Victory* hovers over a general
or perches on a standard; but *Fame* and *Victory* can do no
more.' This is entirely true of the personifications in our
own 'classical' poets; and if in later Roman poetry such
figures found that they could do many things besides
perching and hovering, this is because they meant, from
the beginning, something more to the Roman than to Gray
and Collins. Roman religion begins with the worship of
things that seem to us to be mere abstractions; it goes on
to build temples to deities like *Fides, Concordia, Mens,* and

[1] Dante, *Vita Nuova*, xxv. 'Non sanza ragione alcuna, ma con ragione la quale
poi sia possibile d'aprire per prosa . . . grande vergogna sarebbe a colui che rimasse
cose sotto vesta di figura o di colore rettorico, e poscia, domandato, non sapesse
denudare le sue parole da cotale vesta in guisa che avessero verace intendimento.'

[2] The experienced reader may be surprised to find no mention here, and little
mention below, of Philo, Origen, and the multiple senses of scripture. It must
be remembered, however, that I am concerned much more to explain a taste than
to record the steps by which it found its gratification; and that my subject is
secular and creative allegory, not religious and exegetical allegory. If Dante is
right in going back to the classics, and if I am right in detecting a *nisus* towards
allegory in Paganism itself, it will follow that the exegetical tradition is less im-
portant for the understanding of secular allegory than is sometimes supposed.
Certainly it will be difficult to prove that multiple senses played any part in the
original intention of any erotic allegory. Dante himself, while parading four
senses (*Conv.* ii. i, and *Ep.* xiii = x in some editions), makes singularly little use
of them to explain his own work.

Salus.[1] Conversely, names which seem to us to be the names of concrete deities can be used in contexts where we can only use an abstract noun—*aequo marte, per veneris res*, and the like. This usage is not particularly late, for it is found in Ennius; nor particularly poetical, for it is found in Caesar. Taking these two facts together, we are forced to the conclusion that a distinction which is fundamental for us—the distinction, namely, between an abstract universal and a living spirit—was only vaguely and intermittently present to the Roman mind. Nor need we despair of recovering, for a moment, this point of view, if we remember the strange border-line position which a notion such as 'Nature' occupies to-day in the mind of an imaginative and unphilosophical person who has read many books of popularized science. It is something more than a personification and less than a myth, and ready to be either or both as the stress of argument demands. This confusion (if it is a confusion) is not the same as allegory; indeed it is largely cleared up before the great age of allegory arrives. But its presence in the personifications and deities of the Augustans qualified them for those changes which they afterwards underwent, and was the condition—though not, of course, the cause—of that drift towards allegory which can be seen in post-Virgilian poetry.

I find this drift towards allegory, in its early stages, well illustrated in the *Thebaid* of Statius. I do not know whether its personifications are more numerous than those of the *Aeneid* or not, for I have not counted them. The question is not one of arithmetic; it is not the number of the personifications that matters, but the way in which they are used and the changing relations between personification and mythology. For in the *Thebaid* there is a

[1] For the nature of deities like *Nerio Martis*, &c., *v.* Aulus Gellius quoted by W. Warde Fowler (*Religious Experience of the Roman People*, p. 150). For *Fides*, &c., *v.* Cicero, *De Natura Deorum*, II. xxiii. 61: 'Tum autem res ipsa in qua vis inest maior aliqua sic appellatur ut ea ipsa nominetur deus, ut Fides, ut Mens, quas in Capitolio dedicatas, videmus,' &c. Cf. also Boissier, *La Fin du Paganisme*, tom. ii, p. 259.

double process at work. On the one hand, the gods are
becoming more and more like mere personifications; on
the other, the personifications are beginning to trespass
farther and farther beyond the boundaries which Johnson
assigns them. The first process can be seen in the treat-
ment of Mars. Statius has a good deal to say about Mars,
but the place which he finds for him in the story is not
a genuinely mythological place—such, for example, as
Juno's place in the *Aeneid*. Juno has a mythological reason
for disliking the Trojans. She is still brooding over the
spretae injuria formae. She has personal motives for her
conduct, and those motives can be explained by the
earlier history which is presupposed in the poem. If Mars
were to be introduced in the Theban war in the same
mythological fashion, we should expect to find him inter-
fering on one side or the other for some intelligible per-
sonal motive: he might be provided with an old grudge
against the Thebans, or he might be the ancestor of some
prominent combatant. In the *Thebaid*, however, he has
no such motive. Indeed he does not act independently at
all. He is simply summoned by Jupiter; and it is equally
significant that Jupiter commands him, not to interfere
in the war, but simply and solely to stir it up.

> Thee let them all desire, headlong to thee
> Vow hand and heart: snatch them from slow delay
> And break their treaties.[1]

This is, in effect, precisely what he does—'enamours of
himself their quivering souls'.[2] In other words, he does
nothing which the personification *War* (or *Bellona*) might
not do equally well.

His business is not to influence wars, but to inspire them;
he is in fact 'an accident occurring in a substance', the
martial or pugnacious spirit as it exists in the mind now

[1] Statius, *Thebaid*:
 Te cupiant, tibi praecipites animasque manusque
 Devoveant! Rape cunctantes et foedera turba! (iii. 232.)
[2] Ibid.
 Trepidantia corda
 Implet amore sui. (423.)

of one nation, and now of another, at the bidding of Fate.
It is quite in accordance with the allegorical nature of the
Statian Mars that he should not be present at the councils
of Jupiter, but should have to be summoned. *'War'* or
'Bellicosity' is not itself Fate: it is one of the instruments
of Fate, to be called up in the minds of men when Fate
requires. This is well brought out in the seventh book,
where Jupiter, finding his previous employment of Mars—
that is, his previous dose of martial ardour—insufficient
to stimulate the combatants, sends Mercury to rouse Mars
a second time. For this purpose Mercury has to go to
Thrace and to find Mars at home, and here we have the
fully developed 'House' of an allegorical being, in the
sense in which we speak of the 'House' of Fame, or of
Pride.

> Here he beheld, Mars' home, the leafless woods
> 'Neath Haemus crags, and shuddered as he saw,
> Beset with thousand Phrensies, his dread house . . .
> Fit sentries guard it: from the portal leaps
> Passion insane, blind Wrong, and Angers red.[1]

It is equally characteristic that Mars, who was out when
Mercury arrived, should suddenly appear 'fair-attired In
gore Hyrcanian' and so terrible that Jove himself would
have felt reverence[2] if he had been present. In the same
way when Jupiter had summoned him for the first time,
he had been found 'wasting the Getic and Bistonian
cities'. In other words, Mars is 'discovered raging' when
the curtain rises and before he has any reason to rage.
Naturally; for when *War* is not raging he does not exist. It
is his *esse* to rage. But that is not the nature of a genuinely
mythological figure. The Homeric Ares has many interests
besides war. Poseidon has a life and character of his own

[1] Ibid. Hic sterilis delubra notat Mavortia silvas
 Horrescitque tuens, ubi mille Furoribus illi
 Cingitur averso domus immansueta sub Haemo . . (vii. 40.)
 Digna loco statio; primis salit Impetus amens
 E foribus caecumque Nefas Iraeque rubentes. (47.)
[2] Ibid. Hyrcano in Sanguine pulcher. (69, 75.)

apart from his quarrel with Odysseus. The *esse* of Juno is not exhausted in her opposition to the Trojans.[1]

The same thing strikes us in Statius' description of the attendants of Bacchus; and this is all the more remarkable because Bacchus is elsewhere used by him, not as an allegorical, but as a romantic figure. He is the *Ismeno* of the poem who delays the invading army by his enchantments. Yet in spite of this, when the poet gives us a full-length description of Bacchus he seems to forget both his own romance and the materials with which Greek mythology would so readily have supplied him. We expect Silenus and his ass: what we get is

> Nor less inflamed his followers, Madness, Wrath,
> Valour and Fear and drunken Zeal succeed,
> All staggering, like their lord, with steps unsure.[2]

Bacchus has become merely Drunkenness personified, and a medieval poet would have put just such companions —with the exception of *Virtus*—as followers in the train of *Gula*. The astonishing appearance of Pallas in the second book, where Pallas is undisguisedly a state of Tydeus' mind, is yet another example of the same tendency; and it is a useful critical exercise to compare this with the corresponding passage in the *Iliad*.[3]

But the twilight of the gods is the mid-morning of the personifications. Perhaps the most obvious example of this is to be found in the tenth book.[4] The oracles have just announced that Thebes can be saved only by a human sacrifice; and it is quite in accordance with the epic tradition that a supernatural being should descend, should put on the disguise of a familiar mortal, and in that form appear to the young Menoeceus where he is fighting at

[1] No doubt the beginning of this process can be traced already in the *Aeneid*: cf. H. W. Garrod in *English Literature and the Classics*, p. 164.

[2] Statius, *Thebaid*:

> Nec comitatus iners. Sunt illic Ira Furorque
> Et Metus et Virtus et numquam sobrius Ardor
> Succiduique gradus et castra simillima regi. (iv. 661.)

[3] *Iliad*, A, 188 et seq.; Statius, *Thebaid*, ii. 682–90.

[4] Statius, *Thebaid*, x. 632 et seq.

the gate, there to warn him of the heroic destiny that
awaits him and to urge him to seize it. But who that knows
only his Virgil and his Homer would have expected this
part to be played, not by Pallas or Mercury or Apollo, but
by the personification *Virtus*? We must not call this frigid.
Virtus too had her temples, and if Statius employs her
rather than the Olympians as the machine for one of the
gravest and most affecting passages in his poem, this is
because she is to him a deity more serious and, in a sense,
more real than all the Graeco-Roman pantheon. Indeed,
if we do not understand this gravity in his personifications,
if we do not see that his Olympians come nearest to *mere*
machinery and his personifications nearest to real imagina-
tive expression, we shall have missed the whole significance
of his work. His Juno is a mere scold; his Bacchus an
irrelevant magician. It is when he comes to speak of *Cle-
mentia* that we find something like real religious emotion.

> An altar midst the city rose
> Which none of all the mightier gods can claim,
> Mild Mercy's seat, hallow'd continually
> By suppliant sorrow, never thence repulsed—
> To ask is to obtain.[1]

Yet with all this—and the point is crucial—there is no
pretence that Clementia is other than a state of mind; 'the
mind and heart of man her chosen haunt', says Statius;[2]
and the same might be said of all his gods. They are all
things that live and die in the inner world of the soul, all
'accidents occurring in a substance'; but it is those which
are most confessedly so, which drag after them the least
train of irrelevant mythological association, that engage his
deepest reverence and evoke his best poetry. If there is
anything in the whole poem which is serious, which is

[1] Ibid. Urbe fuit media nulli concessa potentum
 Ara deum. Mitis posuit Clementia sedem
 Et miseri fecere sacram. Sine supplice numquam
 Illa novo, nulla damnavit vota repulsa;
 Auditi quicumque rogant. (xii. 481.)

[2] Ibid. Mentes habitare et pectora gaudet. (494.)

struck out from the author's real sense of life, it is surely the words with which *Pietas* begins her speech:

> Why didst thou make me, Sovran Nature? Why
> Create me to oppose the cruel will ·
> Of mortals, and oft-times immortals too?[1]

—words in which one can almost see the faded gods of mythology being shouldered aside between those potent abstractions *Pietas* and *Natura*—*Pite* and *Kind* as they are called in the centuries that follow. But *Pietas* is not content merely to complain; and here we approach the core of Statius' poem. A few hundred lines before the speech of *Pietas*, Tisiphone and Megaera—themselves scarcely less allegorical than she—have met to consummate the horrors of the Theban war by promoting a single combat between the brothers Polynices and Eteocles. 'It shall be done', cry the Furies.

> Though Piety, though gentle Faith forbid,
> They shall be conquer'd![2]

If this stood alone it might pass for ordinary rhetoric, and the reader who felt himself, in this suggested conflict of the fiends and the virtues, reminded of the theme of the *Psychomachia*, might be suspected of whimsicality. But what the Furies prophesy actually comes to pass; *Pietas* is introduced for no other purpose than that she should descend to the field of battle, not primarily to influence the brothers—though she does that too—but to meet Megaera and Tisiphone face to face.[3] She is, indeed, defeated, and flies at a blow from the torch and serpents of her adversaries; but in that moment, while the human (and Olympian) action of the poem stays suspended and the personified good and evil of the human soul contend, not through their human representatives, but, face to face, with each other, lies the germ of all the allegorical poetry.

[1] Statius, *Thebaid*:
> Quid me, ait, ut saevis animantum ac saepe deorum
> Obstaturam animis, princeps Natura, creabas? (xi. 465.)

[2] Ibid. licet alma Fides Pietasque repugnent
> Vincentur! (98.)

[3] Ibid. 482 et seq.

Here already in the pagan poet we have in no ambiguous form the favourite theme of the Middle Ages—the battle of the virtues and the vices, the Psychomachia, the *bellum intestinum*, the Holy War. Nor is this passage merely an irrelevant decoration in the *Thebaid*. The climax of the whole poem is the coming of Theseus, and the consequent cutting away of all the tangled foulness of Thebes. This is told rapidly, as it ought to be; not, as a modern critic thinks,[1] because the poet is tired and perfunctory, but because it is essential that we should have the impression, not of new wars following upon the old, but of awaking from nightmare, of sudden quiet after storm, of a single sword-stroke ending for ever the abominations. But brief as he is, Statius finds time to put the significance of his Theseus beyond mistake. His war is a holy war: his victory wipes out the momentary defeat of *Pietas*. For Theseus, like *Pietas* herself, claims *Natura* as his patron, and sees the struggle as a Psychomachia.

> Comrades, defenders of the laws of Earth
> And universal covenant, be your minds
> Worthy the task! on whose cause gods and men
> Smile, and our captain Nature, and the realms
> Of mute Avernus. On the other side
> For Thebes the snaky-headed sisters raise
> Their standard and the Spirits of Vengeance come.[2]

And this point of view, which is assuredly that of the poet, is not peculiar to Theseus. It is what is expected of him; and the spokesman of the Argive widows, in first invoking his assistance, had appealed in the very words of *Pietas* to *Princeps Natura*.[3]

[1] H. E. Butler, *Post-Augustan Poetry from Seneca to Juvenal*, 1909, p. 210. The chapter on Statius is perhaps the least sympathetic part of this interesting book.

[2] Statius, *Thebaid*:

> Terrarum leges et mundi foedera mecum
> Defensura cohors, dignas insumite mentes
> Coeptibus. Hac omnem divumque hominumque favorem
> Naturamque ducem coetusque silentis Averni
> Stare palam est. Illic Poenarum exercita Thebis
> Agmina et anguicomae ducunt vexilla sorores. (xii. 642.)

[3] Ibid. 561.

I am not, of course, contending that the *Thebaid*
is so grave a poem as these quotations would suggest.
It stands, indeed, at about the same distance from true
epic seriousness as the *Gerusalemme Liberata*, though,
to be sure, the Latin poem is journeying away from the
epic while the Italian is returning to it. Much of the
charm of Statius depends on his deliberate departure from
the heroic tension, his quest of graceful and romantic
variation; he is a pioneer in that art of interweaving to
which later literature owes so many wilful beauties, and
his fourth and fifth books are a kind of early draft of the
Orlando Furioso. There are many reasons for that popu-
larity which our modern classical tradition—a charming
mistress but a bad master—finds so hard to understand.
But it does not matter for our present purpose exactly how
serious we take the *Thebaid* to be. The important thing
is that *just in so far* as it is serious, so far it is tending to be
allegorical. Whatever in it is serious is in the nature of
a Psychomachia. The theme of its noblest passages could
almost be described in words adapted from Dante—
literaliter bellum Thebanum; allegorice Homo. Its gods are
only abstractions and its abstractions, though confessedly
belonging to the inner world, are almost gods.

III

We have touched already on those characteristics in
Roman religion which rendered possible this double move-
ment. Conditions, however, are not causes. It remains to
discover, if we can, the process by which the fading of the
gods and the apotheosis of the abstractions actually came
about. To some extent, no doubt, such a process was
likely to occur with the mere decline of creative literary
power. Rhetoric is the readiest substitute for poetry, and
rhetoric loves personification; while, on the other hand,
the uninspired use of the pantheon as mere epic machinery
is pretty sure to bring to the surface any element of ab-
straction which is already latent in them. But this sort of
explanation will not carry us so far as is often supposed. It

depends on a serious exaggeration of the faults of silver Latin literature; it fails to account for the real poetry that breathes in some of the most allegorical passages of Statius; and it fails still more conspicuously to explain the charm which allegory continued to exercise on the following centuries. The truth is that neither of these two developments was a merely literary phenomenon: few literary phenomena are. Both spring from the whole mental life of the period in question; both reflect the spirit of those centuries of moral and religious experiment from which Christianity finally emerged victorious.

The twilight of the gods—to take this aspect first— must not be supposed to be in any sense a result of Christianity. It is already far advanced in Statius, and Statius, as a poet, but feebly reflects what philosophy had done long before him. It represents, in fact, the *modus vivendi* between monotheism and mythology. Monotheism should not be regarded as the rival of polytheism, but rather as its maturity. Where you find polytheism, combined with any speculative power and any leisure for speculation, monotheism will sooner or later arise as a natural development. The principle, I understand, is well illustrated in the history of Indian religion. Behind the gods arises the One, and the gods as well as the men are only his dreams.[1] That is one way of disposing of the Many. European thought did not follow the same path, but it was faced with the same problem. The best minds embrace monotheism. What is to be done with the gods of the popular religion? The answer—or at least that form of the answer which concerns us most—was given by the Stoics. 'Deus pertinens per naturam cuiusque rei, per terras Ceres, per maria Neptunus, alii per alia, poterunt intelligi'[2]—where the very construction *Deus poterunt* hits off the corresponding state of mind to a nicety. The gods are to be aspects, manifestations, temporary or partial embodiments of the single power. They are, in fact, personifica-

[1] V. H. Jacobi's article on 'Brahmanism' in the *Encyclopaedia of Religion and Ethics*. [2] Cicero, *De Natura Deorum*, II. xxviii. 71.

tions of the abstracted attributes of the One. We must cease to repine at the gods of Statius as if they were the arbitrary blunders of an individual poet. They are a necessary stage in the life of ancient religion and the poet, in attempting to depict them, is giving expression to the deepest experience of his age. It is his mythological treatment of Bacchus which is purely literary and derivative; it is his allegorical treatment of Bacchus and of Mars which is alive. The same clue enables us to understand his *Princeps Natura*; for this 'Nature', to whom *Pietas* can appeal over the heads of men and gods, is no other than that One in whose light the Olympians are beginning to look pale. She is the Whole (or God, or Nature, or Cosmus) of the Stoics; the φύσις of Marcus Aurelius, the *Natura* of Seneca; the ancestress of Alanus' *Natura* and Chaucer's *Kinde*.

The allegorization of the pantheon is thus seen to depend on causes that go beyond merely literary history; and the same may be said of the flourishing of the personifications. They also depend upon a profound change in the mind of antiquity; but this time it is a change of moral experience rather than of thought. A ready way of indicating its nature—for I have foresworn any attempt to explain its causes—will be to remind the modern student of a certain surprise which he probably felt when he first read the *Ethics* of Aristotle. For us moderns the essence of the moral life seems to lie in the antithesis between duty and inclination. Special moral theories may attempt to resolve it, and some of 'our late fantasticks' may try to look round it or over it; but it remains, nevertheless, the experience from which we all start. All our serious imaginative work, when it touches morals, paints a conflict: all practical moralists sing to battle or give hints about the appropriate strategy. Take away the concept of 'temptation' and nearly all that we say or think about good and evil would vanish into thin air. But when we first opened our Aristotle, we found to our astonishment that this inner conflict was for him so little of the essence of the moral life, that he

tended to thrust it into a corner and treat it almost as a
special case—that of the ἀκρατής. The really good man, in
Aristotle's view, is not tempted. Where we incline to
think that 'good thews inforced with pains' are more
praiseworthy than mere goodness of disposition, Aristotle
coolly remarks that the man who is temperate at a cost is
profligate:[1] the really temperate man abstains because he
likes abstaining. The ease and pleasure with which good
acts are done, the absence of moral 'effort' is for him the
symptom of virtue.[2]

Now when we turn to the moralists who lived under the
Roman Empire, all this is changed. I do not know whether
they were better or worse than the contemporaries of
Aristotle; but they were certainly more conscious of a diffi-
culty in being good. 'Fight the good fight'—how oddly
the words would sound in the *Ethics*! Under the Empire,
they are on every moralist's lips. The examples which
could be drawn from the writings of St. Paul alone would
be enough to prove a far-reaching change. But the pheno-
menon is by no means a result of Christianity, however
much Christianity may have done to deepen and perpetu-
ate it. Here again, as in the case of monotheism, we have
to do with a characteristic, not of Christianity alone, but
of the whole period from which the Christian empire
emerged. We must not attribute solely to the precipitate
that which was already present in the solution. 'The life
of every man is a soldier's service', writes Epictetus, 'and
that long and various'.[3] 'For we also must be soldiers,'
says Seneca, 'and in a campaign where there is no inter-
mission and no rest.'[4] Or again, in words more closely

[1] Aristotle, *Ethic. Nicom.* 1104 B ὁ μὲν γὰρ ἀπεχόμενος τῶν σωματικῶν ἡδονῶν καὶ
αὐτῷ τούτῳ χαίρων σώφρων, ὁ δ᾽ ἀχθόμενος ἀκόλαστος.

[2] Ibid. 1099 A οὐδ᾽ ἐστιν ἀγαθὸς ὁ μὴ χαίρων ταῖς καλαῖς πράξεσιν· οὔτε γὰρ δίκαιον
οὐθεὶς ἂν εἴποι τὸν μὴ χαίροντα τῷ δικαιοπραγεῖν, etc. 1104 B. Σημεῖον δὲ δεῖ ποιεῖσθαι
τῶν ἕξεων τὴν ἐπιγινομένην ἡδονὴν ἢ λύπην τοῖς ἔργοις. The 'intellectualism' of
which Aristotelian and (still more) Platonic ethics are so often accused is another
aspect of the same tendency. [3] Epictetus, *Diss.* III. xxiv. 34.

[4] Seneca, *Epist.* li. 6 'Nobis quoque militandum', &c. My attention was first
drawn to the importance of Seneca for our subject by S. Dill's *Roman Society from
Nero to Marcus Aurelius.* I am much indebted to it throughout this chapter.

reminiscent of the New Testament, 'let us also conquer all things. For our prize is not a crown nor a palm nor a herald calling silence to cry our name, but virtue, and strength of mind, and peace.'[1] Nor are these conflicts, for Seneca, merely an accident of the moral life; they are its essence. He can describe (none better) the dewy freshness of the golden age, but he closes his account with a corrective. Its children were not Stoic saints (*sapientes*). They were innocent because they knew no evil, but innocence is not goodness. Even divine Nature, even in her prime, cannot make virtue a gift; *ars est bonum fieri*.[2]

The first step, then, towards understanding the role which the abstractions play in Statius and in his successors is to remark that the men of that age, if they had not discovered the moral conflict, had at least discovered in it a new importance. They were vividly aware, as the Greeks had not been, of the divided will, the *bellum intestinum*. The new state of mind can be studied almost equally well in Seneca, in St. Paul, in Epictetus, in Marcus Aurelius, and in Tertullian.

But to be thus conscious of the divided will is necessarily to turn the mind in upon itself. Whether it is the introspection which reveals the division, or whether the division, having first revealed itself in the experience of actual moral failure, provokes the introspection, need not here be decided. Whatever the causal order may be, it is plain that to fight against 'Temptation' is also to explore the inner world; and it is scarcely less plain that to do so is to be already on the verge of allegory. We cannot speak, perhaps we can hardly think, of an 'inner conflict' without a metaphor; and every metaphor is an allegory in little. And as the conflict becomes more and more important, it is inevitable that these metaphors should expand and coalesce, and finally turn into the fully-fledged allegorical

[1] Seneca, *Epist.* lxxviii. 16 'Nos quoque evincamus omnia', &c.

[2] Ibid. xc. 44 et seq. The whole letter is extremely beautiful and anticipates Milton in some points—*spiritus ac liber inter aperta perflatus*—*prata sine arte formosa*.

poem. It would be a misunderstanding to suggest that there is another and better way of representing that inner world, and that we have found it in the novel and the drama. The gaze turned inward with a moral purpose does not discover *character*. No man is a 'character' to himself, and least of all while he thinks of good and evil. Character is what he has to produce; within he finds only the raw material, the passions and emotions which contend for mastery. That unitary 'soul' or 'personality' which interests the novelist is for him merely the arena in which the combatants meet: it is to the combatants—those 'accidents occurring in a substance'—that he must attend.[1] Nor will he long attend to them—specially if he has had a Roman training in the schools of rhetoric—without giving them their Hegelian 'hands and feet'. For such a man allegory will be no frigid form. It is idle to tell him that something with which he has been at death-grips for the last twenty-four hours is an 'abstraction'; and if we could be free, for a little, of our own *Zeitgeist*, we might confess that it is not very much more abstract than that 'self' or 'personality' on whose rock-bottom unity we rest so secure and of which we would so much rather hear him talk.

The explanation which I have just given of the allegorical tendency does not, of course, exclude the acknowledgement of other, subsidiary, causes. Such were pretty certainly at work. The sheer momentum which the rhetorical machine had gathered from several centuries' running counts for something. Again, the habit of applying allegorical interpretation to ancient texts naturally encouraged fresh allegorical constructions, and this method was freely

[1] The obvious parallel is modern psycho-analysis and its shadowy personages such as the 'censor'. At a different level, it might be argued that the application of psychological terms *at all* to the unconscious is itself a species of allegory. As Passions become People for the allegorist, so *x* (in the unconscious) becomes Passions for the analyst; or at least he can talk of them only *as if they were* 'desires', &c.—*la quale cosa secondo la veritade è falsa*. As the first century dived to the psychological by the aid of Personification the twentieth dives to the sub-soul by the aid of 'Passionification'.

practised by both pagans and Christians. During a period of religious controversy it is, indeed, the most obvious way of tuning primitive documents to meet the ethical or polemical demands of the moment. The Stoics, apart from their general doctrine of the gods as manifestations of the One, were always ready to explain particular myths by allegory. Saturn eating his children could be harmlessly interpreted as Time 'bearing all his sons away'. Jove could be *hoc sublime candens* embracing the inner *aer* which was Juno.[1] During the pagan revival which Christianity later provoked in the bosom of its enemy, the largest claims were made for this method by the patrons of the old religion. Allegory would solve all difficulties, and it would be found that ancient myth and modern philosophy were only two vestures for the same doctrine.[2] On the Judaic and Christian side the same expedient was used. Philo Judaeus in the first century takes over from Rabbinical tradition this method of interpreting the Hebrew scriptures; and the doctrine of the hidden senses of the Bible passes from Origen and the Alexandrians to the West and is handed down by such writers as Hilary of Poitiers and Ambrose.[3] It is, however, extremely probable that any help which this method of exegesis lent to the original allegory was amply repaid: when allegory becomes a man's natural mode of expression it is inevitable that he will find more and more allegory in the ancient authors whom he respects. What is not to be thought of is that the mere practice of allegorical interpretation or the mere impetus of rhetoric, by themselves, could have imposed an 'allegorical period' on the literature that followed. They were

[1] *v.* Cicero, op. cit. II. xxv. 64, 65 (where *hoc sublime candens* is a quotation from Ennius) and xxvi. 66.

[2] Maximus Tyrius (quoted by Dill) *Diss.* x. i ποιητικὴν καὶ φιλοσοφίαν χρῆμα διττὸν μὲν κατὰ τὸ ὄνομα ἁπλοῦν δὲ κατὰ τὴν οὐσίαν. Ibid. 5 Πάντα μεστὰ αἰνιγμάτων καὶ παρὰ τοῖς ποιηταῖς καὶ παρὰ τοῖς φιλοσόφοις. The attempts of the pagan revivalists to carry out the reconciliation of the One and the Many by means of allegory, hierarchical daemonism, emanations, and what not, are of course very various and complicated. I give only the barest outline.

[3] *v.* A. Ebert, *Allgemeine Geschichte der Literatur des Mittelalters im Abendlande* (1874), Bd. I, pp. 133, 139.

influential; but we must ask why they were influential.
The answer, I believe, is to be found in that need for
allegory which much deeper causes had produced. The
root of this need as we have seen is twofold; on the one
hand, the gods sink into personifications; on the other, a
widespread moral revolution forces men to personify their
passions.

In the writers who lead up to Prudentius we can see this
second process—the emergence of mental facts into alle-
gory—steadily at work. A few pages ago I quoted passages
from Seneca to show the kind of moral experience which
separates him from Aristotle; but it was impossible to
choose passages which did not at the same time illustrate
how naturally such experience expressed itself in meta-
phors—and in just those metaphors, borrowed from the
battle-field and the arena, which are the basis of the later
allegory. The list might have been greatly increased. The
pleasures are to be fought down (*debellandae*).[1] We must
watch more carefully than the soldiers in an ordinary war,
for if we once let the enemy (Pleasure) slip through, she
will drag a host of other enemies after her.[2] Or again, we
are engaged in a lawsuit which must be pursued *sine modo*
and *sine fine* for our adversary also is endless and im-
moderate.[3] Our appetites are lying in wait for us, to
strangle us like the thieves in Egypt.[4] Life is a journey
wherein we shall often be weary; at one place we shall lose
a fellow traveller, at another be afraid.[5] One is reminded
of the *Pilgrim's Progress*, and there is nothing whimsical
about the association. It is perception of a real similarity,
based on a common cause. Evidences of the same personi-

[1] Seneca, *Epist*. li. 6.
[2] Ibid. 7 et seq. 'Minus nobis quam illis Punica signa sequentibus licet', &c.
[3] Ibid. 13, 'Satis diu cum Bais litigavimus, numquam satis cum vitiis', &c.
[4] Ibid.
[5] Ibid. cvii. 2: 'Longam viam ingressus es, et labaris oportet et arietes et cadas
et lasseris et exclames "o mors!" id est mentiaris. Alio loco comitem relinques,
alio efferes, alio timebis; per eiusmodi offensas emetiendum est confragosum hoc
iter.' Cf. lxxvii. 3. 'Hoc etiam si senex non essem, fuerat sentiendum, nunc vero
multo magis, quia quantulumcumque haberem tamen plus iam mihi superesset
viatici quam viae.'

fying tendency, in an even more advanced form, meet us
from an unexpected quarter. If Apuleius is to be trusted,
the stage of the second century already tolerated such
characters as *Terror* and *Metus*.[1] From Tertullian the
industry of a French scholar has collected the most signifi-
cant passages for our purpose.[2] One of them is sufficiently
remarkable. Patience is represented as sitting calm and
peaceful, her stainless brow unwrinkled by grief or anger;
and yet she 'shakes her head at the devil and laughs
a threatening laugh'.[3] This is very odd behaviour for
Patience; but the author's inability to represent even this
mild virtue except in conflict proves how deeply the idea
of the *bellum intestinum* has entered into his mind. The
same feeling inspires the more famous passage at the end
of his *De Spectaculis*: 'If you must have gladiators', says
Tertullian, 'then behold Shamelessness hurled down by
Chastity, Perfidy slain by Faith, and Cruelty crushed by
Pity'.[4]

But perhaps there is no writer who admits us so inti-
mately into the heart of that age as Augustine. Sometimes
he does so by accident, as when he comments on the fact—
to him, apparently, remarkable—that Ambrose, when
reading to himself, read silently. You could see his eyes
moving, but you could hear nothing.[5] In such a passage
one has the solemn privilege of being present at the birth
of a new world. Behind us is that almost unimaginable
period, so relentlessly objective that in it even 'reading'
(in our sense) did not yet exist. The book was still a λόγος,
a speech; thinking was still Διαλέγεσθαι, talking. Before us is
our own world, the world of the printed or written page,

[1] Apuleius, *Metam.* x. 30 et seq. The scene of this play is Mt. Ida, and the
dramatis personae include Paris, Mercury, Juno (followed by Castor and Pollux),
Minerva (followed by Terror and Metus), Venus (followed by Cupids, Hours,
and Graces). It is not, of course, certain that Apuleius is describing the sort of
performance that actually took place in his day. My attention was first drawn
to this passage by A. Puech (*Prudence*, Paris, 1888).

[2] Puech, op. cit., pp. 244 et seq.

[3] Tertullian, *De Patientia*, cap. xv. 4. [4] Ibid., *De Spectaculis*, cap. xxix.

[5] Augustine, *Confess.* vi. iii (p. 116 ed. Knöll in *Corp. Script. Ecclesiast.*, vol.
xxxiii).

and of the solitary reader who is accustomed to pass hours
in the silent society of mental images evoked by written
characters. This is a new light, and a better one than we
have yet had, on that turning inward which I have tried
to describe. It is the very moment of a transition more
important, I would suggest, than any that is commonly
recorded in our works of 'history'. But it is seldom that
Augustine is so unconscious as in this statement; more
often he conveys to us a vivid sense of the delighted and
horrified wonder with which he is consciously exploring
the new inner world—

> His ibi me rebus quaedam divina voluptas
> Percipit atque horror.

'I myself comprehend not all the thing I am.'[1] He is
lost and bewildered. Every new path in this country ex-
cites his curiosity and his awe. Why did he rob the pear
tree? Why does tragedy please? He worries such prob-
lems as a dog worries a bone. He wanders hither and
thither in his own mind and speaks the very language of
a traveller.

> 'Climbing up, therefore, step by step to Him that made me, I
> will pass beyond this faculty of my nature and come to the fields
> and wide pavilions of the Memory'[2] ...
> 'Great is the power of Memory, Lord; an astonishment, a deep
> and boundless manifold. Yet this also is mind and I am this.
> What am I, Lord? What is my kind? Even a life that changes
> and hath many modes and cannot in any wise be measured. The
> fields, the caves, the dens of Memory cannot be counted; their
> fulness cannot be counted nor the kinds of things counted that
> fill them. ... I force my way in amidst them, even as far as my
> power reaches, and nowhere find an end.'[3]

Such a passage, if not allegorical itself, paints vividly for us
the experiences of the age in which allegory was born—
experiences strangely analogous to those of the beginner
in modern psychology. And though Augustine writes no

[1] Ibid. x. viii. [2] Ibid. [3] Ibid. x. xvii.

full-length allegory, he pushes his imagery elsewhere a little farther in the allegorical direction. He also must talk of soldiers and of a road;[1] and in the great scene of his conversion, the temptations—here none will dare to call them abstractions—step forth in bodily form.

'Trifles of trifles and very vanities which I had made my mistresses now held me back and plucked me by my carnal robe, whispering me, "Will you turn us away? Shall the moment come when you must part from us for ever? Shall the moment come when this—and this—will be forbidden you for ever?" . . . And now I hearkened to them with less than half myself. No longer did they gainsay me openly nor look me in the face, but came as it were behind me whispering and plucking at my robe as I went away; holding me back while I yet delayed to tear myself from them, to shake them off, to leap whither I was called —tyrannous custom asking me the while, "Is it possible, think you, to live without them"?'[2]

IV

The historian is not at liberty to dispose his fable as he would wish. If, in fact, the mountains travailed and a mouse was born, his narrative must be content with the anticlimax. Such an anticlimax has to be faced when we reach the fully-fledged allegorical poem, the *Psychomachia* of Prudentius. It is unworthy of the great utterances which lead up to it and explain its existence. Indeed, if those utterances did not reveal more clearly than the poem itself the nature of the experience which is behind it, its lasting popularity and influence would be mysterious. In their light both are intelligible. When the demand is very strong a poor thing in the way of supply will be greedily embraced. Thus the intense desire of the eighteenth century for literature of a certain kind led them to accept MacPherson's *Ossian*; thus, it is legitimate to suppose, certain contemporary works owe their reputation to the public desire for a new movement. What we long to see

[1] Augustine, *Confess.* VII. xxi. [2] Ibid. VIII. xi.

we readily believe that we have seen. If there is any safe generalization in literary history it is this: that the desire for a certain kind of product does not necessarily beget the power to produce it, while it does tend to beget the illusion that it has been produced.[1] From this point of view we can see that it is possible to overrate the importance of the *Psychomachia*. If Prudentius had not written it, another would. It is a symptom rather than a source.

But we must not misunderstand its genesis. It has been supposed that Prudentius wrote as a propagandist, inspired by motives wholly irrelevant to poetry; that his aim was to provide educated Christians with something less dangerous in subject-matter than Virgil, while possessing all the charm of the epic manner and machinery; and that it was for this he chose the battle of the virtues and the vices.[2] That some such intention was present in his mind as a subsidiary motive is, indeed, extremely probable. He is certainly very Virgilian; and he certainly carries out Tertullian's recipe for a 'sublimation' of the gladiatorial taste.

> Chance led the stone, shattering the ways of breath
> To mingle lips with palate; the rent tongue,
> With gory gobbets and the wreck of teeth
> Dashed inward, stuff'd the lacerated throat.[3]

That is as 'really horrid' as the Ovidian battle of the Centaurs and the Lapithae. But to suppose that Prudentius, or any of his contemporaries, needed such extraneous motives to guide him to the theme of a *psychomachia* is to

[1] It is of course the χαρίεντες rather than the πολλοί who are specially likely to make this sort of mistake. Certain cultured contemporary verdicts on *Gorboduc* and *Gondibert* (we might add, on James Joyce and Gertrude Stein) naturally occur to the mind.

[2] See Puech, op. cit., p. 240.

[3] Prudentius, *Psychomachia*, 421:

> Casus agit saxum medii spiramen ut oris
> Frangeret et recavo misceret labra palato;
> Dentibus introrsum resolutis lingua resectam
> Dilaniata gulam frustis cum sanguinis implet.

misread the whole history of that age. Nor do I think that Prudentius had before him as his only model the brief hint in the *De Spectaculis*. When he writes thus of *Libido* attacking *Pudicitia*,

> On comes the foe and bears a torch of pine
> Instinct with burning sulphur, and intends
> To assail with fire and dash with noisome smoke
> Her modest eyes and face.[1]

it does not seem to me fanciful to suppose that he remembered the similar attack suffered by *Pietas* in the *Thebaid*, where the Fury

> came on and while she shunned
> That sight, withdrawing far her modest face,
> Pressed home the more with hissing snakes and aim'd
> The torch.[2]

It is true, as I said before, that the *Psychomachia* is not a good poem: if it were indeed the result of some purely unpoetic purpose it could hardly be worse. But there are many ways in which poetry can go wrong and an impurity in the intention is only one of them. The *Psychomachia* fails, partly because Prudentius is naturally a lyrical and reflective poet—there is some fine, cloudy grandeur in the *Hamartigenia*—to whom the epic manner comes with difficulty, and partly for a deeper reason. While it is true that the *bellum intestinum* is the root of all allegory, it is no less true that only the crudest allegory will represent it by a pitched battle. The abstractions owe their life to the inner conflict; but when once they have come to life, the poet must fetch a compass and dispose his fiction more artfully if he is to succeed. Seneca, with his imagery of life

[1] Prudentius, *Psychomachia* 43:

> Adgreditur piceamque ardenti sulphure pinum
> Ingerit in faciem pudibundaque lumina flammis
> Adpetit et taetro temptat subfundere fumo.

[2] Statius, *Thebaid* xi. 492–5:

> Urget et ultro
> Vitantem aspectus etiam pudibundaque longe
> Ora reducentem premit astridentibus hydris
> Intentatque faces.

as a journey, was nearer to the mark than Prudentius; for
Seneca outlined the theme of the *Pilgrim's Progress*, and
the *Pilgrim's Progress* is a better book than the *Holy War*.
It is not hard to see why this should be so. The journey
has its ups and downs, its pleasant resting-places enjoyed
for a night and then abandoned, its unexpected meetings,
its rumours of dangers ahead, and, above all, the sense of its
goal, at first far distant and dimly heard of, but growing
nearer at every turn of the road. Now this represents far
more truly than any combat in a *champ clos* the perennial
strangeness, the adventurousness, and the sinuous forward
movement of the inner life. It needs the long road and
mountain prospects of the fable to match the ἄπειρον
within. But there is another and more mechanical defect
in the pitched battle, and this is one which already appears
in Tertullian's description of Patience. It arises from the
fact that fighting is an activity that is not proper to most
of the virtues. Courage can fight, and perhaps we can
make a shift with Faith. But how is Patience to rage in
battle? How is Mercy to strike down her foes, or Humility
to triumph over them when fallen? Prudentius is almost
everywhere embarrassed by this difficulty, and his attempts
to solve it are failures because they betray his deficiency
in humour. When *Patientia*, having provided herself with
an excellent suit of armour (*provida nam virtus*),[1] stands
stock-still in the middle of a furious encounter and allows
the darts of *Ira* to rattle harmlessly off her breastplate and
the sword of *Ira* to break upon her helmet, we may ap-
prove the moral but we smile at the picture; and when *Ira*,
having spent all her weapons, proceeds, as it were in a pet,
to commit suicide, we are reminded irresistibly of the *Tale
of a Tub*. The meeting between *Superbia* and *Mens Humilis*
is almost equally unhappy.[2] *Superbia*, on her horse, 'quem
pelle leonis Texerat et validos villis oneraverat armos',
rushes upon the virtue whom she has taunted in vain for
nearly fifty lines, and falls head over heels into the pitfall

[1] Prudentius, *Psychomachia*, 125 et seq.
[2] Ibid. 178 et seq.

which her own ally *Fraus* had dug shortly before the
armies engaged. The moment has now come when Hu-
mility must triumph and yet remain humble. The un-
happy poet, torn between the epic formula and the
allegorical meaning, can only explain that she triumphs
modestly:

> Uplifts her face
> With moderated cheer, and civil looks
> Tempering her joy.[1]

Os quoque parce Erigit—nothing could suggest more vividly
the smirk of a persevering governess who has finally suc-
ceeded in getting a small boy into trouble with his father.
In the end *Spes* has to come to the assistance of *Mens
Humilis*, to dispatch the fallen enemy, and to uplift over
her body the *bēotword* which epic usage demands.

Of the seven combats described, that between *Luxuria*
and *Sobrietas* is perhaps the best.[2] It should be noticed
that Prudentius' seven champions do not exactly corre-
spond with the familiar list of the seven deadly sins in later
writers.[3] *Luxuria*, in the medieval sense, does not appear
at all—Prudentius' *Libido* is *unnatural* vice—and the sin
which here bears her name is a kind of blend of *Gula* and
Superbia. She is, in fact, something very like 'luxury' in
the modern meaning of the word—the sin of the profiteer
—and *Amor*, with *Jocus* and *Petulantia*, is still an unim-
portant attendant in her train. Yet it is Luxuria who of
all the enemies comes nearest to success and lends the
combat a faint colour of dramatic interest. The onset of
the drunken champion, weakening the line of virtues with

[1] Prudentius, *Psychomachia*, 276:

> Os quoque parce
> Erigit et comi moderatur gaudia vultu.

[2] Ibid. 310 et seq.

[3] The list took some time to settle into its medieval form. Prudentius' seven
enemies are: (1) *Veterum Cultura Deorum*, (2) *Sodomita Libido*, (3) *Ira*, (4) *Superbia*,
(5) *Luxuria* (= *Gula*), (6) *Avaritia*, (7) *Discordia* (*cognomento Heresis*). Cassianus
(A.D. 360–435) in his *De Institutis Coenobiorum* (Bks. V–XII) gives a list of eight:
(1) *Gastrimargia*, (2) *Fornicatio*, (3) *Philargyria*, (4) *Ira*, (5) *Tristitia*, (6) *Acedia*,
(7) *Cenodoxia*, (8) *Superbia*. He is dealing, of course, with *monastic* vices.

the fragrance that breathes from her car, is feelingly de-
scribed.[1] There is merit, too, and a kind that might escape
modern attention, in the Ἀολωνεία of *Avaritia* who steals
among the virtues disguised as *Frugality*

> that the white pretended robe
> May veil the lurking fury, and beneath
> 'Care for our children' (honourable style)
> Hide theft and rapine and close-hoarded spoil.[2]

The psychology of this may not seem to us profound nor
hard to come by; but we must try to read these things as
if the novelty were still upon them, and we must remember
how rarely we find in classical literature any adequate
recognition of the great fact of self-deception. An age that
piques itself, as our does, on detecting the veiled egoism
beneath the smooth masks of conventional virtues should
not be slow to praise the admirable pioneer work which
was done in this kind by the allegorists.

But it is only when Prudentius turns away from the
actual fighting that his allegory begins to convince us.
There are two passages near the end of the *Psychomachia*
which are worth all the rest. The first comes when the
celestial army returns within its lines after the defeat of
Avarice. There is a loosening of belts, a sudden silence of
trumpets, swords are returned to their sheaths, and as the
dust of battle settles on the plain the blue sky once more
becomes visible.

> Bless'd Concord gives the word and bids recall
> The conquering eagles to their tented camp.[3]

The generals mount the *tribunal* in the midst of the camp

[1] Prudentius, *Psychomachia* 320 et seq.
[2] Ibid. 560:

> ut candida palla latentem
> Dissimulet rabiem diroque obtenta furori,
> Quod rapere et clepere est avideque abscondere parta,
> 'Natorum curam' dulci sub nomine iactet.

[3] Ibid. 644: Dat signum felix Concordia reddere castris
 Victrices aquilas atque in tentoria cogi.

and prepare to address the troops. The word is passed through the ranks:

> From all the lines th' assembling army hastes . . .
> The tents, with canvas brail'd, thrown open wide
> Discover all within, lest any there
> Should snore obscure.[1]

All this belongs to a different world from the outworn rags and tatters of the heroic tradition. It is given with the vividness of something seen. We can all but hear the voices shouting 'Show a leg—show a leg'. Here, as in all those other military metaphors, whether of the Christian or of the pagan moralists, we are reminded of the lasting impression which the discipline and circumstance of the legions made upon all the nations of the empire; and, if we are wise, we are set pondering on the far-reaching consequences which that impression had for the imagination. We must never forget that the medieval Latin for a knight is *miles*; that the conception of earthly knighthood and that of the angelic knighthood (*militia*) are sometimes connected;[2] and that both pre-suppose the discipline of the real Roman army. It is doubtful whether the whole ideal world of chivalry could have existed unless the legions had existed first; for by their aid both the Germanic *comitatus* and the Hebrew God 'of hosts' were touched to new issues. The second passage is only a single sentence; but it comes from the heart and reveals in a flash the real genesis of the poem.

> War rages, horrid war
> Even in our bones; our double nature sounds
> With armèd discord.[3]

[1] Prudentius, *Psychom.* 740 et seq.:

> Concurrent alacres castris ex omnibus omnes . . .
> tentoria apertis
> Cuncta patent velis, reserantur carbasa, ne quis
> Marceat obscuro stertens habitator operto.

[2] Cf. *Piers Plowman*, A, i. 103 et seq.; *v.* also D'Ancona, *I Precursori di Dante* (Florence, 1874), p. 105.

[3] Prudentius, *Psychom.* 902: Fervent bella horrida, fervent
> Ossibus inclusa fremit et discordibus armis
> Non simplex natura hominis.

Cf. *Hamartigenia*, 393 et seq.

It was no prosaic desire for innocent epic that moved
Prudentius to write, and his contemporaries to read, the
Psychomachia. It was their daily and hourly experience of
the *non simplex natura*.

The further history of the *genre* which Prudentius here
invented is no small part of the history of medieval litera-
ture; but for the moment it is time to return to the other
side of our subject—the ever-deepening twilight of the
gods. The steady decline of mythology into allegory can
be traced in three writers of whom the first—Claudian
—is Prudentius' contemporary. It is true that Claudian
might be cited equally well to illustrate the theme of the
bellum intestinum; and the riot of personifications in his
work is the answer to any theory which attributes the
Psychomachia to some individual and specifically Christian
purpose on the part of Prudentius. For Claudian, just as
for the religious poet, allegorical conflict is the natural
method of dealing with psychology. Thus, when he wishes
to describe the moral excellences of Stilicho, he can do so
only by telling us that in Stilicho the virtues have defeated
the vices:

> He puts to flight the spirits importunate
> That hell sends from her monster-teeming gate.[1]

We have travelled far indeed from the classic serenity of
Aristotle; even a good man, even in a panegyric, can now
be good only as the result of a successful psychomachy. To
the same class belongs the visit of Astraea to Manlius
Theodorus, and the flyting of Megaera and *Justitia*.[2] But
it would be foolish to emphasize this side of Claudian. We
do not suspect in him any great depth of moral experience;
he is in this merely symptomatic and follows, as a court
poet must, the fashions of the moment. But this same
lightness and shallowness in Claudian enables him to be-
come, in another respect, a herald and pioneer. There are

[1] Claudian, *De Cons. Stilichonis*, ii. 109:

> procul importuna fugantur
> Numina monstriferis quae Tartarus edidit antris.

[2] Ibid. *In Rufinum*, i. 354 et seq.

two passages in his poetry which are full of the promise
of the Middle Ages. The first comes in the *Consulship of
Stilicho*.[1] We have been long immersed in the virtues and
the vices of the hero, and in the rhetoric of the personified
nations; then suddenly, at the end of the book, the scene
changes. We are shown the cavern of all the years, *annorum
squalida mater*, scarcely approachable by God or man. On
the floor the serpent of eternity lies sleeping with his
tail in his mouth. Before the entrance sits Nature, *vultu
longaeva decoro*, and the souls of the unborn flit round her;
by her side is an old man who writes her decrees in a book.
To the threshold of this cave comes Sol; as he alights,
Nature rises to greet him. No words are spoken, and we
see the two turn back together through the adamantine
doors that open unbidden, and pass into the recesses of the
cave where the ages of gold, of silver, and of brass lie
piled. Those of gold are selected to grace the consulship
of Stilicho, and Sol returns with them to his own garden
where dews of fire bathe the turf, and his horses, unyoked,
clip the grass wet with liquid flame. The allegory here is
trite. As allegory it is not worth the space allotted to it;
the poet's aim is decoration. But for that very reason,
because he is merely decorating, he is free to rest from the
serious purpose of his poem, and to luxuriate in description.
The drowsy cavern and the silent figures meeting at its
threshold exist, for a moment, in their own right. The
allegory is only the pretext. The second passage comes in
the *Epithalamium for Honorius*.[2] In poems of this type
it is natural to invoke Venus and Hymen, but Claudian
is not content with invocation. Turning his back on the
nominal subject of his poem, he carries us away to a moun-
tain in Cyprus which the frosts never whiten and the
winds never beat. On the mountain head is a meadow
guarded by a hedge of gold, and all within it blooms un-
sown, *zephyro contenta colono*. Only the sweetest song-
birds live in its copses, where

[1] Claudian, *De Cons. Stil.* ii. 424 et seq.
[2] Ibid. *Epithal. de Nuptiis Honorii Augusti*, 49 et seq.

Each happy tree
Woos and is wooed. Palms nodding from above
Exchange their vows and poplar sighs for love
Of poplar, plane for plane, and whispers low
Of love along the alder thickets go.[1]

There are two fountains here, one sweet, the other bitter, and here live the *Amores* and *Metus* and *Voluptas*. *Juventas* also is there and he has shut *Senium* out from the garden.[2] In all this the student of medieval allegory will find the first outline of much that is familiar to him. The two fountains can be paralleled by the single fountain in Andreas Capellanus which is sweet and gracious at its source, but freezing and baleful as it spreads into the region of *Humiditas*. The hedged garden or park already anticipates the scenery of the *Romance of the Rose*; and, as in the *Romance*, Youth is in the garden and Eld is outside. But it is not for this reason only that I have cited the passage. It is because I would willingly begin to show as soon as possible that the decline of the gods, from deity to hypostasis and from hypostasis to decoration, was not, for them nor for us, a history of sheer loss. For decoration may let romance in. The poet is free to invent, beyond the limits of the possible, regions of strangeness and beauty for their own sake. I do not mean, necessarily, that Claudian is a romantic. The question is not so much what these things meant to him as he wrote, but what they meant to later generations, and what they paved the way to. Under the pretext of allegory something else has slipped in, and something so important that the garden in the *Romance of the Rose* itself is only one of its temporary embodiments—something which, under many names, lurks at the back of most romantic poetry. I mean the 'other world' not of religion, but of imagination; the land of longing, the Earthly Paradise, the garden east of the sun

[1] Ibid. 65: Omnisque vicissim
Felix arbor amat; nutant ad mutua palmae
Foedera, populeo suspirat populus ictu
Et platani platanis alnoque adsibilat alnus.

[2] Ibid. 77 et seq.

and west of the moon. Just as the gods—and their homes
—are fading into mere decoration, in the mythological
poets of this age, we catch a glimpse of the new life and
the new dwellings that poetry will find for them.

The point—which can never be made clear in the sense
of being made 'fool-proof'—will, I trust, become a little
clearer before the end of the chapter. Let us turn to
Claudian's fifth-century successor, Sidonius Apollinaris.
Here again we find the luxuriance in mythological descrip-
tion for its own sake; and here again the pretext—without
which the mythology could hardly gain admission—is alle-
gorical. In many ways Sidonius is far more medieval than
Claudian. The graces, or what he conceives to be the
graces, of his style are far removed from the classical model;
sometimes it is a series of puns (*glaucus, glauce, venis—
Phoebus ephebus*),[1] sometimes a tasteless reduplication of
examples which anticipates the worst passages in Alanus.[2]
The Cave which he assigns to Venus (of course in an *Epi-
thalamium*) is intolerably bright with jewels, and antici-
pates similar dwellings in Gavin Douglas and elsewhere.[3]
We even have the typically medieval theme of the proud
young man (Bayard-Troilus) tamed by Venus. 'Gaudemus,
nate', says Venus, 'rebellem quod vincis'.[4] We have the
allegorical 'houses'. Pallas, in the *Epithalamium for Pole-
mius and Araneola*, has two of them; one belongs to her
as the patroness of wisdom, the other as patroness of
needlework. The first is described in terms that might
have been used by Lydgate:

> Here sit the Seven Wise Men, the source and fount
> Of more philosophies than I can count; . . .

[1] Sidonius Apollinaris (ed. Luetjohann, *Mon. Germaniae Hist.* tom. viii, p. 204)
Carm. vii. 27, 32.

[2] Ibid. *Carm.* xi. 65 et seq. (p. 229): 'Impenderet illi Lemnias imperium,
Cressa stamen labyrinthi, Alceste vitam, Circe herbas, poma Calypso, Scylla
comas, Atalanta pedes', &c. Cf. Alanus de Insulis, *Anticlaudian*, Dist. ii, cap. vi.
34: 'Ut Xeuxis pingit chorus hic, ut Milo figurat. Ut Fabius loquitur, Ut Tullius
ipse perorat, Ut Samius sentit, sapit ut Plato', &c. There are exactly 20 lines of it.

[3] Sidonius, *Carm.* xi. 14 et seq (pp. 227, 228).

[4] Ibid. 72 (p. 229); cf. supra 61 et seq. (Amor is speaking): 'Nova gaudia porto
Felicis praedae, genetrix; calet ille superbus Ruricius.'

Shut out, but near the door, the Cynics are,
But Epicurus Virtue keeps afar.[1]

But, once again, such poetry as Sidonius has does not lie
in the *significatio* of these fictions. It is strange and bright
places that he wishes to describe, not moral realities. His
best work—niggling, exotic, miniature work it is—is ex-
pended on the trappings of the allegory; on the effect of
light and water in the *Epithalamium Ruricio et Iberiae* and
on the Triton a few lines farther.[2]

The late epithalamium, indeed, played an important
part in saving both the love-lore and the mythology of
paganism for Christian poetry. This is rather startlingly
illustrated in the work of Ennodius, who lived at the turn
of the fifth and sixth centuries. Ennodius was a bishop
(like Sidonius), the author of a devotional autobiography
and some hymns; but when he comes to write an epitha-
lamium he follows the example of Claudian and Sidonius,
in preference to the chaster model of Paulinus Nolensis.
He goes, however, beyond his masters, and allegorizes with
a boldness and gusto that are somewhat surprising. He
begins by striking the genuine May morning note of the
later poets:

When young blades shoot and Nature in her bower,
Sits at her work, the world grows warm the while,
And when the sun paints earth with many a flower,
Love, beauty, bravery, all are in his smile.[3]

From this we pass to the picture of Venus playing
among the flowers, *orbe captivo*, and her naked beauty—

[1] Ibid. *Carm.* xv:

> Illicet hic summi resident septem Sapientes
> Innumerabilium primordia philosophorum. . . . (42.)
> Exclusi prope iam Cynici sed limine restant
> Ast Epicureos eliminat undique Virtus. (124.)

[2] Ibid. *Carm.* xi. 10, 34 (pp. 227, 228).

[3] Ennodius, *Carm.* lib. i, iv. 1–4 (ed. Hartel in *Corp. Script. Ecclesiast.* vol. vi,
pp. 512 et seq.):

> Annus sole novo teneras dum format aristas
> Natura in thalamis orbe tepente sedet.
> Pingitur et vario mundus discrimine florum;
> Una soli facies; gratia, cultus, amor.

'Proditum risit sine nube corpus'—is described.[1] Cupid approaches her with a complaint. 'We have lost our old empire. Cold virginity possesses the world. Arise! Shake off your sleep.' His mother replies: 'We shall be all the stronger for our rest. Let the nations learn that a goddess grows in power when no one thinks of her.' Their consequent expedition against the proud youth—that is, the bridegroom—and his capture, follow conventional lines. No comment can add anything to the startling significance of this little poem. If the gods had not died into allegory, the Bishop would not have dared to use them; conversely, if he had not had allegorical gods for his mouthpiece, he could scarcely have put the 'case' of Venus against asceticism so strongly. I do not mean that it was his intention to put it at all. He had probably in his allegory no purpose but to decorate an occasional copy of verses according to the best models. Yet in so doing he stumbles upon freedom. He is free to wander in fairyland, and he is also free to anticipate the eleventh-century reaction against asceticism. In one of the lines which I have translated—

> Discant populi tunc crescere divam
> Cum neglecta iacet[2]—

it is as if some mischievous spirit of prophesy took the pen out of his hand and wrote for us the history both of allegory and of courtly love.

It is to the same class of mythological allegory that I would assign the work of another writer, if I felt sure that any classification could hold him; for this universe, which has produced the bee-orchid and the giraffe, has produced nothing stranger than Martianus Capella. Characteristically, we know little of the man. He lived in the 'blessed city of Elissa' (he means Carthage), and he wrote when he was old.[3] It is uncertain whether he was a Christian or a pagan. Indeed, the distinction scarcely applies to him;

[1] Ennodius, *Carm.* lib. 1, iv. 29–52.
[2] Ibid. 84.
[3] Martianus Capella, *De Nuptiis Philologiae et Mercurii*, ix. 336 G (ed. Eyssenhardt, Teubner, pp. 374, 375).

such men do not have beliefs. I have heard the scholar defined as one who has a propensity to collect useless information, and in this sense Martianus is the very type of the scholar. The philosophies of others, the religions of others —back even to the twilight of pre-republican Rome—have all gone into the curiosity shop of his mind. It is not his business to believe or disbelieve them; the wicked old pedant knows a trick worth two of that. He piles them up all round him till there is hardly room for him to sit among them in the middle darkness of the shop; and there he gloats and catalogues, but never dusts them, for even their dust is precious in his eyes. Formally considered, his book *De Nuptiis Philologiae et Mercurii*, is a treatise on the seven liberal arts,[1] set in the framework of an allegorical marriage between Eloquence (Mercury) and Learning (*Philologia*). But the author deceived himself if he thought that by this framework he was gilding the pill for the benefit of his pupils. On the contrary, it was for himself that the fable was a necessary outlet—a receptacle into which he could work every scrap of erudite lumber and every excruciating quirk of his euphuism which was left over from the seven arts. It enables him, in fact, to lead us wherever he will; and lead us he does, through a chaos beside which the work of Rabelais has unity and that of Mandeville probability. We see Mercury and Virtue visiting the Cirrhaean cave where they find the Fortunes in a melodious grove. The different musical functions of the higher and lower branches are exhaustively treated and the passage looks backward to Tiberianus' *Amnis ibat* and forward to the Bower of Bliss.[2]

[1] The distribution is as follows: Books I to II, Arrangements for the match and the apotheosis of Philology; Books III to VIII, Grammar, Dialectic, Geometry, Arithmetic, Astronomy; Book IX, Music, and a return to the story concluding with the nuptials.

[2] Ibid. i. 6 G (p. 6). The comparison with Tasso's stanza (*G. L.* xvi. 12) or Spenser's (*F. Q.* ii. xii. 71) is a very instructive example of the common element that may exist in a merely conceited and a genuinely poetic passage. Martianus runs: 'Nemorum etiam sussurrantibus flabris canora modulatio melico quodam crepitabat appulsu. Nam eminentiora prolixarum arborum culmina perindeque distenta acuto sonitu resultabant. Quicquid vero terrae confine ac propinquum

Close to this are the rivers *caelitus defluentes*, each of which has a different colour and in which the Fortunes are often carried away, with complex allegorical significance. Hence, having first met Apollo with his vessels of iron, of silver, of lead, and of glass, they ascend to heaven (like Scipio, Dante, and Chaucer) and are speeded in their flight by the universal rejoicing of nature—*conspiceres totius mundi gaudia convenire*.[1] (This passage may have helped Alanus to one of his best scenes.) Arrived in heaven they see the globe in which the gods behold depicted the whole universe *tam in specie quam in genere*, and we are reminded of Venus' mirror in the *Palice of Honour*.[2] From these regions we descend to earth again and visit the bride Philology. Her fears and hesitations about the proposed match allow the author to display his curious knowledge of the various obscurer kinds of augury, until Philology is interrupted by the arrival of the Muses, the Virtues, and Athanasia. The latter compels her to vomit books (like Error in the *Faerie Queene*) before allowing her to taste the cup of immortality.[3] When these preparations are completed, a second ascent to heaven furnishes an opportunity of cataloguing, and assigning to their proper places, the whole fauna of Martianus' universe: *Di, Caelites, Medioxumi* or *Daimones* (*Graeci dicunt* ἀπὸ τοῦ Δαήμονας εἶναι), *Semidei, Longaevi* (such as satyrs), and the rest. A little later we are watching the solar ship, with its cat, its crocodile, and its lion, and its crew of seven sailors. Arrived at her journey's end, the bride leaps from her floating couch, and sees 'the immense plains of light and the springtime of the ethereal peace'; but knowing that the true God is beyond all these and far even from the knowledge

ramis adclinibus fuerat gravitas rauca quatiebat. At media ratis per annexa succentibus duplis ac sesquialteris nec non etiam sesquitertiis, sesquioctavis etiam sine discretione iuncturis, licet intervenirent limmata, concinebant. Ita fiebat ut nemus illud harmoniam, totam superumque carmen modulationum congruentia personaret.'

[1] Martianus, *De Nupt.* i. 11 G (p. 12); cf. Alanus, *De Planctu Naturae*, Prosa II (pp. 445 et seq. in Wright's *Anglo-Latin Satirical Poets*, 1872, vol. ii).

[2] Ibid. i. 18 G (p. 20); cf. Gavin Douglas, *Palice of Honour*, iii, stanzas 24 et seq.

[3] Ibid. ii. 34 G (p. 39); cf. Spenser, *F. Q.* i. i. 20.

of the gods—words which may bear a Neoplatonic as well
as a Christian interpretation—she prays in silence to the
dweller in that intelligible world, and propitiates—mys-
teriously enough—a *fontana virgo*.[1]

The *De Nuptiis*, as is well known, became a text-book
in the Middle Ages. Its encyclopaedic character made it
invaluable for men who aimed at a universality in know-
ledge without being able, or perhaps willing, to return to
the higher authorities. The fantastical 'babu' ornaments
of the style were admired. The mixture of fable with
grammatical or scientific doctrine was a *damnosa hereditas*
which it bequeathed to the following centuries; Martianus,
I take it, must bear the chief responsibility for Hawes'
Tower of Doctrine and Spenser's House of Alma. He
established a disastrous precedent for endlessness and form-
lessness in literary work. Yet I cannot persuade myself that
the Middle Ages were entirely unhappy in their choice
of a master. Martianus may have been a bad fairy; but
I think he had the fairy blood in him. His building is
a palace without design; the passages are tortuous, the
rooms disfigured with senseless gilding, ill-ventilated, and
horribly crowded with knick-knacks. But the knick-knacks
are very curious, very strange; and who will say at what
point strangeness begins to turn into beauty? I must
confess, too, that I am sufficiently of the author's kidney
to enjoy the faint smell of the secular dust that lies upon
them. At every moment we are reminded of something
in the far past or something still to come. What is at hand
may be dull; but we never lose faith in the richness of the
collection as a whole. Anything may come next. We are
'pleased, like travellers, with seeing more', and we are not
always disappointed. Among all these figurative woods
and streams, these wheeling poles and pedantic rituals,
these solemn processions and councils of the gods—gods
that seem no bigger than marionettes, but stiff with gold
and carved with Chinese curiosity—among all these, some
at any rate suffer us to forget their doctrinal purpose, and

[1] Ibid. ii. 45 G (p. 50).

breathe the air of wonderland. I have an idea that if Lamb had known Latin enough to read it, this book might stand higher to-day in our estimation.

But the lasting consequence of all these writers, for the history of imagination, is far more certain than any assessment of their individual merits. In all of them alike, as I hinted above, we see the beginnings of that free creation of the marvellous which first slips in under the cloak of allegory. It is difficult for the modern man of letters to value this quiet revolution as it deserves. We are apt to take it for granted that a poet has at his command, besides the actual world and the world of his own religion, a third world of myth and fancy. The probable, the marvellous-taken-as-fact, the marvellous-known-to-be-fiction—such is the triple equipment of the post-Renaissance poet. Such were the three worlds which Spenser, Shakespeare, and Milton were born to. London and Warwick, Heaven and Hell, Fairyland and Prospero's Island—each has its own laws and its appropriate poetry. But this triple heritage is a late conquest. Go back to the beginnings of any literature and you will not find it. At the beginning the only marvels are the marvels which are taken for fact. The poet has only two of these three worlds. In the fullness of time the third world crept in, but only by a sort of accident. The old gods, when they ceased to be taken as gods, might so easily have been suppressed as devils: that, we know, is what happened to our incalculable loss in the history of Anglo-Saxon poetry. Only their allegorical use, prepared by slow developments within paganism itself, saved them, as in a temporary tomb, for the day when they could wake again in the beauty of acknowledged myth and thus provide modern Europe with its 'third world' of romantic imagining. And when they rose they were changed and gave to poetry that which poetry had scarcely had before. Let us be quite certain of this change. The gods—and, of course, I include under this title that whole 'hemisphere of magic fiction' which flows indirectly from them—the gods were not to paganism what they are to us.

In classical poetry we hear plenty of them as objects of worship, of fear, of hatred; even as comic characters. But pure aesthetic contemplation of their eternity, their remoteness, and their peace, for its own sake, is curiously rare. There is, I think, only the one passage in all Homer; and it is echoed only by Lucretius.[1] But Lucretius was an atheist; and that is precisely why he sees the beauty of the gods. For he himself, in another place, has laid his finger on the secret: it is *religio* that hides them.[2] No religion, so long as it believed, can have that kind of beauty which we find in the gods of Titian, of Botticelli, or of our own romantic poets. To this day you cannot make poetry *of that sort* out of the Christian heaven and hell. The gods must be, as it were, disinfected of belief; the last taint of the sacrifice, and of the urgent practical interest, the selfish prayer, must be washed away from them, before that other divinity can come to light in the imagination. For poetry to spread its wings fully, there must be, besides the believed religion, a marvellous that knows itself as myth. For this to come about, the old marvellous, which once was taken as fact, must be stored up somewhere, not wholly dead, but in a winter sleep, waiting its time. If it is not so stored up, if it is allowed to perish, then the imagination is impoverished. Such a sleeping-place was provided for the gods by allegory. Allegory may seem, at first, to have killed them; but it killed only as the sower kills, for gods, like other creatures, must die to live.

V

In the preceding sections I have tried to explain and to characterize the allegorical legacy which the ancient world

[1] *Odyssey*, vi. 41 et seq. Lucretius, *De Rerum Nat.* iii. 18. No doubt a good classical scholar will be able to produce more passages, but the rarity, on the whole, of this note in ancient literature will hardly be disputed. Of course the numbers of such passages can be increased to any extent by skilful verse-translation in the romantic style.

[2] Lucretius, vi. 68 et seq. Lucretius hits off with strange accuracy the highest function of the supernatural in romantic poetry:

> 'Nec de corpore quae sancto simulacra feruntur
> In mentis hominum divinae nuntia formae,
> Suscipere haec animi tranquilla pace valebis.'

on its death-bed bequeathed to the Dark Ages. It is not my purpose to follow in detail the history of that legacy from Martianus Capella to the *Romance of the Rose*. Some understanding of the seed was necessary for the appreciation of the flower, but we need not follow every winding of the stem. The unexperienced reader, must, however, be saved from a misapprehension which our discussion naturally invites. He must not suppose that in passing over the centuries between the sixth and the twelfth we are leaving on one side a series of lengthy allegorical poems in which it would be possible to trace the continuous development of the *Psychomachia* or the *De Nuptiis* into the romantic allegory of the Middle Ages. The later allegory with its free, and often ingenious, plot, and its luxuriant poetry, is a genuinely new creation. It owes to antiquity and to the Dark Ages not so much its procedure as the preservation of that atmosphere in which allegory was a natural method. The Dark Ages produced few original allegorical poems on the large scale; but they kept alive the mood which was later to beget such poems, they read and admired the older allegorists, and they constantly employed allegory in the parts, if not in the structure, of their works. Thus it would be odd to class Boethius as an allegorist. On the other hand, his use of personification in the figure of *Philosophia* raises personification to a new dignity and is worthy to stand beside the Wisdom-literature of the Jews. He himself does not greatly allegorize; he leaves something, and something potent, ready to the hand of later writers. In the same way, his contemporary Fulgentius writes no new allegorical poem, but he does what is perhaps of more importance. In his famous—or notorious—*Continentia Vergiliana* we see for the first time the method of allegorical explanation applied in thoroughgoing fashion by a Christian grammarian to a pagan poet. The whole story of the *Aeneid* is interpreted as an allegory of the life of man. Sometimes Fulgentius does little more than harden and render explicit that which is dimly present to the mind of every reader of Virgil in every age. When

Aeneas meeting Dido in the shades is made to typify the
converted and corrected soul remembering the passions of
dead youth, few of us will quarrel with the commentator.
We are less pleased when the whole of the first book is
treated as a picture of babyhood, and the song of Iopas
is equated with the lullaby of our nurse.[1] But the im-
portance of Fulgentius is plain. When once the ancients
are read in this way, then to imitate the ancients means
to write allegory. Without himself allegorizing Fulgentius
creates models for the later allegorist; by a sort of retro-
spective magic he creates models who lived centuries
before his own time. It is true, no doubt, that the Dark
Ages sometimes offer us a fully-fledged allegory. Fortu-
natus in the sixth century continues in his *Epithalamium*
for Brunchild the erotic-mythical allegory of Claudian,
Sidonius, and Ennodius. We have the May morning, the
archery of Cupid, and his boast to his mother, 'Mihi vin-
citur alter Achilles'.[2] Purely religious allegory, of a far
more developed type than the *Psychomachia*, is to be found
in the beautiful, but desperately difficult, poem called the
Well of Life, which was written by Audradus in the ninth
century.[3] The allegorical use of the beast fable was prac-
tised—perhaps for the first time—by an unknown poet of
the tenth. What is of more consequence than these to the
medievalist is the beginning of the floral symbolism and of
the allegorical *débat*, both of which count for much in later
poetry. They are to be found united in the very pleasant
Contention of the Lily and the Rose by Sedulius Scotus (ninth
century). Their strife is ended by the arrival of Spring—
'Tunc Ver florigera iuvenis pausabat in herba'. The claims of
the two disputants are thus adjusted in his concluding speech:

> O rosa pulchra tace, tua gloria claret in herba
> Regia sed nitidis dominentur lilia sceptris—

[1] *v.* Comparetti, *Vergil in the Middle Ages*, trans. Benecke (London, 1895), pt.
i, ch. viii, pp. 107 et seq.

[2] Venantius Fortunatus (ed. Leo, *Mon. Germ. Hist.* tom. iv), lib. vi, c. 1, (pp.
125 et seq.).

[3] Audradus Modicus, *Carm.* 1 (ed. Traube, *Mon. Germ. Hist.*, *Poet. Lat. Med.*
Aev. tom. iii, p. 73).

Tu Rosa martyribus rutilam das stemmate palmam,
Lilia virgineas turbas decorate stolatas.[1]

It is an appealing specimen of that fragile yet awkward prettiness which remains, in spite of our heroic preconceptions, one of the most predominant characteristics both of the Dark and of the Middle Ages.

But while it is natural to draw attention to such things, they do not very directly concern our subject. They do not constitute transitional works midway between the ancient and the medieval allegory. In this matter, as I have said, the Dark Ages held a waiting brief. It is not their complete allegories that count: it is the reiterated, though incidental, use of allegory in sermon and treatise, the repeated appearance of the virtues and vices in art, which steeped the mind of Europe in this mood and so prepared the way for Alanus de Insulis and Guillaume de Lorris. With the decay of civilization the subtleties of St. Augustine were lost: the vivid interest in the inner world, stimulated by the horrors and hopes of Christian eschatology, remained, and drove men, as always, to personification. The Seven (or Eight) Deadly Sins, imagined as persons, became so familiar that at last the believer seems to have lost all power of distinguishing between his allegory and his pneumatology. The Virtues and Vices become as real as the angels and the fiends. Such, at least, is the inference I draw from the vision of an English monk, in the seventh or eighth century—and dreams, in such a matter, are not the worst evidence. This monk—one of a hundred successors of Er and predecessors of Dante—could see all round him, as he left the body, the demons and angels contending for his soul. But mixed with the former were his own sins, whom he recognized by their voices as they cried out, 'Ego sum cupiditas tua, Ego sum vana gloria', and the like. On the other side, but smaller—*parvae virtutes*—his Fasts and his Obedience came

[1] Sedulius Scotus, *Mon. Germ. Hist.* (*Poet. Lat. Med. Aev.* tom. iii, p. 231). An earlier specimen of the allegorical *débat* will be found in Alcuin's (?) *Conflictus Veris et Hiemis* (ibid. ed. Duemmler, tom. i, p. 270).

to offer him their aid. From these he passes to the flaming river with its narrow bridge and sees the good souls pressing to cross over *desiderio alterius ripae*.[1] All the actors and all the scenery are on the same plane of reality; and the story, like many others of its kind, may well record an actual dream. Such was once the concreteness of those figures whom our criticism would dismiss as 'abstractions'.

The twilight of classical antiquity and the Dark Ages, then, had prepared in diverse ways for the great age of allegory. Antiquity had first created the demand and partly supplied it. The Dark Ages, while not adding very remarkably to the supply, had kept alive, and even rendered chronic, the demand. But the poets of courtly love were not the pioneers of the medieval allegory. It came to their hands already revivified by authors of a different stamp, who yet had something in common with them. To these authors—the great philosophical poets of the twelfth century—we must turn before we close the chapter. They are in themselves sufficiently remarkable; and I can at least promise the reader that they constitute the last digression which still divides us from our main theme.

VI

These writers may be described as the poets of the school of Chartres. Their leader, Bernardus Sylvestris, was a scholar in that school,[2] and possibly chancellor; and they are all connected with it by clear lines of intellectual descent. For the reader, and still more for the writer, who is not learned in medieval philosophy, a very brief characterization of this school must suffice. In dealing with the Middle Ages we are often tricked by our imagination. We think of plate armour and Aristotelianism. But the end of the Middle Ages is already in sight when these attractive things appear. And just as the lobster shell of steel gave to the warrior, along with the security, some-

[1] *Mon. Germ. Hist. (Epist. Merowingici et Karolini Aevi*, tom. i, pp. 252 et seq.)
[2] See Raby, *Secular Latin Poetry* (Oxford, 1934), vol. ii, p. 8; also Miss Helen Waddell, *The Wandering Scholars* (London, 1927), p. 115, n. 1.

thing of the inertia, of the crustacean, so it is possible, without disrespect to that great philosophical panoply in which Dante and Aquinas walked complete, to hint that those who wore it necessarily lost some of the grace and freedom of their forebears. The recovery of Aristotle's text dates from the second half of the twelfth century: the dominance of his doctrine soon followed. Aristotle is, before all, the philosopher of divisions. His effect on his greatest disciple, as M. Gilson has traced it, was to dig new chasms between God and the world, between human knowledge and reality, between faith and reason. Heaven began, under this dispensation, to seem farther off. The danger of Pantheism grew less: the danger of mechanical Deism came a step nearer. It is almost as if the first, faint shadow of Descartes, or even of 'our present discontents' had fallen across the scene. Certainly, something fresh and adventurous, which belonged to the earlier movement, has disappeared. Of that earlier movement the school of Chartres, in the first half of the twelfth century, may perhaps be regarded as the culminating point. The school of Chartres is Platonic, as Platonism was understood in those days, when Chalcidius' translation of the *Timaeus*, and the pseudo-Dionysius, were the important texts. It was humane, in both senses of the word. It was a school of naturalism, and this again in the double sense of studying and of reverencing nature. Thus Thierry of Chartres— like some of his Platonic descendants at the Renaissance— will reconcile *Genesis* and the *Timaeus*; while in the poets of the school Nature appears, not to be corrected by Grace, but as the goddess and the *vicaria* of God, herself correcting the unnatural. It goes without saying that in such a school, on the theological side, immanence is more stressed than transcendence; and I have read that by two of its philosophers—Thierry and William of Conches—the Holy Ghost is identified with the *Anima Mundi* of the Platonists.

I have ventured to use the word 'great' of the poets who derive from this school; and great by the 'historic estimate' they certainly are: in their influence, great beyond all

question. But if I endeavour to rise to any absolute stan-
dard of criticism I become aware that the epithet cannot
be maintained. Their literary position is, indeed, a pecu-
liar one. If it were ever legitimate to speak of genius
hampered by lack—or misdirection—of talent, it would
be legitimate in the case of Bernard and his successors.
Such a description is nearly meaningless; but even a bad
shot may sometimes give us a rough indication of where
the target lies. For these poets, in their intention, in the
originality of their point of view, above all in their fresh
and revelling appreciation of natural beauty, have merits
which almost deserve the name of genius. But alas!—in
certain periods, to choose the medium is almost to seal the
fate of the work. If they had written in the vernacular and
so been forced to invent their own style, they might have
become not utterly unworthy predecessors of Dante. If
they had written in riming Latin verse, or unadorned
chronicler's prose, they would not have lacked a vigour and
sweetness of their own. But writing, as they did, in
quantitative verse and consciously artistic prose, they in-
evitably followed the approved models in those forms. The
great model was Martianus Capella. I have called him a
bad fairy; but in respect of style, it is his badness alone,
not his fairyhood, that is evident. Hence, over all the
really fine qualities of these poets, lies the loathsome trail
of the rhetorician—the infuriating derangement of every
sentence from its natural order, the fantastic choice of
vocabulary, the *anadiplosis*, the *sententia*, and the *amplifi-
catio*. They are all terribly obedient to the rhetor's pre-
cept *varius sis et tamen idem*.[1] Their reader must have
endless patience and dig deep if he is to find the real merits
that lie buried beneath the 'curious terms', the 'fresh
colours', the 'sugared rhetoric', and all the other tasteless
foolery which corrupts the 'literary' Latin of the time, as
it was later to corrupt the vernacular. Yet the task is worth
attempting; for surely to be indulgent to mere fashion in

[1] Geoffroi de Vinsauf, *Poetria Nova*, iii. A 225 (Faral, *Les Arts Poétiques du XII*
et du XIII Siècles*.

other periods, and merciless to it in our own, is the first step we can make out of the prison of the *Zeitgeist*?

The work of Bernardus Sylvestris is entitled *De Mundi Universitate sive Megacosmus et Microcosmus*.[1] It is written in the alternating metres and proses of Boethius. Its subject is the creation of the world and of man. The classical reader traces in it easily enough the influence of the *Timaeus*; but there are other influences at work which must be left to the skilled medievalist to determine. It is the story of creation told from the point of view of the created: the female longing of matter to receive the form, not the creative impulse of the Deity, is the moving passion of the work, which thus becomes a curious pendant to the Miltonic handling of the same theme. In adopting such a standpoint it is clear that the author incurs certain dangers. Of necessity he comes perilously near to representing non-existents as petitioners for their own existence. Yet, as a philosopher, he may reply that he is dealing with processes that are not in time at all, and that such a presentation is therefore not more inadequate than another: from the purely literary point of view we may plead in his defence that we, after all, belong to the created ourselves and that the response of the work to the workman is precisely that aspect of creation which comes, by remote analogy, within our experience and is therefore a proper object for the imagination. Nor would such an analogy be foreign to the mind of the author; for the very words in which he describes the longing of matter to be 'born again' by the reception of form, must have suggested, then as now, an individual, and specifically Christian, experience:

> Lo! Matter, eldest of all things, would fain
> Be limited by shape and born again.[2]

[1] Ed. Barach and Wrobel, *Bibliotheca Philosophorum Mediae Aetatis*, i. (Innsbruck, 1876).

[2] Bernardus Sylvester, *De Mundi Universitate*, i. i. 35:

> Rursus et ecce cupit res antiquissima nasci
> Ortu silva novo circumscribique figuris.

(Ed. Barah and Wrobel, *Bibliotheca Philosophorum Mediae Aetatis*.)

I have quoted these words from the speech of Nature
with which the book opens. The goddess is addressing
Noys (νοῦς) and pleading the cause of matter; the re-
mainder of the book relates in detail the answering of her
prayer. That Noys answers it favourably is inevitable;
it is the necessity of Reason's own nature that Reason
should work up to her own likeness, as far as may be, even
the lowest and most remote effluences of her productivity.
Yet Noys replies with a warning that the primeval squalor
of the *silva* cannot be perfectly reformed. Matter is the
lowest grade of appearance—the rim of the wheel and
farthest from the divine centre. If it could perfectly receive
the form it would not be matter. Somewhere in the eman-
ative descent of the divine virtue there must be a lowest
point; and this metaphysical necessity is allegorically repre-
sented by references to the *malignitas* and *malum* of the
silva.[1] But the author is not a manichee or even an ascetic,
and to press these expressions beyond their metaphorical
meaning is to misread the book. For the same reason the
aeternae notiones cannot be directly impressed upon the
material world; and the first act of Noys is to inform
matter with *species* which are themselves but copies of the
eternal Ideas—so that Bernardus, following Plato himself,
finds room both for the Platonic and for the Aristotelian
type of universal. The next step is to separate the ele-
ments, and when this is done, Noys proceeds to generate
soul: for the Macrocosm, here as in Plato, is a lively and
reasonable animal, whose indwelling spirit comforts and
protects it against the elemental catastrophes which would
otherwise speedily unmake it again. Having thus, through
a long and tortuous chapter of prose, conducted the world
to its birth, the author shakes off his metaphysics, and
rejoices for some five hundred elegiac verses in the visible
and tangible. The Angelic Hierarchies are briefly disposed
of. The stars are described in a passage which will fatigue
most modern readers, though it might fatigue us less if our

[1] Ed. Barach and Wrobel, *Bibliotheca Philosophorum Mediae Aetatis*, 1. ii. 20
et seq.

education had not left us so ignorant of astronomy. The planets are better, and the mountains better still; but it is among the beasts, the trees, the spices, and the forests that the author is really at home. Among the latter it is pleasant to find, as well as Academe and the *Aonium nemus*, woods more endeared to the northern fancy,

> Briscelim sinus Armoricus, Turonia vastem,
> Ardaniam silvam Gallicus orbis habet.[1]

The Earthly Paradise is pleasantly described:

> Through happy woods with serpentine meanders
> Of ever-varying ways a river wanders;
> Now chattering over stones, now gliding round
> The roots of trees, it falls with murmuring sound
> —A land of streams and flowers, by man possessed
> So short a time it scarce could call him Guest.[2]

The 'procession' of the beasts is incurably quaint. It is difficult to know how the poet intended us to be affected by such a couplet as the following:

> Great-hearted is the horse: the donkey bears
> A soul bowed down beneath his load of ears.[3]

Yet his naïvety—a naïvety, of course, eminently compatible with an extreme and conceited artfulness of style— does really enable him to strike a note of fresh and delighted applause which is, in some ways, more suited to the theme than a classical solemnity. I cannot but think that the wonder of creation, the moment at which we can

[1] Ed. Barach and Wrobel, *Bibliotheca Philosophorum Mediae Aetatis*, i. iii. 351.
[2] Ibid. i. iii. 330:
> Inter felices silvas sinuosus oberrat
> Inflexo totiens tramite rivus aquae.
> Arboribusque strepens et conflictata lapillis
> Labitur in pronum murmure lympha fugax.
> Hos, reor, incoluit riguos pictosque recessus
> Hospes sed brevior hospite primus homo.

[3] Ibid. i. iii. 213:
> Cor fervens erexit equum, deiecit asellum
> Segnities, animos praegravat auris onus.

fancy each beast appearing as a new *tour de force* of Deity—
is well expressed in his couplet of the lynx:

> Forth comes the lynx to test those streams of light
> That flow in him, his miracle of sight.[1]

Before closing the first book, Bernardus, with a sure enough
instinct, having refreshed his readers, leads them back again
to metaphysics. Into the brightly coloured world at which
we have been glancing, time is introduced. But the world
is everlasting in time; for its causes are eternal and from
them it descends with hierarchical continuity, and, being
lively and reasonable, it knows well how to protect itself
from harm. Thence the author passes by a natural transi-
tion into lofty speculations on the everlasting and the
eternal, which are different and yet the same ('For time
in his beginning goeth out from eternity and into the lap
of eternity returneth again being weary after his long cir-
cuit'[2]), and with these concludes his first book.

The second book opens with a speech of Noys. The
world has been made and is very good: it remains to make
the little world of Man. But for this task new powers must
be invoked; and here the difficulty in Bernard's concep-
tion of Nature begins. Besides Natura there is Physis.
Physis has not, like Natura, the entry in the court of Noys:
'You will find her,' says Noys, *in inferioribus conversantem*.[3]
Her daughters are *Theorica* and *Practica*. The crucial pas-
sage for determining the respective parts of Natura and
Physis is the scene in which Man is actually created.[4]
Natura is equipped for this work with the *Tabula Fati*
which contains 'eorum quae geruntur series decretis fatali-
bus circumscripta'. Physis, on the other hand, is given a
Liber Recordationis. It deals with matters which are the
field of probable conjecture; and these turn out to com-
prise most of what we should call 'natural history'. One

[1] Ibid. i. iii. 225:

> Prodit ut ignoti faciat miracula visus
> Lynx liquidi fontem luminis instar habens.

[2] Ibid. i. iv. 97.
[3] Ibid. ii. iii. 24. [4] Ibid. ii. xi.

consults the *Liber Recordationis* to find out why lions are
fierce, and why some plants have their virtue in the root,
others in the seed. The *Tabula Fati*, given to Natura, is
apt to mislead a modern until he remembers that the
course of history is written in the stars,[1] and that the genius
of inorganic nature, the spirit who guides the stars in their
courses, would also be, for a medieval writer, the spirit of
destiny. Natura, in fact, is a personification of the general
order of things, in the largest sense, and has a wider field
of action than we should ordinarily attribute to 'nature'.
Physis is less easily understood. The key to her mystery is
possibly to be found in Thierry or some such writer; but
to seek it at any length would be beyond my undertaking.
For a merely *literary* understanding of Bernardus a vague
'feel' of the character of Physis will have to suffice. She is
almost 'organic nature', the object of biology: she is the
reservoir of vital possibilities on which the general ordering
of Natura draws: she lives on earth, and in visiting her
fruitful garden Natura really descends to 'the Mothers'.
Her two daughters—Theory and Practice—may suggest
for a moment that she is also 'human nature' developing
itself either in the contemplative or the active life; but
I do not think that this is what the author intended,
and the two daughters represent rather the theoretical
and therapeutic sides of the Physicus' profession. We find
Physis in her garden meditating upon the origins and
powers of the several 'natures', and also on the remedies
for diseases. Such, then, is one of the new powers invoked
for the making of man. In order to fabricate the organism
inhabitable by human mind, the ordering spirit of Nature
must invoke those yet unexhausted possibilities of the vital
force, which are symbolized as Physis, the earth dweller.
But this is not all. Man is to have something more than
that mediated impress of the divine idea which rests upon
creation as a whole: in him something of immediate
divinity is to dwell. Along with Physis, therefore, Urania,

[1] Ed. Barach and Wrobel, *Bibliotheca Philosophorum Mediae Aetatis*, i. iii. 33
et seq.

the heaven-spirit, must be summoned; and the dwelling
of Urania Natura accordingly sets out. Urania, too
bright for the eyes of Natura, rises at her approach,
prophesies the high destinies of Man, whose soul, by
birth, is to be made acquainted with all the influences of
the heaven to which some day she will return:

> With me through all the expanse of heaven must go
> Man's soul, and I will make her know
> The laws of Fate allowing no repeal
> And Fortune's alterable wheel . . .
> Her godlike essence when her body dies
> Will seek again those kindred skies.[1]

The two goddesses descend together to the earth in search
of Physis. Their journey through the various planetary
levels is well described; and once beyond the lunar frontier
of air and ether, whence stretches the realm of Sum-
manus, we are in the world of folk-lore. Between earth
and moon dwell the 'airish' folk, and on the earth's surface
those long-livers who are fairies undisguised, for all their
classical names.

> 'Wherever earth is most delightful, be it with grassy ridge or
> flowery mountain top, wherever it is brightened with streams or
> robed in woodland greenery, there Silvans, Pans, and Nerei,
> blameless of conversation, wear out the period of their longer
> life. Their bodies are of elemental purity: yet these too die,
> though late, in the season of their dissolution.'[2]

The travellers approach the garden of Granusion, where
the air is tempered by 'the boyhood of the sun'. There, at
the coming of Natura, the turf swells and the groves drop
new odours; and there Physis is found with her daughters,

[1] Ibid. ii. iv. 31:

> Mens humana mihi tractus ducenda per omnes
> Aethereos ut sit prudentior
> Parcarum leges et ineluctabile fatum
> Fortunaeque vices variabilis . . .
> Corpore iam posito cognata redibit ad astra
> Additus in numero superum deus.

[2] Ibid. ii. vii. 111.

deep in contemplation of the secret potencies of life, until she is awakened by the face of Urania, seen not directly, but reflected in a well. The three goddesses are ready for the making of man. But the supreme Mind, though it delegates, is not absent, and works itself in its lower agents: 'such privilege hath omnipresence'. Suddenly, therefore, Noys is visibly among them in the garden, and her voice is heard propounding the nature of Man, in lines which give lofty expression to the humanism of Chartres, and which, if they were written in English blank verse, would be universally hailed as typical of the Renaissance.

> He shall be heavenly, earthly; by his care
> Shall rule the earth, and reach the heaven by prayer,
> For as the diverse sources whence he drew
> His being, so himself will still be two; . . .
> He shall drag forth to light the causes hid
> In secret gloom, though Nature long forbid . . .
> To him, unbounded, in all lands, I give
> High crown and priesthood over all that live.[1]

Obedient to the word of Noys, the three powers fall to the work. Out of the remnants of the elements, left over from the fashioning of the Macrocosm, the four complexions are made; the Whole Man, to be an image of the mighty world, where God rules in heaven and earth lies below, divided by the aerial and ethereal regions, is made a kind of trinity of head, breast, and loins; and lest the perfect correspondence should be lacking, not only between the two wholes, but between the ruling parts of each, the head also has its threefold subdivision. At last, the five senses

[1] Ed. Barach and Wrobel, *Bibliotheca Philosophorum Mediae Aetatis*, II. ix:

> Divus erit, terrenus erit, curabit utrumque
> Consiliis mundum, religione deos;
> Naturis poterit sic respondere duabus
> Et sic principiis congruus esse suis. (II. x. 19.)
> Viderit in lucem mersas caligine causas
> Ut Natura nihil occuluisse queat. (35.)
> Omnia subiiciat, terras regat, imperet orbi,
> Primatem rebus pontificemque dedi. (49.)

are made, and Man is created. Sight comes first, both in
order and dignity:

> As the world's eye, the Sun, excels by far
> And claims the heaven from every vulgar star,
> So doth the eye all other senses quite
> Out-go, and the whole man is in the sight.[1]

Touch comes last: even as, among the organs, those of
generation come last. It is characteristic of the author,
however, that there should be no trace of ascetic contempt
for sexuality; and equally characteristic that there should
be no 'romantic' glorification of it. The hierarchical prin-
ciple finds room for every fact: there is a place for every-
thing, and everything is in its right place. Everything
is less noble than that which stands above it, and more
noble than that which stands below: it is only the whole
scale of being which is good and fair absolutely. Hence
comes the sanity with which Bernardus can speak of these
organs; and there is no better way to prove his universal
and 'classical' quality as a thinker than by comparing with
Ovid's smirkings or with some modern ravings on the same
subject the following lines from the conclusion of his
allegory:

> Pleasant and fitting both their use will be
> When time and mode and measure do agree,
> Else withering from the root all lives would fail
> And that old Chaos o'er the wreck prevail.
> Conquerors of Death! they fill each empty place
> In Nature and immortalize the race.[2]

[1] Ibid. II. xiv. 41:

> Sol oculus mundi quantum communibus astris
> Praeminet et caelum vendicat usque suum,
> Non aliter sensus alios obscurat honore
> Visus et in solo lumine totus homo est.

[2] Ibid. II. xiv. 155:

> Iocundusque tamen et eorum commodus usus
> Si quando, qualis, quantus oportet, erit.
> Saecula ne pereant decisaque cesset origo
> Et repetat primum massa soluta chaos;
> Cum morte invicti pugnant genialibus armis,
> Naturam reparant perpetuantque genus.

Of the literary merits of Bernardus, the reader can judge best by comparing the account I have just given with the equally favourable, but differently directed, account of Miss Waddell, who touches nothing which she does not adorn. That a writer who describes the *Timaeus* as 'the driest of the Platonic dialogues'[1] does not start from a position or a temper very near my own, ought by now to be sufficiently obvious; and a book which pleases two such critics—who are certain, when they err, to err in precisely opposite directions—can hardly fail to have in it some real merit. Its historical importance, and its relevance to our main theme, will be already apparent to most; but the attempt to define them had better wait until we have glanced at its successors. For the moment it will be enough to say that Bernardus, despite those faults of style which he shares—though in a less degree—with his contemporaries, has real freshness and piquancy in some of his descriptions; he can be elevated when his subject raises him, though never for many lines together before some ruinous conceit or 'boyism' breaks in; he can respond to, though of course he could not have created, the sublime suggestions of Plato's most sublime and suggestive work; above all, his mind is whole and balanced. Ascetic theology will not tempt him to forget that the material world is the image of the eternal ideas; but neither will his delight in the world tempt him to forget that it is only an image. The wilfulness of extreme monasticism, and the complementary wilfulness of Chrétien, cannot touch him. The world of Andreas Capellanus was cut in two. On the one side *omnis curialitas*; on the other, the anger of God. Not so the world of Bernardus. Here at last we find a whole man. Here at last is sense and heartsease and the possibility of growth.

The *Anticlaudianus*[2] of Alanus ab Insulis is a work in every respect inferior to the *De Mundi Universitate*, and may be described as nearly worthless except from the

[1] Helen Waddell, op. cit. (London, 1927), p. 118.
[2] I have used the text printed by Wright in his Anglo-Latin *Satirical Poets of the Twelfth Century*. The poem is also to be found in Migne's *Patrologia*.

historical point of view. From that point of view it is important. It was written to be a kind of pendant to Claudian's *In Rufinum*. In that glorified lampoon Claudian had tried to give an original turn to the abuse of an enemy by a setting of the allegorical mythology which was congenial to his age. In the opening of his first book Allecto is introduced lamenting the return of the golden age, and the consequent diminution of her old empire, under Theodosius. An infernal council is summoned and Megaera carries the proposal of entrusting to her nursling Rufinus the championship of the cause of evil. Alanus reverses the idea and describes the creation of a perfect man by Natura as her champion against Allecto; and hence the title *anti-Claudian*. Since the perfect man, at the end of the poem, proves his mettle in combat against the vices, the poem may be described as a *Psychomachia* with a lengthy introduction; and Alanus, like Prudentius, probably believed himself to be composing an epic. The work is written throughout in hexameters and always couched in the same monotonous rhetoric. It is a principle with Alanus that whatever is worth saying once is worth saying several times. Thus 'she thinks about the way to heaven' becomes

> She thinks, inquires, devises, seeks, elects
> What way, or path, or road may guide her steps
> To high heav'n and the Thunderer's secret throne.[1]

'She bids them make a chariot' becomes

> She bids, commands, orders, enjoins, begs one
> Of those in Wisdom's train, with hand and heart
> And faith and zeal and sweat and toil to effect
> The carriage into being of her carriage.[2]

[1] *Anticlaudianus*, Dist. II, cap. vi. 6 (Wright, p. 303):

> Cogitat, exquirit, studet, invenit, eligit ergo
> Quae via, quis callis, quae semita, rectius ipsam
> Deferet ad superos arcanaque regna Tonantis.

[2] Ibid. Dist. II, cap. vii. 3:

> Ordinat, injungit, jubet, imperat, orat ut instans
> Quaelibet illarum comitum, comitante Sophia
> Corpore, mente, fide, studeat, desudet, anhelet,
> Instet et efficiat ut currus currat ad esse. (Wright, p. 304.)

But no quotation can do justice to the effect of the book as a whole. Those who have read it to the end—a small company—and those only, can understand how speedily amused contempt turns into contempt without amusement, and how even contempt at last settles into something not far removed from a rankling personal hatred of the author. Nor are the vices of the style redeemed, as their much more pardonable counterparts were redeemed in Bernardus, by any real profundity or freshness in the matter. Once or twice, when he is describing external nature, the author shows a trace of real feeling; once or twice, in moral passages, he attains a certain dignity; for the rest this book is one of the melancholy kind that claim our attention solely as influences and as examples of a tendency.

Natura, the story says, once resolved to sum up in a single crowning work all the goodness that lay scattered among her creatures. But her old anvil was worn away and the task beyond her powers. Therefore she called her sisters to council, in her secret place. Thither they came —Concord and Youth, Laughter who clears the clouds of the mind, and Reason who is the measure of good: Honesty, Prudence, Good Faith, and that Virtue *par excellence* (for she is called *Virtus* simply).

> Who scatters wealth and pours her gifts abroad
> Nor lets her treasure basely fust in ease.[1]

Last of all came Nobility. To these Natura opened her heart. In all her works she saw nothing that was wholly blessed. The old stain could not be removed; but still it might be possible to make one work which could redeem the whole, and be the mirror of themselves. In the meantime, they knew that her decrees were scorned by mortals and Tisiphone triumphed on the earth. To this the Virtues replied that such a project showed the divine wisdom

[1] *Anticlaudianus*, Dist. i, cap. ii. 11:

> Quae spargit opes, quae munera fundit,
> Quam penes ignorat ignavam gaza quietem. (Wright, p. 274.)

of the speaker, but that among themselves there was no power to perform it. Let Prudence and Reason be dispatched to heaven to ask of God a soul for the perfect man. Prudence at first was coy ('Fluctuat haec, se nolle negat nec velle fatetur'),[1] but Concord overruled her. A chariot was built and to it they yoked the five horses whose names are Sight, Hearing, Smell, Taste, and Touch, and the two virtues ascended in it to heaven, passing as they went, the *aerios cives quibus aer carcer*.[2] On the brow of the world they met Theology, who unyoked Hearing and setting Prudence on his back—for Reason could come no farther—conducted her to the throne of the Almighty; to whom she offered her prayer, representing the ill treatment which she and her sisters now suffered on earth, and rounding all off with the cogent argument

> A neighbour's house on fire imperils thine.[3]

God then called Noys to bring him an exemplar out of her treasury and impressed its likeness with his seal upon the new soul which he gave to Prudence. She rejoined her sister Reason whom she found waiting at the celestial frontier, and the two returned together to the house of Natura. A perfect body was fashioned and united to the soul *gumphis subtilibus*,[4] and the Virtues in turn endowed the man with their choicest gifts. Only Nobility could do nothing until he had visited his mother Fortune and secured her goodwill. Meanwhile Fame had carried as far as Hell the tidings of this new creation. Allecto summoned the infernal peers, whose deliberations were so effective that the new man was scarcely living before an army of vices was advancing to attack him. The whole

[1] Ibid. Dist. II, cap. iv. 6 (p. 297 Wright).

[2] Ibid. Dist. IV, cap. v. 4 (Wright, p. 338); cf. Chaucer, *Hous of Fame*, ii. 930, 986.

[3] Ibid. Dist. VI, cap. vi. 19: 'Nam tua res agitur paries dum proximus ardet (Wright, p. 375). The daring theology of this never crossed the poet's mind: a proverb was regarded as a rhetorical beauty.

[4] Ibid. Dist. VII, cap. ii. 4 (Wright, p. 384.)

concludes with the psychomachy, and the victory of the perfect man ushers in the golden age.

The importance of this work, whose literary merits I have already denied, is twofold. In the first place it conferred new prestige on the allegorical method, of which it was a specimen more attractive to that age than any of its predecessors. It was the last word in poetic style as style was then understood. It was longer and more encyclopaedic than the *Psychomachia*. It was a good deal easier and more popular than Bernardus. In the second place, it is significant by reason of its moral content: as a document of the 'humanism' of Chartres, as the celebration of a *tertium quid* between the courtly and the religious conceptions of the good life, it is perhaps more important than the *De Mundi Universitate* itself. For when we come to examine in detail the perfect man presented by Alanus, we find much that accords ill, by any strict standard, with the theological framework of the poem. The Virtues who are summoned to his making are purely secular virtues. If *Fides* appears, it is made clear that *Fides* means 'good faith'—the virtue that keeps promises and plays fair in friendship—and not 'Faith' in the Christian sense.[1] If *Pietas* appears, *Pietas* means 'Pite' and not piety.[2] And among the virtues we find some whom a very moderate ascetism might exclude from that title altogether, such as *Favor* (popularity), *Risus*, and *Decus*;[3] and others whom no philosophy can treat as virtues at all, such as *Copia*, *Juventus*, and *Nobilitas*.[4] Again, in the psychomachy which concludes the whole we find among the army of the vices such unexpected champions as *Pauperies*, *Infamia*, and *Senectus*:[5] characters very proper to be excluded from the garden of *Amor*—as 'Poverte' and 'Elde' are excluded in the *Romance of the Rose*—but very oddly included

[1] *Anticlaudianus*, Dist. VII, cap. vii (Wright, pp. 394, 395).
[2] Ibid. Dist VII, cap. vi. 69 et seq. (Wright, p. 393, *Succedens Pietas*, &c.).
[3] Ibid. Dist. I, cap. ii (Wright, p. 274).
[4] Ibid.
[5] Ibid. Dist. IX, *Pauperies*, cap. ii, *Infamia*, cap. 3, *Senectus*, cap. 4 (Wright, pp. 414, 416, 417).

among 'vices' from the theologian's point of view. Is it not, then, apparent that Alanus is depicting not so much a perfect man by the standards of the Church as a 'noble and virtuous gentleman' according to the standards of chivalry? Is not Alanus, in fine, to be numbered less among the followers of Prudentius than among the predecessors of Castiglione, of Elyot, and of Spenser? We have already seen that he appropriates the common name of *Virtus* to the typically courtly virtue of Largesse; and the scene in which the Virtues adorn the new man puts the question beyond doubt. He is not complete without *Nobilitas*, though *Nobilitas* admittedly depends upon *Fortuna*.[1] *Fides*, in words later to be echoed by Guillaume de Lorris, recommends to him the choice of a confidant:

> To whom he may entrust his complete self,
> Lay bare his mind and speak his perfect will
> Showing the secret places of the heart.[2]

—advice much more useful to a gentleman than to a saint. *Ratio*, in direct defiance of the gospel teaching, recommends to him moderation, not abstinence, as regards the desire for fame:

> Not swayed with popular applause, nor yet
> Spitting it out, unless it bear the stamp
> Of flattery and would purchase wealth for words;
> It smacks too much of sour austerity
> To scorn all fame.[3]

Modestia, who turns out to be none other than the old

[1] Ibid. Dist. VIII, cap. viii. ix; Dist. VIII, cap. i, 2. (Wright, pp. 396–403.)
[2] Ibid. Dist. VII, cap. vii. 28:
 Quaerat cui possit se totum credere, velle
 Declarare suum, totamque exponere mentem,
 Cui sua committat animi secreta latentis. (Wright, p. 395.)
[3] Ibid. Dist. VII, cap. iv. 26:
 Nec petat impelli populari laude, nec ipsam
 Respuat oblatam nisi sit velata colore
 Hypocrisis verbo quaerens emungere lucrum:
 Nam nimis austerum redolet qui despicit omnem
 Famam. (Wright, p. 388.)

Hellenic and Provençal virtue of *mesura*, actually gives him lessons in deportment, and even in hairdressing:

> Let not the hair, too wanton-fine, appear
> Like woman's bravery and belie the man.
> Nor too unkempt, lacking its due regard,
> Lest that proclaim thee by its tangled shock
> In thy fresh years too philosophical.[1]

We do wrong to laugh at such a passage. Once we have decided to describe, not the perfect man, but the perfect gentleman, we cannot stop short of these externals, which are, as a matter of fact, included in the character: a really exhaustive treatise on music must range from aesthetic philosophy to methods of fingering, and the same defence holds good for Castiglione when he doubles the roles of Platonic philosopher and dancing master. But while Alanus thus stands side by side with Castiglione, and indeed fills up the concept of virtue with purely secular and courtly excellences, it is of the essence of his work that he does so with no slightest sense of rebellion or defiance. The courtesy of the Troubadours, of Andreas, of Chrétien, was a truancy. Behind the courtly scale of values rose the unappeasable claims of a totally different and irreconcilable world: it was to this truancy and insecurity that the courtly life owed half its wilful beauty and pathos. But Alanus is equally serious in his theological passages and in his notes on deportment. He acknowledges no breach; for the naturalism of Chartres has given him a *tertium quid* that can moderate both the rigours of theology and the wantonness of the court. Goodness does not mean asceticism; knighthood does not mean adultery. Both are brought together under the law of Natura who is the vicar of God and essentially good. It is not a question of grace redeeming Nature: it is a question of sin departing from Nature.

[1] *Anticlaudianus*, Dist. VII, cap. iii. 32: (Wright, p. 387.)
> Ne cultu nimio crinis lascivus adaequet
> Femineos luxus sexusque recidat honorem,
> Aut nimis incomptus iaceat, squalore profundo
> Degener et iuvenem proprii neglectus honoris
> Philosophum nimis esse probet.

The position is summed up in the advice given by *Honestas*
to the perfect man:

> Let him love Nature who would flee from vice,
> Eschew what guilt or naughty will brought forth
> And to his breast clasp all that Nature made.[1]

It is in this that the true value of Alanus consists. I do not
say he has effected a real reconciliation between the two
ideals of the Middle Ages. The rift went deeper than he
thought. He assumes, rather than makes, a peace. But he
is at least trying to be a whole man, and however the ele-
ments of his synthesis may hereafter fall apart, they will
retain some mark of their brief union. The courtly ideal
is becoming, as Arnold would have said, more 'possible',
and for that reason more potent: if you will, more in-
sidious. Its long hold upon the vernacular poetry, its
adaptability to some future compromise, are now assured.

It is a relief to turn from the *Anti-Claudian* to its
author's more famous work the *De Planctu Naturae*, the
'Plaint of Kind'.[2] Here we are back in the metres and
proses of Boethius; and in laying aside the pretentious epic
form, Alanus lays aside the most intolerable vices of his
style. He is still a fantastic and over-decorated writer; but
he is aiming chiefly at sweetness and richness of effect,
whereas in the *Anti-Claudian* he had aimed at grandeur.
But sweetness tolerates barbarism as grandeur does not.
There can be bizarre luxury, though there is no bizarre
grandeur. It is the difference between excess in a sham
Gothic railway hotel and excess in a hot house; and every
one knows that while the first is a mere burden, the second
is pardonable, and even, in some moods, not unpleasing.
The *Plaint* has, moreover, the enormous advantage of
being comparatively short. The story may be told in a
few words. Nature appears to the author and laments the

[1] Ibid. Dist. VII, cap. v. 7:
> Ut vitium fugiat Naturam diligat, illud
> Quod facinus peperit damnans, quod prava voluntas
> Edidit, amplectens quidquid Natura creavit. (Wright, p. 389.)

[2] Also in Wright, op. cit.

unnatural vices of humanity; the Virtues come to share
their grievance with hers; and Genius is ordered to pro-
nounce an anathema against the offenders.[1] That is the
whole matter. The importance of the theme, for our pur-
pose, clearly lies in the advantage to which Nature appears
in such a setting; and, with Nature, natural love. The
earthly Cupid, after being for ages contrasted with the
celestial Cupid, suddenly finds himself in contrast with an
infernal Cupid. This time it is his turn to be the respect-
able character; the righteous indignation is on his side.
Such is the inevitable result of Alanus' choice of subject,
and it is the only result. The reader who expects either
prurience or prophetic denunciation will be disappointed.
There is nothing so cold, so disinterested, as the heart of
a stylist; and I believe that Alanus was tempted to this
peculiar theme by the endless opportunities which it
offered for fantastic grammatical metaphor about the
proper relations of *masculine* and *feminine*, or *subject* and
predicate in the grammar of Venus.[2] Agreeably with time's
common way of punishing, these conceits are now the
author's chief disgrace; but because, hidden in the rhetori-
cian, there was, after all, a real, though wayward, lover of
nature, the *Plaint* still has a claim on our attention above
and beyond its historical significance. As the book is diffi-
cult to read, and rather more difficult to buy, I have ven-
tured to translate two passages, both of them elaborations
of hints furnished by Bernardus. The first describes the
coming of Natura and the ἱερὸς γάμος of the world at her
approach:

'The virgin, as I have before signified, at her first coming forth
out of the coasts of the heavenly region into the hovel of the
world passible, was borne in a glassy coach, and was drawn of
Juno's own birds, not managed with any yoke, but joined thereto
of their proper will and election. A certain man also that with
his height overtopped both the virgin and her coach, whose
countenance smacked not of vile earthliness but rather of the
Godhead's privity, as though he should succour the insufficiency

[1] See App. I. [2] *De Planctu, Prosa* V. 40 et seq. (Wright, pp. 475 et seq.)

of her sex feminine, did guide its course with measurable regiment. To the beholding of whose beauty when I had (as it were) drawn together the soldiers of mine eyes, that is, the rays visual; the same, not daring to issue out in the face of so great a majesty, and being blunted with the strokes of his splendour, betook themselves for fear into the tents of mine eyelids. At the coming of the said virgin you would a thought that all the elements, as though they then renewed their kinds, did make festival. The heaven, to lighten (as it were) the maid's journey with his candles, gave order to his stars that they should shine beyond their wont; wherefore methought the daylight marvelled at their hardihood who durst so insolently be seen in his presence. Phoebus also, putting on a jollier countenance than he was used, poured forth all the riches of his light and made a show of it to meet her; and to his sister (from whom he had taken away the garniture of his beaming), giving her back again the garment of jocundity, he bade that she should run to meet such a queen as was now come among them. The air, putting off his weeping clouds, with serene and friendly cheer smiled upon her where she came, and whereas he was before grieved with the raging of Aquilo, now popularly took his ease in the bosom of Favonius. The birds, moved by a certain kindly inspiration, rejoicing with the plausive playing of their pinions, showed unto the virgin a worshipping countenance. Juno forsooth that before had scorned the kissings of Jupiter, was now with so great joy made drunken, that by a darting prologue of her glances she set her husband on fire for pleasing passages of love. The sea also that before was enraged with stormy waves, at the maid's coming made an holiday of peace and swore an everlasting calm; for Aeolus, lest they should move their wars (more than civil) in the virgin's presence, bound in their prisons the tempestuous winds. The fishes, even, swimming up to the eyebrows of the waves, so far forth as the lumpish kind of their sensuality suffered them, foretold by their glad cheer the coming of their lady; and Thetis, being at play with Nereus, bethought her that time to conceive another Achilles. Moreover certain maidens, the greatness of whose beauty was able not only to steal away the reason from a man but to make those in heaven also to forget their deity, coming forth out of places where streams sprang, brought unto her gifts of pigmentary's nectar, making as they should offer tithes to their newcome queen. And truly, the earth, that before lay stripped, by winter's

robbery, of her garnishments, made shift to borrow from the largesse of the spring a scarlet smock of flowers, lest in the dishonour of her old clouts she might not decently be seen before the virgin.'[1]

Here everything is sophisticated, everything is 'classical' and pedantic; but the decorations do not completely obscure the note of delight. The author is intoxicated not only with his style but with his subject; his worst excesses serve only to show how wildly the new love of the visible world 'wantoned in its prime', and if we have here a wilderness it is a 'wilderness of sweets'. The passage may be compared with one of those old tapestries where the richness of the material suggests indoor luxury, but the forms, nearer viewed, reveal, however faintly, the stir and morning airs of a hunting scene. But the *Plaint* has passages of a more masculine beauty than this, as my next quotation shows:

'Consider, quoth she, how in this world, as in some noble city, Reason is set up and established by the measurable governance of the commonweal's majesty. In Heaven, as in the castle of an earthly city, the eternal Emperor eternally hath his throne, from whom eternally goeth forth his edict that the notions of things single be written in the book of his providence. In the Air, that is, in the middle parts of the city, there liveth in arms an heavenly host of angels, the which with delegated service doth diligently exercise its watch over men. And man, truly, as an alien that dwelleth without the city wall, refuseth not his obedience to those angelic knights. Therefore in this commonweal God commandeth, the angel operateth, the man obeyeth. God by

[1] *De Planctu Naturae, Prosa* II. 11 ff. (Wright, pp. 445 ff.). A faintly sixteenth-century flavour seemed to me the only method of representing in English the quality of the original, which neither modern nor Chaucerian prose could reproduce. If an historical justification for my choice is demanded, I can claim that certain characteristics of Euphuism are already present in Alanus. The antithesis and the playing with words in the following are noteworthy: 'Eius opus sufficiens, meum opus deficiens. Eius opus mirabile, meum opus mutabile. Ille mei opifex operis, ego opus opificis. Ille operatur ex nihilo, ego mendico ex aliquo. Ille suo operatur numine, ego operor illius sub nomine.' (*Prosa* III, Wright, p. 455.) A complete translation of the *Plaint* has been published by Mr. Moffat (*Yale Studies in English*, 1908); it is greatly to be regretted that the limits of his book did not allow him to accompany it with a text and commentary.

commandment maketh man, the angel by operation bringeth him to being, the man by obedience remaketh himself again ... of the which right ordinate commonweal the likeness is within man also reflected. In the castle of whose head Sapience sitteth and is at rest as an empress, unto whom, as to a goddess, the residue of his powers as half-goddesses do obey. For his power of engin, and his force logical, and his virtue memorial of things passed, having their habitations in divers chambers of his head, are ever busied about their obedience to her. In the heart, forsooth, that is, in the middle parts of the city, Magnanimity hath her house; who having received the order of knighthood under the reign of Wisdom, doth by operation fulfil whatsoever things that governance deliberateth. But the reins, which is as much as to say the parts without the wall, permit a dwelling in the uttermost region of the body to lustful pleasures, which serve the will of Magnanimity, neither dare they set themselves against her commandment. Therefore in this commonweal, Sapience beareth the part of one commanding, Magnanimity hath the likeness of one operating, Lust showeth the image of one obeying.'[1]

The ideas derive, of course, from Bernardus, and ultimately from Plato, but they are set forth with conviction and with dignity, and here, at least, the greatness of the matter keeps the rhetorician within the bounds of *mesura*. Such a passage shows us how well Alanus might often have written if he had had the fortune to stumble upon better models or the individuality to resist bad ones. As it is, he remains an author in whom there is much more to blame than to praise; but no one who has plodded doggedly through him will wholly regret the time he has spent.

One more poem deserves mention before we leave the Nature-poets of the school of Chartres. This is the *Architrenius* of Johannes de Altavilla.[2] This long narrative, which is written throughout in hexameters, tells the story of the 'Arch-mourner', the youthful Architrenius, who, in mere despair at the wickedness within him and about him, sets out to seek his mother Nature and be healed. His journeys lead him through many places, including the

[1] Ibid. *Prosa* III. 108 et seq. (Wright, pp. 452 et seq.)
[2] Also in Wright, op. cit.

university of Paris and the island of Thule, thus offering
the author the opportunity for lavish satiric description,
before the wanderer finally meets Nature. The account of
the university is said to be of great interest to the social
historian, but the work as a whole has little relevance for
our special study except in so far as it illustrates the popu-
larity of the personification Natura[1] and gives us an early
example of the allegory in the form of a journey—that
is, in its best form. But what really matters in the poem is
the unusual energy with which the wanderer's motive is
presented. Later, no doubt, the poet may lose himself in
garrulity; but in his picture of Architrenius at his setting
out he far excels any of his fellow workers in this kind.
Suddenly, amid all the gradus work of his hexameters,
a living voice begins to speak. Our historical interests
are forgotten. Dates no longer concern us. A universal
human longing is expressed, and, but for the language,
the lines might have been written in any age:

> This must I do—go exil'd through the world
> And seek for Nature till far hence I find
> Her secret dwelling-place; there drag to light
> The hidden cause of quarrel, and reknit,
> Haply reknit, the long-divided Love.[2]

We have now glanced at the chief writers who descend
from the school of Chartres. Their significance has, I trust,
been growing clear as we advanced, and a very short sum-
ming up will be sufficient. As regards content, the great
work which they attempted was to reunite the courtly and
the religious ideals. In an age of wilful asceticism and wil-
ful *Frauendienst* they asserted the wholeness of the nature
of man; it is this far more than their prosecution of classi-

[1] Cf. also the interesting anonymous poem quoted by Raby, op. cit., vol. ii,
pp. 22, 23.

[2] *Architrenius*, lib. i (Wright, vol. I, p. 251):

> Quid faciam, novi: profugo Natura per orbem
> Est quaerenda mihi. Veniam quacumque remotos
> Abscondat secreta lares, odiique latentes
> Eliciam causas et rupti forsan amoris
> Restituam nodos.

cal studies, which entitles them to the name of Humanists. What they attempted they did not accomplish. A new system of thought was already at the door; 'the knots of the love now broken', which they had striven to re-tie, rapidly came undone again in the hands of their followers. But though they failed fully to reconcile courtesy with religion, they left courtesy in a more reputable, and less precarious, situation. It had gained a new solidity and prestige; and while it could not maintain its footing on the philosophical heights it continued, in the vernacular poetry, to profit by its brief sojourn on those levels. On the side of form, the school of Chartres had set the example of allegory on a large scale, and of allegory that made a genuine advance on the old models. It had enlarged upon the narrowly ethical scheme of Prudentius and shown itself capable of dealing with any subject the author cared to attempt. Finally it had enriched the poetic stock with a score of new figures and fruitful ideas. The *Natura* of Statius and of Claudian, under the influence of its naturalistic philosophy, had been remade and become a new and appealing character. She, and her companion Genius, continued to fascinate the vernacular poets for many years. Already in the lifetime of Alanus, the *Anti-Claudian* was being re-written in French octosyllables. In the following century the impress of the school of Chartres can be traced on almost every page of the allegorical love poetry.

III. *THE ROMANCE OF THE ROSE*

I

THE reader who has followed—if any has followed—
my first two chapters may well feel that he has been
taken on a long journey through scenery more various than
agreeable, and may pardonably ask why such a circuitous
approach to our subject was needed. But, for myself,
however it has fared with the reader, I know that nothing
less would have sufficed to enable me to approach the
Roman de la Rose with a sympathetic understanding. The
allegorical love poem, as I confessed at the outset, makes
little natural appeal to a modern reader. It is foreign to
us not only in its sentiment but also, and more radically,
in its form. In order to read it justly—to give the poet his
chance, and with him to give most of the literature of the
fifteenth century *its* chance—it was necessary to 'remount
the stream of time': to reconstruct imaginatively, so far
as our knowledge would allow us, the growth and quality
both of that sentiment and of that form. As far as I my-
self am concerned, the experiment has in a measure suc-
ceeded. I can never again look upon the *Romance* as an
'artificial' poem, nor call its personifications 'shadowy',
nor its mechanisms an arbitrary fashion.

The sentiment, in so far as it was a real novelty, I have,
of course, failed to explain. One does not 'explain' such
things, or not in that sense. We must be content, like the
biologist, to explain the workings of the organism, and
take for granted that which makes it an organism at all;
'seminal forms' and the like we hand over to the meta-
physician. And this limitation in our account is the less
disastrous because we are still living, to some extent, under
the influence of courtly love and can therefore experience
imaginatively, from within, what we tried in vain to
understand discursively from without. And if once the
germ is granted, we find the history of its development

neither mysterious nor unnatural. We have seen how social conditions gave the new feeling its bent towards humility and adultery; how literary conditions entangled it with the pre-existing Ovidian tradition though it was forced to modify and even to misunderstand that tradition; how the Arthurian stories supplied it with matter; and how, in the hands of a great poet, the Arthurian story, treated in terms of courtly love, produced the first notable examples of psychological or sentimental fiction.

The origins of the allegorical method turned out to be a longer story. We saw that allegory was in no sense a mere device, or figure of rhetoric, or fashion. It was not simply a better or worse way of telling a story. On the contrary, it was originally forced into existence by a profound moral revolution occurring in the latter days of paganism. For reasons of which we know nothing at all—here again comes the 'seminal form' not to be explained by history—men's gaze was turned inward. But a gaze so turned sees, not the compact 'character' of modern fiction, but the contending forces which cannot be described at all except by allegory. Hence the development of allegory, to supply the subjective element in literature, to paint the inner world, followed inevitably.

The two threads of our story come together in Chrétien. We found that Chrétien was psychological. And this we could explain by the whole history of courtly love. But we also found that wherever Chrétien became psychological he became allegorical. And this again we could explain, for we had seen that allegory had been born and perfected for the very purpose to which Chrétien put it. Chrétien combined two methods in his work because he combined two different appeals. He wished to satisfy the taste for marvellous adventure, and he did so by writing thousands of couplets (little mentioned in histories of literature) about honest knightly deeds and enchantments no different in essence from the work of any other metrical romancer. But he also wished to satisfy the taste for refined emotionalism, and he did this by interrupting his

objective story from time to time with those long passages
of soliloquy or analysis in which, as we noticed, he is always
slipping into allegory. The radical defect in Chrétien's
poetry is that these two kinds of interest lie side by side
in it without being really fused. The emotions of Lancelot
and Guinevere are not really illustrated, save in a very
shallow sense, by their adventures; their adventures are
not really explained by their emotions. It was inevitable,
therefore, that a story by Chrétien must have appeared
in very different lights to different members of his audi-
ence. To some it must have seemed that a good story of
the right kind, about splintering lances and castles danger-
ous, was constantly being held up, in the most tiresome
way, by mere talk from the hero and the heroine. This
class of readers was soon provided for by the prose roman-
cers who took over the purely adventurous side of Chré-
tien's work and set it up on its own feet. But there must
also have been a second class of readers—history proves
them to have been the larger and more influential class—
who read Chrétien in the opposite way. For them, his
poems were serious love-stories, holding the mirror up to
nature, as nature appeared in the courtly circles of the
time, but unfortunately interrupted at every turn by
irrelevant excursions into fairyland.

II

Of those who wrote for this second class of readers, the
most important was Guillaume de Lorris. In placing him
thus, I am not, of course, assuming that Chrétien was the
only, or the nearest, influence at work upon him. Those
who wish to determine accurately the immediate pre-
decessors of the *Roman de la Rose* will seek more skilful
guides than the present writer.[1] I am merely insisting on
a general literary relationship which is constantly mis-
understood. Many people, misled by the platitudinous
allegory produced in ages to which allegory is a toy—the

[1] *v.* Langlois, *Origines et sources du R. de la Rose*, 1890.

allegory of Maeterlinck or Addison—are disposed to think
that in turning to Guillaume de Lorris we are retreating
from the real world into a shadowy world of abstractions.
But the whole truth about Guillaume is missed until we
see that he is more of a realist than Chrétien. Of the two
things that he found in Chrétien it was the fantastic that
he rejected and the natural that he used. Do not let us be
deceived by the allegorical form. That, as we have seen,
does not mean that the author is talking about non-entities,
but that he is talking about the inner world—talking, in
fact, about the realities he knows best. No doubt, from
a grammatical or logical point of view, the land of Gorre
in *Lancelot* is 'concrete', and Danger in the *Roman*, being
a personification, is 'abstract'. But no one, least of all
Chrétien, has ever been to the land of Gorre, while
Guillaume, or any courtly lover of the period—or, for that
matter, any lover in any subsequent period—has actually
met Danger. In other words, the 'concrete' places and
people in Chrétien are mere romantic supposals: the
'abstract' places and people in the *Romance of the Rose* are
presentations of actual life. The biography of a poet has
little relevance for criticism, and we have no data for con-
structing the biography of Guillaume de Lorris; but there
is nothing unlikely in the theory that his poem is auto-
biographical. Everything that happens in it might have
happened to the author in real life, and had happened to
dozens of his contemporaries: no small part of it may hap-
pen to any man in our own days.

This, then, is the first condition necessary to an under-
standing of the *Roman de la Rose*, and in this sense Guil-
laume de Lorris is the great representative of one of those
two groups into which I have divided the successors of
Chrétien. In Chrétien Guillaume de Lorris found, on
the one hand, fantastic adventure, on the other, a realistic
account of imaginative passion, as imaginative passion
actually existed, or believed itself to exist (the distinction
is a barren subtlety) in the world around him. It was
the second that interested him. He conceived the idea

that this, by itself, stripped of its Arthurian supports, might stand on its own feet and make the subject of a poem. As such a poem would concern itself exclusively with what the lovers felt, it would, of course, be allegorical. The device—never a very happy one—of trumping up some mere skeleton or succedaneum of external happenings for a story whose real interest is subjective did not and could not, at that period, occur to him. I say that it was Guillaume who conceived and did all this, for the sake of brevity. I am not concerned to establish his actual precedence in point of time. What he owed to the *Altercatio Phyllidis et Florae*—when *Li Fablel dou Dieu d'Amours*[1] was written—these are questions that need not delay us. The transition from amatory romance to amatory allegory, and the motives for that transition, were as I have described; and of the poets who became the instruments of that transition Guillaume is incomparably the most important.

In spite of its allegorical form, then, what we have in the *Roman de la Rose* is a story of real life. Here, at last, the muse of courtly love 'stoops with disenchanted wing to truth'; a fact which goes far to explain the charm that it had for that age and for the age which followed. The allegorical method in general, as well as the particular mechanism of the *Roman*, were familiar to thirteenth-century readers. They needed no search to find the *significacio*. The poem came home immediately to their business and bosoms. Young readers in the not ignoble ardours of calf-love, and elderly readers in the mood of reminiscence, whether wistful or ironic, could all find in it the reflection of their own experience. But we are not so fortunately placed. We have to reckon not only with the unfamiliar erotic psychology, but with the unfamiliarity of allegory in general; and, to speak plainly, the art of reading allegory is as dead as the art of writing it, and more urgently in need of revival if we wish to do justice to the Middle Ages.

[1] For the *Altercatio* v. *The Oxford Book of Medieval Latin Verse*, ed. Gaselee, 1928. For Langlois' final view on *Li Fablel* v. his edition of *Le Roman de la Rose* (Société des Anciens Textes Français, 1914), tome i, p. 4 et seq.

I have heard a very sensible man say sadly of the *Romance
of the Rose* 'It all has some sort of mystical meaning, of
course', and the words 'some sort' sounded like the accent
of despair, and the word 'mystical' like something worse.
I have known readers long familiar with the fragmentary
Middle English version of the *Romance* who had never
noticed that the fountain of Narcissus represented the
heroine's eyes. Even Mr. Saintsbury once suggested that
Danger was the heroine's husband.[1] In the face of all this
I cannot be accused of beating upon an open door if I offer
a few explanations.

The best preparation for a study of Guillaume de Lorris
is to read a curious little dialogue in which Mr. Aldous
Huxley, whether consciously or not, has revived its
method.[2] A man and a girl are talking in a conservatory.
Instead of representing their conversation directly, the
author has chosen to distribute it among a number of
attendants whom he allots to each. The attendants repre-
sent the various selves, or facets of personality, whom the
two lovers contain. Thus when they begin to talk, and are
still engaged in purely formal courtesies, they use two little
dolls which represent their conventional and 'social' selves.
The humans pull the strings and the dolls say whatever
politeness demands. Guillaume de Lorris would have
called these puppets *Courtesye* and *Bialacoil*; though to
be sure, differing widely in his outlook from the lively
Mr. Huxley, he would not have made them puppets. Then
there is, among the attendants of the young man, the very
fleshly negro who looks over his shoulder and kisses the girl,
greatly to the astonishment of the young man's other
attendants, and with disagreeable results. Guillaume
would have called the negro *Vilanie*, and would have left
him outside the conservatory. Similarly on the young
woman's side we have two attendants, one of whom is a
prude who foresaw the kiss and would have averted it if she
had not been lulled asleep; the other finds it thrilling to be

[1] Saintsbury, *The Flourishing of Romance and Rise of Allegory*, 1897, p. 307.
[2] *Happy Families* (in *Limbo*, 1920).

kissed by negroes and is sorry when her fellow is waked. The names of these two in Guillaume are *Honte* and *Venus*.

This little *jeu d'esprit* gives us, in principle, the whole procedure of the *Romance of the Rose*. But Guillaume de Lorris differs from his modern successor in some important respects. In the first place he practically abolishes the hero, as one of his dramatis personae, by reducing him to the colourless teller of the tale. The whole poem is in the first person and we look through the lover's eyes, not at him. In the second place he removes the heroine entirely. Her character is distributed among personifications. This seems, at first, a startling device, but Guillaume knows what he is about. You cannot really have the lady, and, say, the lady's Pride, walking about on the same stage as if they were entities on the same plane. Nor is it unnatural for a lover to regard his courtship as an adventure, not with a single person, but with that person's varying moods, some of which are his friends and some his enemies. A man need not go to the Middle Ages to discover that his mistress is many women as well as one, and that sometimes the woman he hoped to meet is replaced by a very different woman. Accordingly, the lover in the *Romance* is concerned not with a single 'lady', but with a number of 'moods' or 'aspects' of that lady who alternately help and hinder his attempts to win her love, symbolized by the Rose. I hope to show later that this ostensible banishment of the heroine from the stage does not prevent her being vividly present to an attentive reader throughout. Rather, it gives her a place in the poem which only a great novelist could have given her by other means. If she takes no part in the action, it is because her heart is most often the scene of the action. Any protracted wooing involves a conflict not only between the man and the woman but between the woman and herself; it is this second conflict which occupies the most interesting scenes in the *Romance*.

If Guillaume had stopped here, his method would be

flawless. Unhappily, however, the friends and enemies of the lover are not all contained in his own, and in his lady's, breast. There is the interference of her relatives to be reckoned with; and this forces the poet to introduce the character *Jalosie*—a personification not quite on all fours with the personified moods of the heroine. Again, there is the advice and support which the lover receives from the other young gallants: hence the character *Amis*, the typical Friend, who is hardly a personification at all. Finally, there is the Nurse or Duenna of the heroine who carries out the instructions of *Jalosie*, and whose introduction in her proper person constitutes a complete break-down of allegory at one point. It is true that these breaches of the allegorical rule do not really confuse us as we read; but we feel that a technical difficulty has not been neatly turned, and acknowledge it a serious, though not a fatal, defect in the poem. When once the scheme has been grasped, our next step is to master in some detail the scene and dramatis personae. Much will become clearer when we turn to the poem itself, and the following does not pretend to be exhaustive.

1. *The Scene. Literaliter* the scene is 'at first, a river bank outside a walled garden; later the interior of the garden; and later still, a rose-plot surrounded by a hedge inside the larger garden'. All these places, as my poor friend supposed, have 'some sort of mystical meaning'. *Allegorice*, therefore, the scene is 'at first, the river of life in general, in early youth; later, the world of courtly society; later still, the mind of a young girl living in the world of courtly society'. It is not to be supposed, of course, that this allegorical garden is Guillaume's invention. It is the same garden which we have met in Andreas and, before him, in Claudian. In some writers it means Love; in Guillaume it is changed slightly and made to mean the life of the court, considered as the necessary sphere or field for love's operation. But, of course, its classical and erotic models only partially account for it. Deeper than these lies the world-wide dream of the happy

garden—the island of the Hesperides, the earthly paradise, Tirnanogue. The machinery of allegory may always, if we please, be regarded as a system of conduit pipes which thus tap the deep, unfailing sources of poetry in the mind of the folk and convey their refreshment to lips which could not otherwise have found it.

2. *The Characters*. These may conveniently be divided into three groups, according as they are neutral qualities who may qualify now the hero's and now the heroine's mind; or qualities belonging to the hero; or again, qualities belonging to the heroine. The last is the largest and most interesting group.

Of the neutral characters the only two that require much comment are the god of Love and his mother Venus. A reader bred on the classics would expect to find these two together at the outset of the poem. But the consistent tendency of medieval love poetry was to substitute for Venus and her son a King and Queen of Love who are, of course, themselves a pair of lovers.[1] In the *Roman* we meet the god of Love accompanied by his mistress *Biautez* as soon as we enter the garden. Venus appears at a much later stage. More than one cause probably contributed to this change in the mythology. A King and Queen provided a better parallel to the real feudal courts of which Love's court was in some degree a copy. But if we reflect for a moment on the constant connexion between the god of Love and the month of May, we must suspect a deeper reason. We still have the Queen of the May, and we know that she once had a King: in the forgotten fertility rites of the *ludus de rege et regina* we may with great probability find one of the origins of the medieval King and Queen of Love, and the explanation of their continued charm.[2] Myth is a stronger thing than formal literature. But as courtly literature is refreshed by myth from beneath, so it is also refreshed by larger philosophic conceptions from above;

[1] Cf. the passage quoted from Andreas, *supra*, p. 38.

[2] Cf. E. K. Chambers, *Medieval Stage*, vol. i, pp. 91, 172; also Frazer, *Golden Bough*, 'The Scapegoat', p. 406 et passim.

and it was philosophic conceptions that supplied a third motive for removing Cupid from the immediate tutelage of his mother. Venus is a personage who belongs to quite another realm than Cupid. As one of the real Olympians, she inherited from ancient times a gravity which Cupid never had. But, besides being a goddess, she was a planet; and, if a planet, then a real source of 'influence', not according to any poetic convention but according to the science of the time. When a poet wrote about *Amor* he knew that he was merely personifying an 'accident', which personification, as Dante says, 'according to the truth is false'. But he could not be so sure about Venus. Perhaps Venus was only an 'accident'; but then, again, perhaps Venus was the name of a real force in nature, or even the name of the intelligence of the third heaven. In the *Romance* Venus is the sexual appetite—the mere natural fact, in contrast to the god of Love who is the refined sentiment. She is the generative force in nature whom the school of Chartres had taught men to contemplate philosophically, to look upon with the eyes of a Lucretius, not with the eyes of Ovid or Jerome. This distinction between Venus and her son, which becomes explicit in Jean de Meun,[1] is merely implicit in Guillaume de Lorris; but it is necessary to an understanding of his story.

The remainder of the neutral characters are not important. *Deduit* is the lord of the garden; that is, the courtly life is a life of pleasure and amusements. *Oiseuse* is its doorkeeper, for no busy man can lead that life. The happy dancers whom we find carolling in the presence of *Deduit* have such names as *Joy*, *Largesse*, *Courtesy*, and the like; and all this is sufficiently obvious.

The characters who belong to the hero are mere men of straw (*Hope*, *Sweet Thought*, &c.) with the single exception of *Reason*. *Reason* is almost the only character in the poem who remains the same in Jean de Meun's continuation as she was in Guillaume's original. In both writers some of the best passages are put into her mouth, and in both she

[1] Cf. specially *Roman de la Rose*, 10749 et seq.

speaks to rebuke the lover for the enterprise which he has undertaken. In Jean de Meun there is some confused struggle—as I shall explain later—to follow the poets of Chartres in their attempt to find a solution for the conflict between the courtly and the Christian ideals; but in Guillaume de Lorris there is no conflict. His hero has no reply to *Reason* beyond a wilful *sic volo sic iubeo*. The story, in other words, is the story of a lover whose deepest convictions remained opposed to his love and who knew that he acted neither well nor wisely. By implication the author therefore condemns what he relates. If he had finished his poem it would probably have closed with the familiar palinode. He gives to *Reason* exactly the function which she had in the *Lancelot*;[1] to speak the truth and not to be heard.

In the third group we have those characters who belong to the heroine. These are the most important actors in the drama and we shall go far astray if we do not understand them. Among them *Bialacoil* perhaps holds the first place. The name, of course, means 'fair welcome'— the *belh aculhir* of the Provençals.[2] If we ask what he represents, I think the answer is as follows: there is such a thing as failing or succeeding in mere ordinary conversation with one's mistress, long before there is any question of succeeding or failing as a lover. At the first introduction the lady may be, as modern English would say, 'nice to you' or she may not. If she has been 'nice to you' you have met *Bialacoil*. When Pandarus extorted from Cresseide a promise to show Troilus 'bettre chere and more feste',[3] he was extorting a promise that she would show him Bialacoil. Bialacoil is not the same as Courtesy, but he is the son of Courtesy.[4] He is something more than mere politeness and yet a something more which a woman of gentle breeding will find it hard to withhold from any acquaintance not

[1] v. *Lancelot*, 369–81.
[2] Cf. Guilhem de Peitieu: . . . '*Midons per son belh aculhir E per son belh plazent esguar*'. Appel, *Prov. Chrestomathie*, p. 52.
[3] v. Chaucer, *Troilus*, ii. 360–1.
[4] *Roman de la Rose*, 3527.

obviously dishonourable or vulgar. He is a false friend to
a maidenhead; and yet, when all is done, you can say truly,
or almost truly, that he meant no harm. His chief allies
are the lady's *Franchise* and her *Pity*. The latter needs no
gloss. The former is the quality of the freeborn:[1] the
innocent security of a great lady who does not, like her
maids, see a ravisher on every lonely road and a lover in
every friend; who accepts—pitifully enough in the present
story—

> The fiction of the Christian law
> That all men honourable are.

But Bialacoil and his allies are not always dominant in
the lady's heart. If you make a false step you will bring
Fear to the surface instead and Bialacoil may vanish for
hours together. If you endanger her reputation you may
have *Shame* to deal with—an uncertain spirit, who will try
to defend Bialacoil, it may be, and yet mar all with her
silly sooth. But these two are not the most serious enemies.
A lover can always manage Fear and Shame, who are help-
less if once Venus comes to his aid. The real enemy who
cannot be flattered or overcome, who must be kept asleep
because, if he wakes, your only course is to take to your
heels, the ever-present dread of lovers and the stoutest
defence of virgins, is *Danger*. It is not easy to determine
who this Danger is. He is certainly not the lady's husband.
If he were, the fact that lovers live in perpetual terror of
him would reduce the whole situation to broad comedy.
You cannot, in serious poetry, have a Tristram who says,
'I don't mind having to leave the court and skulk in the
greenwood, and I don't mind Iseult's temper, but what
I can't stand is the idea of Marc and his glaive.' This is
to make the good knights into Bobadills, and if a further
refutation is needed, we may remind ourselves that the
husband (if there is a husband at all in the *Romance*) is
already provided for in the character of *Jalosie*. The late

[1] The semantic development from *Franc* (= a Frankish invader > a freeman,
as opposed to a Gallo-Roman *villanus*) to *franchise* as an ethical quality is almost
exactly the same as that in the Greek ἐλευθερία.

M. Langlois thought that *Danger* corresponded to Ovid's
Pudor.[1] I do not say that this is disproved by the existence
of shame as a separate character, for Shame seems to repre-
sent not so much sexual modesty as the public or social
shame which follows scandal. But I find M. Langlois's view
difficult to reconcile either with the history of the word
'danger' or with the behaviour and attributes of the personi-
fication Danger. The word, we know, comes from *Dominus*
through *Dominiarium*; and from the meaning of 'lordship'
and 'lordliness' all its other semantic history can be ex-
plained. I can well see how a word of this origin could acquire
the sense of 'haughtiness' or, in our modern colloquial
language, 'stand-offishness', or 'difficulty in granting'; that
it should mean *Pudor* would be a grave, though scarcely
unparalleled, semantic difficulty. Again, if I turn to the
Romance of the Rose, I find that Danger is a *vilains*; that
he is swarthy, huge, and hirsute; that his eyes burn like
fire and that he bawls at the top of his voice.[2] Even if
Ovid calls *Pudor* '*rustice*', and even if a rustic is a *vilains*,
I cannot but feel that this ogre is a very odd description
of womanly modesty. The most obvious trait of Danger
is his conviction that attack is the best form of defence. Is
this the character of *Pudor*? Does not *Pudor* use in this
erotic warfare something more like the strategy of Fabius?
I hesitate to give my vote against a great critic; but I can-
not help thinking that Danger means something very
different from *Pudor*: means rather the rebuff direct, the
lady's 'snub' launched from the height of her ladyhood,
her pride suddenly wrapped about her as a garment, and
perhaps her anger and contempt.[3]

Such, then, is the scene, and such the characters. But
when a reader has understood them, and thus escaped the
danger of missing the poet's real story, it is always possible
that he may fall into the opposite danger. When we have
seen what an allegory signifies, we are always tempted to

[1] Langlois, *Origines et Sources*, pp. 29, 30.
[2] *Roman*, 2920–4.
[3] See Appendix.

attend to the signification in the abstract and to throw aside the allegorical imagery as something which has now done its work. But this is not the way to read an allegory. Allegory, after all, is simile seen from the other end; and when we have seen the point of simile we do not throw it away. We keep in mind the dawn 'walking', 'in russet mantle', although we know that the reference is to colours in the sky and not to a human figure walking in a cloak: nay, we imagine that dawn precisely because we keep the 'untrue' imagery in mind. And in reading allegory we must do the same. It is not enough to see that the dreamer gazing into the fountain signifies the lover first looking into the lady's eyes. We must feel that the scene by the fountain side is an imaginative likeness of the lover's experience. If it occurred in a simile no reader would find this difficult; and to read an allegory as a continued simile, but a simile which works backward, is hard for us only because we have lost the habit. This habit is not hard to acquire, and we must acquire it before we can tell, save by hearsay, which of the old allegories are good and which are bad. You cannot find out except by reading them as they are meant to be read; by keeping steadily before you both the literal and the allegorical sense and not treating the one as a mere means to the other but as its imaginative interpretation; by testing for yourself how far the concept really informs the image and how far the image really lends poetic life to the concept.

III

Suppose, then, that you are a youth born into the higher ranks of a feudal society. You have just emerged from the restraints of boyhood. Your life is in the spring, and all the world is opening to you. As yet no determinate ambitions have been formed. The life of the court, not yet envisaged as the basis of advancement, but as mere living, as a self-sufficient paradise of wit and love and revelry, has drawn to itself all your desires. It is an

enchanted garden 'from whose walls sorrow flies far', a world raised almost above nature,[1] from which the disabilities of childhood have too long excluded you. Now at last the door opens and the entry is easy, at least for such as you. Poverty, vulgarity, old age—these are the qualities that disable a candidate, and you are guilty of none of these. All that is required of you is to swim with the tide, to wrap yourself in voluptuous idleness, and to gather rose-buds while you may.

Such is the situation which Guillaume de Lorris presents in the opening of the *Romance of the Rose*. The dreamer is wandering on a May morning, aimlessly at first, beside the river of Life; but aim and purpose come to him as soon as he has seen the garden enclosed, four-square, in its high, embattled wall. On the outside of the wall he sees the images of those whom the garden for ever excludes. They seem at first sight a curious collection, in which vices (such as Avarice and Envy) are mingled with misfortunes like Poverty, Age, or Sadness. But the appropriateness of the list is apparent as soon as we remember the allegorical intention. The courtly life, symbolized by the garden, is neither a purely moral entity, as Plato's aristocracy might have been, nor a purely animal one, like the aristocracy of a school, nor purely economic, like the 'society' of our own times. To enter into its full enjoyment a man still needs, along with certain gifts of nature, and a sufficient fortune, a certain selection of genuinely moral qualities; it is for this reason that Hatred, Covetise, and Envy find themselves side by side with Poverty and Age upon the outer side of the wall. The only figure in this gallery which need give us pause is *Papelardie*. She is the personification of hypocrisy in religion, no doubt; a vice which, under different names, will be found to play an important part in Jean de Meun's continuation of the *Romance*. But in that continuation Hypocrisy is by no means left on the outer side of the wall, and there is no reason to suppose that Guillaume de Lorris would have used her at all in his

[1] Cf. *Roman*, 637, 638.

conduct of the story. What then is her relevance? The answer is to be found in a single line:

> Ne she was gay, fresh ne iolyf.[1]

Papelardie is, in fact, that quality which parents call Chastity, and courtly lovers Prudery. No doubt, in the courtly world, ladies who supported their unkindness with moral or religious pretensions were accused of being hypocrites. In the same spirit, and for the same reasons, small boys in our schools are accused of being *pi*. It is thus very natural that *Papelardie* should rank among the disqualifications for the courtly life.

But all this time, like the dreamer himself in the poem, we are delayed too long upon the outside of the wall; and in the inevitable dryness of interpretation we lose what is the life of the allegory—the alluring secrecy of the enclosure, the tree-tops seen above the battlements, the singing of the birds within, and the long journey round to find the door. When at last the door is discovered, the dreamer meets there the portress Idleness, who is well described:

> Whan she kempt was fetisly
> And wel arayed and richely,
> Thanne had she doon al hir iournee.[2]

She tells him that this is the garden of Delight, who takes his pleasure there with his people, under the shade of the trees which he has imported from the land of the Saracens; and invites him to enter.

The young man is now launched into society; and for the first few months a delighted apprenticeship in courtly usage is all his occupation. In the allegory he meets the various courtly personifications whose uncourtly opposites he has already seen on the wrong side of the wall; and then wanders away from them, alone, admiring the trees, the beasts, the streams, and the flowers of that garden. But

[1] *Roman*, 427 (435 in the English version in Skeat's *Chaucer*, vol. 1).
[2] Ibid. 568 (English version 576).

all this while the god of Love was following him, unseen.
The effortless, unrippled flow of natural description in this
passage, never forgetful of the allegoric meaning, yet never
marred by it, and often to a modern reader suggesting a
symbolism far more profound and less explicit,[1] is an ad-
mirable example of the poet's quality.

But though the youth could not foretell—the god, you
will remember followed him unseen—his elders could
easily have foretold that the life of the court as mere living
would not long continue to satisfy him. 'Love', we know,
is 'first learned at a lady's eyes', and among the many
ladies whom he meets there is one into whose eyes he looks
both long and close. Those eyes seem to him to contain
in themselves, or to sum up, the whole of that vague de-
light in which he has lived the last few months. But they
contain more also; in them he sees the promise of the lady's
love.

This important step in the story is allegorized in a
manner which quite intelligent readers have been found
capable of misunderstanding or of simply overlooking.[2]
Yet the equivalences are very easy, and even approach
dangerously near to that physiological allegory which
burdens Spenser's *House of Alma*. The dreamer in his
wandering comes to a fountain. Above it, in small letters,
he reads that this is the same fountain in which Narcissus
saw his shadow, for whose love he died. The dreamer is
afraid and draws back; but in the end his curiosity over-
comes him and he also looks in. Around it the grass grows
thick and luscious, both winter and summer. In the
bottom of the fountain there lie two crystal stones, in
which the whole garden can be seen reflected. This is the

[1] Not only to a modern reader. The Middle Ages had the same feeling and
a crude expression of it is to be found in Jean Molinet's fifteenth-century 'mora-
lized' version of the *Roman*. *v.* Langlois' edition, tom. i, pp. 32 et seq.

[2] The right interpretation is put beyond doubt by the following lines of Bernart
de Ventadorn (*v.* Bartsch, *Chrestomathie Provençale*, 1904. 69) which may be the
indirect source. 'Anc non agui de mi poder Ni no fui meus des l'or' en sai Que·m
laisset en sos olhs vezer, En un miralh que mout mi plai. Miralhs, pos me mirei
en te M'an mort li sospir de preon, Qu'aissi·m perdei cum perdet se Lo bels
Narcisus en la fon.'

mirror perilous and the well of love, whereof many have told 'in romans and in boke'. As soon as he looks into the crystals he sees in them, a little way off, a garden of roses, and among them one bud not yet unclosed. He is filled with longing for that bud; and turning away from the reflection he rises and approaches the rose garden to pluck the bud itself.

Of this passage I would observe two things. In the first place it ought to remove for ever the very disastrous confusion which would identify the Rose with the Lady. The Rose, in Guillaume, is clearly the Lady's love: in Jean de Meun it has a different signification; but nowhere does it mean the Lady herself. In the second place, I would ask the reader whether this passage, despite a little over-elaboration, is not well handled by the poet. Descriptions of the act (or passion) of 'falling in love' tend to be among the most banal passages of fiction; but Guillaume, with his crystals and his well, seems to me to give us some of the real magic of eyes (and of mirrors) as that magic actually exists, not indeed outside the human mind, but outside any school of poetry.

In the lines that follow the meaning is too simple to need interpretation. As the dreamer puts his hand forward to pluck the Rose, he is suddenly struck by an arrow. The god of Love, who had followed so far unseen, is beginning to shoot. It is here, for once, that the dream-allegory has something of the flavour of real dreaming. *In mediis conatibus aegri succidimus!* The dreamer can neither reach the Rose nor yet be stayed from approaching it by the five arrows which strike him in succession. At last the god calls upon him to yield. He yields and does homage and becomes Love's man. In other words, the youth finds himself unmistakably in love and accepts the situation.

In the three hundred lines that follow we find one of those passages in which the work of the old poet has 'dated'. The god of Love instructs his new vassal in the duties he will have to perform and the pains he will have to bear.

By an irony not uncommon in literary history Guillaume prefaces this speech with a promise that

Now the romance ginneth amende.[1]

He is approaching the doctrinal part of his work, and claiming a place beside Ovid and Andreas Capellanus. He clearly expects this passage to be read more often and more eagerly than any other. We cannot, indeed, say that the allegory at this point corresponds to nothing in the real (i.e. the psychological) story. Even in our own times, when a young man recognizes that he is 'in love', he may well feel that he has come to a place where others have come before him, a place with laws of its own that existed before he met them, in which certain things, not unknown from literature and tradition, are now to be done and suffered. In the thirteenth century the erotic institutionalism which I sketched in the first chapter might greatly increase such a feeling: for there is nothing in literature which does not, in some degree, percolate into life. And thus, behind the long speech of Love, we can, and should, suppose some experience which could really have befallen a lover of that period. But it remains, when all has been said, a passage for historians rather than for poets.

In line 2767 Love vanishes away. The first shock of finding that he loves is over, and the young man has to consider what he will do. He cannot immediately demand the Lady's love: there is a thorny hedge around the rose garden. What he can do is to advance himself in her favour by means of ordinary social intercourse; and at first he makes good headway. The Lady is disposed to be friendly, and soon they are on terms which render it possible to begin to think of raising the question of love. The Lady's friendliness, or 'good reception' is personified in the fair young squire Bialacoil who leads the Dreamer beyond the hedge, into the rose garden itself. But as they draw near the Rose, they must pass by the lair of Danger, Male-

[1] *Roman*, 2062 (English version 2154).

bouche, Shame, Fear, and Jealousy. It is one of the exquisite traits in the allegory that a quality within the Lady herself, her 'fair-welcoming', is from the first her lover's accomplice against certain other qualities, equally her own, which the two conspirators fear to arouse—her own 'danger' and her own modesty, who are enemies as carefully to be hoodwinked as the court gossips (Malebouche) and the suspicions of her relatives (Jealousy). Bialacoil is always being distracted between his natural kindness and his fear of these enemies. Thus of his own free will he offers the dreamer a leaf that had grown near the Rose; but he is shocked and frightened at a request for the Rose itself. Scarcely has this request escaped the Dreamer's mouth when Danger leaps up from his slumber, drives the intruder back beyond the hedge, and scolds Bialacoil to flight.

The lover has made his first attempt and failed. He is as yet no cynic, and has neither vanity nor experience to teach him that such reverses are not always final. He only knows that he has lost the intimacy he had gained and that 'bial acoil' has vanished from his Lady's face and manner. The sting of disappointment drives him to reflect: or, as the allegory has it, Reason chooses this moment to descend from her high tower and address him.

> Hir eyen two were cleer and light
> As any candel that brenneth bright,
> And on hir heed she hadde a croun:
> Hir semede wel an high persoun:
> For rounde enviroun, hir crounet
> Was ful of riche stonis fret.
> Hir goodly semblaunt, by devys,
> I trowe were maad in paradys;
> Nature had never such a grace
> To forge a werk of such compace.[1]

She tells him

> Thou hast bought dere the tyme of May.[2]

[1] Ibid. 2981 (English version 3199).
[2] Ibid. 3000 (English 3222).

It was in an evil hour that Idleness opened the garden door
to him. His enemies are too strong for him. Better to
renounce the folly of love and to tame his heart,

> Who-so his herte alwey wol leve
> Shal finde among that shal him greve.[1]

The case could scarcely be better put. But it is true to
nature that the lover should hear and understand and yet
renounce all this good sense, not as something too high and
hard for him, but as something beneath him, as a disloyalty
to love. As the modern poet says:

> People in love cannot be moved by kindness
> And opposition makes them feel like martyrs.

Reason—and this again is true—does not outstay her wel-
come. The lover is left free to console himself with the
conversation of Frend who takes his designs upon the Rose
for granted, and gets on with the practical side of the
business. It is as a result of his advice that he dares once
more to approach the hedge and even to parley with
Danger.

At this point the interest of the story begins to be trans-
ferred to the heroine. The girl is beginning to recover
from the first shock of her lover's demand. Danger still
guards her rose garden; but it is already a Danger more
sullen than violent, and when the lover asks leave only to
stand without the hedge and to love the Rose at a distance,
Danger is content to growl a surly permission.

> Love where thee list. What recchith me
> So thou fer fro my roses be?[2]

But the girl has enemies within as well as without. There
is her *Franchise*, which is averse from grudging or sus-
picion. There is also *Pite*. After all, the young man looks
so very miserable. And what has poor Bialacoil done that
he should be treated like this? Bialacoil meant no ill; there
can be no harm in being civil and agreeable. With such
arguments Pite and Franchise extort Danger's consent to

[1] *Roman*, 3071 (English 3303). [2] Ibid. 3199 (English 3477).

the return of Bialacoil. 'Fair welcome' once more shows
on the Lady's face; and after that it is not long before the
lover is again within the hedge.

The youth has profited by experience. This time his
request is more moderate. He asks not to pluck, but only
to kiss, the Rose. Bialacoil replies with perfect frankness,

> Thou shuldest not warned be for me,
> But I dar not, for Chastite.
> Agayn hir dar I not misdo.[1]

To this the lover has naturally no reply. His affairs are at
a standstill. The story has reached its turning-point. All
that Bialacoil can be expected to do for him has been done;
thus far and no farther will the qualities intrinsic to the
Lady carry her—her frankness, her friendliness, her pity.
If all were in the Lady's hands this check might prove
final. But all is not. The lover has allies far mightier than
any of the qualities personal to his mistress, allies who can
make his mistress their puppet. Natural passion may fall
upon her and carry her whither she never intended. It is at
this moment that Venus enters the poem; Venus, who is
passion, lawless and natural, who sometimes works hand
in hand with courtly love, but has no need of his assistance,
and often works without him. Venus is that element in the
situation which Bialacoil left out of account when he led
the lover a second time within the hedge. The lady pitied
the young man's passion and readmitted him to her inti-
macy; she did not realize that she had senses of her own.
Innocence is carried away by the unforeseen. At the touch
of Venus' torch Bialacoil grants the request, and the lover
kisses the Rose.

After this all is in confusion. Tale-bearers are on the
lover's track. Jealousy, summoned by Malebouche, is on
the scene in a moment, and rating Bialacoil who has not
a word to say for himself. Shame answers, timidly and
brokenly, on his behalf. It is touching and natural, that
in the long speech here allotted to Shame no word is

[1] Ibid. 3397 (English 3669).

spoken for or against the lover. It is Bialacoil who has
betrayed her: Bialacoil who is to be defended, for he does
no more than his mother Courtesy taught him, and meant
all for the best. The girl cannot believe that her habit—
if we may drop into our own vernacular—of 'being nice
to people' is a fault: perhaps unconsciously she knows that
Bialacoil, however disgraced for the moment, is of all her
retinue the likeliest to serve her turn. Shame will promise
to guard him more carefully in the future.

Some such settlement would have satisfied the Lady
herself, but it will not do for her guardians, symbolized by
Jealousy. Nothing will satisfy them but that Bialacoil
should be thrown into prison. Shame and Fear are sent to
waken Danger and chide him from his negligence. The
gaps in the hedge are repaired. A moat is dug and within
it a castle built, at whose four gates Shame, Danger, Fear,
and Malebouche stand sentinel. Inside, Bialacoil is im-
prisoned and given as a keeper an old woman, called in our
English text the Vekke. The lover, excluded, can but
weep without the castle walls, and launch one despairing
appeal to Bialacoil within.

> Though thou be now a prisonere
> Kepe atte leste thyn herte to me.[1]

It is here that Guillaume's work breaks off. His Lady
has been given a Duenna who will strictly supervise hence-
forth her 'bial acoil'. This dangerous friendliness of hers
is to be watched. And the Lady herself is more than half on
the side of the Duenna and of her parents. Her modesty,
her fears, and her 'danger', co-operate with the gossips of
the court and with the jealousy of her relations to shut
up and to suspend from all operation that 'fair welcome'
which, none the less, she cannot root out of her heart.
Thus, on the surface, all is over with the lover's suit.
Nothing in the overt behaviour of his mistress gives him
hope: but across the barrier of that overt behaviour he
makes his appeal to that element in her which, having once

[1] *Roman*, 4004 (English 4378).

seen, he divines to be still alive within, though under lock
and key.

Such is the first part of the *Romance of the Rose*. We are
fortunate to have a complete text of it—in part possibly
by Chaucer—in fourteenth-century English; a version
which lacks, to some extent, the plashing fluidity of the
original, and which makes the poem in places racier and
more pointed, less gentle and equable, than it really is.
There is a quality in the best Old French which Gower
alone among the English has approached. No poetry could
be more tranquil, more pellucid. It has a winning and un-
obtrusive way which the harder-hitting style and deeper-
chested voice of English cannot reproduce. Ours is 'all
instruments'; theirs is the 'lonely flute'. I labour the point
because it is this side of the original which necessarily
escapes my analysis. While we talk of psychology and of the
conduct of the story, the reader must try to remember that
all this story is conveyed in a medium that is nearly per-
fect; that the bright beauty of the scenes depicted and the
wistfulness (it is hardly pathos) of many speeches would
make the poem worth reading for their sakes alone. And
few poets have struck better than Guillaume de Lorris that
note which is the peculiar charm of medieval love poetry—
that boy-like blending (or so it seems) of innocence and
sensuousness which could make us believe for a moment
that paradise had never been lost.

On the psychological side Guillaume's merits are more
easily displayed and I hope that they are now apparent. It
is arguable that Guillaume, even more than Chrétien,
deserves to be called the founder of the sentimental novel.
A love story of considerable subtlety and truth is hidden
in the *Romance*. It would be a work not of creation, but
of mere ordinary dexterity, to strip off the allegory and
retell this story in the form of a novel. Nor would the
change be an improvement. We see how little the alle-
gorical form hampers the novelist in Guillaume by the fact
that when we have finished his poem we have an intimate
knowledge of his heroine, though his heroine, as such, has

never appeared. In her fears and hesitations, in her constant betrayal at the hands of Bialacoil (who means no harm), in our certainty that she will yield and yet will claim—in a sense honestly—that she has been won against her will, we see the outlines of the character which Chaucer has developed for us in his Cresseide. For Chaucer's Cresseide is a borrowing, not from Boccaccio, but from Guillaume de Lorris.

The story, as told in the first part of the *Romance*, is sufficiently interesting to excite speculation. How would the poet have ended it, if he had had time? The late M. Langlois, from whom it is rash to differ in such a matter, was of opinion that the story is near its end when it is interrupted, and that the Dreamer would soon have won the Rose.[1] I cannot, for myself, feel any certainty that it would have ended in this way. I am not sure that a poet so removed from ribaldry as Guillaume would have introduced Reason so gravely if Reason was to be finally defeated. The speech of Reason may well have been written to prepare the way for some such palinode as is by no means foreign, we know, to medieval love-lore. The *Romance* might have ended with the defeat and refutation of Love.

Such speculation began soon after Guillaume's death. The gigantic continuation by Jean de Meun will occupy us in the next section; but this continuation does not stand alone. It was (probably) preceded by a much shorter attempt, the work of an anonymous poet.[2] In this version Bialacoil and the other powers friendly to the lover escape from the castle while Jealousy sleeps and simply present the lover with the Rose. Such a conclusion is absolutely inconsistent with the character of the heroine in Guillaume's

[1] *v.* Langlois' edition, tome i, p. 3. His statement that, at the point where Guillaume breaks off, the heroine 'n'est plus séparée de lui [*sc.* l'amant] que par l'étroite surveillance de ses parents' seems to me untrue. Her relatives (i.e. *Jealousy*) have indeed built the castle but they have enlisted *Danger*, *Shame*, and *Fear* among its wardens. In other words the girl has proved largely amenable to the scolding of her relatives and is now herself almost entirely on their side.

[2] *v.* ibid., pp. 3 et seq.

work. It seems to be the product of an anxiety to untie
knots as quickly as possible and make some sort of con-
clusion, rather than of any deep sympathy with the
original poem. In this sympathy Jean de Meun was, of
course, at least equally defective. But then Jean de Meun
did not write a mere conclusion. Rather he made the
original *Romance* the pretext for a new poem which com-
pletely dwarfed it and which is now to be considered on
its own merits.

IV

'Let no one *tell* you', said Schopenhauer, 'what is in the
Critique of Pure Reason.' A similar caution might well be
given about the second part of the *Romance of the Rose*.
It is with a despair and an 'astonishment' such as Lydgate
once felt that I approach the task of conveying to those
who have not read it, or recalling to those who have, some
idea of this huge, dishevelled, violent poem of eighteen
thousand lines. The tradition of literary history has given
us for our guiding thread the principle that Jean was a
satirist. As if he were not a dozen things beside; as if he
had not at least equal claims to be classified as a contro-
versialist, a philosopher, a scientist, a poet of nature, a
perfectly serious religious poet, a poet of the school of
Chartres. The one thing that he is not is an allegorist; he
is as helpless with the dainty equivalences of Guillaume de
Lorris as Dr. Johnson would have been among Pope's
sylphs and gnomes. He utterly lacks, perhaps despises,
Guillaume's architectonics and sense of proportion. We
never know, at one page, what we shall be reading about
on the next. He is incapable, as Langland and Dryden
were incapable, of producing a poem, a ποίημα, a *thing
made*; but this is not to say that he is incapable of poetry,
and even of a poetry that comes nearer at times to great-
ness than that of Guillaume de Lorris.

It is as well to make it clear at the outset that Jean's
work is only in a very superficial sense a continuation of
Guillaume's. It is not the allegorical narrative which

swells it to its prodigious length; it is the digressions. The actual story in the second part of the *Romance* can be very briefly told, and as the book is not, perhaps, very often read in England, I will venture to tell it. I shall not stop to indicate the course of the love story which the allegory conceals. Jean de Meun has no place among the founders of the novel, and his *significacio* is hardly worth the finding.

The Dreamer, left alone outside the castle, laments his fate, and wavers in his allegiance to Love. Reason again descends to counsel him. (His conversation with Reason, which ranges over a great variety of subjects, and occupies 3,000 lines, constitutes the *First Digression*.) When he has got rid of Reason he turns again to Frend, who assures him that Danger's bark is worse than his bite, and gives him a great deal of Ovidian advice about deceiving the Rose's guardians and corrupting her servants (Frend then insensibly glides into other topics for over 1,000 lines: this is the *Second Digression*). The Dreamer, following Frend's advice, attempts to approach the castle by the way of Much-giving, but finds it guarded by the lady Richesse who will admit none but her friends. The god of Love again appears to him, catechizes him, and finally summons all his barons to take part in an assault upon the castle. He prophesies to them the life and work of Jean de Meun, who will continue the *Romance* begun by Guillaume de Lorris. The barons advise that Venus be summoned, but Love replies that she is not at his beck and call, and explains at some length the relation in which he stands to her. He then notices that religious hypocrisy, in the persons of Falssemblant and Constrained Abstinence, have found their way into his retinue. They are admitted as allies, after a little hesitation. (In reply to Love's questions, Falssemblant describes himself—and a good many other things—in a speech of 1,000 lines, which makes the *Third Digression*.) Love now gives the order for the attack. Constrained Abstinence, dressed as a pilgrim, and Falssemblant, dressed as a friar, approach the gate where Malebouche is warden, and induce him to be shriven. As

soon as he is on his knees Falssemblant strangles him and throws his body into the moat. The two hypocrites, in the midst of their success, are reinforced by Courtesy and Largesse, and all four enter the castle and parley with the Vekke. The latter, on hearing that Malebouche is dead, has no hesitation in promising to smuggle the lover into the castle, and hobbles off to prepare Bialacoil for his visit, and to present him with a chaplet of flowers which the lover has sent him. She has some difficulty in persuading Bialacoil to accept it, but wins her point in the end and settles down to read him a highly autobiographical lecture on love. (This is the *Fourth Digression*, and takes over 2,000 lines.) Bialacoil's timid consent being granted, the lover is brought into his presence, and again asks for the Rose, but is again interrupted by Danger, Fear, and Shame, who threaten Bialacoil with fresh rigours and drive the intruder out. At this the outposts of Love's army call up the main body to assist him; the defenders take up their positions; and a sort of erotic psychomachia follows. (But not before the author has interrupted us with an apology for his work, which forms the *Fifth Digression*.) After some dullish fighting, Love asks for a truce and sends messengers to ask the help of Venus. They find her with Adonis (his story is told in the *Sixth Digression*) and persuade her to accompany them to the front. She threatens the garrison of the castle, and she and Love swear to reduce it. Nature, working at her forge, is pleased to overhear the oath. (Her subsequent dialogue with her confessor Genius —the *Seventh Digression*—occupies us for about 4,000 lines.) Nature sends Genius to visit Love's army and present the barons with a pardon. Genius does his pardoner's work (not without a 2,000 line sermon, the *Eighth Digression*), the barons cry Amen, and Venus, after calling on the castle in vain to surrender, aims with her bow at a certain image. (It was as fair as that image which Pygmalion loved. Pygmalion's story, in 1,000 lines, is the *Ninth Digression*.) Venus then shoots her fiery arrow. The castle bursts into flames. The defenders fly. Bialacoil is rescued and brought

before the lover to whom (after a *Tenth* and last *Digression*)
he surrenders the Rose. The Dreamer wakes.

Even from this summary the case against Jean de Meun
becomes apparent. He chose to continue a work in which
the unity of subject was conspicuous: but he himself had
no interest in that subject. He escaped from it at every
turn and seems always to have come back to it with reluc-
tance. And in those passages where he keeps himself to the
matter in hand, his treatment is perfunctory and con-
fused. Thus three of his episodes—the descent of Reason,
the reassurances of Frend, and the coming of Venus—
merely repeat episodes in his original. Again, he is utterly
lacking in the power, so necessary for allegory, of keeping
the two stories—the psychological and the symbolical—
distinct and parallel before his mind. He describes how
the Vekke smuggles the lover into Bialacoil's presence
through a window. This is quite meaningless if we take
it allegorically. Jean has forgotten that the castle and
Bialacoil's prison within it are purely figurative: he has
stumbled into the literal narration of a real intrigue, in
which the duenna is admitting the gallant, by a real win-
dow, into the house or castle where his mistress lives. He
makes the Vekke lecture Bialacoil on the behaviour proper
to a young woman, on the deception of husbands and the
treatment of lovers; he makes Bialacoil hesitate before
accepting the lover's gift of a chaplet—a hesitation proper
only to Shame and Fear—and yield, at last, under the in-
fluence of vanity. 'His' mirror tells 'him' that the chaplet
looks very well on 'his' fair hair. In other words, Jean de
Meun forgets for thousands of lines together that Bialacoil
is a 'young bachelor'. He identifies Bialacoil with the
heroine and describes female conduct accordingly: the
name, with the masculine pronouns and adjectives which
it demands, survives to remind us of the absurdity. The
allegory has broken down. It would not be hard to defend
such passages on the ground that they look forward to the
art of literal love story and spoil the allegory only to give
us something better in its place. But in fact they give us

something much poorer. The delicate psychological hand-
ling without which a long and serious love story is the
most tedious of all things, is still possible only by allegorical
devices. What Jean really does is to substitute a third-rate
literal story for a first-rate allegorical story, and to confuse
the one with the other so that we can enjoy neither. When
Chrétien slips into allegory, he knows what he is about
and subordinates the allegorical digression to the main
theme so that it enriches his poem without confusing it;
when Jean de Meun, by a reverse process, slips out of
allegory, he does so by mere inadvertence, and produces
chaos. Clumsiness is the characteristic vice of his work.
He is a bungler. His hand is heavy and his fingers, as they
say, are 'all thumbs'.

His digressions constitute a different, but equally serious
fault. There are some, indeed, who would excuse them as
characteristically medieval, and who would plead that we
are here foisting a classical rule, a unity, upon an art to
which it is foreign. I admit no such defence. Unity of
interest is not 'classical'; it is not foreign to any art that
has ever existed or ever can exist in the world. Unity in
diversity if possible—failing that, mere unity, as a second
best—these are the norms for all human work, given, not
by the ancients, but by the nature of consciousness itself.
When schools of criticism or poetry break this rule, this
rule breaks them. If medieval works often lack unity, they
lack it not because they are medieval, but because they are,
so far, bad. Even the irregularity of a medieval street was
an accident, and proceeded from no 'Gothic' love of wild-
ness. When the Middle Ages dreamed of an ideal town—
of the town they would have built if they could—they
saw its houses all of the same height:

> And ther was non that other hath surmounted
> In the cite, but of on heght alyche

It is true that medieval art offends in this respect more
often than most art. But this is its disease, not its essence.
It failed of unity because it attempted vast designs with

inadequate resources. When the design was modest—as in *Gawaine and the Green Knight* or in some Norman parish churches—or when the resources were adequate—as in Salisbury Cathedral and the *Divine Comedy*—then medieval art attains a unity of the highest order, because it embraces the greatest diversity of subordinated detail.

The meandering in Jean de Meun's work is therefore a fault, and a fault fatal to his poem. But of course it is not fatal to his poetry. In reading the second part of the *Romance of the Rose*, as in reading *The Hind and the Panther* or the *Essay on Criticism*, we have to give up the poem as a whole: we are thrown back on the incidental merits, the scattered poetry which survives the ruin of the poem. With these incidental merits, which in the *Rose* are plentiful and influential, we are now to deal.

V

Of the numerous and incompatible ends which Jean set before him, the most successful, and one of the most frequent though hardly the most significant, is that of instruction. And by instruction I do not mean moral didacticism, but plain lecture-like conveyance of the best contemporary theories in science, history, and philosophy. In this there is nothing peculiar to him. It was the tendency of the age to make every lengthy poem something of an encyclopedia; a tendency eminently natural and reasonable in an age of unspoiled curiosity, when a clerk, riming in the vernacular, became for 'lewed' audiences the popularizer of clerkly learning. It may be thought that this extension-lecture function of the medieval poets has nothing to do with their poethood, and does not concern the literary historian; but such a view—as the great example of Dante shows—is too rigid. The kingdoms of pure and applied literature may be as distinct in principle as those of animal and vegetable life, but they are also as indeterminate at the frontier. Certainly good popularized doctrine in verse calls for many of the qualities of the literary artist—clarity, mastery of

the medium, appositeness of metaphor, and the like: and if he has really imagined as well as understood his theme—and it is hard to do one without the other—he will slip into poetry and out of it again so often and so unobtrusively that only a very austere Crocean will wish to draw a hard line between the 'poetry' and the 'science'. Jean de Meun possessed in a high degree all the qualifications for this sort of work. He is the best of popularizers and thoroughly deserves the immense influence which his encyclopedic character gave him over his successors. His treatment of the problem of freedom,[1] based on Boethius, is at once far less jerkily prosaic than Chaucer's, and far more of a real popular résumé of the debate than Dante's. In the unlikely event of finding a beginner in philosophy who read Old French I should confidently direct him to the *Romance of the Rose* for an introduction to this particular part of the subject. Jean's account is much easier going than Boethius'; but I have not been able to find that it is much less cogent and accurate. Other instructive digressions, which call for less power of exposition, are richer in poetical elements, yet without losing their didactic value in irrelevant decoration. Jean's account of the origin of civil society and the social contract[2] is none the worse doctrine for including a charming picture of 'the former age', for that charming picture is an integral part of the theory. His discussion of alchemy,[3] by abstaining from all technical details and giving only the root idea of that science, which is all that a layman can be expected to learn, gives also, as it happens, just that part of the alchemical idea which is truly imaginative. His meteorology, which is given in some detail, blossoms quite naturally and relevantly into pleasing natural description.[4] Thus his science and his poetry appear much more often as allies than as enemies. Where there seems to be a cleavage—in his attack on the superstition of Habundia and her night-riders—it is we who make it. For us the poetry is

[1] *Roman*, 17059–874. [2] Ibid. 8355–454 and 9517–678.
[3] Ibid. 16083–112. [4] Ibid. 17885–18023.

on the side of the witcheries which the author is condemn-
ing, not of the rationalism he upholds. But for him this
was not so. A firm rationalistic bias is present in all his
scientific passages: he writes to refute vulgar errors. His
imagination was not at all seduced by Habundia; if ours
is, that is an accident of our historical position. The
romantic revival has come in between.

I do not suggest that this side of Jean de Meun's work
is of much significance for the modern reader. We no
longer believe the doctrines he teaches, and the roles of
poet and extension lecturer are no longer habitually
doubled. But though such work has dated, it is our duty
as historians to note that such work was once both useful
and pleasant, and that Jean de Meun did it very well—
probably better than any of his competitors. On this
score he thoroughly deserves his fame. He did honest work
of the highest quality to satisfy a legitimate demand:
and with that recognition, having discharged our con-
sciences, we may turn to the more permanent elements
in his talent.

The satiric element, as I have said before, is that which
critics have most often attended to. And a satirist Jean de
Meun frequently is, often at intolerable length. The
subjects of his satire are, in the main, two: women and
churchmen. It will be noticed that neither of these is a
novel subject for satire. How should they be? Whatever
claims reverence risks ridicule. As long as there is any reli-
gion we shall laugh at parsons; and if we still(though much
less frequently than our grandfathers) make fun of women,
that is because the last traces of *Frauendienst* are not yet
wholly lost. In the objects chosen for his satire, then, Jean
de Meun follows traditional lines. Even in combining love-
poetry with satire on women he follows traditional lines—
the lines laid down by Ovid, by the *Concilium*, and by
Andreas Capellanus. There is a misunderstanding abroad
that the second part of the *Roman de la Rose* represents a
turning-point in the history of courtly love; that in it,
something which had been the object of whole-hearted

reverence becomes the object of wholehearted ridicule; that a 'cynical' period here succeeds an 'idealistic' period. But the truth is that 'cynicism' and 'idealism' about women are twin fruits on the same branch—are the positive and negative poles of a single thing—and that they may be found anywhere in the literature of romantic love, and mixed in any proportions. In Jean de Meun the emphasis is on the negative, for reasons which will presently appear; but this by no means puts him in a class apart or makes him the pioneer of a 'cynical' age. He is well within the tradition and inaugurates no revolution: as he looks back to Ovid and Andreas, so he looks forward to Chaucer (where Pandarus supplies the negative), to Malory (who probably understood the place of Dinadan better than is supposed), to Hawes (who created Godfrey Gobelive), and even to the vituperative element in the sonnet sequences. The negative note was there before him, and it was there after him; but it is not—at any rate among his English followers—more prominent after him than before him. It has nothing to do with a supposed cynical period; it is there for the same reason as the palinode (with which Andreas combined it)—it is there because *Frauendienst* is not the whole of life, or even of love, and yet pretends to be the whole, and then suddenly remembers that it is not. The history of courtly love from beginning to end may be described as an 'amorous-odious sonnet', a 'scholar's love or hatred'.

What is the explanation of Jean de Meun's unusually lengthy excursions into satire? Partly, the explanation is to be found merely in his general vice of diffuseness. He brings many other things besides satire into his poem, and deals with them at equally inordinate length. If the satiric passages appear to be a specially aggravated instance of this his chronic disease, we must remember that for his satire he had almost inexhaustible materials both from earlier writers and from those oral sources which are the small change of every taproom. Where the turf was so smooth a gallop of thousands of couplets proved irresistible.

But I am not denying that there is a further reason, and that when we have understood it we shall have the truth behind the popular critical error about the *Roman*. The truth is that Jean de Meun, though he inaugurates no new 'period', is profoundly dissatisfied with the erotic tradition. The error consists in supposing that this dissatisfaction led him solely or primarily to ridicule. In fact, ridicule is only one of the ways in which he endeavours to 'place' his love-lore, to find room for it in the complete synthesis of values which he is always groping towards and which he never reaches. The school of Chartres, as I have told, had been similarly troubled, and had attempted to find a *modus vivendi* not, indeed, between religion and courtly love in particular, but between religion and the courtly life as a whole. Jean de Meun, with a far less explicit consciousness of the problem, and far less ability to solve it, was troubled in the same way. He does not know what to do with this erotic tradition; and he makes spasmodic and inconsistent efforts to do *something* with it; 'take it or leave it' will not satisfy him. Thus in places he falls back on the old simple method of the *volte-face* and heavy-handed abuse of women. Such is the speech of the Jealous Husband reported by Frend.[1] In other passages—witness the advice of the Vekke to Bialacoil—he adopts the Ovidian method. Women are given ironical instructions; how to fleece their lovers, how to deceive their husbands, how to 'make up', and so forth.[2] Or, again, irony of a lighter and more playful sort is used in the conduct of the story itself—as in the scene where Bialacoil receives the chaplet.[3] All these methods are equally satirical, and it is these which are responsible for the common view of Jean de Meun. But these by no means exhaust his repertory: nor are they of more than respectable merits. The scene of Bialacoil and the chaplet, as also the Vekke's advice to girls, are dearly purchased at the price of the ruin of the allegory. The speech of the husband has a certain vigour and gusto of abuse; but it would argue great ignorance of good

[1] *Roman*, 8467–9360. [2] Ibid. 12976–14546. [3] Ibid. 12678- 735.

satiric writing to put it in the first rank. It is when Jean abandons satire altogether and contends by quite different methods with the problem of *Frauendienst* that he becomes most truly a poet.

Of these other methods the least original and the least significant is that of the direct and serious palinode—the grave denunciation of love from some higher point of view, which need not be satirical at all, and still less cynical. In such a palinode what is to be said cannot be new: but one of the chief interests of our subject is to observe the varying success with which authors attempted to give a new turn to the inevitable palinode by their treatment. Jean's method is to put it into the mouth of Reason. In this device he had been anticipated, of course, by Guillaume, and even by Chrétien. But he goes beyond his models, and his own contribution is an interesting one. He represents Reason as a rival mistress pleading for the Dreamer's love. Later, and in another part of the poem, he was to work out more fully the idea that courtly love is a μίμησις or a parody of which divine love is the archtype; an idea profoundly imaginative and no less profoundly true to history. The speech of Reason contains only the germ or the hint of this solution; but the conception of Reason as mistress, by keeping the rival claims on the hero *in pari materia*, gives a unity to the whole passage which it would otherwise have lacked. It is a distinct advance on the form of palinode which Andreas had used, and it lends to the character of Reason a dignity and even a pathos which she has not in Guillaume de Lorris. 'Grant me your love', says Reason, 'And then

> Thou shalt have at thyn avantage
> A leman of so heigh linage
> As noon stant in comparisoun;
> For goddes doughter, that is croun
> Of fadres alle, ich am. Lo see
> Of whiche a forme he made mee!
> See her thiself in my visage!
> There is no maid of heigh parage

Hath leve in love ben so large;
Mi fader yaf hit mee in charge
Loven and love for to graunte;
Therof me thar no shame daunte,
Ne thou of shame tak no kepe;
Mi fader wol thee sauve and kepe
The bet, and fede us bothe tweie.
 How liketh hit thee that I seye?
That god that doth thee so awede,
Can he so wel his folkes fede?
Foles that maken him homages
Han thei therof so riche wages?
 For Crist ne seyeth me nat No!
God woot hit is greet shonde and wo,
A maiden for to ben refused,
For why, to axen sche is used
Ful lyte . . .[1]

A second and more interesting way in which Jean deals with courtly love is learned from the school of Chartres. He attempts, spasmodically, to depart from the conventions, not into ridicule or direct denunciation, but into a genuinely naturalistic theory of sex, as of a thing noble in its place and not to be repented of. This point of view, as I have said, appears—like all Jean's thoughts—intermittently and without much attempt on his part to harmonize it with any system. It appears in Frend's speech in the conception of marriage as a state that could be both happy and honourable if 'maistrie' were banished and the maxims of Chaucer's franklin adopted.[2] It appears in the scene between Reason and the Dreamer, where Reason, having referred to certain physiological facts as plainly as Reason would, is accused of being unmaidenly and indecent. But Reason cannot understand the charge. She has learned her manner of speech from God.

God, the courteis, but vileinye,
Of whom is alle courtesye.[3]

[1] *Roman*, 5813–36. [2] Ibid. 8451–54 and 9421–92.
[3] Ibid. 7073.

She is fully prepared to defend her practice.

> For in my life I dide amis
> Nevere, ne do nat now, iwis,
> Thogh ich withouten glose name
> Tho thinges by hir propre name
> That of his owne hond and thoght
> In paradis mi fader wroght.[1]

The courtly lover is as embarrassed as Gulliver was among the horses, and can only plead that, if God made the things, at least he did not make the *names* by which Reason refers to them. A modern reader is reminded of Shaw's dictum—'it is impossible to explain decency without being indecent'. The whole scene implies a criticism of courtly love far more damaging than the bludgeon work of Jean de Meun's explicitly satirical passages. That the spirit of polite adultery should be genuinely shocked by the unrepentant grossness of the divine Wisdom—should wish, like Milton's enemies, to speak more cleanly than God—is a conception as profound as it is piquant.

But this passage—though, in its way, the gem of the whole *Romance*—is only a prelude to the appearance in person of Nature at a later stage in the poem. Nature and her priest Genius (the god of reproduction) hold the stage for nearly five thousand lines. These lines are crowded with digressions and we forget the speakers, as we so often do in the *Romance of the Rose*; but in its earlier phases this unwieldy passage is nothing less than a triumphal hymn in honour of generation and of Nature's beauty and energy at large. It has really nothing to do with courtly love. Nature is introduced working at her forge not in the interests of human sentiment but in the interests of human perpetuity; labouring without rest and without weariness to keep her lead in a race with death. Death catches all individuals but cannot reach the inviolable Form: to preserve that Form incarnate the goddess is ever beating out new coins from those eternal stamps of hers which art

[1] Ibid. 6955–60.

imitates in vain. It is for this reason that Nature rejoices when she hears the great oath which Love and Venus swear to take the castle. Her joy is based on an interest equally indifferent to human morality—that is not Nature's business—and to human refinements of feeling. What has impressed the poet—no doubt through the pages of Bernardus —is a vivid sense of the ageless fecundity, the endless and multiform going on, of life. This sweeps aside both his traditional love-lore and his traditional condemnation of it. And, what is more, this passes easily and inevitably into the expression of his delight in natural beauty. His 'Nature' is no abstraction. He does not forget in the personification *Natura* that visible nature which confronted him in the valley of the Loire. The traditional refusal to describe Nature takes on new beauty in his hands. The more he thinks of her, the less he can say,

> For God, that fair is but mesure,
> Of fairnesse, in dame Nature,
> When he hir schoop, sette a rivere
> That evere in oon goth ful and clere;
> Of hit the shore and sours noon can,
> Of hit al other fair bigan.
> I dar not in making desface
> With worde hir faiture and hir face,
> Who is so fresshe, fair, and gai,
> That lilye flour in month of mai,
> Ne rose on reise and snow on tree
> Nis nat so reed and whyt to see.[1]

This intuition of natural beauty, reinforcing and reinforced by his devotion to Nature, appears elsewhere in Jean de Meun; in his description of the flowers in the Good Pasture, of rain and floods and their effect on fairy life, of Venus resting in the woods. It is not often that the headlong course of his ideas allows him to rest in mere imagery: but we feel that in him a good 'nature poet' (in the modern sense) was lost. The sky-scenery of the following lines, though marred by some of the quaintnesses he

[1] *Roman*, 16233-44.

had learned from Alanus, goes beyond the usual medieval
recipe of May morning and singing birds. The clouds
observe that the fine weather is coming back; and then

> Therof greet iolitee thei taken
> And to be fair and fresshe, maken
> Robes newe aftir hir dolour
> Of many queynt and glad colour,
> And hongen oute hir fleeces clene
> To dreye ayein the sonne shene,
> And goon a-scatered on lofte
> When wederis ben warm and softe:
> Tho spinnen thei and casten oute
> Foisoun of white threed aboute.[1]

It was the misfortune of Jean de Meun to have read and
remembered everything: and nothing that he remembered
could be kept out of his poem. Mystical ideas were present
to his mind along with naturalistic ideas: from his natural
treatment of sex he reverts, towards the end of the poem,
to the mystical parallel of human and divine love which he
had hinted at in the speech of Reason. This final attempt
to 'do something' with courtly love is made, oddly and
clumsily enough, through the mouth of Genius: not that
justifications, both subtle and pleasing, cannot be found,
but that Jean has not found them. From the lips of Genius
we learn for the first time that the garden of Love and
Delight is, after all, only the imitation of a different garden;
and not only a copy, but that misleading kind of copy which
the philosophers call *Schein* rather than *Erscheinung*,

> For who made comparisoun
> Hit wer a greet misprisioun,
> Sauf that comparisoun that is
> Betwixen trouthe and fable iwis.[2]

When we have seen the true garden we look back and
realize that the garden of courtly love is an impostor. The
well in Love's garden with its two crystal springs is but
a parody of the triune well that rises in the 'park of good
pasture'. The one garden contains corruptibles, the other

[1] Ibid. 17989-99. [2] Ibid. 20285-9.

incorruptibles. Yet they are curiously alike, too. Each is
enclosed in its four-square wall: and each is carved with
images on the outer side of that wall. On the wall of
Love's garden, as the reader will remember, we had such
figures as *Time*, *Vilanye*, and *Papelardie*. On the wall of
the 'good park', as we should expect, are the sins and the
devils: but a reader who has not the taste for this sort of
thing will learn with surprise that we find there also the
earth and the stars, and in fact the whole material universe.
But Jean de Meun is right. He is talking of the *realis-
simum*, of the Centre, of that which lies beyond the
'sensuous curtain': and to that, not only hell and sin and
courtly love, but the world and all that is in it, and the
visible heaven, are but painted things—appearances on the
outside of the wall whose inside no one has seen. What
the wall shows from without are, in fine, *phenomena*.

> Who lokede on that park withoute,
> Portrayed on the wal but doute
> Are alle develes and depe helle,
> Ful feendliche on to see and felle,
> And every vyce and eek outrage
> That hath in helle his herbergage,
> And Cerberus our aller foo;
> Ther mihte he loke on erthe also
> And these secree richesses olde
> That erthe can in barme folde;
> Ther openly he mihte see
> The fisshes fletinge in the see,
> The salte see and alle his thinges;
> Wateres bittere, swete springes,
> And creatures alderkynne
> These smale wateres withinne,
> And in the eyre briddes goon
> And smale flyes everychoon
> That maken aldai soun and route;
> Also the fyr that faste aboute
> Clippeth the reste and the meving
> Of thelementes in a ring.[1]

[1] *Roman*, 20305–26.

This is the outer face of the wall, the side we know. If we could pass the wall we should see the white flocks, who are not shorn or slaughtered any more, following their Shepherd through the good pastures. The turf there is covered with little flowers which the sheep browse on, but whose number never decreases and whose freshness never withers. For all this region is out of the reach of time. Never does Jean de Meun show himself a truer poet than when he touches on the idea of eternity—of all metaphysical ideas the richest in poetic suggestion. If the pleasure I take in these lines is 'philosophical', then so is my pleasure in *Kilmeny*, and in folk tales and morning dreams innumerable.

> For alwey stant in oo moment
> Hir dai that nevere night hath shent,
> Ne hit conquered nevere a del;
> For no mesure temporel
> Hit nath, but alwey as at prime
> That brighte dai, withouten time
> Of temps futur ne preterit,
> Also hit laugheth, evere abit.[1]

And it is this walled garden, apparently, which we were really in search of all the time, and by aping which the garden of Cupid seduced us; and of that lesser garden we can say, in the long run, no more than this, that

> Tho thinges in that garden smale
> Nis but lesinge and trotevale.[2]

This passage represents Jean's highest reach as a poet. No one who remembers the fatuity of most poetical attempts to describe heaven—the dull catalogues of jewellery and mass-singing—will underrate this green park, with its unearthly peace, its endless sunshine and fresh grass and grazing flocks. It represents also what may be called his point of maximum differentiation: in this passage he is most *unlike* Chaucer, or Guillaume de Lorris,

[1] Ibid. 20010–16. [2] Ibid. 20351.

or (for the matter of that) Dante. Does it also represent his final view of love? The answer, I think, is that Jean de Meun has no final view either of love or of anything else. This is but another aspect of his formlessness. The same defect which prevented him from writing a poem (as opposed to a mere heap of poetry) prevented him also from combining his ideas into any consistent whole. His work reads best in quotation because his mind—if I may hazard the metaphor—reads best in quotation. On any subject presented to him—and his reading presented him with nearly every subject—he can think vigorously; and from his thought his imagination catches fire: and he has language at will to make poetry of that result. But it is always a short flight. To-morrow he will be thinking differently, feeling differently, making a different kind of poetry. He lacks the power, or the will, to unify these inspired moments. Thus he tackles the problem of courtly love in several different ways, and tackles it in all of them with considerable success. In one place he is all for ridicule; and the ridicule (though it contains none of his best work) is lively enough. In another place he follows the school of Chartres; and his naturalism about sex produces noble verses. In a third place he will be a mystic; and on this theme of human and divine love he keeps a respectable place, despite the greatness of those who here become his rivals. But while all these solutions are good, the fatal defect is that they really have nothing to do with one another. They could have been connected. The doctrine that human sexuality is the μίμησις of which divine love is the παράδειγμα is not incompatible with the doctrine that human sexuality, in its place, is a glorious energy of nature; and neither of these is incompatible with scathing satire on human abuse of sexuality. All Jean's ideas were, in themselves, capable of fusion, but he could not fuse them. The nature and extent of his failure become clear as soon as we think of Dante. Odd as it may sound, it is none the less true that the materials of the two poets are very nearly the same. It is almost true to say that there was nothing

in Dante which was not also in Jean de Meun—except
Dante himself. In both we find the same starting-point—
courtly love: in both the same stores of scholastic learning
and the same determination to impart them: the same
unfettered range of heterogeneous experiences, both
actual and imagined. If it is said that they differ in merely
technical power, I reply that technique is itself only one
manifestation of the unifying faculty. The power which
welds raw masses of experience into a whole is the same
which, in the single phrase, elicits from the chaos of lan-
guage the perfect words and the perfect syntactical device.
Thus, in a sense, Jean lacked nothing which Dante had,
except the power to co-ordinate. But that exception is
fatal. Because of it, Dante remains a strong candidate for
the supreme poetical honours of the world, while Jean de
Meun is read only by professional scholars, and not by very
many of them.

This is not simply to repeat, at excessive length, that
the *Divine Comedy* is a better poem than the *Romance of
the Rose*. We do not need to be told that: but perhaps we
do need to know precisely how, and how far, the *Romance*
is bad. For there are many kinds of failure, and not every
unsuccessful poet can say, as Jean de Meun could, *inopem
me copia fecit*. Some poets, we know, have failed because
they 'never spoke out', but that is not Jean de Meun's
trouble. No writer is less jejune, none gives us a greater
sense of wide resources. If he lacks the bones of good
poetry, he has all its flesh. And this explains how the
Romance, though a failure, is a great failure. It explains
why the *Romance* is the typical poem of the Middle Ages
in a sense in which the *Comedy* is not—typical in its rich-
ness and variety, and typical also in its radical vices. It
explains that enormous influence from which Chaucer—
say what we will of his 'Italian' period—never at any stage
of his career escaped. In the work of Jean de Meun suc-
ceeding generations found almost everything ready to
their hands. Though he had not, like Dante, conquered,
he had at least journeyed round the whole world of ideas

and social life and character, and brought together spoils from every part of it. He had, for his immediate followers, the practical utility of a general store, and for us he retains some of its chaotic attraction; and all this without prejudice to those passages of pure poetry into which he often rises—I had almost said 'tumbles'—unawares.

IV. CHAUCER

I

THE *Romance of the Rose* is one of the most 'successful' books, in the vulgar sense, that have ever been written. It exists in 300 manuscripts; it was paraphrased and moralized in prose; it was 'answered'; it was translated or imitated in German, English, and Italian; and Agrippa d'Aubigny in the seventeenth century still speaks of it as an admired work.[1] The poems that derive from it constitute the most important literary phenomenon of the later Middle Ages. As a germinal book during these centuries it ranks second to none except the Bible and the *Consolation of Philosophy*.

But all this can easily be misunderstood. The *Roman* is not the first of any long series of poems essentially similar to itself. On the contrary, few, if any, attempted to do over again what Guillaume de Lorris had done—that is, to represent an action or story of love in a thoroughgoing allegory. Thoroughgoing allegories we shall find in plenty, but they do not deal, or do not deal exclusively, with love. Again, we shall find love poems, but these will be often but superficially allegorical or not allegorical at all. The elements into which the *Roman* can be analysed are constantly used by later poets: the gracious, yet frank, eroticism, the opening with a dream, the allegory, the satire against women and the Church, the encyclopedic didacticism; but these are hardly ever found in just such combination as the *Romance of the Rose* displays, nor with the same result. That is why we are justified in speaking of it as a germinal book. It is not a dead thing, a model to be imitated; it is a parent, begetting offspring at once like and unlike itself, and each new child has his individual traits as well as his family likeness.

The rest of this book will be concerned with the English

[1] *v.* Langlois' edition, tom. I, pp. 32 et seq.

branch of this literary family, and I shall touch on foreign literatures only in so far as these bear on our native development. Our starting-point will naturally be the fourteenth century, for it was then that the fully developed sentiment of courtly love, embodied in allegory, first made its effective appearance in England. A full history either of English allegory, or of English love poetry, would have to begin much farther back; but even Bernard the monk did not see all, and it is time to turn to our own great poets of the fourteenth century.

The greatest English allegory of this period falls a little outside our subject. I relinquish *Piers Plowman* with the less regret because I leave it in better hands than mine;[1] my only anxiety is lest, by passing it over, I may seem to place it in a false isolation from the literature of the period, and thus to confirm certain misunderstandings. Scholars more interested in social history than in poetry have sometimes made this poem appear much less ordinary than it really is as regards its kind, and much less extraordinary as regards the genius of the poet. In fact, its only oddity is its excellence; in *Piers Plowman* we see an exceptional poet adorning a species of poetry which is hardly exceptional at all. He is writing a moral poem, such as Gower's *Miroir de l'homme* or Gower's Prologue to the *Confessio Amantis*, and throwing in, as any other medieval poet might have done, a good deal of satire on various 'estates'. His satire falls heaviest where we should expect it to fall—on idle beggars, hypocritical churchmen, and oppressors. Like Chaucer he reverences knighthood.[2] Even as a moralist he has no unique or novel 'message' to deliver. As a cure for all our ills he can offer us only the old story—do-wel, do-bet, and do-best. His advice is as ancient, as 'conventional', if you will, as that of Socrates; not to mention names more august. It is doubtful whether any moralist of unquestioned greatness has ever attempted more (or less)

[1] *v.* N. K. Coghill, 'The Character of Piers Plowman', *Medium Aevum*, vol. ii, no. 2, pp. 108 et seq.

[2] *P. Plowman*, C, Passus IX; Chaucer, *C.T. Prol.* 43 et seq.

than the defence of the universally acknowledged; for 'men more frequently require to be reminded than informed'. As a politician, Langland has nothing to propose except that all estates should do their duty. It is unnecessary, I presume, to state that his poem is not revolutionary, nor even democratic.[1] It is not even 'popular' in any very obvious sense. A poem every way unsuitable for recitation cannot have been addressed to those who could not read; and any one who supposes that Langland had in view an audience very different from the audience of Gower and Chaucer may be advised to imagine the probable results of reading aloud in a tavern or on a village green such lines as the following:

> The whiles I quykke the corps, quod he, called am I *Anima*;
> And whan I wilne and wolde, *Animus* ich hatte;
> And for that I can and knowe, called am I *Mens*;
> And whan I make mone to God, *Memoria* is my name.[2]

Or, if he prefers,

> Thus is relacion rect ryht as adiective and substantif
> Acordeth in alle kyndes with his antecedent.[3]

Langland is a learned poet. He writes for clerks and for clerkly minded gentlemen. The forty-five manuscripts, and the presence of quotation from Langland in Usk's *Testament of Love*,[4] prove that he did not write in vain. It would have been strange if he had. He offered to his educated contemporaries fare of a kind which they well understood. His excellent satiric comedy, as displayed in

[1] The mention of *Peres Plouȝman* in John Ball's Letter to the Peasants of Essex (*v.* Sisam, *Fourteenth Century Prose and Verse*, p. 160) may have misled some. In my opinion it is most probable that John Ball is not indebted for the name to Langland, but that both he and Langland are using a product of folk imagination. I suppose that Langland's use of Piers as a symbol of Christ is his own; but the figure of Piers the honest ploughman may already have been as recognized as that of Tommy Atkins, John Bull, or Father Christmas.

[2] *P. Plowman*, B, xv. 23 et seq.

[3] Ibid. C, iv. 363.

[4] Usk, *Testament of Love*, i. iii (Skeat, *Chaucerian and other Pieces*, p. 18, l. 153; *v.* p. xxvii).

the behaviour of the seven Deadly Sins belongs to a tradition as old as the *Ancren Riwle*; and his allegorical form and pious content were equally familiar.

What is truly exceptional about Langland is the kind, and the degree, of his poetic imagination. His comedy, however good, is not what is most characteristic about him. Sublimity—so rare in Gower, and rarer still in Chaucer—is frequent in *Piers Plowman*. The Harrowing of Hell, so often and so justly praised, is but one instance. There is not much medieval poetry that does not look pale if we set it beside such lines as these:

> Kinde huyrde tho Conscience, and cam out of the planetes
> And sente forth his foreyours, fevers and fluxes—
> Ther was 'Harow!' and 'Help! Here cometh kynde,
> With Deth that is dredful to undo us alle!'
> The Lord that lyuede after lust, tho aloude criede
> After Comfort, a knyght, to come and bere hus baner.
> 'Alarme, alarme!' quath that Lord, 'eche lyf kepe hus owene!'[1]

In a quieter mood, the great vision wherein the poet beholds 'the sea, and the sun, and the sand after' and sees 'man and his make' among the other creatures, is equally distinctive.[2] There is in it a Lucretian largeness which, in that age, no one but Langland attempts. It is far removed from the common, and beautiful, descriptions of nature which we find in medieval poetry—the merry morning and the singing birds; it is almost equally far from the sterner landscapes of *Gawain and the Greene Knight*. It belongs rather to what has been called the 'intellectual imagination'; the unity and vastness were attained by thought, rather than by sense, but they end by being a true image and no mere conception. This power of rendering imaginable what before was only intelligible is nowhere, I think, not even in Dante, better exemplified than in Langland's lines on the Incarnation. They are, so far as I know, perfectly accurate and clear in doctrine; and the result is as con-

[1] *P. Plowman*, C, xxiii, 80 et seq.
[2] Ibid. C, xiv. 135 et seq. I take it that Langland had read Alanus' *De Planctu Naturae*.

crete, as fully incarnate, as if the poet were writing about apples or butter:

Love is the plonte of pees and most preciouse of vertues;
For hevene holde hit ne my3te so hevy hit semede,
Til hit hadde on erthe 3oten hym-selue.
Was never lef upon lynde lyghter ther-after,
As whanne hit hadde of the folde flesch and blode ytake.
Tho was it portatyf and pershaunt as the poynt of a nelde.[1]

Doubtless such heights are rare in Langland, as they are rare in poetry at all; but the man who attains them is a very great poet. He is not, indeed, the greatest poet of his century. He lacks the variety of Chaucer, and Chaucer's fine sense of language: he is confused and monotonous, and hardly makes his poetry into a poem. But he can do some things which Chaucer cannot, and he can rival Chaucer in Chaucer's special excellence of pathos.

II

For many historians of literature, and for all general readers, the great mass of Chaucer's work is simply a background to the *Canterbury Tales*, and the whole output of the fourteenth century is simply a background to Chaucer. Whether such a view is just, or whether it has causes other than the excellence of the *Tales*, need not here be inquired; for us, at any rate, Chaucer is a poet of courtly love, and he ceases to be relevant to our study when he reaches the last and most celebrated of his works. Nor does he stand, for us, in isolation from his century; he stands side by side with Gower and the translators of the *Romance of the Rose* —of whom, he himself was one—and co-operates with them in the work of assimilating the achievements of French poetry, and thus determining the direction of English poetry for nearly two hundred years.

By considering Chaucer in this light we shall lose much; but we shall have the advantage of seeing him as he

[1] Ibid. C, ii. 149 et seq.

appeared to his contemporaries, and to his immediate
successors. When the men of the fourteenth or fifteenth
centuries thought of Chaucer, they did not think first of
the *Canterbury Tales*. Their Chaucer was the Chaucer of
dream and allegory, of love-romance and erotic debate,
of high style and profitable doctrine. To Deschamps, as
every one remembers, he was the 'great translator'—the
gardener by whom a French poet might hope to be trans-
planted—and also the English god of Love.[1] To Gower,
he is the poet of Venus: to Thomas Usk, Love's 'owne
trewe servaunt' and 'the noble philosophical poete'.[2] In
the age that followed the names of Gower and Chaucer
are constantly coupled. Chaucer's comic and realistic style
is imitated by Lydgate in the Prologue to the *Book of
Thebes*, and by an unknown poet in the Prologue to the
Tale of Beryn; but this is a small harvest beside the in-
numerable imitations of his amatory and allegorical poetry.
And while his successors thus show their admiration for
his love poetry, they explicitly praise him as the great
model of style. He is to them much what Waller and
Denham were to the Augustans, the 'firste finder' of the
true way in our language, which before his time was 'rude
and boystous'.[3] Where we see a great comedian and a pro-
found student of human character, they saw a master of
noble sentiment and a source of poetic diction.

It is tempting to say that if Chaucer's friends and fol-
lowers were dunces who treasured the chaff and neglected
the grain, yet this is no reason why we should do likewise.
But the temptation should be resisted. To grow im-
patient with the critical tradition of the earliest lovers of
Chaucer is to exclude ourselves from any understanding
of the later Middle Ages in England; for the literature of

[1] *v.* Deschamps' *Ballade to Chaucer*, lines 11 and 31.

[2] Gower, *Conf. Amantis*, viii, 1st version, 2941; Usk, *Testament of Love*, III.
iv (p. 123 in Skeat's *Chaucerian and other Pieces*).

[3] Hoccleve, *Regement of Princes*, 4978 (cf. ibid. 1973, *Bookes of his ornat endyting
That is to al this land enlumynyng*); Lydgate, *Troy Book*, iii. 4237. 'For he [sc.
Chaucer] oure English gilt with his sawes, Rude and boistous firste be olde dawes
That was ful fer from al perfeccioun Til that he cam.'

the fifteenth and sixteenth centuries is based (naturally enough) not on our reading of Chaucer, but on theirs. And there is something to be said for them.

In the first place, we must beware of condemning them for not working the vein which Chaucer had opened up in the *Canterbury Tales*, lest in so doing we condemn the whole course of English poetry. What they have left undone, their successors have left undone likewise. The *Canterbury Tales* are glorious reading, but they have always been sterile. If the later Middle Ages can offer us only the Prologue to *Thebes* and the Prologue to *Beryn*, we ourselves are not in much better plight. William Morris's discipleship to Chaucer was an illusion. Crabbe and Mr. Masefield are good writers; but they are hardly among the greatest English poets. If Chaucer's *Tales* have had any influence, it is to be sought in our prose rather than in our verse. Our great and characteristic poets—our Spenser, Milton, Wordsworth, and the like—have much more in common with Virgil, or even with *Beowulf*, than with the *Prologue* and the *Pardoners Tale*. Perhaps none of our early poets has so little claim to be called the father of English poetry as the Chaucer of the *Canterbury Tales*.

But even if the first Chaucerians were dunces, it would not be safe to neglect their testimony. The stupidest contemporary, we may depend upon it, knew certain things about Chaucer's poetry which modern scholarship will never know; and doubtless the best of us misunderstand Chaucer in many places where the veriest fool among his audience could not have misunderstood. If they all took Chaucer's love poetry *au grand sérieux*, it is overwhelmingly probable that Chaucer himself did the same; and one of the advantages of keeping the *Canterbury Tales* out of sight, as I have proposed to do, will be that we may thus hope to rid ourselves of a false emphasis which is creeping into the criticism of Chaucer. We have heard a little too much of the 'mocking' Chaucer. Not many will agree with the critic who supposed that the laughter of Troilus in heaven was 'ironical'; but I am afraid that many of us now

read into Chaucer all manner of ironies, slynesses, and archnesses, which are not there, and praise him for his humour where he is really writing with 'ful devout corage'. The lungs of our generation are so very 'tickle o' the sere'.

There is one respect in which the severest critic will admit that the old Chaucerians were right; that is, in their recognition of Chaucer as a great model of poetical style. It is true that the Chaucerian style, imitated ill, and with gross exaggeration of its foreign and polysyllabic elements, may have been one of the sources of the later 'aureate' style, which, along with some beauties, has many vices. But Chaucer is not to blame for this. The history of his influence on the fifteenth century is closely parallel to that of Milton's on the eighteenth; in each we see the work of a great poet partially vulgarized, and hardened into a mannerism, by indiscreet imitation. The original style is to be judged on its own merits; and it is one of the pleasures of studying Chaucer to trace its development. That development is from a style essentially prosaic and yet pretentious, to a style which has since become almost the norm of English poetry. Examples will make all plain:

> To speke of goodnesse: trewly she
> Had as moche debonairte
> As ever had Hester in the bible,
> And more, if more were possible.
> And soth to seyne therwith-al
> She had a wit so general,
> So hool enclyned to alle gode,
> That al hir wit was set, by the rode,
> Withoute malice, upon gladnesse.[1]

This is the old, bad manner. A man could forgive, as mere honest debility, the lumber of expletives—'as *ever* had Hester'—'and more if more were possible'—'by the rode'; what is radically bad is the fussy prolixity, the air of saying so much while so little is said, the pseudo-legal or pseudo-logical pretentiousness. 'To speke of goodnesse', he begins;

[1] *Book of the Duchesse*, 985 et seq.

like a lecturer turning to a new head. 'She had a wit so
general', he continues; and who would not expect that
some real consequence was coming? Such a style makes
the worst of both worlds: it is as heavy as the prose of
instruction, and as empty as an Elizabethan song, while
yet it neither sings nor instructs. It is a style which Lyd-
gate in his worst places may be said to have brought to its
own terrible perfection. To turn from such a passage to
the preludings of the new style is like passing from the
engine-room of a ship to the deck.

> Gladeth, ye foules, of the morwe gray,
> Lo!—Venus risen among yon rowes rede;
> And floures fresshe, honoureth ye this day . . .[1]

> Through Phebus, that was comen hastely
> Within the paleys-yates sturdely
> With torche in honde, of which the streymes brighte
> On Venus chambre knokkeden ful lighte.[2]

> And then at erst hath he
> Al his desyr, and ther-with al mischaunce.[3]

But Chaucer's conversion is gradual, and in the same poem
he can suddenly plunge us back into the old manner at its
very worst—

> The ordre of compleynt requireth skilfully
> That if a wight shal pleyne pitously,
> Ther mot be cause wherfor that men pleyne, &c.[4]

which is sheer nonentity yawning in thirty syllables. Even
in the *Parlement of Foules*, side by side with the calculated
and comic prosiness of the goose, we find the uninten-
tionally and unjustifiably prosaic verbiage of

> Foules of ravyne
> Han chosen first *by pleyn eleccioun*
> The tercelet of the faucon, *to diffyne*
> *Al hir sentence and as him list termyne.*[5]

[1] *Compleynt of Mars*, 1 et seq. [2] Ibid. 81 et seq.
[3] Ibid. 240. [4] Ibid. 155 et seq.
[5] *Parlement of Foules*, 527 et seq.

It seems ungracious to hunt out the faults of a great poet.
But Chaucer's achievement in style cannot be understood,
cannot be praised so sincerely as contemporaries praised it,
until we realize the depth from which he raised himself,
and, at times, raised his disciples also.

The form and sentiment of Chaucer's love poems well
illustrate what I said at the beginning of this chapter
about the living and therefore ever-changing influence of
the *Romance of the Rose*. They are all recognizable descen-
dants of it, but none of them is a poem of the same type.
Nowhere in Chaucer do we find what can be called a
radically allegorical poem. The point is of some impor-
tance; for it is in Chaucer that many readers make their
first acquaintance with allegory, and Chaucer thus becomes
the innocent cause of a deep-seated misunderstanding. By
a radical allegory I mean a story which can be translated
into literal narration, as I translated the first part of the
Romance of the Rose in the preceding chapter, without
confusion, but not without loss. Thus, if there is no story
—if the literal version, when extracted, proves to be a
mere maxim or description, and not the 'imitation of an
action', then the work in question does not pass my test.
If, again, there are passages which cannot be so 'trans-
lated'—episodes for which no *significacio* can be found—
then, again, it fails. Still more if there are passages which
need no translation, being already literal in the original
text, then the original is to that extent unallegorical.
Above all, if we lose nothing by our 'translation', the
original work must be bad. If the story, literally told,
pleases as much as the original, and in the same way, to
what purpose was allegory employed? For the function
of allegory is not to hide but to reveal, and it is properly
used only for that which cannot be said, or so well said, in
literal speech. The inner life, and specially the life of love,
religion, and spiritual adventure, has therefore always been
the field of true allegory; for here there are intangibles
which only allegory can fix and reticences which only
allegory can overcome. The poem of Guillaume de Lorris

is a true allegory of love; but no poem of Chaucer's is. In Chaucer we find the same subject-matter, that of chivalrous love; but the treatment is never truly allegorical. Traces of the allegorical poem survive. Thus we have poems set in the framework of a dream after the manner of Guillaume; but what happens in the dream is not allegorical. Or we have allegory itself used as a framework for something else. We have allegorical persons, each with a brief description, used as a kind of pageantry to decorate a background, in the Renaissance manner; or again we have personifications which have become a mere characteristic of style, a form of poetic diction, after the manner of the eighteenth century. Finally, in his greatest work, we have the courtly conceptions of love, which Chaucer learned from the French allegory, put into action in poetry which is not allegorical at all. Chaucer achieves the literal presentation; but it is Guillaume's allegory which has rendered the achievement possible.

The *Compleynt unto Pite* and the *Compleynt to His Lady* illustrate the use of personification at its lowest level— the most faint and frigid result of the popularity of allegory. Not only do the allegorical figures fail to interact, as in a true allegory; they even fail to be pictorial: they become a mere catalogue:

> And fresshe Beautee, Lust and Iolitee,
> Assured Maner, Youthe, and Honestee,
> Wisdom, Estaat, Dreed, and Governaunce.[1]

—where it is not only the cadence of the last line that reminds us of Lydgate.

In the *Book of the Duchesse* we have the poem framed in a dream, and we have courtly love; but allegory has disappeared. We dream in order to hear a bereaved lover give just such a literal account of his past happiness and present sorrow as he might have given in waking life. The dream is not, however, useless to Chaucer. It casts over his conversation with the lover a certain remoteness, it

[1] *Compleynt unto Pite*, 39 et seq.

transfers the responsibility for what was said from his waking self to the vagaries of dream, and thus renders possible a more intimate picture of his patron's loss than would have been seemly on any other terms. But it would be rash to assume that Chaucer consciously chose it with this in view. The use of the dream for all sorts of purposes which hardly seem to justify it, and even for elegy, appears to have been a device of the French poets,[1] and I think that Chaucer followed it chiefly because he enjoyed it. Machaut had already shown how a poetic dream could be made much more like a dream than Guillaume de Lorris had attempted to make it;[2] and Chaucer, delighted, as any good workman must be delighted, with the task of capturing the most elusive, yet familiar, of experiences, has probably bettered his model. His 'dream psychology' has been described as 'flawless'.[3] Our own concern is naturally more with his psychology of love, for it is in this that Chaucer shows at once his own genius and his faithful discipleship to the *Rose* tradition. In this poem the bereaved lover has passed through all the same phases as the dreamer in the *Roman*: that he has passed also through one more is his tragedy. At first, like the dreamer, he had wandered unattached though in the garden of love,

> And this was longe, and many a year
> Or that myn herte was set o-wher,
> That I did thus and niste why;
> I trowe hit cam me kindely.[4]

He knows well enough, however, who really sits as portress at the garden gate,

> For that tyme youthe, my maistresse
> Governed me *in ydelnesse*.[5]

[1] *v.* C. L. Rosenthal, 'A possible source of Chaucer's Book of the Duchesse', *Mod. Language Notes*, vol. xlviii, 1933.

[2] Cf. Machaut, *Dit dou Vergier*, 1199 et seq., where the waking of the dreamer is convincingly managed: also *Dit dou Lyon*, 279 et seq.

[3] .*v.* J. Livingston Lowes, *Geoffrey Chaucer*, London 1934, pp. 94–9.

[4] *Book of the Duchesse*, 775 et seq.

[5] Ibid. 797 et seq.

When, at length, he falls in love, it is because he has looked
into the well of Narcissus,

> I ne took
> No maner counseyl but at hir look
> And at myn herte: for why hir eyen
> So gladly, I trow, myn herte seyen.[1]

When he first attempts to approach the rose, however, he
is repulsed and driven to lament on the wrong side of the
thorny hedge.[2] In all this Chaucer agrees with the tradi-
tion, but he is not therefore 'conventional' in the bad sense
of the word. How fine and fresh his treatment is may
be judged from the very remarkable fact that though the
poem is a true elegy, yet the abiding impression it leaves
upon us is one of health and happiness. There is no con-
cealment of the loss: the pain rings true in—

> Farwel, swete, y-wis
> And farwel al that ever ther is,[3]

and in the mourner's return upon himself (anticipating
Lycidas) when he calls back his fruitless wish—'And
though, where-to?'[4] But Chaucer's praise of the dead and
his picture of the happiness that has been lost are so
potent that we remember them when everything else in
the poem is forgotten. Successful panegyric is the rarest
of all literary achievements, and Chaucer has compassed
it. I believe in the 'gode faire Whyte', as I have never
believed in Edward King, or Arthur Hallam, or Clough.
I seem to have seen her 'laughe and pley so womanly' and
to have heard 'which a goodly softe speche' she uttered;
and now that she is dead I seem to realize with more
poignancy how 'hir liste so wel to live that dulnesse was
of hir a-drad'.[5] Not because the poem is a bad elegy, but
because it is a good one, the black background of death
is always disappearing behind these iridescent shapes of
satisfied love; and because of these, all its attendant
imagery—the harmony of birds, the sun just rising in the

[1] Ibid. 839 et seq. [2] Ibid. 1236–57.
[3] Ibid. 656. [4] Ibid. 670. [5] Ibid. 948, 850, 919, 879.

'blew, bright, clere' air, the glades starry with flowers that have forgotten winter's poverty and alive with happy animals—all these have a symbolic fitness that is beyond the contract of conscious allegory. If the poem has any faults, apart from its occasional lapses in style and metre, they arise from Chaucer's anxiety to do better than he is yet able. Thus he has the happy idea of trying to show dramatically in his dialogue the impatient self-absorption of grief on the part of the lover, and his demands on the dreamer's close attention. But he does this so clumsily that he sometimes makes the one seem a bore, and the other a fool, thus producing comic effects which are disastrous, and which were certainly not intended.[1]

From the *Compleynt of Mars* I have already quoted lines that illustrate the growth of Chaucer's poetic style; and when we have noticed these, we have, perhaps, given this poem all the attention it deserves. The astronomical allusions are, I confess, too hard for me: the topical allegory is now difficult to recover and hardly worth recovering.[2] The relation of mistress and lover in what was then conceived to be its normal or healthy condition is well described in the lines

> And thus she brydeleth him in hir manere
> With nothing but with scourging of hir chere.[3]

The poem is otherwise remarkable because it contains, agreeably with the example of Jean de Meun, a hint of the opposite point of view. One stanza which is put into the mouth of Mars draws the contrast between Divine and earthly love, apparently to the advantage of the former.[4] But we are now prepared for such losses of confidence at the end, or even in the midst, of an amorous poem.

The *Balade to Rosemounde* is interesting for two reasons.

[1] *Book of the Duchesse*, 749 et seq., 1042 et seq., 1127 et seq.

[2] *v.* Skeat's *Chaucer*, vol. i, pp. 64 et seq., and G. H. Cowling, 'Chaucer's Complaintes of Mars and of Venus', *Review of English Studies*, vol. ii, No. 8, Oct. 1926.

[3] *Compleynt of Mars*, 42. [4] Ibid. 218 et seq.

The first stanza shows Chaucer's style at the point where it approaches most nearly to the aureate style of his successors. The third stanza presents a problem. Is this 'pyk walwed in galauntyne' intended to be comic or not? The modern reader is tempted to reply at once in the affirmative, but I feel no confidence. The conception of the 'mocking' Chaucer must not be so used as to render it impossible for us to say Chaucer ever wrote ill—which is what follows if everything that cannot please as poetry is immediately set down as humour. And what will be very funny if it is meant to be serious, may often be very feeble as a deliberate joke. The pike is a case in point. As serious poetry it is bathos: as jest it is flat. What effect Chaucer intended is just one of those things which, as I conceive, we shall never know, but which Gower or Scogan or John of Gaunt would have known at once and without question.

Passing over the ambitious and soon abandoned *Anelida*, and the exquisite *Merciles Beautee* (where the comic intention of the palinode is not doubtful), I come to the masterpiece among Chaucer's early poems, the *Parlement of Foules*. The occasion and purport of this work have been the subject of a good deal of discussion.[1] The occasion, if discovered, would be but an 'unconcerning thing', a 'matter of fact'. There is, indeed, no necessity to assume any such external stimulus as a royal or noble marriage for the *Parlement*. The species to which the poem belongs —the debate on a hard question of love—is a familiar one. Two of Machaut's poems are *jugements*; and in earlier French poetry—not to mention our own *Owl and Nightingale*—birds had already debated.[2] What concerns us much more is the dispute about the purport or tendency—the emotional and imaginative upshot—of the poem as a whole. It is here that the exaggerated concep-

[1] *v.* Skeat, *Chaucer*, vol. i, p. 75; E. Rickerts, 'A New Interpretation of the Parlement of Foules', *Mod. Philology*, vol. xviii, No. 1, May 1920; D. Patrick, 'The Satire in Chaucer's Parliament', &c. *Philological Quarterly*, vol. ix, Jan. 1930; J. Livingston Lowes, op. cit., pp. 124 et seq.

[2] *v.* Langlois, *Origines et Sources*, chap. ii.

tion of the 'mocking' Chaucer has produced its most disastrous results. Critics have been found to support the view that Chaucer—now herkeneth which a reson I will bring—wrote the *Parlement* in order to ridicule the courtly sentiment of the nobler birds through the criticism of 'the lewednes behinde'. It would almost be better to miss every joke in Chaucer than to believe that the Goose and the Duck are his spokesmen, and the Turtle and the Eagles his butt. I will not insist on my conviction that to believe thus is to attribute to Chaucer a square-headed vulgarity of thought and feeling which would be regrettable in any age and all but impossible to a court poet of the age of Froissart: all may not share that conviction. But surely this view is based on a misunderstanding of the whole procedure of medieval love poetry? The courtly sentiment is, from the outset, an escape, a truancy, alike from vulgar common sense and from the ten commandments. Chrétien, and Guillaume de Lorris, and every one else had always known that Reason was on the other side. Yet the truancy is felt to be, in some flawed and fragile way, a noble thing: the source of every virtue except chastity, the 'flemer' of every vice save one. Hence those strange comings and goings in every medieval love-book. The delicate dream protects itself against moral or common-sensible attack by every kind of concession and tergiversation—by ambiguities in the sense of the word Love, as in Gower's *Prologue*, by a blending of love earthly and love heavenly as in Dante, or (less successfully) in Thomas Usk, by direct palinode, as in Andreas. Above all it protects itself against the laughter of the vulgar—that is, of all of us in certain moods—by allowing laughter and cynicism their place *inside* the poem; as some politicians hold that the only way to make a revolutionary safe is to give him a seat in Parliament. The Duck and Goose have their seats in Chaucer's *Parlement* for the same reason; and for the same reason we have satire on women in Andreas, we have the shameless Vekke in the *Rose*, we have Pandarus in the *Book of Troilus*, and

Dinadan in Malory, and Godfrey Gobelive in Hawes, and the Squire of Dames in the *Faerie Queene*. Even so, long after the original reasons for the tradition have been forgotten, the *homme sensuel moyen* with his fair, large ears appears in the *Midsummer Night's Dream*, and Papageno, the child of nature, parallels and, in a sense, parodies, the loves and trials of Tamino. The appearance of such figures in a poem does not mean that the main tendency of the work is satiric: it almost means the opposite. When the soldiers followed Caesar in his triumph singing *calvum moechum adducimus*, this did not mean that the purpose of a triumph was to ridicule the general. It meant precisely the opposite: the Fescennine licence was included as a concession to Nemesis, and Nemesis needed to be placated just because the ceremony as a whole aimed at the glorification of the general. In the same way, the comic figures in a medieval love poem are a cautionary concession—a libation made to the god of lewd laughter precisely because he is not the god whom we are chiefly serving—a sop to Silenus and Priapus lest they should trouble our lofty hymns to Cupid. When this has been understood (and not till then) we may, indeed, safely admit that Chaucer has sympathy with the Goose and the Duck. So had every knight and dame among his listeners. There would be no need to make a concession to the 'lewd' point of view if it were not present in the minds of all. Chaucer and his audience knew, better than some know now, that human life is not simple. They were able to think of two things at once. They see the common world outside the charmed circle of courtly love; they also have been in that common world and will be there again; and they let it have its say, its 'large golee', for a moment, even amidst their ardours and idealisms.

All this may seem over-subtle. But Chaucer, whatever we may think of him, was not a 'regular fellow', *un vrai businessman*, or a rotarian. He was a scholar, a courtier, and a poet, living in a highly subtle and sophisticated civilization. It is only natural that we, who live in an

industrial age, should find difficulties in reading poetry that was written for a scholastic and aristocratic age. We must proceed with caution, lest our thick, rough fingers tear the delicate threads that we are trying to disentangle.

When these confusions have been removed, every reader who loves poetry may safely be left alone with the *Parlement of Foules*. No such reader will misunderstand the mingling of beauty and comedy in this supremely happy and radiant work—a hearty and realistic comedy, and a beauty without effort or afterthought, like Mozartian music. It is not a radical allegory, by my standard, for it allegorizes no inner action. Its *significacio*, if extracted, would prove to be a state and not a story. Here, as in the *Book of the Duchesse*, the old garden of the *Rose* is used to paint a picture of love itself, of love at rest. If a man will compare the beauties of this garden—the almost imperceptible wind, the darting fish, the rabbits playing in the grass, and the 'ravishing sweetness' of stringed instruments—with any literal portrayal of the same thing, he will find out what allegory was made for. This is the kind of symbolism that never grows old. But suddenly, in the middle of the poem, we come on something else. In this matter I may claim to have made (quite accidentally) an imaginative experiment. When I was last reading the *Parlement*, and came to the description of its various inhabitants, which begins at line 211, I said to myself, 'Now this is very strange. These are not like Chaucer, nor like the Middle Ages at all. They are mere pageant figures put in for decoration.' A moment later, I remembered that I was in that part of the poem which is borrowed from Boccaccio.

This little story, on my bare word, is naturally not offered as a proof of anything; but it may serve to direct the reader's attention to something of importance. Boccaccio's Cupid, Pleasaunce, Beautee, Peace, Priapus, and the rest are Renaissance allegory, not medieval allegory. They are neither, on the one hand, a mere catalogue (like the abstractions in Chaucer's *Compleynts*); nor are they

true incarnations of inner experience, like the characters of the *Romance of the Rose*. They have nothing to do, but each has his little bit of description and his recognizable emblems. They are pure decoration—things to be carved on a mantelpiece, or pulled along the streets in a pageant, 'posed' each in his cart with anchors, scales, and other apparatus. They are pretty enough, but they have given the word 'allegory' a meaning from which it will, perhaps, never recover—with what injustice to certain great poets, it is one purpose of this book to show. And the odd thing is that Chaucer does not seem to be aware of the difference. He is too true a child of the Middle Ages even to resent the alien Renaissance quality in his model. That it is alien to him is proved by his treatment of it, for his omissions and alterations are all in the medieval direction; but he does not reach the point of throwing the Boccaccio over, as he might have done if he had read it with our eyes. In the *Teseide* Boccaccio takes a personified Prayer—readers of Homer will remember that prayers are among the oldest personifications—to the home of Venus. Chaucer goes thither himself. On arriving in the garden, Chaucer follows the Italian closely for two stanzas, because the Italian is here describing what every medieval poet wished to describe—the joyous life of the place.[1] In the next stanza, after two lines on the music heard among the trees, he deserts his model; and where Boccaccio tells us how the Prayer went to and fro admiring the *bell' ornamento*, Chaucer compares the music with the harmonies of heaven, and mentions 'a wind, unnethe hit might be lesse'.[2] He then proceeds to insert a stanza which has no counterpart in the original at all, and in which he explains how 'the air of that place so attempre was', that

> No man may ther wexe seek ne old.[3]

Chaucer is, of course, remembering the garden in Guillaume de Lorris, which 'semed a place espirituel'[4] and

[1] *Parlement*, 183–96, *Teseide*, vii, stanzas 51, 52.
[2] Ibid. 197–203, *Tes.* vii, stanza 53.　　　　[3] Ibid. 204–10
[4] *Roman de la Rose*, 642, English version, 650.

the garden in Jean de Meun where there is no time.[1] But while he thus makes his garden more spiritual, with heavenly music and a dateless present, he makes it more earthly too by the mention of his inaudible breeze; he deepens the poetry every way. There is in Chaucer a far fuller surrender of feeling and imagination to his theme than Boccaccio was prepared to make. Chaucer was working with 'ful devout corage': Boccaccio, for all his epic circumstance, feels in his heart of hearts that all this stuff about gardens and gods of love is 'only poetry'. And so Boccaccio will include a touch of satire and make his Beautee go by *sè riguardando*, and Chaucer will naturally omit this.[2] Only false criticism will suppose that this superior gravity in Chaucer is incompatible with the fact that he is a great comic poet. Dryden went to the root of the matter when he called him a perpetual fountain of good sense. A profound and cheerful sobriety is the foundation alike of Chaucer's humour and of his pathos. There is nothing of the renaissance frivolity in him.

A firm grasp of this contrast between Boccaccio and Chaucer is the best preparation for reading the *Book of Troilus*. For it is possible to misunderstand *Troilus*. His earlier works require historical explanation, and *Troilus* speaks at once to the heart of every reader. His earlier works have French models, and it is from the Italian; and they have little humour, while it has much. Above all, they easily pass as allegory with readers who do not inquire closely, while it is not allegorical at all. All these facts make it fatally easy to regard *Troilus* as Chaucer's first break away from medieval tradition—to interpret it as a 'modern' poem, with much consequent exaggeration of its comic and ironic elements. In reality, the writing of *Troilus* betokens no apostasy from the religion of Cupid and Venus. Chaucer's greatest poem is the consummation, not the abandonment, of his labours as a poet of courtly love. It is a wholly medieval poem. Let us take one by

[1] *Roman de la Rose*, 20010 et seq.
[2] *Parlement*, 225, *Tes.* vii, stanza 56.

one the facts which seem to point to the opposite inter-
pretation. It speaks at once to our hearts, not because it
is less medieval than the *Compleynt of Mars*, but because
it deals with those elements in the medieval consciousness
which survive in our own. Astrology has died, and so have
the court scandals of the fourteenth century; but that
new conception of love which the eleventh century in-
augurated has been a mainspring of imaginative literature
ever since. It is borrowed from an Italian, and not from
a French, source; and the Italian source is, in many
respects, a Renaissance poem; but then Chaucer is careful
to take from his model only what is still medieval, or what
can be medievalized. The effect of all his alterations is to
turn a Renaissance story into a medieval story. Again, the
Book of Troilus is full of humour; but it is medieval
humour, and Pandarus, as I have already suggested, is a
son of Jean de Meun's *Vekke*. Finally, it is literal, not
allegorical; but so is the work of Chrétien de Troyes.
Chaucer's *Troilus* is best understood if we regard it as a
new *Launcelot*—a return to the formula of Chrétien, but
a return which utilizes all that had been done between
Chrétien's day and Chaucer's. The reader will remember
how, in Chrétien, the story of external happenings and
the story (already partly allegorized) of inner experience,
proceeded side by side. We have seen how the two ele-
ments fell apart, and how the second element was treated
independently in the *Romance of the Rose*, and raised to
a higher power. Guillaume de Lorris deepens, diversifies,
and subtilizes the psychology of Chrétien: the heroine of
the *Rose* is truer, more interesting, and far more amiable
than Guinevere, and Chaucer has profited by her. He has
profited so well, and learned to move so freely and deli-
cately among the intricacies of feeling and motive that he
is now in a position to display them without allegory, to
present them in the course of a literal story. He can thus
go back again, though he goes back with new insight,
to the direct method. He can re-combine the elements
which had fallen apart after Chrétien, because Chrétien's

combination had been premature. Allegory has taught him how to dispense with allegory, and the time is now ripe for the great love-story which the Middle Ages have so long been in labour to produce. It is not strange that the product should seem to us more 'modern' than the travail. In every age the achievements smack less of their own age than the struggles, and speak a more universal language. That is how we know that they are achievements. The best is at home everywhere: but it was first at home, and remains always at home, in its own parish of space and time. *Troilus* is 'modern', if you will—'permanent' would be a wiser, and a less arrogant, word—because it is successfully and perfectly medieval.

I have tried to show elsewhere[1] how Chaucer medievalizes *Il Filostrato*. He is more allusive and digressive than his original; like a true 'historiall' poet, contributing to the 'matter of Rome', he tells us more of the story of Troy than Boccaccio would have thought relevant. Boccaccio's standard of relevance is purely artistic: Chaucer's, so far as he has one, is historical or legendary. In style, Chaucer obeys the precepts of medieval rhetoric, as interpreted and modified by his own genius: he inserts *apostrophae, descriptiones, circumlocutiones, exempla*, and the like, which are not found in the original, often with beautiful effect. Finally, he brings the whole story into line with those conceptions of love which he had learned, no doubt, from his own experience and imagination, but which he had learned to see clearly and to express from the *Romance of the Rose*. If anything cannot be so brought into line, he omits it. Passages in which Boccaccio displays contempt for women, are dropped: passages where he shows insufficient 'devotioun' to the god of Love, are heightened. Doctrinal passages on the art and law of love are inserted. The cold cynicism of Boccaccio's *Pandaro* disappears, to make room for the humour of Chaucer's Pandarus. And when the whole tale is finished, where Boccaccio simply

[1] 'What Chaucer really did to Il Filostrato', *Essays and Studies*, vol. xvii, 1932.

draws the ugly moral that had been for him implicit
throughout.

> Giovane donna è mobile, e vogliosa
> È negli amanti molti, e sua bellezza
> Estima più ch'allo specchio, e pomposa
> Ha vanagloria di sua giovinezza,[1]

here Chaucer, never more truly medieval and universal,
writes his 'palinode' and recalls the 'yonge, fresshe folkes'
of his audience from human to Divine love: recalls them
'home', as he significantly says.[2]

I do not propose, in this place, to compare the two
poems in detail. An inspection of them will reveal to any
open-minded reader the nature of the change that Chaucer
is making, and my present concern is rather with the
result—with the historical significance and permanent
value of the *Book of Troilus* as it stands.

To speak of *Troilus* in the language of the stable as being
'by *Il Filostrato* out of *Roman de la Rose*' would seem to
be an undervaluing of Chaucer's creative genius only if
we forgot that Chaucer's mind is the place in which the
breeding was done. Provided that we remember this,
such a description is useful. In the story of Cryseide, and
her uncle, and Troilus, Chaucer, by means of episodes
borrowed from Boccaccio, brings the personified 'acci-
dents' of the *Roman* out of allegory and sets them moving
in a concrete story. The *Roman* begins with a young man,
himself still unattached, wandering in the garden; that
is, in the world of youth and courtly leisure. Chaucer
departs from Boccaccio, whose Troilo has already tried
love,[3] and begins with the unattached Troilus in the
Trojan temple. In both stories the God of Love is follow-
ing the wanderer unseen, and his archery (which has
become a mere colour in the language of Boccaccio) is
adequately dealt with by Chaucer.[4] Shot through with
Love's arrows, the Dreamer continues to advance towards

[1] Boccaccio, *Il Filostrato*, viii, stanza 30.
[2] *Troilus*, v. 1835 et seq. [3] *Filostr.* i, stanza 23.
[4] *R. de la Rose*, 1681 et seq.; *Troilus*, i. 204–66; *Filostr.* 1, 25.

the Rosebud, but finds his way stopped by a thorny hedge: similarly, though Cryseide is so gentle that no creature 'was ever lasse mannish', yet her cheer was somewhat disdainful, and

> she leet falle
> Hir look a lite aside in such manere,
> Ascaunces 'What! may I not stonden here?'[1]

At last, when all the arrows stick fast in him, the Dreamer, hearing Love's voice call to him to surrender, yields and kneels, becomes Love's man and awaits his commandments; Troilus likewise says

> O Lord, now youres is
> My spirit which that oughte youres be.
> You thanke I, Lord, that han me brought to this.[2]

In a later passage (which owes nothing to Boccaccio) he beats his breast and asks the god's forgiveness for his former jibes.[3] The commandments which Love gives to the Dreamer are not reproduced by Chaucer, but we see Troilus actually obeying them, and the noble lines which describe the improvement wrought in his character by his service to Love, do not come from the Italian:

> his maner tho forth ay
> So goodly was and gat him so in grace
> That ech him lovede that loked on his face.[4]

As the Dreamer fears to pass the thorny hedge, so Troilus shrinks from telling Cryseide his love—'she nil to noon suiche wrecche as I be wonne'.[5] The Dreamer and the Trojan prince are both visited (though at different phases of the story) by a friend who tells them that the obstacles they fear are not insurmountable;[6] for as Pandarus plays the part of Vekke in his scenes with Cryseide, so he plays

[1] R. de la Rose, 1798 et seq.; Troilus, i. 281–94.
[2] R. de la Rose, 1899 et seq.; Troilus, i. 422 et seq.
[3] Ibid. 932 et seq.
[4] Ibid. 1072–85. Cf. R. de la Rose, 2077–264: specially 2087–108.
[5] Troilus, i. 770–7 (not in Boccaccio); cf. R. de la Rose, 2779–86.
[6] Troilus, i. 890–903 (not in Boccaccio), 974–80 (much altered); cf. R. de la Rose, 3125 et seq.

that of *Frend* in his scenes with Troilus. And Pandarus'
whole aim during the early stages of the wooing is to
produce in Cryseide the condition which Guillaume de
Lorris calls Bialacoil. Troilus, he tells her, 'nought desireth
but your freendly chere';[1] and the promise he extorts
from her is

> only that ye make him bettre chere
> Than ye han doon er this and more feste.[2]

It is thanks to the labours of Pandarus that Troilus finds
Bialacoil awaiting him outside the *roseir* and soon ready
to lead him in beyond it, into the presence of the Rose;[3]
or, to speak in our own way, that Cryseide consents to
receive and to answer the letter of Troilus and finally to
meet him at the house of Deiphebus. Troilus, like the
Dreamer, is grateful for admission, but not content: rather

> This Troilus gan to desiren more
> Than he dide erst, thurgh hope, and dide his might
> To pressen on.[4]

But this is not, or not yet, Bialacoil's intention. He dare
not let the Dreamer pull the rosebud, he will only give him
a leaf that grew near it; and the Dreamer's request for the
rose itself rouses Daunger from his lair.[5] Cryseide's 'bel
aceuil' or 'bettre chere' is to be equally limited in its
functions: her fair welcome Troilus shall have, but if he
and Pandarus 'in this proces depper go', they need look
for no grace at her hands—not if they both die for it, she
adds: for Daunger is very nearly awake.[6] But Bialacoil, in
the one story as in the other, is in a very difficult position.
Soon he is more than half on the enemy's side, and
explains that he, for his part, would gladly let the Dreamer
kiss the rose.

> Thou shuldest not warned be for me,
> But I dar not for Chastite;
> —Agayn hir dar I not misdo.[7]

[1] *Troilus*, ii. 332. [2] Ibid. 360. [3] *R. de la Rose*, 2787 et seq.
[4] *Troilus*, ii. 1339. [5] *R. de la Rose*, 2876–920. [6] *Troilus*, ii. 484.
[7] *R. de la Rose*, 3396 et seq. (English version, 3667 et seq.).

Cryseide's *bel aceuil* is a similar deserter in intent, re-
strained by Shame and Daunger. When she is urged to
speak to Troilus, as he rides beneath her window, she
reflects that

> Considered al thing, it may not be;
> And why? For *Shame*; and it were eek *to sone*
> *To graunten him so greet a libertee.*
> 'For pleynly hir entente', as seyde she,
> Was 'for to love him unwist, if she mighte'.[1]

In both stories Bialacoil has failed to reckon on the activi-
ties of *Pitè*,[2] and, still more, of Venus herself.

We must guard against the danger of identifying Cry-
seide with Bialacoil—an identification which would be
meaningless, since the one is a woman (that is, a 'rational
substance') and the other is merely 'an accident occurring
in a substance'—a way in which a woman sometimes feels
and behaves. Cryseide's analogue is the nameless heroine
of the *Roman*, not any one of the personifications by whom
that heroine is displayed; and those who have followed
Chaucer most closely in his devout study of her, will best
understand Cryseide. There have always been those who
dislike her; and as more and more women take up the study
of English literature she is likely to find ever less mercy.
Yet none who does not love her and wish 'to excuse hir yet
for routhe' is seeing her as Chaucer meant her to be seen.
That she is not a wanton, still less a calculating wanton,
need hardly be argued. The belief that she saw through
the wiles of Pandarus, and only appeared to be led by
circumstances while in fact she went the way she had
intended from the beginning, can be held only in defiance
of the text. Chaucer goes out of his way to tell us that
'she gan enclyne to lyke him first', and afterwards

> his manhod and his pyne
> Made love with-inne hir for to myne.[3]

1 *Troilus*, ii. 1290 (not in Boccaccio).
2 *R. de la Rose*, 3285 et seq.; *Troilus*, ii. 1281, iii. 918, 1044 et seq.
3 Ibid. ii. 674 (not in Boccaccio).

He tells us that she came to the house of Deiphebus 'al innocent' of Pandarus' machinations; and 'al innocent' she entered the chamber of Troilus;[1] and when she admitted Troilus to hers it was because the story she had been told was so probable and so pitiful, and she was 'at dulcarnon, right at her wittes ende'.[2] If we are determined to criticize her behaviour in the first part of the poem from any standpoint save that of Christian chastity, it would be more rational to say that she is not wanton enough, not calculating enough: that we hear too much of her blushes, her tears, and her simplicities, and not enough of her love: that she is 'cold as ice And yet not chaste; the weeping fool of vice'. This would be an error with some sort of foundation, but it would be an error. In the Cryseide of the first three books Chaucer has painted a touching and beautiful picture of a woman by nature both virtuous and amorous, but above all affectionate; a woman who in a chaste society would certainly have lived a chaste widow. But she lives, nominally, in Troy, really in fourteenth-century England, where love is the greatest of earthly goods and love has nothing to do with marriage. She lives in it alone; her husband is dead, her father a self-banished traitor: her only natural protector, whom she 'wolde han trusted' to have rebuked her without 'mercy ne mesure'[3] at any suspected frailty, is on her lover's side, and working upon her by appeals to her curiosity, her pity and her natural passions, as well as by direct lying and trickery. If, in such circumstances, she yields, she commits no sin against the social code of her age and country: she commits no unpardonable sin against any code I know of—unless, perhaps, against that of the Hindus. By Christian standards, forgivable: by the rules of courtly love, needing no forgiveness: this is all that need be said of Cryseide's act in granting the Rose to Troilus. But her betrayal of him is not so easily dismissed.

Here there is, of course, no question of acquittal.

[1] Ibid. 1562, 1723.
[2] Ibid. iii. 918, 920, 931.
[3] Ibid. ii. 414, 418.

'False Cryseide' she has been ever since the story was first
told, and will be till the end. And her offence is rank. By
the code of courtly love it is unpardonable; in Christian
ethics it is as far below her original unchastity as Brutus
and Iscariot, in Dante's hell, lie lower than Paolo and
Francesca. But we must not misunderstand her sin; we
must not so interpret it as to cast any doubt upon the
sincerity of her first love. At the beginning of that first
love there was some vanity in it: she could not help re-
flecting that she was 'oon the fayreste, out of drede', and
'with sobre chere hir herte lough'. But Coventry Patmore,
who knows about such matters, has told us that a woman
without this kind of vanity is a monster: and, as Chaucer
asks,

> Who is that ne wolde hir glorifye
> To mowen swich a knight don live or dye?[1]

Such venial self-complacencies are, in Cryseide, but the
prelude to a complete abandonment of self. Soon she can
ask with perfect sincerity

> Hadde I him never leef? By God, I wene
> Ye hadde never thing so leef,[2]

and in the happy days of their mutual love 'eche of hem
gan otheres lust obeye'.[3] When the blow falls and she must
leave Troy, she is gone so deep in love that she can feel
Troilus' pain more acutely than her own,

> But how shul *ye* don in this sorwful cas,
> How shal *your* tendre herte this sustene?
> But herte myn, foryet this sorwe and tene
> And me also.[4]

There is dramatic irony in the last sentence, but this must
not be confused with the irony sometimes falsely attributed
to Chaucer in this poem. It is destiny that laughs and
Chaucer is far from laughter as he records it: if any grief
that poetry tells of was ever sincere, then so was Cryseide's

[1] *Troilus*, ii. 746, 1592 et seq. [2] Ibid. iii. 869.
[3] Ibid. 1690. [4] Ibid. iv. 794 (not in Boccaccio).

grief at leaving Troilus. And lest, with the end of the story in our minds, we should make any mistake, Chaucer tells us in so many words

> That al this thing was seyd of good entente,
> And that hir herte trewe was and kinde
> Towardes him, and spak right as she mente.[1]

If it be asked how this sincerity and unselfishness in the earlier Cryseide is compatible with her subsequent treachery, we can reply only by a further consideration of her character. Fortunately Chaucer has so emphasized the ruling passion of his heroine, that we cannot mistake it. It is Fear—fear of loneliness, of old age, of death, of love, and of hostility; of everything, indeed, that can be feared. And from this Fear springs the only positive passion which can be permanent in such a nature; the pitiable longing, more childlike than womanly, for protection, for some strong and stable thing that will hide her away and take the burden from her shoulders. In the very opening of the poem we find her 'wel nigh out of her wit for sorwe and fere',[2] alone in Troy, the widowed daughter of a traitor: a moment later we see her weeping and on her knees before Hector, whom she temporarily identifies with the strong defender of her dreams.[3] Hector, who is the noblest minor character in Chaucer, reassures her; but even in apparent safety, even in her jests, there is a significance,

> For Goddes love, is than the assege aweye?
> I am of Grekes so ferd that I deye.[4]

Her playful and trusting affection for her uncle Pandarus, on which so much of her story hangs, is, of course, but one more form of the desire for protection; and the relation between the two is well depicted in the scene where she begs her uncle not to leave her until they have had a talk about business.[5] Women of her kind have always some male

[1] Ibid. 1416. (Not in Boccaccio, despite Chaucer's 'as writen wel I finde'. The statement that he is taking something from his source, is, in Chaucer, almost a proof that he is inventing.)

[2] Ibid. i. 108.

[3] Ibid. 110.

[4] Ibid. ii. 123.

[5] Ibid. 214-20.

relative to stand between them and the terrifying world
of affairs. And Pandarus thoroughly understands his niece.
Having roused her curiosity by the hint of a secret, almost
in the same breath he begins to allay her fears,

> Beth nought agast, ne quaketh nat. Wher-to?
> Ne chaungeth nat for fere so your hewe.[1]

and yet to allay them wholly is not his purpose; a moment
later he is threatening her with the death of Troilus and of
himself. Few things in the poem are sadder or more illu-
minating than the burst of tears with which Cryseide
receives the news, and the bitter reproach

> What! Is this al the joye and al the feste?[2]

—wrung from her by the realization that the protector of
the moment (i.e. Pandarus) has deserted her, while she is
still unprepared to find the new protector in Troilus, and
can only pray

> O lady myn, Pallas!
> Thou *in this dredful cas* for me purveye.[3]

For dreadful to Cryseide it is. She knows that 'unhappes
fallen thikke alday for love';[4] she believes that her uncle's
life 'lyth in balaunce';[5] she fears scandal, and she fears
love itself, its pains, uncertainties, and anxieties.[6] She fears
the anger of Troilus, as well she may, remembering her
ambiguous position in a besieged city:

> Eek wel wot I my kinges sone is he;—
> Now were I wys me hate to purchace
> Withouten nede, ther I may stonde in grace?[7]

It may be doubted whether Cryseide herself knows pre-
cisely how this form of fear affects her. It may reason-
ably be asked whether there is not in such a woman
(though in no impure sense) a dash of what is now called
masochism—whether the prince's power to hurt, which
is but the other side of his power to defend, is not the

[1] *Troilus*, ii. 302. [2] Ibid. 421. [3] Ibid. 425.
[4] Ibid. 456. [5] Ibid. 466.
[6] Ibid. 461, 462, 771–805. [7] Ibid. 708–14.

most potent of all the spells that are cast upon her. However this may be, Chaucer makes us to understand that Cryseide's first fears of love and of her lover spring from the same root as her later contentment and confidence. The 'tyme swete' of love, for such a nature, could not be more accurately described,

> Wel she felte he was to hir a wal
> Of steel, and shield from every displeasaunce;
> That to ben in his gode governaunce,
> So wys he was, she was no more afered.[1]

No longer afraid, and no longer unloving; even no longer selfish. Such as Cryseide, once given the shelter they desire, repay it with complete devotion; it is not to be believed that she would ever have been faithless to Troilus, ever less than a perfect lover to him, as long as he was present. What cruelty it is, to subject such a woman to the test of absence—and of absence with no assured future of reunion, absence compelled by the terrible outer-world of law and politics and force (which she cannot face), absence amid alien scenes and voices

> With wommen fewe, among the Grekes stronge.[2]

Every one can foresee the result. No one, not even Troilus, is deceived by those desperate speeches in which Cryseide, with pitiful ignorance of her self, attempts to assume the role of comforter and to become a woman of practical ability, resource, and hardihood,[3] who will arrange everything; because, forsooth, some one has told the poor child that women are like that—'wommen ben wyse in short avysement'.[4] Her attempt to be 'feminine' in this sense is short-lived. The very depth of her love for Troilus facilitates her fall, in so far as it produces in her, when once Troilus is left behind, a desolation that heightens to imperative craving her normal hunger for comfort and protection. The old 'wal and shield' is gone: the more she misses it, the more she needs a new one, and hardly has she

[1] Ibid. iii. 479.
[2] Ibid. v. 688.
[3] Ibid. iv. 1261–1309.
[4] Ibid. 936.

ridden out of Troy gate before the new one is at hand: the
first, and the only friendly and protective thing that meets
her in the new, homesick life among those 'Grekes stronge'
who have been a bogey to her for the best part of ten years.
The situation, in itself, is half the battle for Diomede; but
Diomede, in any situation, would have been a dangerous
wooer to Cryseide. Except for fashion's sake, and for a
short time, he is no suppliant like Troilus. With swift,
nonchalant cruelty he hammers into pieces all her hopes of
any comfort save from himself:

> The folk of Troye, as who seyth, alle and some
> In preson been, as ye your-selven see;
> For thennes shal not oon on lyve come
> For al the gold bitwixen sonne and see
> —Trusteth wel and understondeth me![1]

The stinging brutality of that last, trochaic line is a master-
piece: we can almost see the handsome, blackguardly jaw
thrust out. But while all men, and all good women, will
hate Diomede, Cryseide cannot. I spoke just now of mazo-
chism 'in no impure sense'; but the descent to hell is easy,
and those who begin by worshipping power soon worship
evil. Chaucer had better be left to tell in his own words
the effect of Diomede's tactics upon Cryseide,

> Retorning in hir soule ay up and down
> The wordes of *this sodein Diomede*
> His greet estat, and peril of the toun,
> And that she was allone and hadde nede
> Of freendes help.[2]

It must be said for Cryseide that she does not reach this
point without a struggle: a struggle so intense that she can
even propose, or think that she proposes, 'to stele awey
by night'.[3] That Cryseide, for whom even flight with
Troilus was too terrible, will ever really go out alone, by
night, to cross the no man's land between the camp and
Troy, is a psychological impossibility; but the fact that she

[1] *Troilus*, v. 883.
[2] Ibid. 1023 et seq. [3] Ibid. 701–7, 750–3.

can consider such a project bears witness to her desperate
efforts to rise above herself. And yet, such is the cruelty
of her situation, that this very effort must speed Diomede's
suit. As soon as she has resolved, or striven to resolve, upon
it, Diomede becomes, no longer the alternative to Troilus,
but the alternative to flight. The picture of herself in
Diomede's arms gains the all but irresistible attraction
that it blots out the unbearable picture of herself stealing
out past the sentries in the darkness. And so, weeping and
half-unwilling, and self-excusing, and repentant by anti-
cipation before her guilt is consummated, the unhappy
creature becomes the mistress of her Greek lover, grasping
at the last chance of self-respect with the words

<p style="text-align:center">To Diomede algate I wol be trewe.[1]</p>

What follows detracts little further from the character
whose ruin we have been watching. It is disgusting that
she should give Troilus' brooch to Diomede, and her last
letter to Troilus is abominable;[2] but these are involved in
her fall. Such a woman has no resistant virtues that should
delay her complete degradation when once she is united
with a degrading lover. The same pliancy which ennobled
her as the mistress of Troilus, debases her as the mistress
of Diomede. For when she yields, she yields all: she has
given herself to the Greek *tamquam cadaver*, and his vices
are henceforth hers. Her further descent from being
Diomede's mistress to being a common prostitute, and
finally a leprous beggar, as in Henryson, cannot be said to
be improbable.

Such is Chaucer's Cryseide; a tragic figure in the
strictest Aristotelian sense, for she is neither very good
nor execrably wicked. In happier circumstances she would
have been a faithful mistress, or a faithful wife, an affec-
tionate mother, and a kindly neighbour—a happy woman
and a cause of happiness to all about her—caressed and
caressing in her youth, and honoured in her old age. But
there is a flaw in her, and Chaucer has told us what it is;

[1] Ibid. 1071. [2] Ibid. 1040 (the brooch), 1590–1631 (the letter).

'she was the ferfulleste wight that mighte be'.[1] If fate had
so willed, men would have known this flaw only as a
pardonable, perhaps an endearing, weakness; but fate
threw her upon difficulties which convert it into a tragic
fault, and Cryseide is ruined.

Pandarus is exactly the opposite of his niece. He is,
above all, the practical man, the man who 'gets things
done'. It is his delight to manipulate that world of affairs
from which Cryseide longs to be protected. Every one has
met the modern equivalent of Pandarus. When you are
in the hands of such a man you can travel first class through
the length and breadth of England on a third-class ticket;
policemen and gamekeepers will fade away before you,
placated yet unbribed; noble first-floor bedrooms will open
for you in hotels that have sworn they are absolutely full;
and drinks will be forthcoming at hours when the rest of
the world goes thirsty. And all the time, he will be such
good company that he can

> make you so to laugh at his folye
> That you for laughter wenen for to dye.[2]

Yet he is no mere comedian: he can talk with you far into
the night, when the joking and the 'tales of Wade' are
over, of

> many an uncouth glad and deep matere
> As freendes doon, whan they been met y-fere,[3]

and if it is necessary to speak to others on your behalf he
can 'ring hem out a proces lyk a belle'.[4] He is faithful, too,
once you have won him to your side: a discreet, resource-
ful, indefatigable man; and if it is unwise to entrust your
affairs to him, that is largely because his friendship will
lead him to go too far on your behalf. So far the character
is easily recognizable, for it is happily not uncommon in
life, though rare in fiction. What surprises us is to find in
conjunction with this practical efficiency, this merriment,
and this warm, not over-scrupulous, affection, all the

[1] *Troilus*, ii. 450. [2] Ibid. 1168.
[3] Ibid. 151. [4] Ibid. 1615.

characteristics of a fourteenth-century gentleman; for Pandarus is a lover and a doctor in Love's law, a friend according to the old, high code of friendship, and a man of sentiment. The 'ironic' Pandarus is not to be found in the pages of Chaucer, and those who approach him with this preconception will be disappointed as they read how he 'neigh malt for wo and routhe' at the sight of Troilus' love-sickness; how 'the teres braste out of his iyen' while he pleaded with Cryseide; and how, while he heard Troilus pleading for himself in the house of Deiphebus, 'Pandare weep as he to watre wolde'.[1] I do not say that he did not in some way enjoy his frequent tears; but he enjoyed them not as a vulgar scoffer, but as a convinced servant of the god of Love, in whose considered opinion the bliss and pathos of a gravely conducted amour are the finest flower of human life. A moment after he has thus wept we are told that

> Fil Pandarus on knees and up his iyen
> To hevene threw, and held his hondes hye,
> 'Immortal God!' quod he, 'That mayst nought dyen,
> Cupide I mene, of this mayst glorifye. . . .[2]

If Pandarus is consciously playing a part at this moment, he is a buffoon of the most odious sort. The whole scene becomes crude and farcical: fitter for a harlequinade than for a romance. Not to such characters does Chaucer entrust the comic element in a great poem; for nothing that I have said must be taken to contradict the view that Pandarus is comic, or even that he represents, in a way, the negative element of common sense amidst the courtly idealisms. But the thing is far more delicate—the comedy more subtle—than the modern reader expects it to be. Pandarus is perfectly serious when he expounds the commandments of Love—or even general philosophy—to Troilus. And Chaucer is serious, too, to the extent that he seriously wishes to include all this erotic, or other, instruction: what would a love-poem be without 'doctryne'?

[1] Ibid. 1, 582, ii. 326, iii. 115. [2] Ibid. iii. 183.

What is funny—and doubtless intended to be funny—is
the contrast between love's victim and love's doctrinaire;
the contrast which leads poor Troilus to cry

> Freend, though that I stille lye
> I am not deef.[1]

and again

> Lat be thyne olde ensaumples I thee preye.[2]

There is comedy, too, in the prolixity and pedantry of
Pandarus—the ease with which he reels off the letter of
Oenone, the doctrine of contraries, the rules for a lover's
service, and the lover's guide to letter writing[3]—as though
he had learned them by heart, as very probably he had.
Complacent instruction, when the instructor is willing
and the pupil not, is always funny, and specially funny to
Chaucer. But the intention of Pandarus is not comic—
Pandarus would be less comic if it were—and the content
of his instruction is not meant to be ridiculous. Certainly,
Chaucer would be ill pleased if we laughed at such a
stanza as the following:

> What! Shulde he therfor fallen in despeyr,
> Or be recreaunt for his owene tene,
> Or sleen himself, al be his lady fayr?
> Nay, nay: but ever in oon be fresh and grene
> To serve and love his dere hertes quene
> And thenke it is a guerdoun hir to serve
> A thousandfold more than he can deserve.[4]

Here, and in many similar passages, Pandarus combines
with his comic role another function equally necessary in
Chaucer's eyes. Chaucer intends to teach, as well as to
paint, the mystery of courtly love;[5] and the direct doc-
trine which Love himself, or Frend, or the Vekke, would
have spoken in an allegory, is given to Pandarus. It is not
what Pandarus says that is comic, on Chaucer's view: it is

[1] *Troilus*, i. 752. [2] Ibid. 760.
[3] Ibid. 656 et seq., 638 et seq., 890–966; ii. 1023–43.
[4] Ibid. i. 813–19.
[5] Ibid. 20, 246 et seq.; ii. 22–49, 666 et seq.

the importunity, the prolixity, the laughable union of
garrulity and solemnity, with which he says it. And this
is only part and parcel of his general officiousness. If by
a busybody we mean one who is ineffectively busy, then,
to be sure, 'busybody' is the last name we can give to
Pandarus. But he has the fussiness of the busybody; even
where there is nothing to be done, he must needs do
something. When Troilus sinks to his knees at Cryseide's
bedside, Pandarus comes bustling forward with a cushion
for him to kneel on.[1] This is exquisitely funny if we
imagine Pandarus doing it with the anxious and perspiring
gravity of an old-fashioned nurse—'he for a quisshen *ran*';
but it is hardly funny at all, it is merely silly, if he does it
as a joke. Similarly it is not a knowing leer on the part of
Pandarus, it is rather the poor man's despair at finding
he can be busy no longer, his sense of anticlimax, which
should make us laugh when he says plaintively:

> For ought I can espyen
> This light nor I ne serven here of nought.[2]

And yet, of course, there is knowing humour, or raillery,
in the words that immediately follow; and in the banter
with which he greets Cryseide next morning,[3] there is
humour of a familiar avuncular or parental type, some-
what now discredited. It is this side of Pandarus—a real
and important element in his character, no doubt—which
has led, by exaggeration, to misunderstandings of his char-
acter as a whole. The old gentlemen who joked about
christenings at marriages in the nineteenth century were
no doubt being gross and common-sensible at the expense
of the devout emotions felt by the bridal pair. To that
extent they were playing the part of the Goose, or the
Vekke, or Godfrey Gobelive. But you must not suppose
that these same old gentlemen repudiated the monogamic
idealism and romanticism of their period, or would have
been anything but outraged at a serious attack upon it:
to that extent they play the part of the eagle, or Troilus,

[1] *Troilus*, iii. 964. [2] Ibid. 1135. [3] Ibid. 1555 et seq.

or Grand Amour. They eat their cake and have it too,
like rational creatures. If romantic love were not vener-
able, who but a simpleton would poke fun at it? And so
it is with Pandarus. He is inside the magic circle of courtly
love—a devout, even a pedantic and lachrymose, exponent
of it. But he, like every one else, except the lovers them-
selves for short moments in 'the fury of their kindness',
sees also the hard or banal lineaments of the work-day
world showing through the enchanted haze; and that on
two levels. On the first, he sees eye to eye with the merry
old Victorians, and can tease the lovers' pudency or laugh
away their fears; 'she will not bite you', as he says to
Troilus.[1] On the second level, like all Love's medieval
servants, he sees the fatal discrepancy between the com-
mandments of Love and the commandments of God,
and becomes uneasy about the part he is playing. He
begins to protest too much. He has never done it before
—he will never do it again—he had been half in fun at the
beginning—at least he is not being paid for it—it was sheer
pity for Troilus that made him do it. But when all is
said, he cannot resist the obvious conclusion:

> Wo is me that I, that cause al this
> May thenken that she is my nece dere,
> And I hir eem and traytor eke y-fere.[2]

The character of Pandarus cannot be put in a nutshell:
the subtlety of a poet's creation is 'far greater than the
subtlety of discourse'. There is fold within fold to be
disentangled in him, and analysis, with its multiple dis-
tinctions, will never exhaust what imagination has brought
forth with the unity of nature herself. But we must not
substitute a neat satiric abstraction for the richly concrete
human being whom Chaucer has given us.

Troilus, throughout the poem, suffers more than he
acts. He is the shore upon which all these waves break,
and Chaucer has accurately described his theme as being
how Troilus' 'aventures fellen Fro wo to wele and after

[1] *Troilus*, iii. 737. [2] Ibid. 248–73.

out of joye'.[1] This is not to say that the character of
Troilus is ill drawn, but rather that the drawing of Troilus'
character is no principal part of Chaucer's purpose; that
about Troilus there still hangs something of the anonymity
of the Dreamer, the mere 'I', of the allegories. He can be,
to some extent, assumed: he is in one sense unimportant,
because he is, in another, all important. As an embodi-
ment of the medieval ideal of lover and warrior, he stands
second only to Malory's Launcelot: far, I think, above
the Launcelot of Chrétien. We never doubt his valour,
his constancy, or the 'daily beauty' of his life. His humi-
lity, his easy tears, and his unabashed self-pity in adversity[2]
will not be admired in our own age. They must, however,
be confessed to be true (intolerably true in places) to
nature; and, for their admirableness or the reverse, Chau-
cer forewarns us,

> and wordes tho
> That hadden prys, now wonder nyce and straunge
> Us thinketh hem; and yet they spake hem so
> And spedde as wel in Love as men now do.[3]

Of such a character, so easily made happy and so easily
broken, there can be no tragedy in the Greek or in the
modern sense. The end of *Troilus* is the great example in
our literature of pathos pure and unrelieved. All is to
be endured and nothing is to be done. The species of
suffering is one familiar to us all, as the sufferings of Lear
and Oedipus are not. All men have waited with ever-
decreasing hope, day after day, for some one or for some-
thing that does not come, and all would willingly forget
the experience. Chaucer spares us no detail of the pro-
longed and sickening process to despair: every fluctuation
of gnawing hope, every pitiful subterfuge of the flattering
imagination, is held up to our eyes without mercy. The
thing is so painful that perhaps no one without reluctance
reads it twice. In our cowardice we are tempted to call it
sentimental. We turn, for relief, to the titanic passions

[1] Ibid. i. 3. [2] Ibid. v. 260, 616–27. [3] Ibid. ii. 23.

and heroic deaths of tragedy, because they are sublime and remote, and hence endurable. But this, we feel, goes almost beyond the bounds of art; this is treason. Chaucer is letting the cat out of the bag.

The odd thing is that *Troilus and Cryseide*, despite this terrible conclusion, is not a depressing poem. A curious phenomenon is to be noted here, similar to that which was noted in the *Book of the Duchesse*, where Chaucer's picture of the lost happiness proved so potent as almost to override the consideration of its loss. It is the same with *Troilus*. Chaucer has lavished more than half his work, if we regard mere number of lines, upon the happy phase of his story, the first wooing and winning of Cryseide: he has spent almost the whole of the third book upon fruition. But the question is not one of arithmetic. It is the quality of the first three books, and above all of the third, that counts; that book which is in effect a long epithalamium, and which contains, between its soaring invocation to the 'blisful light' of the third heaven and its concluding picture of Troilus at the hunt (sparing the 'smale bestes'), some of the greatest erotic poetry of the world. It is a lesson worth learning, how Chaucer can so triumphantly celebrate the flesh without becoming either delirious like Rossetti or pornographic like Ovid. The secret lies, I think, in his *concreteness*. Lust is more abstract than logic: it seeks (hope triumphing over experience) for some purely sexual, hence purely imaginary, conjunction of an impossible maleness with an impossible femaleness. So Lawrence writhes. But with Chaucer we are rooted in the purifying complexities of the real world. Behind the lovers—who are people, 'rational substances', as well as lovers—lies the whole history of their love, and all its ardours and dejections are kept well before us up to the very moment of consummation: before them lies the morning and the beautiful antiphonal *alba*, remade from old Provençal models, which they will then utter. Outside is the torrential 'smoky' rain which Chaucer does not allow us to forget; and who does not see what an innocent

snugness, as of a children's hiding-place, it draws over the whole scene? Finally, beside them, is Pandarus, so close to them in outlook, and yet so far removed: Pandarus, the go-between, the bridge not only between Troilus and Cryseide but also between the world of romance and the world of comedy.

Thus *Troilus* is what Chaucer meant it to be—a great poem in praise of love. Here also, despite the tragic and comic elements, Chaucer shows himself, as in the *Book of the Duchesse*, the *Parlement*, and the *Canterbury Tales*, our supreme poet of happiness. The poetry which represents peace and joy, desires fulfilled and winter overgone, the poetry born under festal Jove, is of a high and difficult order: if rarity be the test of difficulty, it is the most difficult of all. In it Chaucer has few rivals, and no masters. In the history of love poetry *Troilus* represents the crowning achievement of the old Provençal sentiment in its purity. The loves of Troilus and Cryseide are so nobly conceived that they are divided only by the thinnest partition from the lawful loves of Dorigen and her husband. It seems almost an accident that the third book celebrates adultery instead of marriage. Chaucer has brought the old romance of adultery to the very frontiers of the modern (or should I say the late?) romance of marriage. He does not himself cross the frontier; but we see that his successors will soon inevitably do so. In the centuries that follow, poems of secondary importance in the history of poetry acquire primary importance in the history of humanity, because they pour the sentiment which the Middle Ages had created into moulds that the law of Reason can approve. The conflict between Carbonek and Camelot begins to be reconciled. In this momentous change Chaucer and the graver of his predecessors have borne an important part, for it is they who have refined and deepened the conception of love till it is qualified for such sanction. The wild Provençal vine has begun to bear such good fruit that it is now worth taming.

V. GOWER. THOMAS USK

I

THE artistry of the *Confessio Amantis* has not always been recognized. Gower has told us that his design was to

> go the middel weie
> And wryte a bok betwen the tweie,
> Somewhat of lust, somewhat of lore,[1]

—that is, in more familiar critical language, to combine 'profit with delight'. Delight, for a fourteenth-century poet, almost inevitably meant courtly love, and 'lore' would naturally include both ethical diatribe and information, both wisdom and knowledge. The work is to be moral, yet also encyclopedic, and the whole is somehow or other to be given a courtly and amatory colouring. In other words, Gower is proposing to do for his countrymen what Guillaume de Lorris and Jean de Meun had already done in France, and the impulse behind his work is the same which drove Chaucer to undertake a translation of the *Roman* itself. It is by considering the *Romance of the Rose* as Gower's original that we first become conscious of the technical problem involved in the *Confessio Amantis* and of the success—imperfect indeed but none the less astonishing—with which Gower has solved it. For in his original all was in confusion. The design of the first writer was incomplete; and, in the continuation, the amatory, satiric, pedagogic, and religious interests jostled with one another untidily and unprofitably. If Gower had been nothing more than the mere man of his own age with a talent for verse which he is sometimes supposed to have been, he would have been content to reproduce this confusion; for architectonics were not the strong point of the Middle Ages. But Gower everywhere shows a concern for form and unity which is rare at any time and which, in

[1] *Confessio Amantis*, Prol. 17.

the fourteenth century in England, entitles him to all but the highest praise. He is determined to get in all the diversity of interests which he found in his model, and even to add to them his own new interest of tale-telling; but he is also determined to knit all these together into some semblance of a whole. And he almost succeeds.

The key to Gower's solution of the problem is to be found in Andreas. It will be remembered that Andreas had extended the erotic code so that it almost coincided with the real ethical code. Except on certain obviously untractable points, the virtues of a good lover were indistinguishable from those of a good man; the commandments of the god of Love for the most part were mere repetitions of the commandments of the Church. The special courtly and amatory ethic—whose exposition forms a natural part of a medieval love poem—was not so very 'special' after all. If the exposition of this code, from being an episode, were enlarged to become the framework of the whole book, then you would in effect have something which was always ostensibly (and sometimes actually) a treatment of courtly love, but which could at any moment pass into serious moralizing with no excessive strain on the fabric of the poem. Sloth in love is a vice by Cupid's law; but Sloth *simpliciter* is a vice by the moral law. But it is permissible—nay, it is logical—to precede your account of the *species* 'Sloth in Love' by an account of the *genus* 'Sloth'. Thus at one stroke the main problem is solved, and all the serious 'sentence' can be dovetailed into a poem on love without discrepancy. Furthermore, an old and reasonable homiletic tradition, exemplified in such a work as *Handling Synne*, justified the illustration of the virtues and vices by exemplary tales. Thus Gower can bring in his stories, and another problem is solved. It still remains to find some plausible reason for tabulating the virtues and vices. A sermon, or a confession, naturally suggests itself; and the confession is clearly the better device of the two. A sermon would leave Love, or his representative, the sole speaker: in a

confession the Lover can speak as well, and tell his own
love story. The choice of Genius as the confessor is
obvious, for Genius has already been made a priest by
Alanus and Jean de Meun. The scheme in its essentials
is now complete. It only remains to variegate it with a
few episodes or digressions—in which some 'lore' hitherto
unused can be accommodated—and to add a prologue at
the beginning, and a recantation or palinode at the end.
Both these are to serve as transitions between the world
of courtly love and that ordinary world which the reader
is living in before he begins to read and to which he returns
again when he has finished the book. In the prologue,
therefore, we are introduced to Love, but not yet to
Love in its sexual sense. Gower traces the condition of the
world to the fact that Division has ousted Love.[1] In the
epilogue he effects his withdrawal from the court of love,
as we shall see, in a very charming and original manner.

It will be obvious that the device of the lover's con-
fession is the master-stroke which organizes the whole of
Gower's material. It is, as far as I know, entirely Gower's
own,[2] and he has seldom received full credit for it. It may
be urged that the unity which he gains by it is, after all,
an external and mechanical unity: that the poem shows
rather the cleverness of a Chinese puzzle than the organic
life of a work of art. I might grant both points and yet
claim for Gower a higher place than has usually been ac-
corded him. After being so long the 'moral' Gower, to
be even the 'clever' Gower, would be no bad exchange;
and if we thought him artificial we should at least have
outgrown the misunderstanding which represents him as
naïve. But I am far from granting so much. The unity of
Gower's poem is not dramatic, for he was not writing drama.
But it is not merely external—not merely one of those
abstract excellences which critics can detect while readers

[1] *Confessio Amantis*, Prol. 881 et seq. Empedocles' Love and Strife were known
to the Middle Ages from Aristotle, *Met.* I. iv and elsewhere: cf. Dante, *Inf.*
xii. 42.
[2] The confession in the *Roman de la Rose* taught Gower nothing except,
possibly, the name and office of Genius.

fail to feel them. His work is more *pleasurable* because
he has laboured to arrange it well; that is, to arrange it
plausibly and with variety. It has, in places, merits of an
even higher order; but the beauty of the architectonics
is constant.

One can say almost as much of the style—almost, but
not quite, for Gower can be prosaic. He is our first con-
siderable master of the plain style in poetry, and he has
the qualities and defects that go with such a style. He can
be dull: he can never be strident, affected, or ridiculous.
He stands almost alone in the centuries before our Augustans
in being a poet perfectly well bred. When I read Chaucer
I am tossed to and fro between rich and racy imitations of
the speech of taverns on the one hand, and, on the other,
the heights of a newly discovered poetic diction. Often a
single line such as

> Singest with vois memorial in the shade

seems to contain within itself the germ of the whole
central tradition of high poetical language in England.
It is not so much poetical, as 'English poetry' itself—or
what Englishmen most easily recognize as poetry; and the
diction of the Chaucerians in the century that followed is
a blundering witness to the fact. There is nothing of this
in Gower. In him we seem rather to be listening to the
speech of 'ladies dead'—the language of our ancestors not
as they spoke in the street or in the field, but as they spoke
in polite and easy society. The politeness, to be sure, is
that of the Middle Ages, not of the eighteenth century:
it is noble rather than urbane, of the castle not of the
town: the speech of a society in which courtiers still 'went
upon the carole', and rode hawking along the river banks.
It thus has a sweetness and freshness which we do not find
in the 'polite' style at later periods. Often a couplet in
Gower sounds like a snatch of song—

> The daies gon, the yeres pass,
> The hertes waxen lasse and lasse.[1]

[1] *Confessio Amantis*, ii. 2259.

> Fy on the bagges in the kiste!
> I hadde ynogh, if I hire kiste.[1]

> Who dar do thing which Love ne dar?[2]

These effects are not striven for. They are the natural reward of a direct and genuine language and a metre well controlled. They rise only by the smallest perceptible eminence above the verse that surrounds them, and yet they rise. When something songful is to be said, Gower finds himself singing. Nor is it only in such hints of song that the unexpected powers of his simple diction reveal themselves. Again and again, in gnomic or pathetic passages, he astonishes us by the memorable precision and weight of his lines. As in this—

> The hevene wot what is to done,
> Bot we that duelle under the mone
> Stonde in this world upon a weer.[3]

Or in this complaint to heaven, spoken by a girl over the body of her lover:

> For he your heste hath kept and served,
> And was yong and I bothe also:
> Helas, why do ye with ous so?[4]

Of a country laid waste he writes:

> To se the wilde beste wone
> Wher whilom duelte a mannes sone.[5]

A princess sees her knight going into danger:

> Sche preide, and seide 'O God him spede
> The kniht which hath mi maidenhiede?'[6]

In all these—and there are many more—the poetry is so pure in its own kind that no analysis can resolve it into elements. They seem, to the inexperienced, to be what any one would, and could, have said; yet to have said more would be to have marred all. Sometimes this art of omission becomes more explicit, and even the dullest reader

[1] *Confessio Amantis*, v. 83. [2] Ibid. vi. 1261. [3] Ibid. Prol. 141.
[4] Ibid. iii. 1470. [5] Ibid. iii. 1829. [6] Ibid. v. 3739.

can see what Gower is leaving out. It is almost a rule with him not to tell us what his people thought—and a very good rule for certain kinds of poetry. Alcestis, after her great decision, returns to the husband for whom she is to die:

> Into the chambre and whan sche cam
> Hire housebonde anon sche nam
> In bothe hire armes and him kiste,
> And spak unto him *what hire liste*.[1]

Lucrece lies sleeping as Tarquin approaches her bed, 'but what sche mette, God wot.'[2] Of the princess who has fallen in love with Apollonius we are told that

> *forto thenken al hir fille*
> Sche hield hire ofte times stille
> Withinne her chambre.[3]

Who wishes to know, or to know further, *what* she thought when she had closed the door? So in the story of Rosiphilee we are content to learn that when she came to the forest-clearing,

> It thoghte hir fair, and seide, 'Here
> I wole abide under the schawe',
> And bad hire wommen to withdrawe,
> And ther sche stod *al one stille*
> *To thenke what was in hir wille*.[4]

The silence of the poet enables us to hear the silence of that wood; for we have all done what Rosiphilee was doing.

All plain styles, except the very greatest, raise a troublesome problem for the critic. Are they the result of art or of accident? If we were sure that Gower was himself unconscious of the beauties I have quoted, that he said so little only because he had little in his mind, our enjoyment of his poetry would not be impaired, but our judgement of the poet would be different. The question is perhaps ill put. Not all that is unconscious in art is therefore accidental. If seemingly plain statements rise to poetry, where the subject is imaginary, this shows at least that the writer

[1] Ibid. vii. 1937. [2] Ibid. vii. 4967. [3] Ibid. viii. 861. [4] Ibid. iv. 1292.

had his eye on the object; that he was thinking not of himself but of his tale, and that he saw this latter clearly and profoundly; and such vision is a poetical, as well as a moral, excellence. That Gower always, or often, calculated—as Stevenson might have calculated—those reticences which delight us in his poetry, is very unlikely. But there is evidence that he knew, in his own way, what he was about. The famous line

> The beaute faye upon her face[1]

attained its present form only by successive revisions— revisions which demonstrate, so far as such things can be demonstrated, the working of a fine, and finely self-critical, poetic impulse. The first version—

> The beaute of hire face schon
> Wel bryhtere than the cristall ston,

—is just what would have contented the ordinary 'unconscious' spinner of yarns in rhyme; but it did not content Gower. Nor am I persuaded that the plain style of the *Confessio Amantis* was the only style he could compass. An element of choice came to aid his natural propensity. There are indications that he could have assumed a different manner if he had so desired.

> Ferst to Nature if that I me compleigne,
> Ther finde I hou that every creature
> Som time ayer hath love in his demeine,
> So that the litel wrenne in his mesure
> Hath yit of kinde a love under his cure;
> And I bot on desire, of which I misse:
> And thus, bot I, hath every kinde his blisse.[2]

I do not think it would be easy, at sight, to attribute this to Gower. No doubt, the different quality of these lines is largely due to the different metre; but if Gower can thus adapt himself with equal felicity to the two metres, and use two differing styles, then the style of his octosyllabics is art, not nature—or is nature in such a way as

[1] *Confessio Amantis*, iv. 1321. [2] Ibid. viii. 2224.

not to be the less art. The movement of the stanza I have quoted, and the rhetorical building of the clauses, are as perfect in their own way as anything in Gower's narratives: more perfect than some of Chaucer's stanza work. Elsewhere in the *Confessio*, and this time in octosyllabics, Gower writes successfully in a manner slightly different from his wont. The beautiful *alba* put into the mouth of Cephalus[1] is too long to quote in full; but a few selections will show the heightening that I refer to:

> And thus whan that thi liht is faded
> And Vesper scheweth him alofte,
> And that the nyht is long and softe,
> Under the cloudes derke and stille
> Thanne hath this thing most of his wille . . .
>
> Withdrawgh the banere of thin armes,
> And let thi lyhtes ben unborn,
> And in the signe of Capricorn,
> The hous appropred to Satorne,
> I preie that thou wolt sojorne,
> Where ben the nihtes derke and longe . . .
>
> That thou thi swifte hors restreigne
> Lowe under erthe in Occident,
> That thei towardes Orient
> Be cercle go the longe weie.

The whole passage is interesting, for it seems to have been a sort of holiday for Gower. The whole 'tale of Cephalus' is nothing but Cephalus' *alba*, and is all, apparently, original.

To some, Gower's poetry seems lacking in imagery. The glittering of the golden fleece 'bright and hot' as Jason rows back with it from the dangerous island, or the beards of the three beggars which were white 'as a bush that is besnewed', may serve to show that he is not wholly lacking in this respect. But they are admittedly not typical of Gower. The pictorial imagination finds little to feed on in the *Confessio Amantis*; but often this is because imagina-

[1] Ibid. iv. 3208 et seq.

tion of another kind, and a kind perhaps more proper to narrative, is brought into play. Gower does not dwell on shapes and colours; but this does not mean that he keeps his eyes shut. What he sees is movement, not groups and scenes, but actions and events. In so far as he approximates to the visible arts at all, it is a cinematograph rather than a painting that he suggests. When Elda returns to the room where his wife lies murdered, we are not told what the scene looked like; but we are told that

> stille with a prive lyht
> As he that wolde noght awake
> His wif, he hath his weie take
> Into the chambre.[1]

King Philip, at the wars, is informed in a dream of the love which the god Amos has cast upon the queen. Here again there is no attempt to build up a picture; what is added is significant action and event:

> And tho began the king awake
> And sigheth for his wyves sake
> Wher as he lay . . .[2]

Medea sends her maid to Jason in secret, and the maid returns to tell her how she sped.[3] We can all imagine how Spenser or Keats would have dealt with the blushes and beauty of Medea. Gower, on the other hand, has nothing to say of how she looked. But he knows what she did— 'sche for joie hire maide kiste'—and the whole scene is alive in six words. When Apollonius embarks to take vengeance upon the land of Tharse,[4] the pageantry of the embarkation—which Chaucer or Marlowe might so happily have dwelled on—is passed over with the bald statement that the king took 'a strong pouer'. Then follows the couplet that Chaucer perhaps would scarcely have thought of:

> Up to the sky he caste his lok
> And syh the wind was covenable.

[1] *Confessio Amantis*, ii. 836.　　[2] Ibid. vi. 2153.
[3] Ibid. v. 3800.　　[4] Ibid. viii. 1928.

That first line is businesslike, but it is poetry. It might come from a traveller who wrote thinking of anything rather than literature: it might also come from a ballad: it might come from Homer. Ships and the sea, indeed, are always good in Gower; not only in such full-length passages as the storm (in the story of King Namplus),[1] but also in the two lines that make the vision of Alceone as vivid as a remembered dream of our own ('The tempeste of the blake cloude, The wode see, the wyndes loude'),[2] and even in such a brisk bit of ordinary connecting narrative as

> The wynd was good, the schip was yare,
> Thei tok here leve, and forth thei fare . . .[3]

—which looks easier to do than it is. This excellence in Gower's sea-pieces has led some to suppose that he was familiar with sea travel—as he may well have been; but it is, in fact, only one manifestation of his devotion to movement and progression, his preoccupation with things that change as you watch them. If he is to speak of knight errantry, he imagines his knight 'somtime in Prus, somtime in Rodes', and the heralds cry out,

> Vailant, vailant, lo, *wher he goth*![4]

The appearance of Nebuchadnezzar, transformed into a beast, is passed over; but we hear how he beheld himself and sighed.[5] The death of Ulysses is not described—but 'every man The King! The King! Began to crie'.[6] In the story of the Courtiers and the Fool Gower paints no interior, but the King and the two lords

> stoden be the cheminee
> Togedre spekende alle three,

while the fool sat by the fire 'as he that with his babil pleide'.[7] When Progne receives the fatal sampler on which her sister has woven the story of their common ruin, she faints: but afterwards 'Eft aros and gan to stonde And

[1] Ibid. iii. 981 et seq. [2] Ibid. iv. 3063. [3] Ibid. v. 3299.
[4] Ibid. iv. 1633. [5] Ibid. i. 2992. [6] Ibid. vi. 1711.
[7] Ibid. vii. 3951 et seq.

eft she takth the cloth on honde'.[1] When the Lover
dances with his mistress—

> Me thenkth I touche noght the flor;
> The Ro which renneth on the mor
> Is thanne noght so lyht as I.[2]

If we have few set pictures in Gower it is sometimes
because the poet nods; more often it is because he is wide
awake and on the move.

This ever-present movement is the strength of Gower
as a narrative poet. It is in this capacity alone that he
is usually praised, and deservedly; but in speaking of his
Tales we must beware of some false opinions. They are
not, as has been supposed, the only part of the *Confessio
Amantis* which deserves reading. They are not the sole
end and aim of the poem, for which all the rest exists.
The love allegory in which they are set, the moral, and
even the scientific, digressions by which they are inter-
rupted, are just as interesting to Gower as the tales them-
selves, and often just as capable of giving pleasure to the
reader. To read the tales alone, or the framework alone,
is to miss the variety which the poet has taken pains to
provide for us; and then 'it dulleth ofte a mannes wit'.
Nor is it by any means certain that the Tales, as a whole,
constitute Gower's best work. They contain, perhaps,
his best work; but certainly they also contain his worst;
for story-telling is a function which brings out the defects
as well as the qualities of the plain style. It does not follow
that a tale which avoids all the characteristic faults of
Chaucer—the rhetoric, the digression, and the occasional
rigmarole—is therefore a good tale. Perhaps it makes no
faults because it makes nothing; certainly there are tales
in Gower so concise that they read not like narrative
poems but like metrical arguments for narrative poems
still to be written. Such are the *Sirens*, *Capaneus*, the
Beggars and the Pasties, and many others. Even where
this fault is avoided Gower can still fail. The humorous

[1] *Confessio Amantis*, v. 5789. [2] Ibid. iv. 2785.

tale of *Hercules and Faunus* is flat; and possibly no other narrator ever allowed a story to get under weigh, as Gower does in *Acis and Galatea*, before telling us—and then in a most casual parenthesis—that one of the three characters involved, and already set in action, is a Giant.

Even when we have ruled out the failures—which are, after all, in the minority—it remains, from the very nature of the case, a difficult matter to assess Gower's skill. In this kind of narrative, so spare, so direct, and so concentrated on the event, it is not easy to distinguish the merit of the telling from the intrinsic merit of the story. We sometimes suspect that Gower succeeds only when he has a good story to tell, and fails only when he has a bad one. This does not, of course, detract from his value; but it modifies the critic's judgement. Stories, or stories of this kind, are not matter but already form: Gower's art is rather to liberate the beauty of this form, to find this Hercules in the marble, than to add it. And of his art, so conceived, we may say, I think, that it is nearly always on the same level of achievement—always somewhere beneath the highest, yet very high. What changes is his discretion in selecting the tales. The stories of *Constance* or of the *Education of Achilles* are not worse told than those of *Florent* or *Apollonius*: Gower's error lay in telling them at all. Here, as everywhere in medieval literature, we must try to repress our modern conception of the poet as the sole source of his poetry: we must think more of the intrinsic and impersonal beauty or ugliness of matters, plots, and sentiments which retain their own living continuity as they pass from writer to writer. *Trouvere* as well as *maker* is the name for a poet.

If we are speaking of the art of narration in its strictest sense, this is as far as we can go. But of course there are qualities not strictly narrative, though properly manifested in narrations, which are really characteristic of Gower. The account of Medea's sorceries (*Thus it befell upon a nyht*, &c.)[1] seems to have stuck in the mind of

[1] Ibid. v. 3957 et seq.

every reader from Shakespeare down; and the *beaute faye*[1] upon the faces of the dead in *Rosiphilee*, which I have already referred to, is quoted as often as any line in the whole poem. Both passages have a common quality, and it is this quality, perhaps, which marks Gower's point of maximum differentiation as a poet. For Gower is 'romantic' in the nineteenth-century meaning of the word. He excels in strange adventure, in the remote and the mysterious: like his own Jason, him

> sore alongeth
> To se the strange regiouns
> And knowe the condiciouns
> Of othre marches.[2]

He loves to tell us, in the story of Nectanabus,

> Hou fro the hevene cam a lyht
> Which al hir chambre made lyht.[3]

His strangely vivid, because strangely ambiguous, description of the dream[4] in *Ulysses and Telegonus* is almost among the great dreams of English poetry. And this quality in Gower is worth noticing because it is rare in the Middle Ages. It is indeed what many expect to find in medieval literature, but we do not often find it. It is not in the *Romance of the Rose*; it is not in Chrétien, nor in Langland, nor Alanus; it is rare in the metrical romance; and it is, in places, even painfully lacking in Chaucer. Gower's use of this neglected, yet characteristically English, vein of poetry, entitles him to the praise of independence. No doubt it is possible to overrate—as perhaps the present writer does—'the fairy way of writing'. But it has its own function. In this dim medium the shocking tale of *Tereus* acquires a bittersweet beauty not otherwise attainable. Like all romantics Gower builds a bridge between the conscious and the unconscious mind.

A consideration of the *Confessio Amantis* falls naturally

[1] *Confessio Amantis*, iv. 1321. [2] Ibid. v. 3282.
[3] Ibid. vi. 1981. Spenser (cf. *F.Q.* v. vii. 13 et seq.) possibly owes something to this passage. [4] Ibid. vi. 1519-63.

into three divisions—the tales (of which I shall say no
more), the didactic passages (religious, moral, and scienti-
fic), and the love allegory in which all the rest are set. As
a didactic poet in general Gower does not stand very high.
I do not mean by this that accidents of time have rendered
his alchemy, astronomy, and anthropology uninteresting;
that is the sort of thing which the good reader can over-
come by an effort of historical imagination. I mean that
we find in Gower no such real grasp of conceptual thought,
and no such power of felicitous popularization, as we find
in Jean de Meun. Contemporary readers could, I fancy,
have got all that Gower has to tell them, and got it better,
elsewhere. His euhemeristic account of the pagan deities
descends to mere abuse. The following description of
Apollo, with its flat and grumbling expostulation, seems
to me irresistibly funny:

> He was an hunte upon the helles;
> Ther was in him no vertue elles
> Wherof that enye bokes karpe
> Bot only that he kouthe harpe . . .[1]

Sometimes he falls into mere absurdity, as where he tells
of a certain star:

> Nature on him his name caste
> And clepeth him Botercadent;[2]

yet time, which obliterates so many beauties, creates some,
and if much of Gower's 'doctrine' has lost whatever merits
it once had, parts of it have acquired a quaintness which
only very sophisticated readers can fail to enjoy. It must
be a hard heart that can resist geography of this kind:

> Fro that unto the worldes ende
> Estward, Asie it is algates
> Til that men come unto the gates
> Of Paradis, and there Ho![3]

As a moral and religious poet, on the other hand, Gower
is often excellent, and that not only in explicitly didactic

[1] Ibid. v. 919. [2] Ibid. vii. 1419. [3] Ibid. vii. 568.

passages. His ethics and his piety, now stern, now tender, and now again satiric, colour the whole work, and always for the better. Sometimes they colour it without the author's knowledge. The heathen theogamies which form the pivot of *Mundus and Paulina* and *Nectanabus* are conceived in the light of the Christian sentiment that surrounds the story of the Annunciation:

> Glad was hir innocence tho
> Of suche wordes as sche herde,
> With humble chere and thus answerde . . .[1]

This is not art, for doubtless Gower never dreamed of envisaging the story otherwise; but it makes the story better. At the opposite end of the scale we have those passages where Gower shows, unexpectedly, his powers as a humorist—the picture of the drunkard who wakes next morning (unlike his weak successors in our own day) with the stirring cry, 'O whiche a sorwe it is a man be drinkeles'[2]—or the longer, and even funnier, passage in which the faithless husband gives his wife an account of his day's sport.[3] But neither tenderness nor satire is Gower's highest reach as a moralist. His true quality comes out rather in the ring of such a line as

> The newe schame of sennes olde,[4]

where we are surprised at this element of iron in a poet elsewhere so gentle, so fanciful, and so at peace. Yet we find it again and again. The noble description of the Last Judgement in Book II:[5]

> That dai mai no consail availe,
> The pledour and the plee schal faile;

the lines on the insight of God into 'the privites of mannes herte', which

> speke and sounen His ere
> As thogh thei lowde wyndes were;[6]

[1] *Confessio Amantis*, i. 852. Cf. vi. 1918. [2] Ibid. vi. 55.
[3] Ibid. v. 6123 et seq. [4] Ibid. vii. 5116. [5] Ibid. ii. 3406–30.
[6] Ibid. i. 2807.

and the paragraph in Book V[1] which begins 'Whan Peter, fader of the feith'—all these serve to remind us in how worthy a sense (and how unlike the sneering modern interpretation) he deserves the name of 'moral' Gower. Above all, the vision of the elements sickening with the Fall of Man, in the Prologue, which is not the offspring of platitude and conformity, but of a stern, and passionate, and highly imaginative impulse, rises to a climax that is nothing short of the sublime—

> The Lond, the See, the firmament,
> Thei axen alle jugement
> Ayein the man and make him werre[2]—

—lines which are as far outside Chaucer's range as the *Milleres Tale* is outside Gower's.

But it is time to turn to the Love Allegory itself, which forms the framework of the whole *Confessio*, and which concerns the present study most nearly. I have already protested against the view which treats Gower's allegory as nothing more than the thread on which his stories are strung. Gower comes before us as a poet of courtly love; and I think he makes good his claim. He has not indeed written a love poem comparable to *Troilus* or to the first part of the *Romance of the Rose*. But he has his own contribution to make. In his own way he works side by side with Chaucer to realize what Guillaume de Lorris had rendered possible.

The story is simple. The poet, 'Wisshinge and wepinge al min one', and wandering in the usual May morning, meets Venus and is handed over by her to the priest Genius, to confess himself as regards the code of love. The confessor—availing himself, as I said above, of the parallelism between the erotic and the moral law—goes through six of the seven deadly sins, illustrating them with stories, and eliciting replies from his penitent. He digresses twice on a large scale, once to give an account of the religions of the world, and once to give a general scheme of

[1] Ibid. v. 1904.　　　[2] Ibid. Prol. 959.

education: minor digressions deal with Crusading and
with Great Inventors. The seventh deadly sin, in a moral
work, ought to have been Luxury, which naturally cannot
be a sin against Venus; its place is taken by Incest, agree-
ably with the doctrine of Andreas.

It is at once apparent that we have here no allegorical
conduct of a complex love story, as we had in Guillaume
de Lorris. But this does not mean that we have no
presentation of love; on the contrary, in the replies of the
poet to the questions put by Genius, we have his life as
a lover presented directly and without allegory. These
replies make no inconsiderable part of the poem; for the
historian, even if they had no intrinsic beauty, they would
have great importance; for in them Gower is doing, after
his own fashion, what Chaucer did in *Troilus*—presenting
directly, in terms of tolerably realistic fiction, what he has
learned from the allegory of the *Roman*. Guillaume de
Lorris has taught Gower, as well as Chaucer, to look
within; and now that the lesson has been learned it is
possible to look outwards again. Hence it comes that the
lover's speeches are full of the movement of the actual
world. We see the 'yonge lusty route' of his rivals sur-
rounding his mistress: we see Gower himself bowing and
proffering his service, conducting her to church, playing
with her dog, and riding beside her chariot: we see the
lady at her needlework, or at the dice, dancing, or listening
to the story of Troilus as he reads aloud. We see Gower
postponing the moment of leave-taking, and, after he has
gone, rising at night to look across the housetops to his
lady's window.

To those who find allegory difficult this direct method
will doubtless come as a relief; but it is not only the method
that deserves attention. The content may claim to be a
'just representation of general nature'—and therefore, as
seldom fails, of individual nature too. The experience of
the lover is presented with a truth that convinces us, and
with much mingling of humour and pathos. Gower is
not the slave of any *mere* convention. When he conforms,

his heart goes with it. When he writes a full-length paean
in the praise of Love—

> It makth curteis of the vilein &c[1]—

he repeats what his predecessors have said. But he wishes
to repeat it, and is not the less a poet because he agrees
with the common experience of gentle hearts. His humi-
lity, perhaps, smacks more of that age, and less of all time;
though it may be argued that his cowering like 'the yonge
whelp' at his mistress's rebuke is rather disagreeable than
incredible. But we forgive even this when he pierces to
the spiritual reality behind all this tradition of humility
and thus reminds us of the sense in which courtly love is
no convention and cannot die:

> So lowe couthe I nevere bowe
> To feigne humilite withoute,
> That me ne leste betre loute
> With alle the thoghtes of myn herte.[2]

In the light of such a passage we can understand and
approve the remark of Genius:

> Sche mai be such, that hire o lok
> Is worth thin herte manyfold—[3]

and while we read we feel that this is but reason. We feel
it the more easily because such devoutnesses exist in Gower
side by side with much shrewdness and realism. He ex-
plicitly rejects that part of the code which demands that
a lover should be a knight-errant.

> Forto slen the hethen alle
> I not what good ther mihte falle . . .
> What scholde I winne over the see
> If I mi ladi loste at hom?[4]

He is too good a moralist to have any delusions about
himself. Gower the poet handles Gower the lover with
a somewhat sour, half-smiling, detachment. He knows
that he does not offer his mistress a virgin heart, or body.

[1] *Confessio Amantis*, iv. 2300. [2] Ibid. i. 718.
[3] Ibid. v. 4542. [4] Ibid. iv. 1659, 1664.

He 'has tasted in many a place', with no higher purpose than 'forto drive forth the dai'.[1] He can claim that he has been always sincere towards his lady; but 'as touchende othre' he cannot say so much.[2] The *lover* confesses with naïveté—which assuredly argues no naïveté in the *poet*—that he is spiteful and a backbiter. He cannot help telling the lady discreditable stories about the young men who visit her, and his excuse for doing so is delicious:

> So fayne I wolde that sche wiste.[3]

Equally true, and equally comic, is the confusion of mind which enables him to feel a moral indignation against his rivals who busy themselves

> Al to deceive an innocent.[4]

We have the picture of a very ordinary kind of human heart—'A nothing that would be something if it could'. It is only in his love that the Lover is transfigured. This can cast him into a waking trance, in which

> Me thenkth as thogh I were aslepe
> And that I were in Goddes barm.[5]

This can make him lighter than the roe when his lady dances; and her words are 'as the wyndes of the South'. It is this which has penetrated him so deeply that its eradication, if ever it were eradicated, would leave but little of the man to survive,

> For liche unto the greene tree
> If that men toke his rote aweie
> Richt so myn herte scholde deie.[6]

It is this love which teaches him, though simple, to surprise his Confessor with an answer of unerring and subtle truth. Genius has been speaking of the sin of Ravine, whose counterpart in the code of love is Rape. Is the penitent guilty in this matter? The question is shocking in this context of courtly love. We wonder what indignation,

[1] *Confessio Amantis*, v. 7792.　　[2] Ibid. i. 742.　　[3] Ibid. ii. 491.
[4] Ibid. ii. 465.　　　　[5] Ibid. vi. 226.　　　　[6] Ibid. iv. 2680.

what protests of courtesy and humility, what rhetoric
or what exaggeration will be sufficient to meet it. But
there is that in the poet's heart which enables him to
neglect all these, and to make a reply that exhausts the
subject for good and all. It is in nine short words—

> Certes, fader, no:
> For I mi ladi love so.[1]

If Gower's heroine is but a pale shadow beside Cryseide,
his hero is at times a worthy rival to Troilus.

There is some danger of monotony in the continued
failure of this lover's suit; and though the tales and other
digressions relieve this, the poem would be unsatisfactory
if it left the lover's history where it found it. But Gower
has a story to tell. He has, perhaps, no very striking
beginning; but he has a middle and an end—one of the
best ends, indeed, in medieval poetry. For the *Confessio
Amantis* tells the story of the death of love. The lines
about the green tree which must die without its root
are beautiful in themselves; but they gain incalculably
when we discover that the green tree actually is to lose its
root, and that this indeed is the primary subject of the
poem. At the beginning we may suspect that the ill
success of the lover is merely conventional, that the
'cruelty' of the lady serves only to delay a happy ending.
But even from the first there are indications that this is
not what Gower intends to do. The words of Venus, at
her first appearing, strike cold:

> With that hir lok on me sche caste,
> And seide, 'In aunter if thou live!
> Mi will is ferst that thou be shrive'.[2]

Long afterwards we learn the reason. This lover is sepa-
rated by a fatal barrier from the 'yonge lusti route' of his
rivals. He is old. The *Confessio Amantis*, written by an
old poet, in failing health, appropriately tells the story of
an old man's unsuccessful love for a young girl. It is a
subject that lends itself with equal ease to a rather brutal

[1] Ibid. v. 5532. [2] Ibid. i. 188.

kind of comedy or a sentimental kind of tragedy: finer and truer than either of these is Gower's conception in which the aged lover at last reconciles himself to the reality of the situation and wakes from his long illusion, 'in calm of mind, all passion spent'. The handling of this quiet close is so beautiful, and the thing itself so wisely and beautifully imagined that it constitutes Gower's highest claim as a poet; and that not only for its content, but for its artistry.

It is worth our while here to pause and consider Gower's ending simply as the solution of a technical problem. I have tried to show how the very nature of courtly love demanded that the perfect love poem should end with a recantation. The claims of the objective moral law—of *Resoun* as the Middle Ages said—must, in the end, be faced. Hence the last Book of Andreas, and the conclusion of *Troilus and Cryseide*. Gower, as well as another, is faced with this necessity. For him, as for Chaucer, the love which he celebrates is a sin, and in the lover *Will* has usurped dominion over *Resoun*.[1] Gower is not enough of a philosopher to achieve, like Dante, or even to attempt, like Alanus, any reconciliation between the claims of his two worlds: but he is much too careful and sincere an artist to be content with some formal palinode which would stultify the whole of the rest of his poem. He solves the problem by keeping his eye on the object. He finds in his own experience—the experience of an old man —how Life itself manages the necessary palinode; and then manages his in the same way. It is Old Age which draws the sting of love, and his poem describes the process of this disappointing mercy. Venus promises the lover that he will find peace

> Noght al per chance as ye it wolden,
> Bot so as ye be reson scholden.[2]

—lines which describe, perhaps unconsciously, the very nature of life's discipline in this, as in a thousand other matters, and which might even express the promise kept

[1] *Confessio Amantis*, viii. 2135. [2] Ibid. viii. 2369.

by Venus to successful lovers. This is the deepest note in
Gower; but though it is heard distinctly only at the end,
its influence is over the whole poem. For when once he
has hit upon the theme 'Love cured by Age', he has no
more need for the clumsy device of a separate palinode:
the whole story becomes a palinode, and yet remains a love
story—a pathetic, yet not dismaying, picture of Passion at
war with Time, while more than half aware that Reason
sides with Time against it. It is this latter, this half-
awareness, that saves the *Confessio Amantis* from the
spiritual shallowness of a mere lament over the vanished
pleasures of youth. It also explains certain places in the
poem which are commonly misunderstood. Critics smile
when Genius, priest of Venus, denounces Venus herself as
one of the false deities; and if we insist on the original
significance of Genius (the god of reproduction) there may
be some absurdity. But it is not quite the kind of absurdity
that we are tempted to suppose. Gower has not blundered
into it by an oversight. He knows very well what he is
doing, and goes out of his way to underline what we con-
sider the inconsistency. Genius himself is well aware of it.
He is forced against his will to pass sentence on the very
powers that he serves. His penitent presses the question
on him, demanding

> The godd and the goddesse of love
> *Of whom ye nothing hier above*
> *Have told*, ne spoken of her fare,
> That ye me wolden now declare
> Hou thei ferst comen to that name,

and the Priest replies

> Mi sone, I have it left for schame.[1]

He would have kept silence if he could: but if you press
him, he must confess that the whole world which he
represents, Venus and Cupid and the court of Love, are
but idle dreams and feigned consecrations of human in-
firmities. In all this there is some clumsiness: but there is

[1] Ibid. v. 1374–83.

also something very far from absurdity. Genius here stands
for Love—for that whole complex in the lover's mind
which he calls his 'love', and of which he has made his
deity and his father confessor: and in these lines we have
the poetic history of that strange moment—familiar in the
history of other passions as well as of love—wherein a man,
laying his ear close to his own heart, first hears the master
passion itself there speaking with a doubtful voice, and
presently hinting that it knows (the conscious will shouting
it down in vain)—that it knows itself to be all other than
the tongue claims for it—that its foundations are crumb-
ling—that its superstructure is but a tissue of illusions and
decaying habits, soon to dissolve and leave us face to face
with inner emptiness. In the curious tergiversations of
Genius we see love itself betraying the Lover, though for
a long time yet he cannot—lest his Green Tree lose its
root—cease, in some sense, to love. I do not say that all
this was present in Gower's mind in the same conceptual
form which I have been compelled to give it. But some
such significance is implicit in these lines, and becomes
almost explicit in the eighth Book. By then the game is
almost played out. Genius has ceased to speak for the
Love-deities who were originally his patrons. He is simply
the lover's deepest 'heart', telling him bitter truths, now
no longer avoidable; and the change is marked by the
words,

> Mi sone, unto the trouthe wende
> Now wol I for the love of thee,
> And lete all other trufles be,[1]

and the passage ends with the grave lines

> For I can do to thee nomore
> Bot teche thee the rihte weie:
> Now ches if thou wolt live or deie.[2]

It is difficult to speak of what follows without seeming
to over-praise a poet so neglected, and in some respects
so negligible, as Gower. We have here one of those rare

[1] *Confessio Amantis*, viii. 2060. [2] Ibid. viii. 2146.

passages in which medieval allegory rises to myth, in
which the symbols, though fashioned to represent mere
single concepts, take on new life and represent rather the
principles—not otherwise accessible--which unite whole
classes of concepts. All is shot through with meanings
which the author may never have been aware of; and, on
this level, it does not matter whether he was or not. The
two-edged promise of Venus I have already quoted. Is
this an allegorical presentation of the death of love—or of
love only? Or is it the voice of Life itself? The answer
is that it is both: for doubtless it is a rule in poetry that if
you do your own work well, you will find you have done
also work you never dreamed of. And so with all the other
elements in Gower's closing scene; the deadly cold that
quenches the lover's heart, the companies of singing
Youth and singing Age whom he sees in his trance, the
figure of Cupid as he stoops over his body to pull out the
long-embedded dart, the ointment 'mor cold than eny
keie' with which the wound is healed, and the beads, given
him by Venus, which bear the inscription *Por reposer*. All
these images tell the story of this particular lover, and this
death of love, to admiration; but it is of death in many
other senses that our minds are full while we read, and we
rise from the book, as the Lover rose from his trance,
'thenkende thoghtes fele'. But not of death as evil;
rather of death as new life, with a clarity which this con-
ception rarely attains in profane writings. 'Foryet it thou,
and so wol I', says Genius when all the ritual has been
undergone; and Venus bids the poet 'go where vertu moral
duelleth'. The words strike ghost-like on some modern
ears. But no one can miss the heartfelt peace of the line—
so simple in itself, so perfect in its context—

> Homward a softe pas I went.

If Gower had known to stop here he would have made an
ending worthy to stand beside that of the *Iliad* or of
Samson Agonistes.

Unfortunately he did not. He adds a long and

unsuccessful coda; and I am half glad to close on a note
of censure, lest the beauties I have described should carry
our critical judgement too far captive. Gower has risen
to great poetry, but he is not a great poet. The restraint
which is visible in single lines and short passages innumer-
able deserts him in the conduct of the poem as a whole.
He says too much, not at this point or that, but too much
simpliciter. Often the plain style sinks to prose. He has
told, along with his good stories, many bad ones. But he
has merits which render all his faults forgivable. Inferior
to Chaucer in the range, and sometimes (not always) in the
power, of his genius, he is almost Chaucer's equal as a
craftsman. In the content of his work it is interesting to
notice that he is profoundly English. His romanticism,
and his choice of the theme of Time and Age—both these
look back to the Anglo-Saxons and forward to the nine-
teenth century. Yet his form is French. The heart is
insular and romantic, the head cool and continental: it is a
good combination.

II

In addition to the poetry of Chaucer and Gower, the
fourteenth century has left us one other work in the same
tradition—the *Testament of Love* by Thomas Usk. The
comparative mediocrity of Usk's talent, and the political
or biographical problems to which the *Testament* gives rise,
have somewhat obscured its importance in the history of
literature. This importance depends upon its form; for
the *Testament of Love* is written in prose. The medium
is unusual for most subjects[1] in Chaucer's time, and for the
erotic allegory at all times; and Usk deserves the praise of
originality for attempting it. Certainly the use of prose
for matter the reverse of utilitarian marks a phase in the
coming of age of our language. The medium long conse-
crated to official or homiletic uses is beginning to invade

[1] The great exception is devotional literature, on which see R. W. Chambers,
On the Continuity of English Prose, Oxford University Press, 1932.

new fields. Usk is trying to write prose which shall have wings like verse—coloured and tunable prose—*Kunstprosa*, in a word. He thinks that English may be taught to do what Latin has done in the hands of Alanus; and he deserves from posterity more sympathy and indulgence than he has usually received. That his results should be more interesting than beautiful is only what we should expect. But sometimes he succeeds; and many of his failures must be laid at the door of Chaucer's *Boethius*— a radically vicious model which Usk excusably followed because it had, in his time, no rivals.

The *Testament* takes the form of a conversation, held in prison, between the author and a lady who personifies Love. It is closely modelled on the conversation—which was also held in prison—between Boethius and Philosophy, not only in its general conception but in the detail of its arguments. In style it is indebted to Chaucer's translation of Boethius, and indebted so deeply that Dr. Skeat doubted whether Usk had ever read the original Latin.[1] It is questionable whether we can draw any such conclusion from the fact that he chose to follow—as who would not?— —the only specimen of high rhetorical prose which the vernacular afforded him; but the influence of Chaucer, and not only of Chaucer's prose, is certainly very obvious throughout the *Testament*. Usk repays his debt in the third book by the eulogy of Chaucer which I have already quoted.[2] The substance of the *Testament* has baffled many readers.[3] In the earlier chapters it deals, or seems to deal, with the author's love for a certain Margaryte. Love encourages Usk in his 'service' and warns and instructs him in the manner that is now familiar. It is true that Margaryte sometimes ceases to be a woman and becomes a

[1] See Skeat, *Chaucer*, vol. vii, *Chaucerian and other Pieces*, p. xxv.

[2] *v. supra*, p. 162.

[3] See H. Bradley, *Dictionary of National Biography*, s.v. Usk; Skeat, op. cit.; Tatlock, *Development and Chronology of Chaucer's Works*, Chaucer Society, Series II. xxxvii, pp. 20 *et seq.*; Ramona Bressie, 'The Date of Thomas Usk's Testament of Love', *Modern Philology*, vol. xxvi, no. 1. (The case for the influence of Higden is here given.)

pearl;[1] but this will confuse no reader who has understood the *Romance of the Rose*. As we proceed, however, we find that we are concerned less with Margarite than with a certain 'blisse' for which all are seeking by 'kyndly intencion'[2] and which is called the 'knot in the hert';[3] and this bliss or knot turns out to have all the characters of Boethius' *bonum*. It is plain that we have slid over from profane to sacred love, and from the enjoyment of a mistress to the bliss of heaven.

The author himself attempts to explain his allegory in the last paragraph of the book, but the explanation is not very easy to follow. I will quote his words in full:

> 'Also I praye, that every man parfitly mowe knowe thorow what intencion of herte this tretys have I drawe. How was it, that sightful manna in deserte to children of Israel was spiritual meate? Bodily also it was, for mennes bodies it norissheth; and yet never the later Christ it signifyed. Right so a jewel betokeneth a gemme, and that is a stone vertuous or els a perle. Margarite, a woman, betokeneth grace, lerning, or wisdom of god, or els holy church.'[4]

And in a previous passage he has told us that his 'perle' signifies 'Philosophie' with her three species, that is natural and moral and reasonable.[5] It was from these passages that Dr. Skeat concluded that Margarite 'never means a live woman, nor represents even an imaginary object of natural human affection'; and he interpreted the words 'Margarite, a woman', as meaning 'Margarite, a woman's name'.[6] One of the distinctions here introduced we may dismiss at once: whether the mistress in a book of love be 'real' in the sense of being historical, is a question that can seldom be answered and ought never to be asked. I willingly obey Usk's own request; 'for goddes love, no man wonder why or how this question come to my mynde.'[7] But it matters very much whether Margarite is to be

[1] *Testament of Love*, I. iii, II. xii; Skeat, op. cit., pp. 16, 92.
[2] Ibid. II. iv; Skeat, p. 58.
[3] Ibid. II. iv, v; Skeat, p. 61.
[4] Ibid. III. ix; Skeat, p. 145.
[5] Ibid. III. i; Skeat, p. 103.
[6] Skeat, pp. xxviii et seq.
[7] *Testament*, III. ix; Skeat, p. 144.

imagined as a woman or not. For my own part, I cannot agree with Dr. Skeat's interpretation. I do not see how the words 'Margarite, a woman' can mean 'Margarite, a woman's name'. I think it more agreeable to the nature of the English language, to interpret them 'Margarite, though a woman', or 'Margarite, besides being a woman': and we shall find that this is more agreeable to the context too. In the passage quoted, I must confess that I do not quite understand the sentence beginning 'Right so a jewel', but the rest seems plain enough. The manna had a spiritual *significacio*, but 'bodily also it was'; it did not cease to be food by becoming a symbol of Christ. In the same way, Margaret does not cease to be a woman by becoming a symbol of grace. On the contrary, 'Margarite, a woman, betokeneth grace'. The conception is not, perhaps, entirely easy to the modern reader; but I do not think any contemporary of Usk's would have found a moment's difficulty in it. When you accepted the exodus of Israel from Egypt as a type of the soul's escape from sin, you did not on that account abolish the exodus as a historical event. Usk treats courtly love as a symbol of divine love; but, for that reason, he does not cease to treat courtly love. It is a mischievous error to suppose that in an allegory the author is 'really' talking about the thing symbolized, and not at all about the thing that symbolizes; the very essence of the art is to talk about both. And for this particular conjunction, of divine and sexual love, Usk has precedent in the two gardens of Jean de Meun, in the Beatrice of the *Divine Comedy*, and in the *Song of Songs*. A modern may profitably study the same thing in the poetry of Coventry Patmore.

We must, therefore, expect to find in the *Testament* a double ambiguity. On the one hand, Margarite will be sometimes a mortal woman, and at other times the Church or Philosophy. On the other hand, the lady Love will be now Venus from the courts of Love, now Divine Love. And this is just what we do find. Thus Margarite is a woman when her lover is sad 'to think on thing that may

not, at my wil, in armes me hente':[1] she is the church when 'bothe professe and regular arn obediencer and bounden to this Margarite-perle'.[2] When Love says, 'Poore clerkes, for witte of schoole, I sette in churches, and made such persones to preche',[3] she speaks in her divine character; but she is courtly love when she says 'When any of my servauntes ben alone in solitary places, I have ... taught hem to make songes of playnte and of blisse, and to endyten letters of rhethorike in queynt understondinges and to bethinke hem in what wyse they might best their ladies in good service plese'.[4] When she warns the lover not to offend his Margarite 'in asking of thinges that strecchen into shame', and goes on to repeat Pandarus' advice against 'queynt' words which will arouse suspicion,[5] we are wholly in the court of Love. But she is Divine Love in the following:

'O, quod she, there is a melodye in heven, whiche clerkes clepen Armony ... it is written by grete clerkes and wyse, that in erthly thinges lightly by studye and by travayle the knowinge may be geten: but of such hevenly melody, mokel travayle wol bringe out in knowing right litel. Swetenesse of this paradyse hath you ravisshed; it semeth ye slepten, rested from al other diseses: so kyndely is your herte therein y-grounded.'[6]

But in the very next sentence she continues, 'Blisse of two hertes in ful love knitte, may not aright ben imagined', which is equivocal. Sometimes the author brings both the roles of Love together as if there were no distinction at all;

'Hast thou not rad how kinde I was to Paris, Priamus sone of Troy? How Jason me falsed for al his false behest? How Cesars swinke, I lefte it for no tene til he was troned in my blisse for his service? What! quod she, Most of al, maked I not a loveday bytwene God and mankynde, and chees a mayde to be nompere, to putte the quarel at ende?'[7]

[1] *Testament*, I. i; Skeat, p. 5. [2] Ibid. III. i; Skeat, p. 105.
[3] Ibid. II. ii; Skeat, p. 50. [4] Ibid. I. ii; Skeat, p. 12.
[5] Ibid. III. vii; Skeat, p. 134. [6] Ibid. II. ix; Skeat, p. 78.
[7] Ibid. I. ii; Skeat, p. 11. The closing words of this quotation would seem to be fatal to the theory (*v.* Ramona Bressie, op. cit.) that Margaret has a purely political significance. (I accept Skeat's emendation *Cesars swink*.)

It is this coming and going between the natural and the allegorical senses of his 'love' that makes Usk so profoundly interesting to the historian of sentiment. Immeasurably below Dante, and even below Alanus, as an artist, he yet falls into line with them in his attempt at integration: he is not content with that water-tight division of human desires which satisfied Andreas.

Of love in the earthly sense he has written, in places, well enough to convince us that he uses this tradition by right and has not merely adopted it as a means of gilding the pill. When he is first shown the Margarite-perle in the island of Venus he says simply, 'and with that I held my pees a greet while'. In praise of women he writes thus:

> 'For goodnesse, of mans propre body were they maked, after the sawes of the bible, rehersing goddes wordes in this wyse, It is good to mankynde that we make to him an helper. . . . Lo! in paradyse for your helpe was this tree graffed, out of whiche al linage of man discendeth. If a man be noble frute, of noble frute it is sprongen: the blisse of paradyse, to mennes sory hertes, yet in this tree abydeth.'[1]

Human love means to him, essentially, the marriage of true minds: and he is more aware of the mystery in this, less apt to take it for granted, than many medieval writers. It is 'a thing enclosed under secretnesse of privyte, why twey persons entremellen hertes after a sight'.[2] And again:

> 'What! Trowest thou every ideot wot the meninge and the privy entent of these thinges? They wene, forsothe, that suche accord may not be but the rose of maydenhede be plucked. Do way, do way; they knowe nothing of this. For consent of two hertes alone maketh the fasteninge of the knotte; neither lawe of kynde ne mannes lawe determineth, neither the age ne the qualite of persones, but only accord bitwene thilke twaye.'[3]

Every one is familiar with the paradox of the chivalrous

[1] Ibid. II. iii; Skeat, p. 56. [2] Ibid. I. v; Skeat, p. 21.
[3] Ibid. I. ix; Skeat, pp. 40, 41.

ideal as Sir Ector expressed it over the body of Launcelot:
the meekness in hall and the sternness in battle.[1] Usk's
treatment of the same theme uses a more conscious rhetoric
than Malory's, but is not unworthy to be set beside it.
Love's servants are

> 'Lyons in the felde and lambes in chambre: egles at assaute
> and maydens in halle: foxes in counsayle, stille in their dedes; and
> their protection is graunted, redy to ben a bridge; and their baner
> is arered, like wolves in the felde.'[2]

The structure of the paragraph I have just quoted is
clearly that of a deliberate artist. The first three sentences
are antitheses, each with four stresses, and all in falling
rhythm. The last two make up a single antithesis between
them, and are both in rising rhythm, and almost exactly
balanced to the ear. It is at once plain that we are dealing
with an example of *Kunstprosa*, and it is perhaps the style
that is the most important thing in the *Testament*. I have
already suggested that Usk's place in the history of our
prose has been obscured by the dullness of his matter: for
dull his matter mostly is. The good things which I have
quoted occur fairly often—it would have been easy to
quote more—but they do not occur often enough. The
greater part of the book is filled with unoriginal philoso-
phical argument. It is not indeed, inevitable that
borrowed argument should be dull: when we have a good
popularizer, such as Jean de Meun, he may add some
felicity of expression or illustration which sets the old
truth in a new light; at the very least, he can improve on
his original in clarity. But Usk remains, even when we
have made every allowance for a corrupt text, a clumsy
and sometimes an unintelligible dialectician. All that he
has to say can be found, much better, elsewhere. But his
style deserves consideration.

The predominant influence is, of course, that of
Chaucer's *Boethius*. I do not know whether the distur-
bances of natural English word-order in Usk are all to be

[1] Malory, XXI. xiii. [2] *Testament*, I. v; Skeat, p. 24.

traced thither, or whether, in Chaucer, they are all to be traced to the influence of the original Latin. It is possible that both Chaucer and Usk believed such inversions to be a beauty.[1] Whether, indeed, Chaucer is Usk's only teacher, whether he was not also influenced by Alanus and other foreign models,[2] is a problem that could only be solved by a very detailed study of all the relevant texts. I abandon it to those whose primary subject is style. My only concern is with the result, the actual quality of Usk's writing. There is much in it to disgust a modern reader. The word-order is unnatural, the sentences are too full, and the mechanism by which the effects are obtained is too visible. Sometimes we recognize a far-off anticipation of *Euphues*. 'Made not mekenesse so lowe the hye heven?' asks Love.[3] And again, 'Fyr and if he yeve non hete, for fyre is not demed. The sonne, but he shyne, for sonne is not accompted. Water, but it wete, the name shall ben chaunged. Vertue, but it werche, of goodnesse doth it fayle.'[4] And perhaps the following simile has some likeness to Lyly's dramatic style:

> 'As the water of Siloe, whiche evermore floweth with stilnesse and privy noyse til it come nighe the brinke, and than ginneth it so out of measure to bolne with novelleries of chaunging stormes, that in course of every renning it is in pointe to spille al his circuit of bankes.'[5]

But these things are not, after all, the essence of Usk's style. The really surprising thing about him is the extent to which he remains vigorous even in his fetters. There is a homely, and English, and even a manly quality which struggles through, and sometimes avails itself of, the rhetoric. He follows (unconsciously) Aelfred's excellent precedent of using native examples side by side with those

[1] Cf. Geoffroi de Vinsauf, *Nova Poetria*, 758: 'Noli semper concedere verbo In proprio residere loco; residentia talis Dedecus est ipsi verbo.'

[2] Cf. *Testament, Prologue* (Skeat, p. 1): 'In Latin and French hath many soverayne wittes had greet delyt', &c.

[3] Ibid. II. xii; Skeat, p. 93. [4] Ibid. II. xiii; Skeat, p. 98.

[5] Ibid. II. xiv; Skeat, p. 99. (Accepting Skeat's emendation *bankes*.)

he borrows from Boethius. Thus we are told that the
dignity of King John nearly destroyed all England, or that
Henry Curtmantil died miserably;[1] and when Usk has
asked 'Where is now the lyne of Alisaundre the noble or
els of Hector of Troye?' he continues, 'Who is discended
of right bloode of lyne fro King Artour?'[2] He quotes,
inaccurately, from *Piers Plowman*.[3] Sometimes, on his own
account, he catches the alliterative rhythm, as when 'by
woodes that large stretes wern in, by smale pathes that
swyn and hogges haden made, as lanes with ladels their
maste to seche, I walked thinking alone a wonder greet
whyle'.[4] If the coming of winter is, in one passage, ac-
companied by 'Boreas' and other literary phenomena, yet
a few pages later it is the time 'whan bernes ben ful of
goodes as is the nut on every halke'.[5] The lover's resolu-
tion is expressed in words not unworthy of Launcelot:

> 'Although I might hence voyde, yet wolde I not: I wolde
> abyde the day that destenee hath me ordeyned, which I suppose
> is without amendement; so sore is my herte bounden that I may
> thinken non other.'[6]

This is honest work, and makes us hear the speaking voice.
Equally good is the description of the seasons in Book II,
chapter viii;[7] and though I have already quoted too much
I cannot refrain from adding this description of Man, both
for its sentiment and its rhythm:

> 'He hath under god principalite above al thinges. Now is his
> soule here, now a thousand myle hence; now fer, now nigh; now
> hye, now lowe; as fer in a moment as in mountenaunce of ten
> winter; and al this is in mannes governaunce and disposicion.'[8]

Except for certain passages Usk hardly deserves to be
read twice, but he is not a wholly negligible author. In so
far as he shows us what lesser men than Chaucer and
Gower were making of the love tradition in Chaucer's and

[1] *Testament of Love*, II. vi, vii; Skeat, pp. 67, 70. [2] Ibid. II. ii; Skeat, p. 52.
[3] Ibid. I. iii; Skeat, p. 18. [4] Ibid. I. iii; Skeat, p. 15.
[5] Ibid. I. iii; Skeat, p. 15. [6] Ibid. I. iii; Skeat, p. 18.
[7] Skeat, p. 77. [8] *Testament*, I. ix; Skeat, p. 39.

Gower's day, he is interesting to the historian. But he has his place, too, by absolute standards. His interweaving of divine and human love, if sometimes confusing, has an original turn, and gives rise to great beauties of sentiment; and in his style, while the faults are largely those of the models, the merits are his own. He would have been happy if he had kept clear of politics and moderated his philosophical ambitions.

VI. ALLEGORY AS THE DOMINANT FORM

LYDGATE. THE CHAUCERIANA. MINOR ALLEGORIES. THE NEW ALLEGORY

I

IN many periods the historian of literature discovers a dominant literary form, such as the blood tragedy among the Elizabethans, or satire in the eighteenth century, or the novel of sentiment and manners in the last age or in our own. During the years between Chaucer's death and the poetry of Wyatt allegory becomes such a dominant form and suffers all the vicissitudes to which dominant forms are exposed. For it must be noticed that such dominance is not necessarily good for the form that enjoys it. When every one feels it natural to attempt the same kind of writing, that kind is in danger. Its characteristics are formalized. A stereotyped monotony, unnoticed by contemporaries but cruelly apparent to posterity, begins to pervade it. Thus, even in times that I can still remember, the threadbare motives of the novel were not nearly so obvious as they now threaten to become. The monotony of Augustan satire, on the other hand, is easily felt; that of Italianate blank-verse tragedy more easily still; and that of late medieval allegory unescapably and with resentment. In the second place, a dominant form tends to attract to itself writers whose talents would have fitted them much better for work of some other kind. Thus the retired Cowper writes satire in the eighteenth century; or in the nineteenth a mystic and natural symbolist like George Macdonald is seduced into writing novels. Thus in the fifteenth and sixteenth century we have the *Assembly of Ladies* written by a poet who has no better vocation to allegory than that of fashion. And thirdly—which is more disastrous—a dominant form attracts to itself those who ought not to have written at all; it becomes a kind

of trap or drain towards which bad work moves by a certain 'kindly enclyning'. Youthful vanity and dullness, determined to write, will almost certainly write in the dominant form of their epoch. It is the operation of this law which has given later medieval allegory—and hence allegory in general—a bad name. A recognition of the law will perhaps liberate our critical faculties to distinguish between good and bad work—between the poetic use and the fashionable abuse.

But there is yet another 'accident' to which dominant forms are liable, and it is one which much concerns the historian. Often, though not always, we can detect under the apparent sameness of such productions the burgeoning of new forms, and find that a tradition which seemed most strictly bound to the past is big with the promise, or the threat, of the future. I half suspect that such a process is going on about us while I write: that the novel, which we saw becoming so biographical in works like *Sinister Street* and so preoccupied with period in works like *The Forsyte Saga*, is even now transforming itself—has transformed itself, in the work of Strachey and M. Maurois and Mr. Herbert Read—into the imaginative biography, a genuinely new form standing at the same distance from biography proper as the Chronicle play stands from the 'just' history. Our earlier literature, however, provides us with a more certain example. In our Augustan period we find a form which has not yet been named and which is only less dominant than satire. I mean the long Treatise Poem (if I may risk the invention of a name where one is badly needed) as practised by Thomson, Armstrong, Young, Akenside, Cowper, and the like. Here we have a form which begins by being little more than a revival of the ancient 'didactic' poem. It becomes widely dominant, attaches to itself a great quantity of inferior work, admits great variations, tends now to the most practical didacticism and now to disjointed reflection and 'enthusiastic' monologue: and all the while it is preparing the way for a really new and valuable thing, for *The Excursion*, *The*

Prelude, and the *Testament of Beauty*. It is therefore unwise to neglect the adventures of a dominant form, for in so doing we run the risk of misunderstanding its successors. There are few absolute beginnings in literary history, but there is endless transformation. Some of the allegories with which this chapter will be concerned are, perhaps, mere continuations of the past; but others look to the future, and all alike tell us something of taste and sentiment in the period which produced them. The story is a complex one. In order to understand it, we must divide it, and here, with some reluctance, I will abandon a chronological arrangement. Lydgate's *Pilgrimage of the Life of Man* may have been written before *La Belle Dame Sans Merci*, and if I wrote as an annalist I should deal with it among the Chauceriana. But it belongs to a totally different order and illustrates another, and far more important, metamorphosis of the dominant form. I shall not scruple, therefore, to reserve it for treatment along with the work of Hawes and Douglas in the last of the groups into which I am dividing the subject. It must be understood from the outset that the sameness of these later allegories is deceptive. Under the common name of allegory things of quite different natures are concealed.

II

Before approaching the allegories themselves, however, there is a question which ought to be faced. In the *Confessio Amantis* we found naturalistic presentation of the lover's life in many places emerging from the allegory, and in *Troilus* we found allegory abandoned altogether in favour of a direct delineation of love. For Chaucer (and in a less degree for Gower) the long allegorical discipline has done its work. If this interpretation is correct, we might well hope to find among their successors both the impulse and the power to paint the inner world without the help of allegory. It would be too much, indeed, to demand, as of right, a copious and brilliant production

of unallegorical subjective poetry. If we have fallen on
an age poor in genius, it will be more likely that this new
impulse and new power will continue, in its timidity, to
manifest itself in the guise of allegory—a guise which will
henceforth be a defect because it is unnecessary. But one
or two unambiguous attempts in the direction I have
suggested would be a welcome confirmation of our view.
Fortunately they are to hand.

The first of them, as the reader will have guessed, is
The Kingis Quair. The importance of this poem does not
lie in the fact that it introduced the Chaucerian manner
into Scotland. Its importance lies in the fact that it is
a new kind of poem—a longish narrative poem about love
which is not allegorical, which is not even, like *Troilus*, a
romance of lovers who lived long ago, but the literal story
of a passion felt by the author for a real woman. It is true
that the poem contains a dream, and even an allegorical
dream; but the difference between a dream framed in a
literal story and an allegorical story framed in a dream
is of considerable importance. What makes the novelty
even more surprising is the fact that the author seems to
be well aware of what he is doing. Careless reading has
obscured the fact that the poem opens with what is really a
literary preface. The author, after reading Boethius too late
at night, falls into a meditation upon Fortune, and reflects

> In tender youth how sche was first my fo,
> And eft my frende . . .[1]

and well he might, if, as the story tells us, he was once a
solitary prisoner, and is now a free man and an accepted
lover. It is at this point that a brilliantly original idea
occurred to him, a novelty that struck with such unpre-
dicted resonance on his mind that the easiest imaginative
projection sufficed to identify it with the matin bell strik-
ing that same moment in the objective world. As he says

> me thocht the bell
> Said to me, *Tell on man quhat thee befell.*[2]

[1] *Kingis Quair*, st. 10. [2] Ibid. st. 11.

In our own language, the author, who had long desired to write but spent much ink and paper 'to lyte effect', had suddenly perceived that his own story, even as it stood in real life, might pass without disguise into poetry. He had heard the same voice that called Sidney 'Fool!', bidding him 'Look in thy heart and write'; and making a cross in his old manuscript to distinguish the new dispensation from all his previous attempts, he sat down to write what most emphatically deserves to be called 'sum newe thing'. The authorship of the poem has been disputed, but the dispute need not concern us. Whether the story is taken from the poet's life or from the life of another, the originality of thus telling it at all remains. It is true that the inspiration fails before the end, but the poem is full of beauty and the passage in which the lady is seen from the window is at least as good as its analogue in the *Knights Tale*. The differences between the two are significant. When Palamon sees Emelye his hue becomes 'pale and deedly on to see', and he complains that he has a hurt 'that wol his bane be'. The Scottish poet, in the same predicament, is equally 'abaisit', but he explains that it is because his

> wittis all
> Were so overcome with plesance and delyte.[1]

Again, though both lovers become equally the captives of their ladies, it is only the Scot who says

> sudaynly my hert became hir thrall
> For ever, of free wyll.[2]

In this beautiful oxymoron we see how nature has taught the poet to feel and to express both sides of the complex experience where Chaucer wrote in a tradition that invited him to see only one of them. And so also, even where the two poets approximate most, Palamon cries merely 'as though he *stongen* were unto the herte', and the image is one of pain; the later prisoner says

> anon astert
> The blude of all my body to my hert[3]

[1] *Kingis Quair*, st. 41. [2] Ibid. st. 41. [3] Ibid. st. 40.

recording with singular fidelity that first sense of shock which is common to all vivid emotions as they arise and which transcends the common antithesis of pain and pleasure. In a word, Chaucer for the moment is not looking beyond the lachrymose and dejecting aspects of love which the tradition has made so familiar; the Scottish poet, here far more realistic, telling 'what him befell', recalls us to the essential geniality, the rejuvenating and health-giving virtues of awakened passion, and having thus first presented them directly, goes on to give them that symbolic expression which they demand, in his lyrical address to the nightingale,

> lo here thy golden houre
> That worth were hale all thy lives laboure.[1]

Chaucer himself, and all medieval love poets, had excelled in painting the peace and *solempne* festivity of fruition: but it needed this later and minor poet to remind us that Aphrodite even in her first appearance, when all the future is dark and the present unsatisfied, is still the golden, the laughter-loving goddess. Such is the reward of his literalism, his Scotch fidelity to the hard fact. And this fidelity has another, perhaps a stranger, result. As love-longing becomes more cheerful it also becomes more moral. His Aphrodite loves laughter, but she is a temperate, nay a christened, Aphrodite. There is no question in his poem of adultery, and no trace of the traditional bias against marriage. On the contrary, Venus refers the poet to Minerva, and Minerva will not help him without the assurance that his love is grounded in God's law and set 'in cristin wise'.[2]

About the absolute merits of this little poem we are at liberty to disagree; but we must not misunderstand its historical importance. In it the poetry of marriage at last emerges from the traditional poetry of adultery; and the literal narrative of a contemporary wooing emerges from romance and allegory. It is the first modern book of love.

[1] Ibid. st. 58. [2] Ibid. st. 138, 142.

The other production which I wish to mention in this context is, in a way, more interesting precisely because it is not concerned with love at all. I am referring to the earlier parts—especially the first sixteen stanzas—of Hoccleve's *Regement of Princes*. Here we have a description, much infected with allegory but still unallegorical, of a sleepless night. The cause of Hoccleve's insomnia is by no means erotic: it is what we call Worry, and what Hoccleve calls simply Thought. Hoccleve's means are small and uncertain and he does not see how he is going to make both ends meet. Now it is doubtless impossible to prove that Hoccleve could not have written this passage unless the erotic allegories had been written first; but I question whether any reader who comes to it after studying the subject matter of the last few chapters will fail to detect some influence. For if we may make a distinction between writing about one's poverty and writing about the state of mind which reflection on one's poverty produces, then certainly Hoccleve does the second. He analyses the state of his emotions during that wakeful night just as the love poets had analysed the state of the sleepless lover; and Thought personified—as he might be in any erotic allegory —is recognized as the immediate enemy, while the objective circumstances which give rise to Thought are thrust into the background. The result, however it came about, is a piece of very powerful writing; and every one, unhappily, must recognize its truth. The 'troubly dremes, drempt al in wakynge',[1] and the grim generalization (so curiously anticipating Keats)

Who so that thoghty is, is wo be-gon,[2]

deserve to be better known. But there are finer things than these. What balm for all our anxieties there is in the beggar's invitation to the anxious man, to 'Walke at large out of thi prisoun'![3] And though it may seem absurd to mention Aeschylus in connexion with Hoccleve, could

[1] *Regement of Princes*, 109.
[2] Ibid. 80. [3] Ibid. 277.

Aeschylus himself have written much better of Thought
than thus?

> That fretynge Adversarie
> Myn herte made to hym tributarie
> In sowkynge of the fresschest of my blod.[1]

Do not the lines cry out to be re-clothed in sesquipedalian
iambics?

III

As a poet of courtly love Lydgate bears a double charac-
ter. In his style, and in the construction of his poems, he
is the pupil of Chaucer. His conception of poetical lan-
guage, and sometimes his achievement, are based on that
way of writing whose slow, triumphant development within
Chaucer's own work occupied us in a previous chapter.
In this respect Lydgate claims a place in the high central
tradition of our poetry and at times (I fear I cannot say
often) he makes good the claim.

> And with thy stremes canst every thing discerne
> Thurugh hevenli fire of love that is eterne . . .[2]
>
> Redresse of sorrow, o Cithéria . . .[3]
>
> A world of beaute compassid in her face
> Whos persant loke doth thurugh min herte race . . .[4]

Such passages are on the main line of development that
runs from Chaucer to Spenser, and beyond him to Milton,
to Pope, and to the Romantics. In his conception of
allegory, again, Lydgate hardly modifies the practice of
Machault and Chaucer. He is rather inclined to go back
behind Chaucer, or at least to go back to Chaucer's
earliest work. He uses allegory merely as a frame-work for
effusions which are unallegorical or which, at the most,
reintroduce allegory only in the form of rhetorical per-
sonifications. The amorous complaint, or letter, or prayer,
is the form in which he is really most at home. Thus in
the *Black Knight* the spring morning and the bird-haunted

[1] Ibid. 88. [2] *Temple of Glas*, 326.
[3] Ibid. 701. [4] Ibid. 755.

garden serve only to introduce the Knight's soliloquy which constitutes the real body of the poem. In the *Flour of Curtesye* they are merely the setting for the poet's letter. In both poems, indeed, it might be argued that there is no allegory at all: the landscapes probably have a *significacio* in fact, but it is unimportant and uncertain. In the *Temple of Glas*, again, we are brought 'ful fer in wildirness' to a 'craggy roche like ise ifrore', not mainly that we may witness an allegorical action but that we may hear the long soliloquies and conversations of the Lady, the Lover, and the Goddess. And Lydgate was wise to concentrate on these; for nothing is more striking in this poem than the superiority of the stanzaic speeches and dialogues over the poet's own narration in couplets. Nearly all that is of value is in the former. No doubt with Lydgate, as with most minor poets, the choice of a metre almost determines the quality of the work: the couplet offers no obstacle to his fatal garrulity (the first sentence of the poem lasts for nine, and the third for eighteen, lines) while the stanza compels him to 'grow to a point'. But the difference of metre goes with a difference in content. The slow building up and decoration, niche by niche, of a rhetorical structure, brings out what is best in the poet.

But in his conception of love Lydgate is more modern than Chaucer: he ranks with the author of the *Kingis Quair* as one who helped to make the old, wild Provençal tradition more possible and more English. In the *Black Knight*, I confess, he has a conceit sufficiently outrageous, when he says of Vulcan, that is, of Venus' lawful husband, that

> The foule chorl had many nightes glade
> Wher Mars, her worthy knight, her trewe man,
> To finde mercy, comfort noon he can.[1]

Cuckolds have often been ridiculed; but it seems very hard that they should be thus scolded as well. The passage, however, is far from being typical of Lydgate, and in the

[1] *Black Knight*, 390.

Temple of Glas we are moving towards a less wilful conception. In this poem it is easy to miss the importance of the passage where the unhappily married, and those who have been forced into the cloister as children, complain piteously to Venus. It seems natural to us that these two classes of people should complain. But Marie de Champagne would have laughed and so would Andreas. Lydgate regards the matrimonial, or the celibate, vow as a cruel obstacle to the course of true love; but in the original tradition such vows, and the breach of such vows, were so far taken for granted that married people and clerks, or even nuns (in the *Concilium*) were the typical lovers. Plainly, when we reach this passage, we have turned a rather important corner. But the poet does not again speak so clearly, and as we proceed we find interesting ambiguities. The heroine of the poem is certainly married, and not married to her lover; and so far the tradition is preserved. But then her marriage is the heroine's chief grievance (it had not troubled Guinevere) and seems to be regarded as an insurmountable obstacle to her desires,

> My thoght goth forth, my body is behind.[1]

When Venus replies to this complaint, she promises that the Lady will one day possess her lover 'in honest maner without offencioun'. I am not sure what Lydgate means by this. He may mean no more than that time and place will so agree that the Lady can fulfil the code of courtly love without detection and therefore without objective 'dishonour'; but equally he may mean that she can re-marry. No less ambiguous is Venus' charge to the lover:

> But understandeth that al her cherishing
> Shal ben groundid upon honeste,
> That no wight shal thurugh evil compassing
> Demen amys of hir in no degree;
> For neither merci, routhe, ne pite
> She shal not have, ne take of the non hede
> Ferther then longith to hir womanhede.[2]

[1] *Temple of Glas*, 346. [2] Ibid. 869.

We are even left in doubt as to the conclusion of the whole story. When Venus has finally brought the two lovers together, the Lady warns the knight,

> Unto the time that Venus list provide
> To shape a wai for oure hertes ease,
> Both ye and I mekeli most abide.[1]

But what are they waiting for Venus to do? That they are waiting is apparent, for they merely kiss and praise the relevant deities, and there is no suggestion that their love is consummated. The most natural explanation certainly is that they are 'meekly abiding' until Venus 'shapes a way' not to adultery but to marriage. As the euphemism goes, 'something may happen' to the undesirable husband,

> For men by laiser passen many a mile,
> And oft also aftir a dropping mone
> The weddir clereth.[2]

It may well be that Lydgate himself was not quite certain how his story ended; but the uncertainty itself would be significant.

In the poem as a whole this new direction of the sentiment produces an increase of pathos. The lot of the unhappily married becomes more significant for poetry if they assume that the marriage vow must be kept; and the heroine of the *Temple*, even through the medium of Lydgate's imperfect art, moves me more than Chrétien's Guinevere. And when Lydgate pleads, in lines I have already mentioned, for the young girls forced into marriage to mend their father's estates, and for the yet younger and more deeply wronged oblates, snatched from the nursery to the cloister for the good of their fathers' souls,

> In wide copis perfection to feine
> And shew the contrari oitward of her hert,[3]

he rises to true poetry. Probably no reader comes upon the opening words of this passage ('I herd othir crie') without remembering the *voces vagitus et ingens* in Virgil's

[1] *Temple of Glas,* 1082. [2] Ibid. 393. [3] Ibid. 204.

hell, or without reflecting that Lydgate all too probably spoke from his own memory of the secret tears and homesickness of monastic childhood.

Lydgate's best work lies outside his allegories of courtly love, and some of it we shall happily have occasion to study before the end of the chapter. But I cannot forbear, though it carries us for a moment outside our subject, to remind the reader how much better Lydgate can be, even as a love poet, than these slight allegories suggest. It is hard to find in Chaucer so near an approach to the lyrical cry as we find in these neglected lines:

> And as I stoode myself alloone upon the Nuwe Yere night,
> I prayed unto the frosty moone, with her pale light,
> To go and recomaunde me unto my lady dere.
> And erly on the next morrowe, kneling in my cloos
> I preyed eke the shene sonne, the houre whane he aroos,
> To goon also and sey the same in his bemys clere.[1]

IV

The little anthology of love poems by obscure or unknown authors, which the old editions included with the work of Chaucer, has had a curious fate. There is a great deal of chance in literary history. If these poems had never been associated with the name of Chaucer, if they had slumbered in manuscript until the last century and then been released only to the half-waking existence conferred by some learned society's publication, it is doubtful whether the historians would now treat them more kindly than the known works of Lydgate and Hawes. An accident —or something not unlike an accident—has scattered a knowledge of them broadcast, and thus secured for them the justice which is not done to other poems of the same kind and the same age. Thus Milton does not disdain to borrow a phrase from the *Flour of Courtesye* and a conceit from the *Cuckoo and the Nightingale*: thus Dryden, Words-

[1] Lydgate, *Minor Poems*, pt. ii, ed. MacCracken and Sherwood, E.E.T.S., 1934, ii. 425.

worth, and Keats translate or praise poems vastly inferior
to *Reson and Sensualite* or the *Palice of Honour*. Favour
intrudes itself even into the text and format of the books.
Lydgate is sent to press with all his imperfections on his
head, his margin defiled with jocular (and erroneous)
scholia, and his text ugly with diacritics: the *Flower and
the Leaf* is cleansed 'by sheer editing' (in Saintsbury's
phrase) from its metrical and grammatical blemishes and
printed on a clean page. With such adventitious aids it
is not surprising that a poem should outstrip in popular
estimation works at least as good as itself. It is high time
that criticism should redress the balance. It is not, per-
haps, to be desired that we should admire the 'Chau-
ceriana' less; but we must discount the accidental element
in their fame in order to admire some other allegories
more. The best of these favoured pieces deserve their
popularity, and the whole collection is a charming formal
garden, on a small scale, where lovers of antique senti-
ment do well to linger. But it contains none of the greatest
work in this kind, and it contains little promise for the
future.

The *Cuckoo and the Nightingale* is perhaps the earliest
of these poems. It is a bird debate of the familiar kind,
written in an unusual rhyme scheme, and pleasantly full
of country sights and sounds. The vernal love-longing,

> that bringeth into hertes remembraunce
> A maner ese, medled with grevaunce.[1]

is well expressed. The reader will notice that the precision
and felicity of the last line are of a kind as proper to prose
as to verse. This is no reproach, for poetry is not neces-
sarily at its best when it is most unlike the other harmony;
but it serves to distinguish this author's talent from
Chaucer's. We find in him neither the merits nor the
defects of the high style. Despite his airy subject he
remains, as a stylist, on the ground: he has not caught
from Chaucer the new richness and sweetness of speech,

[1] Skeat, *Chaucerian and other Pieces*, xviii. 29.

and the effect is usually that of one who talks and not of one who sings.

This quality—I hardly call it a defect—is well brought out by the contrast between the author of the Cuckoo poem and the author of *La Belle Dame Sans Mercy*. The very first lines of the latter,

> Half in a dreme, not fully wel awaked,
> The golden sleep me wrapped under his wing[1]

give us at once what we have missed in the *Cuckoo and the Nightingale*, and give it triumphantly; and they also introduce us at once to the real importance of the *Belle Dame*. It is as an admirable exercise in poetical style (and I use the word 'exercise' in no derogatory sense) that this poem concerns us. It is a translation from the French of Chartier, and the content is of no great significance. It is not an allegory, but a poem in which some preliminary adventures lead up to a long dialogue between a lover and his mistress—the merciless and immovable mistress who gives her name to the poem. The theme suggests the sentiment of the piece, which consists in a continued emphasis on what I venture to call (but 'let rude ears be absent') the masochistic element in the attitude of the courtly lover. The author is not morbid; he remains everywhere within the bounds of the healthy and normal, but he is playing with shades of feeling which need very little more encouragement to pass those bounds and to become a recognizable perversion.[2] Certainly his picture of the mistress, though well suited to this turn in the sentiment, is poetry, not pathology, and deserves to be quoted:

> In her fayled nothing, as I could gesse,
> O wyse nor other, prevy nor apert.
> A garnison she was of al goodnesse
> To make a frounter for a lovers hert—
> Right yong and fresshe, a woman ful covert,
> Assured wel her port and eke her chere,
> Wel at her ese, withouten wo or smert,
> Al underneth the standard of Daungere.[3]

[1] Ibid. xvi. 1. [2] Ibid. 105–8, 137, 164, 246. [3] Ibid. 173 et seq.

But however we define the sentiment, it would be misleading to regard it as the main thing in the poem. The main thing is the dialectic of the conversation between the lady and her lover, and it is doubtless on the subtlety of her answers, and on the recurrent intellectual suspense between each question and each answer, that Chartier chiefly relied for keeping up the interest of his readers. To us, who have separated our sentimental and our intellectual games so widely, it is not very interesting; and unfortunately it is in these passages that the English translator breaks down. I am not sure that he was a perfect master of the original; and certainly his version of the dialogue contains obscurities. But of English his command is perfect; and throughout the poem—but specially in the earlier stanzas before the dialogue begins—we see an essentially second-rate theme redeemed by sheer good writing. We have to reconsider our whole conception of the culture of the fifteenth century when we read such an accomplished stanza as the following:

> To make good chere, right sore himself he payned
> And outwardly he fayned greet gladnesse;
> To singe also by force he was constrayned
> For no plesaunce, but very shamfastnesse;
> For the complaynt of his most hevinesse
> Com to his voice alwey without request,
> Lyk as the soune of birdes doth expresse
> Whan they sing loude in frith or in forest.[1]

In this, as in the previous extract, it will be seen that we have to deal not with mere writing in stanzas, but with that very different thing, really stanzaic writing. The last line is felt throughout the whole grave minuet which words and sense go through in order to reach it; and when it comes, there is a full close for ear and mind, and a concluding tableau for the inner eye. The thing is difficult to do, and even Chaucer and Spenser do not always succeed. There are single lines, too, in the poem, which tempt me to quotation; but its real quality lies, not in

[1] Skeat, *Chaucerian and other Pieces*, xvi. 117 et seq.

occasional 'beauties' that can be pencilled, but in its *aureum flumen*—the rich, even, melodious continuity of the whole.

The *Flower and the Leaf*—a much later work by an unknown hand—belongs to a different world. Its author is less accomplished and more original, and the poem is, in some respects, of more historical importance. It represents, in a very mild form, that fusion of the courtly and the homiletic allegory of which there will be more to say in a later section. The story is probably familiar to every reader. The author—who represents herself as a woman, and must therefore be assumed to be a woman, by the principle of Occam's razor—wanders into a forest where she witnesses the revels of two parties of mysterious beings, who are distinguished as the company of the Leaf and the company of the Flower. The latter are afflicted by excessive heat and violent showers, while the former remain in comfort under the shade of a 'fair laurer'. When the storm is over, the servants of the Leaf, cool, dry, and comfortable, offer hospitality to the wet and blistered followers of the Flower, and prescribe 'plesaunt salades'

> For to refresh their greet unkindly heet.[1]

Finally an unnamed lady (who is rather artlessly introduced) explains to the authoress the meaning of the vision. The Queen of the Leaf was Diana, and the Queen of the Flower, Flora. Their two companies consisted entirely of ghosts[2]—the ghosts of virgins, true lovers, and valiant knights following Diana, while Flora's retinue consisted of those who had loved idleness and found no better occupation than 'for to hunt and hawke and pley in medes'.[3] This is the surprising conclusion of a poem which began with all the air of an allegory of courtly love. From the courtly tradition it has borrowed the idea of an *exercitus mortuorum*. From the same source it has borrowed the conception of a future reward and punishment which have no connexion with Christian eschatology. But then

[1] Ibid. xx. 413.
[2] Shown by the tenses 477–83, 536.
[3] Ibid. 538.

it allots these rewards and punishments on a purely moral basis: there is no hell for cruel beauties, and if true lovers are rewarded they are rewarded along with virgins. Love and valour and virginity find themselves ranged together and opposed to idleness, frivolity, and inconstancy. The antithesis is purely moral, and the morality is that of modern life. At the core of this little poem—which looks, at first sight, so like *La Belle Dame* or the *Parlement of Foules*—we find a moral allegory on the lines of the choice of Hercules, a little psychomachia of Virtue and Vice. It is, in fact, a hybrid—a moral allegory wearing the dress of the Rose tradition. It is not, indeed, probable that the authoress is consciously drawing upon the homiletic allegory; and perhaps she is not conscious, either, of any call to reform the erotic tradition. One suspects that she knows the more perverse expressions of the latter to be 'only poetry' and is not interested: while the fierce monotony, the unreal black and white, in which the contemporary pulpit painted the *bellum intestinum* leaves her respectfully unmoved. 'She was ful mesurable, as wemen be.' She allegorizes a world she knows: a world in which the more terrifying virtues and vices do not appear, but in which, nevertheless, she is conscious of a better and a worse, a protective leaf and a soon withering flower. As a moralist she stands nearer to Addison than to Deguileville. She too would enlist fancy and fashion on the side of virtue—a virtue pictured in such homely, urbane, and practicable colours as startlingly anticipate our eighteenth-century Whig literature. Hence, though she deals with the moral choice, her treatment of it 'turns all to favour and to prettiness'. Only the most lenient virtues and the most pardonable vices appear, and the contention between them is one of courtesy. It ends with the Virtues inviting the Vices to a picnic and helping them to dry their clothes. In all this we may, if we please, detect a ladylike ignorance of the heights and depths: nor will I plead (though the thing is arguable) that the behaviour of these Virtues is, in a sense, more worthy, because more Christian, than that

of Deguileville's Gracedieu. I do not pretend that the authoress was thinking on so grave a level. But if she does not look very deep, at least she looks with her own eyes: she allegorizes life as it appears to comfortably circumstanced people of good breeding and good will, and not as any convention, homiletic or erotic, would have it appear. If she cannot claim wisdom, she has a great deal of good sense and good humour, and is guided by them to write a poem more original than she herself, perhaps, suspected. A similar merit, and a similar limitation, appear in her execution. Her language is fresh and genuine, but never reaches the last felicity. She describes what interests her, selecting rather by temperament than by art; and she finds considerable difficulty in getting the right number of syllables into each line.

The *Assembly of Ladies* is also put into the mouth of a woman, and critics, anxious to economize hypotheses, have suggested that it is by the same hand as the *Flower and the Leaf*. If this is true—a question which we shall probably never be able to answer—she was a remarkable woman; for the *Assembly* represents a wholly different, and, in some ways, a not less interesting modification of the tradition. Taken as an allegory, it is as silly a poem as a man could find in a year's reading. A number of ladies are summoned to a 'counsayl' at the court of Lady Loyalty; they arrive and present their petitions; Loyalty postpones her answer till her next 'parliment' and the dreamer wakes. As a story, and still more as an allegorical story, this is clearly of no value. The poem belongs to that class in which the allegorical pretence is assumed only at the bidding of fashion. What the writer really wants to describe is no inner drama with loyalty as its heroine, but the stir and bustle of an actual court, the whispered consultations, the putting on of clothes, and the important comings and goings. She is moved, by a purely naturalistic impulse, to present the detail of everyday life; and if her poem were not hampered by being still attached—as with an umbilical cord—to the allegorical form, it would be an

admirable picture of manners. Indeed, if only the first four stanzas survived, we might now be lamenting the lost Jane Austen of the fifteenth century. They read exactly like the beginning of a novel in verse; and in them we have the rare privilege of listening to an ordinary conversation, as opposed to a wooing, between a well-bred man and woman of that age. The dialogue is admirable, and perhaps better than Chaucer's earliest attempts. Nor does this realism fail when the lady begins to tell her dream. We soon forget that it is a dream, or an allegory. The messenger from the court of Loyalty delivers her summons and is already departing when she turns back to say 'I forgot: you must all come in blue'. The heroine, arriving at the court, begs one of the ladies in waiting 'helpe her on with her aray'. An official stands her friend, pulls wires on her behalf, and tells her whose ear she must gain. A cry goes down the presence chamber, 'Voyd bak the press up to the wal'. The waking from the dream is eminently natural; and so is the conclusion of the whole poem,

> Now go, farwel! for they call after me.

We cannot call the piece satisfactory as a whole: for the fatal discrepancy between the real and the professed intention is felt at every turn. To read it is to learn why some critics hate allegory; for here the *significacio* is—what some suppose it to be in all allegories—a chilling and irrelevant addition to the story. But the detail of the poem shows powers akin to genius, and reveals to us that much neglected law of literary history—that potential genius can never become actual unless it finds or makes the Form which it requires. 'Materia appetit formam ut virum femina.' In the *Assembly* a great deal of good 'matter'—kindly satire, lively dialogue, a shrewd eye—remains fruitless.

V

The reader will have observed that all the Chauceriana, with the possible exception of the *Flower and the Leaf,*

display a weakening of the genuinely allegorical impulse. The trappings of allegory are retained but the true interest of the poets lies elsewhere, sometimes in satire, sometimes in amorous dialectic, and often in mere rhetoric and style. Before we can proceed to the true allegories of this period in which the impulse is by no means decadent and is indeed preparing itself to pass on to the new triumphs of *The Faerie Queene*, there are a number of other poems to be considered which fall into the same class with the Chauceriana.

Dunbar is, perhaps, the first completely professional poet in our history. Versatile to the point of virtuosity, he practises every form from satiric pornogram to devotional lyric and is equally at home in the *boisteous* language of his alliterative pieces, the aureation of his allegories, and the middle style of his ordinary lyrical poems. His content is everywhere as central and obvious, as platitudinous if you will, as that of Horace; but like Horace he is such a master of his craft that we ask nothing more. His allegories are not of historical importance. They have no purpose in the world but to give pleasure, and they have given it abundantly to many generations. The *Thistle and the Rose* is an allegorical epithalamion after the manner of Chaucer's *Parlement*, though any comparison between the two is rather unfair to Dunbar. Into the *Parlement* Chaucer has put the whole of his early strength and made a paradise of tenderness and fun and sublimated sensuality. Dunbar's poem does not aspire to be more than a festal exhibition of fine language adding a new touch of magnificence to a royal wedding and strictly comparable to the court dresses of its first hearers. As such it is a brilliant success, but it yields to the *Golden Targe*. In the *Targe* the language is more splendid, the stanza more adapted to support such splendour, and the images more dazzling. To notice the abundance of such words as 'crystalline', 'silver', 'sperkis', 'twinkling', and the like is to indicate sufficiently the quality of the poem. And this peculiar brightness, as of enamel or illumination, which we find

long before in *Gawain* and *Perle* and again in Douglas, is worth noticing because it is the final cause of the whole aureate style—the success which enables us to understand the aims of all the poets who did not succeed. And when the thing is successful it silences all *a priori* objections (such as the Wordsworthian heresy) against artificial diction: when the thing is well done, it gives a kind of pleasure that could be given in no other way. From our own point of view the poem might almost be classified as a radical allegory. It has an intelligible allegoric action: the poet's mind, though long defended by reason, becomes at last the prisoner of beauty. But this action is so slight and degenerates so often into a mere catalogue of personifications (which is the only serious fault of the *Targe*) that we are right to neglect it. The real significance of the poem lies elsewhere: in it we see the allegorical form adapted to purposes of pure decoration, as the Pastoral form was adapted by Pope or the elegiac by Matthew Arnold—we might add, by Milton. For this also is one of the things that happens to a dominant form.

A much less happy example of such decorative allegory occurs in Skelton's *Garland of Laurel*. That Skelton could write genuine allegory when he chose we know from the admirable *Bouge of Court*. The purely satirical content of this poem puts it outside my province; and I suppose that no reader has forgotten the vividness of its characters or its nightmare crescendo from guilelessness to suspicion, from suspicion to acute nervousness, and thence to panic and awakening. The experience of a young man during those painful years in which he first discovers that he has entered a profession whose motto is *Dog eat Dog*, could hardly be better described. But the *Garland* is not, in this sense, an allegory at all. Allegory in it is merely a pretext or a succedaneum—a blank wall on which tapestries of various kinds may be hung. Of such 'tapestries' the lyrics are of course the loveliest; but there are good things even in the Rhyme Royal stanzas, as this, of Phoebus embracing Daphne:

the tre as he did take
Betwene his armes, he felt her body quake.[1]

In Dunbar and Skelton the decay of true allegory is
redeemed by beauties of another kind—beauties so great
that we forgive the false form of the poems for their sake.
But in the work of William Nevill we reach the nadir of
the whole genre. The *Castell of Pleasure* illustrates the
unhappy operation of a dominant form in making medio-
crity vocal. The author was a very dull young man; but
he might have carried the secret to the grave with him if
the whole recipe for making poems of this kind had not
lain so fatally easy to his hand. The plot of the poem is
a debate between Beauty, Pity, Disdain, and Desire framed
in a dream journey to a castle of Pleasure. The ingre-
dients are familiar, but this would not prevent the dish
being palatable; the real trouble is that the cook is naught.
The debate might have represented—like the dialogue of
Pity, Shame, and Danger in the *Roman*—a real psycho-
logical process in the heart of the heroine, or, failing that,
might at least have had the dialectical charm of the *Belle
Dame Sans Merci*. But Nevill makes it predominantly
juristic,[2] and most of the arguments are not even tolerable
conceits. The only good turn is the unexpected thesis of Pity
that love of *effeccyon* (that is of passion and psycho-physical
'affinity') is really more stable than love grounded upon
condicyons—as we should say, on community of tastes and
interests, and companionship.[3] The journey to the Castle,
again, in better hands might have proved full of beauty
and wonder; but in Nevill we get only one good picture,

I was ascendynge a goodly mountayne
About the whiche the sonne over eche syde did shyne,
Whereof the coulour made my herte ryght fayne
To se the golden valeyes bothe fayre and playne . . .[4]

[1] *Garland*, 300.　　　　　　[2] *Castell of Pleasure*, 601–17, 626–33.
[3] Ibid. 710–37. Line 736 contains a crux, which I suspect of being not a
textual corruption but a tangle in the author's mind. He has written *in thoder*,
where we really need *in thoder in an other*, i.e. in the other case (love of
conditions) if he found the same harvest in another (woman).
[4] Ibid. 148.

—where the landscape, though not the metre, is alive. The thought—for even William Nevill will have his thoughts—is banal. He, too, is aware of a choice between the life of love and another life, and the poem is prefaced by a dialogue between the author and the printer on this very subject, to which we return later at the gate of the castle.[1] The alternative is that between love and money. In the prologue he is afraid (or his publisher is afraid) that the public will be more interested in books telling them how to make a fortune than in books of love: at the gate of the castle he finds twin inscriptions in letters of 'golde' and 'yndye blewe' informing him that he must here choose between the road to worldly wealth and that to 'beauties hygh estate'. The reader will remember how the authoress of the *Flower and the Leaf* had softened the old stern theme of the *psychomachia* into a gentle play between the mildest virtues and the most venial faults. Nevill's choice —which he does not hesitate to compare with the choice of Hercules—illustrates the merely bathetic side of the same process. Her antithesis was, at worst, pretty and unimportant: his is irredeemably commonplace and yet by no means universally valid. The two together are a timely reminder how far we have travelled from the real Middle Ages. The great and true antitheses with which the older poets were concerned—the eternal conflict between Venus and Diana or Venus and Reason, or the subtle discrimination, possible only to a civilized society, between Venus and Cupid—these have sunk out of sight. Something of magnanimity and something (in the deeper sense) of realism seems to be lost as the Middle Ages draw to a close: a great tide of the prosaic and the commonplace seems to be rising and carrying old landmarks away. We may, if we please, describe it as a return to nature, but only if we remember that 'spiritual' and 'civil', as well as 'artificial', are the opposites of 'natural'. And even if mere nature is to be endured when she is humble and naïve, as she is in the ballads, or even as she is in the *Flower*

[1] *Castell of Pleasure*, 15–21, 236–81.

and the Leaf, nature pretentiously tricked out in the robes originally devised for rarified and arduous sentiment, is intolerable. The earlier poets used allegory to explore worlds of new, subtle, and noble feeling, under the guidance of clear and masculine thought: profound realities are always visible while we read them. But who can endure letters of gold and azure over a castle-gate to symbolize a worthy young blockhead's decision between the richer and the prettier of two neighbouring heiresses?

For indeed this is all that Nevill means. The love which he celebrates is a perfectly respectable love, ending in marriage, and opposed to the acquisition of a competence only by accident, if at all. It is this, indeed, which constitutes his chief interest for us as historians: we must place him along with Lydgate, King James, and Hawes, as an indication of the way the wind is blowing. In one respect he goes farther than they. He does not hesitate to show us the reversal of the lovers' relations which marriage will effect, by which the 'servant' becomes the master.

> I wyll moreouer be subdued to your correccyon
> Yf it like you to mary me and haue me to your wyfe.[1]

It is remarkable that this change in the real theme leaves unchanged certain characteristics of the old love poetry which, logically speaking, ought henceforth to disappear. Thus Nevill warns lovers to be 'secret',[2] not noticing that there is now nothing to be secret about. Thus, again, he ends, after awakening from his dream, on a note of disillusion and quotes *omnia vanitas*. He does not repent, for he has nothing to repent of; but I cannot help suspecting behind this passage the influence of the old palinode, as in Chrétien, Chaucer, or Gower—as I suspect it also behind the far better close of the *Pastime of Pleasure*. What was originally a moral necessity is becoming a structural characteristic.

I have spoken hardly of Nevill, and it would be unfair

[1] Ibid. 792.　　　　　　[2] Ibid. 908.

to conclude without mentioning his merits. These are not to be found in his style, which varies between excessive aureation ('precyous pryncesse of preelecte pulcrytude'[1] or the like) and the verbose, shuffling, pseudo-logical or legal prolixity which the earlier Chaucer found it so hard to escape from. His merits are two. The less important is a dash of that graphic power which we detected in the *Assembly of Ladies*: the comings and goings on the poet's way to the presence of Beaute are sometimes lively enough. But his real strength, such as it is, lies in his eye for natural appearances, and this sometimes sets us wondering what he might have done if he had lived in an age of descriptive poetry. The best passage, though it has been quoted before, is still so little known as to deserve transcription:

> The nyght drewe nye, the daye was at a syde.
> My herte was hevy, I much desyred rest
> Whan without confort alone I dyd abyde,
> Seynge the shadowes fall frome the hylles in the west.
> Eche byrde under boughe drewe nye to theyr nest;
> The chymneys frome ferre began to smoke;
> Eche housholder went about to lodge his gest;
> The storke, ferynge stormes, toke the chymney for a cloke.
> Eche chambre and chyst were soone put under locke;
> Curfew was ronge, lyghtes were set up in haste.
> They that were without for lodgynge did knocke. . . .

And here a man would willingly break off and conceal the fact that Nevill, having written this, sees fit to conclude the paragraph with the line—

> Which were playne precedentes the daye was clerely paste.[2]

We are accustomed to anonymity in medieval poetry, but few poems are so deeply anonymous as the *Court of Love*. Its style and metre are not those of any known period in our literature; and it is difficult to guess who this author was or when he wrote a poem which scans perfectly provided you make every final -e mute and also sound the -e in every plural and genitive in -es. Fortunately

[1] *Castell of Pleasure*, 802. [2] Ibid. 98 et seq.

it is not part of my undertaking *tantas componere lites*; but even the content of the poem presents us with similar problems. When the poet explains that Nuns, Hermits, and Friars are among the courtiers of Love[1]—for 'there is non excepcion made'—we seem to be back in the ages before Lydgate and King James and Nevill; but then the language of the poem suggests a date so much later that we wonder whether the author can really know the old tradition; whether it is not more probable that he writes from a Protestant dislike of celibacy. So, again, the pedantic enumeration of Love's twenty statutes carries us back to the world of Andreas, and the beautiful matins and lauds sung by the birds at the end of the poem belong to an early stage of the tradition; but the name, and perhaps the character, of 'little Philobone', sound more modern. Most probably we have here to do with a poet who had read widely in the literature of courtly love, with the detachment of one studying a mode that has almost passed away, and who then used a whimsical eclecticism in building up his own poem, which is predominantly satiric. It is a lively piece, full of movement and gaiety; and once at least it strikes the note of rapture:

> O bright Regina, who made thee so fair?
> Who made thy colour vermelet and white?
> Where woneth that god? How far above the air?
> —Great was his craft and great was his delight.[2]

In the story which we are now following that event—or rather that complex of heterogeneous events—which are known as the Renaissance, are not a landmark of primary importance. Metrical and stylistic technique are altered and, in a way, vastly improved; but the big alteration in the sentiment of erotic allegory took place earlier, and in its structure or formula much remained unchanged. If we turn to Barnaby Googe's *Cupido Conquered* (printed among his *Eglogs* in 1563) we shall be struck by its complete fidelity to the oldest models in this kind. It has a

[1] *Court of Love*, 253–66. [2] *Ibid.* 141.

spring morning and a wood full of singing birds: a god appearing in a dream, a flight through the air, an allegorical House where Diana keeps her court, and a psychomachy between her forces and those of Cupid. There is nothing in the content of the poem to show that it was not written in the fourteenth, or even the thirteenth, century. The language and metre alone reveal the date. Both are competent and at times something more than competent, as in the couplet

> And warlike tunes began to dash
> Themselves against the skyes.[1]

We have definitely escaped from the worst diseases of the later Middle Ages, from verses that will not scan and sentences that will not construe. But it would be an error to regard this transition as an unqualified blessing. Compared with Dunbar or Douglas, or the author of the *Belle Dame Sans Merci*, Googe writes like a schoolboy: his work presupposes a coarser and more commonplace audience than theirs and a far less delicate feeling for language. His very competence smells somewhat of the gradus:

> Let not our *weryed* hartes sustaine
> Suche *wrongfull* Tyranie;
> Quench *quickly* now the *fyrie* flames
> Of *open* injury.[2]

And if he is thus naïve beside the most accomplished of his predecessors, on the other hand he has none of the inner voice, the brooding solemnity, the ardour and compassion which redeem so many unsuccessful lines in Lydgate and Hawes. For evil, as well as for good, the medieval ἄπειρον has been subjugated. The trouble in Googe, as in so many of the early Elizabethans, is his satisfied insensibility. A much better attempt in the same kind, Alexander Montgomerie's *Cherry and the Slae*, dates from the last twenty years of the century. As an allegory it is more tedious than Googe's poem; but it is saved by its scenery, its reiterated

[1] Barnaby Googe, *Eglogs, Epytaphes and Sonettes 1563*, Arber's Reprint, London, 1871, p. 124.　　[2] Ibid., p. 117.

imagery of rushing water, and even more by its beautiful stanza. In Montgomerie we seem to hear the scrape of the fiddle and the beat of dancing on the turf: in Googe, the ticking of a metronome.

VI

Hitherto I have been following the story of a death, or something as near a death as we ever reach in the history of literary kinds; and the reader may pardonably feel that this particular form of allegory—-the form which descends from poets like Machault and Chartier—has taken an unconscionable time to die. It is with relief that I turn to that much more interesting branch of my subject which concerns the vital development of allegory in our period, the transformation by which we pass from the *Romance of the Rose* to works within measurable distance of *The Faerie Queene*. In order to understand this transformation we must pick up a thread in the story which was dropped several centuries (or, from our point of view, several chapters) ago. It will be remembered that allegory originally disengaged itself as a literary form under the pressure of a strongly ethical interest. Virtues and Vices were its first *dramatis personae*, and the moral conflict its first theme. The oldest kind of allegory is the moral or homiletic allegory. Our own study abandoned the history of homiletic allegory as soon as erotic allegory had detached itself from it and produced the *Roman de la Rose*; and ever since then we have been following the subspecies, erotic allegory, alone. It is now time to remember that the same age which saw the rise of the *Roman* saw also a rich development of the homiletic kind in such works as the *Songe d'Enfer*, the *Voie de Paradis*, and the *Tornoiement Antecrist*. On allegory of this kind, though it was the parent stem, it was natural that the *Roman* itself should exercise an influence. Great allegories of the moral type were produced by moralizing poets in answer to the libertinism of Guillaume de Lorris and Jean de

Meun; but to answer is to be influenced. Personifications and themes from the culprit work were naturally borrowed by the works that reproved it: they appeared in order to be rebuked, but they appeared. And thus insensibly a new kind of allegory arises. To set Virtue and Venus in action within a single poem is also to transcend the narrowness both of the strictly homiletic and the strictly erotic allegory, and to come a step nearer to a free allegorical treatment of life in general; and with this enlarging of the subject-matter there comes inevitably a complication and variety which were lacking before. A closed battle-field served Prudentius, and a closed garden Guillaume de Lorris. But if the hero is to be subjected to the appeals both of the false gods and the true, some sort of visionary geography at once becomes necessary, and some amount of journeying. And when a poet has reached this stage it is impossible that he should not begin to incorporate into his allegory certain elements from the romances where the journey with adventures is already the norm; and before he has finished he will find himself making an imaginary country whose allegorical pretext justifies it in being rather more imaginary than the countries in romance, being grounded not in Britain or France or even Alexander's East but in the much wider and more indefinite realities of inner experience. Once again, as long before in Claudian, allegory liberates the mind for free excursions into the merely imaginable: a 'world of fine fabling' becomes accessible and we are in sight of *The Faerie Queene*.

It will be noticed that this account of the matter distinguishes two things: the homiletic allegory pure and simple, and the homiletic allegory influenced by, and usually hostile to, the *Romance of the Rose*. The homiletic type in its purity is represented in England by the *Assembly of Gods*—an allegory so purely moral that it hardly falls within the scope of this book. It may be briefly described as a *psychomachia* with trimmings. These trimmings—the complex fable in which the battle of Virtue and Vice is set—are by no means without merit. The visit of

Attropos to the assembled gods faintly anticipates the ascent of *Mutabilitie* in Spenser's poem; and the final agreement of the Rational and Sensitive souls in their common fear of Death is well conceived. The execution displays most of the typical vices of second-rate medieval literature; the phrase is prolix, the language undistinguished, catalogues and commonplaces are frequent. Yet some of the characters are painted lively enough; and if we may bring out by a typographical device the real nature of the rhythm (which is that of *Pease pudding hot!*) the following may please:

> So thedyr came Diana
> Caried in a carre,
> To make her compleynt
> As I told you all;
> And so did Neptunus
> That doth both make and marre,
> Walewyng with his wawës
> And tombling as a ball.[1]

Or the entry of Vice—

> On a gliding serpent
> Riding a great pas,
> Formed like a dragon,
> Scalyd hard as glas;
> Whose mouth flamëd
> Feere without fayll,
> —Wingis had hit serpentine
> And a long tayll.[2]

Such merits as the work has, turn mainly on this kind of vivacity. The strife between moral personifications has something of the stir of a real battle. The battle-field is described, almost in the Anglo-Saxon spirit, as the place 'where sorrow should awake'; the Vices cry 'On in Pluto name! On, and all is oure'; Vertew, coming to succour his men

> Caused hem be mery
> That long afore had mornyd,

[1] *Assembly of Gods*, 554. [2] Ibid. 613.

and as he advances 'his pepyll set up a gret shout. . . . A Vertew! A Vertew!'[1] This manly strain helps us to forgive the clumsy, honest poet; who was certainly not Lydgate if we judge by his metre.

The *Court of Sapience*, though it should be mentioned here, is not so pure an example. Indeed it comes into this class at all only because of its introductory digression. The core of the poem is a modest little encyclopedia in verse which covers jewellery, physics, botany, the liberal arts, and elementary religious knowledge. One is reminded of a sampler; and the author, who may well have been young, seems to have written more for his own pleasure than for that of any reader. But such is the influence of the dominant form that he has seen fit to connect his catalogues on the thin thread of narrative provided by a visionary meeting with Sapience and a journey to her house; and this again gives rise to the matter of his first book where Sapience describes the greatest feat she has performed—that of devising the means to man's Redemption. This passage is homiletic allegory; and, what is more, it is certainly good, arguably great, poetry. The allegory is not original; and the theology turns on a crudely 'substitutional' view of the Atonement. But this does not prevent the poet from rising at this point to almost mythopoeic heights. The whole of the first Book should be familiar to every English lover of poetry. Langland himself has nothing more sublimely imagined than the scene in which Peace turns away from Heaven to voluntary exile, or better expressed than her valediction:

> Farewell Mercy, farewell thy piteous grace,
> So wellaway that vengeance shall prevayle:
> Farewell the beamyd lyght of hevyns place,
> Unto mankinde thou mayst no more avayle;
> The pure derknesse of hell thee doth assayle.
> O lyght in vaine! . . . the clyps hath thee incluse,
> Man was thy lord, now man is thy refuse.

[1] *Assembly of Gods*, 1014, 1077, 1120, 1122.

O Seraphin, yeve up thyne armony,
O Cherubin, thy glory do away,
O ye Thronys, late be all melody,
Your Jerarchy disteyned is for ay.
Your maisteresse, see, in what aray
She lyth in soune, ylorene with debate.
—Farewell, farewell, pure household desolate.[1]

To remember what Dryden, and even Milton, have made
of similar themes, is to have a measure of this old poet's
tenderness and majesty. And in this same book he gives
a beautiful illustration of the homiletic allegory's debt
to the poets of courtly love. Our Lord is imagined as a
knight who takes Mercy for His lady, and promises her
(surely an exquisite transmutation of the old knightly and
heroic bēōt),

Full manfully I shall my payne comport
And thynke on you as on my own lady.[2]

And when His adventure is achieved, He returns to her
with the words,

Have here yowre man; do wyth him what ye lyst.[3]

This introductory allegory, I confess, is the only reason
for mentioning *The Court of Sapience* at this point; but I
find it hard to leave. There is something in the hero's
journeyings with Sapience among the flowers and trees
and precious stones which defies analysis. It is very absurd
that a critic should (apparently) be found who thought
that Milton's description of Eden owed something to
this obscure poem;[4] absurd, yet after all significant. For
I must confess that more than once as I progressed slowly
through these brightly coloured and indistinctly shaped
landscapes, half pleased and half tired with the names of
Asteryte, Charbuncle, Crisopras, and Auripigment (or else
of dolphin, cokadryll, efemeron, or coryaundre, plantane,
and amomum)—more than once I found myself reminded

[1] *Court of Sapience*, 435. [2] Ibid. 759.
[3] Ibid. 877. [4] *v.* Spindler, *Court of Sapience*, p. 100.

of Milton. It is very unlikely that the explanation lies in any real similarity of poetic art: it is of Milton's theme, not of his style, that we are reminded. He wrote of Paradise; but the old poet seems rather to have written *in* Paradise, to be himself paradisal in his piety, his cheerful gravity, his childlike love of matter. For the rest, he uses a moderate degree of aureation and has some talent for what Dryden called the 'turn';[1] he can contrive a conceit;[2] and save in some incorrigibly scientific passages he is hardly ever prosaic.

From such homiletic allegories I must now turn to those which illustrate the fusion of the homiletic and the courtly types. This stage in the history of our subject is represented by the two great allegories which Lydgate translated from the French, the *Pelerinage de la Vie Humaine* and *Les Echecs Amoureux*. Both are of great importance, and the second, though almost universally neglected, is a delight.

Deguileville's *Pelerinage* was an early fourteenth-century poem, somewhat longer than the *Roman de la Rose*. When I speak of it as a 'fusion' of the two kinds of allegory, I do not mean that there is any fusion of erotic and moral sympathies in the author's mind. His intention is purely homiletic, and the fusion is a purely artistic one. But on this level it is well marked. A student of homiletics might take it for an ordinary versified sermon, employing the common allegorical method of the pulpit,[3] and borrowing from the erotic convention. A student of courtly allegory might equally well take it for a true scion of the *Rose* badly inoculated with homiletics.

Its homiletic characteristics are obvious. The author is not only more anxious to teach than to delight, but also more anxious to teach by direct statement and exhortation than by poetic suggestion. Hence his narrative, especially in the earlier parts of his poem, often stands still while long

[1] *Court of Sapience*, 430, 1591.
[2] e.g. the argument used by the First Hierarchy, ibid. 624–37.
[3] See Owst, *Literature and Pulpit in Medieval England*, specially cap. 2.

passages of unmitigated doctrine are uttered by such
characters as Grace Dieu and reason. The positions ad-
vanced are those of an orthodox monastic of that age.
The degrees of humility are cited from Benedict and
Bernard.[1] Heresy is condemned, and the fact that she will

> Hardyd with obstynacye
> Continue til the ffyre be hoot

is mentioned without qualm.[2] The voluntary poverty of
monks is praised in a passage of real beauty; but we also
learn that monasteries lose their wealth only as a punish-
ment for corruption.[3] Ordinary poverty, on the other
hand, seems to have lost its gospel blessing, and we hear
only of *Poverte Impacyent*, figured as a foul, old woman
unfit to appear among the lady Virtues.[4] *Religioun*, in the
technical sense, is the only ark of safety in the troubled
sea of the present world.[5] The founders of monastic life
are pictured as powerful friends who help their clients 'by
ful gret subtylyte' to climb into heaven over the wall, or
pull them up by ropes, while ordinary people have to take
their chance of being admitted at the gate.[6] The author
was far from foreseeing a famous chapter in *The Water
Babies*.

But the influence of the *Roman* is equally marked. It
is explicitly mentioned for reprobation[7]—for the *Pilgrimage*
is a religious counterblast to the profane allegory—but the
author has also learned from his adversary. His picture
of Reason descending from her high tower,[8] and again of
Reason offering herself to the Dreamer as his paramour,[9]
recall famous passages in the *Romance*. More important,
both to the critic and to the historian, is the figure of

[1] Lydgate, *Pilgrimage*, 574. [2] Ibid. 18986.
[3] Ibid. 22665, 23607, 23687.
[4] Ibid. 22725.
[5] Ibid. 21717 et seq.; cf. 13134, 22121.
[6] Ibid. 492 et seq. (the gate); 557 et seq., 586 et seq. (the other routes).
[7] Ibid. 2084 (mentioned again 13200).
[8] Ibid. 1496 (R.R. 2973).
[9] Ibid. 2023 (R.R. 5796 et seq.).

Nature, to whom Deguileville allots perhaps the most obviously beautiful lines in his poem:

> I make alday thinges newe,
> The olde refresshing of her hewe.
> The erthe I clothe yer by yer,
> And refresshe hym of hys cher
> Wyth many colour of delyte,
> Blewh and grene, red and whyt,
> At pryme temps, with many a flour,
> And al the soyl, thorgh my favour
> Ys clad of newe; medwe and pleyn . . .
>
> The bromys with ther golden floure,
> That winter made with his shour
> Nakyd and bare, dedly of hewe
> With levys I kan clothe hem newe;
> And of the feld the lyllyes ffayre.[1]

The origins of this speech are obvious. But Deguileville by no means leaves the goddess Natura as he found her; and for the most part his treatment of her, if less beautiful than this, is more original. His conception of religion is fierce, colourless, and sincere. He is more concerned to exclude than to draw in; and one of the most important parts of his poem is the debate in which Grace Dieu overthrows first Nature, and then the human reason, which is represented by Aristotle. Natura thus becomes one of the enemies, and Deguileville sets about her in a manner which is sufficiently surprising. Her antiquity, which had charmed poets as long ago as Claudian's day— *vultu longaeva decoro*—is shamelessly twisted into a charge against her. As Grace Dieu drily observes

> ye wite wel
> Offte sithe ryot and age
> Putte folkys in dotage,[2]

and the rest of her speech is in keeping with the taunt. She rates Nature without mercy, extorts her abject submission, and sends her away with a harsh warning to mind

[1] Lydgate, *Pilgrimage*, 3448 et seq. [2] Ibid. 5528.

her own business and not to repeat her impertinence.
Since the subject under discussion is the miracle of the
sacrament, the allegorical intention is obvious, and perhaps
unexceptionable. But what is interesting is the poet's
handling of it. He is entirely in agreement with Grace
Dieu and represents Nature, at her first entry, as a mere
bustling and scolding old woman. The comic effect of the
passage is almost certainly intended, for the homiletic
tradition by no means excludes buffoonery, and, after all,
the poet is attacking the *Romance of the Rose* and wishes
to blacken one of its heroines:

> And thanne anon upon the pleyn
> I sawh a lady of gret age
> The which gan holden hir passage
> Towardys Grace Dieu in soth,
> And of her port irous and wroth,
> And her handys eek of pride
> Sturdily she sette a syde . . .
> She was redy for to strive,
> For anger did her herte ryve
> Atweyne.[1]

The conception is ignoble, and perhaps absurd; and I
am inclined to distrust that species of respect for the
spiritual order which bases itself on contempt for the
natural. Deguileville's doctrine that the soul is 'buried
quyk' in the body[2] looks back, in the long run, to pagan
rather than to Christian sources; and is of a piece with
his assertion that nature herself, as opposed to sin, ordained
that flesh and spirit should be at strife.[3] After this we are
not surprised to learn that Music is born of Pride and is
inimical to virtue. But these are questions of doctrine, and
they should not blind us to the vigour of his execution.
His picture of Nature is alive.

It is harder to defend the structural vices of the poem.
Its theme is substantially the same as that of the *Pilgrim's
Progress*, and every comparison between the two serves but

[1] Ibid. 3344 et seq. [2] Ibid. 9995.

[3] Ibid. 9455.

to emphasize the greatness of Bunyan and the weakness of Deguileville. Bunyan opens with a picture which prints itself upon the eye like a flash of lightning; and in a few pages he has his pilgrim started upon a journey as enchanting as any in romance. In Deguileville, of the twenty-four thousand odd lines which make up the poem, ten thousand have already passed before the pilgrim is allowed to set out. This monstrous delay is occupied by instruction and preparation, and is allegorical only in so far as much of it is put into the mouths of personifications. It is not true allegory, and might as well have been uttered by the poet in his own person. His characters, like those whom Aristotle condemns, utter 'not what the tale, but what the poet, desires'. And even when we are at last launched upon the spiritual journey, we travel towards an anticlimax. The pilgrim is kidnapped, dragged in the mire, bound, beaten, and left clinging to a rock in the midst of the sea: it is here that Grace Dieu appears as the *deus ex machina* and takes him on board her ship of 'religioun'.[1] With this rescue the poem ought to have ended. Unfortunately the poet continues to describe the pilgrim's career after his rescue, and makes it plain that the ship is unseaworthy and the rescue ineffective. The ship may bear him to a Cistercian 'castle'; but what awaits him there is rough handling from Envy and her crew, who succeed in breaking all his limbs, which is more than the vices of the outer world ever did to him.[2] Since all associations of human beings are imperfect, this picture of cloistered intrigue and corruption may not be a very strong practical argument against monasticism as an institution; but it is a fatal aesthetic argument against monasticism as the climax of a poem.

In the technique of allegory Deguileville is in places the worst writer with whom the present study will have to deal. Nothing is easier or more vulgar than to make allegories, if we are content with purely conceptual equivalences and do not care whether the product will

1 Lydgate, *Pilgrimage*, 22013 et seq. 2 Ibid. 23163.

satisfy imagination as well. But when they are made they are monstrosities, and of such monstrosities the *Pilgrimage* is guilty. Penance is represented with a besom in her mouth, or the Pilgrim is made to pluck out his eyes and put them in his ears.[1] When we read such things, we can almost excuse the last century of criticism for rejecting allegory root and branch as a mere disease of literature; but if we persevere we shall find even in Deguileville passages that restore our faith. The Pilgrim, newly clad in the armour of righteousness, finds that

> Yt heng so hevy on my bak
> I wolde fayn have lett yt be.[2]

and presently complains, from the interior of his suffocating panoply:

> Myn helm hath rafft me my syyng
> And take away ek myn heryng . . .
> Thes glovys binde me so sore,
> That I may weryn hem no more
> With her pinching to be bounde.[3]

Finally he is allowed to have his armour carried behind him in a cart while he himself walks free, in the hope— a hope which, of course, deceives him—that he will find time to put it on when the enemy appears.[4] The difference between embracing an ideal and acquiring a habit may seem to some (I am not among them) too obvious a point to justify this elaborate treatment. But it is by no means certain that any literal statement could bring it so vividly home to us. Certainly the sense of restraint, the belief that after all there must be an easier way, and the protesting misery, without which no man wins a good habit either in moral virtue or in a mechanic art, could hardly be better expressed than in the image of this comic, pathetic, all too human pilgrim and his armour. Nor does it stand alone. The vision of the crucifixion of the flesh, and the figure of Tribulation with his two commissions, one from

[1] Lydgate, *Pilgrimage*, 4013, 6577.
[2] Ibid. 8235–58.
[3] Ibid. 8203.
[4] Ibid. 8835, 13111.

God and one from Satan, are proper, and moving, employments of the allegorical method.[1]

The poet is so fierce and gloomy a man that we should look in vain in his work for any presentation either of the beauty of holiness or of the pleasures of sin. The severity of the one and the foulness of the other are his natural subjects, and the only relief he allows us is his grim humour. It is, indeed, on this limitation that the quality of his poetry depends: for he also has something of his own—a flavour or an atmosphere which is recognizable, though by no means ever present. The reader who wishes to taste this flavour, to know, as we say, 'what Deguileville is like', should read the central portion of the poem, where the Pilgrim contends with the seven deadly sins and the Devil himself.[2] Here he will find no Spenserian seductions on the one hand, and no Miltonic loftiness on the other. He will meet Venus, not in her youth and beauty, but old and crone-like and masked, riding on a sow. Venus and Gluttony together will knock him down and drag him in the mire, tied to that sow's tail. Pride will come to their aid, not 'tricked and frounced' as she is wont in other allegories, but as a hag riding pick-a-back on Flattery her subject-hag, and both 'ful owgly of ther syht'. The Pilgrim lies helpless while the whole chorus of witches—aged, obscene shapes, all female and all monstrous—stand over him and plot his death. Nothing is more characteristic of Deguileville's imagination than his continued insistence on the old age of these nightmare shapes. Well may he exclaim:

> Allas! what hap have I or grace!
> All they that I meet in this place
> Ben olde, echon.[3]

There is no effort to illustrate the subtleties of evil; but there lies over the whole passage a heavy squalor, a strangeness without glamour, and a disordered variety which

[1] Lydgate, *Pilgrimage*, 11960, et seq.; 15973–16211.
[2] Ibid. 12741–21657. [3] Ibid. 14005; cf. 14025, 22723, 23576

somehow contrives to be monotonous. We have no doubt of the author's desperate sincerity. But there is power also in his unrelieved picture of evil, of bewildered degradation, of nausea. Milton's or Dante's hell, superior as they are by innumerable degrees in art, yet do not come so near to the worst we can imagine. There we have grandeur, fortitude, even beauty; but Deguileville's vision is of the last evil—of something almost omnipotent yet wholly mean; an ultimate deformity. From this point of view (though of course from no other), if I had to mention a modern poet who affects us in something the same way as the blackest parts of Deguileville, I think I should choose Mr. Eliot.

How far such a passage redounds to the credit of the poet may be doubted. We cannot help wondering whether he knew how well he was writing. We may suspect that his very faults helped him as much as his art; that the squalor and the disorder are as much those of Deguileville as of his subject. But though we raise such questions, we cannot answer them. The state of mind which his work produces in us is all that we can record, for the state of the poet's mind can never be known.

The poem is unpleasant to read, not only because of its monstrous length and imperfect art, but because of the repellent and suffocating nature of its content. Yet in a way it is freer than the *Romance of the Rose*, in so far as the moral point of view is an abstraction less rigid than the erotic. It brings in more of our experience. And this widening in the allegorical subject is reflected in the literal content of the story. Dark as the world of the *Pilgrimage* is, it is at least a world in which we can go to seek adventures. We are not confined endlessly to the garden: the road and the resting-places, woods, seas, ships, and islands, distant cities and wayside meetings—these are the great contribution of Deguileville's poem.

It is, nevertheless, with heartfelt relief that we turn to *Les Échecs Amoureux*, or, as Lydgate's version is called, *Reason and Sensuality*. A better antidote to Deguileville

could hardly be devised, for here, while we find once more the new variety of incident and increased romanticism of plot which are proper to the fused allegory, we find also what the reader who has just finished the *Pilgrimage* so badly needs—sunshine and charity.

The story is as follows. As the poet lies between sleep and waking on a spring morning, Nature in all her brightness appears before him, filling his bedchamber with the smell of amber and rose, and thus addresses him: 'Arise and betake yourself to virtuous activity. Prove all my works and see if there be any flaw in them—yet all this beauty was made for you alone. Be worthy, Man, of your dominion.' And he asks, 'Where shall I go?' 'Learn,' says Nature, 'that there are two roads. The road of Reason, beginning in the east, runs westward all about the world and so returns again to the east; but that of sense rises in the west, and though it leads eastward, to the west it comes again at last. To follow the first of these is the prerogative of man who alone among the beasts

> hath intelligence
> To make his wit to encline
> To knowe things that be divine,
> Lasting, and perpetual,
> Hevenly and espirituel,
> Of heven and of the firmament
> And of every element;
> Whos wit is so clere yfounde,
> So perfyt pleynly and profounde
> That he perceth erthe and hevene
> And fer above the sterris sevene.'[1]

With these words the goddess vanishes, and the dreamer rises and goes out into the spring morning, where he soon loses his way. So indeed does the author, and wantons in descriptions which might be called prolix if the theme itself, the relaxed and boundless sweetness of vernal nature 'wilde above rule or art', did not condone and

[1] *Reson and Sensuallyte*, 742 et seq.

invite delay. The thing, so often well done in medieval poetry, has never been done better, and the reader pauses gladly to notice how

> The freshnes of the clere welles
> That fro the mountes were descended,
> Which ne mighte be amended,
> Made the colde silver stremes
> To shine ageyn the sonne bemes;
> The rivers with a soote soune
> That be the wallys ronne doune . . .[1]

It seems but natural, not only to those who love Plato but to those who love poetry also, that the young man, so solicited by ear and eye, should forget the high pre-natal charge of *Natura*,

> That al my lyf which passed was
> Was clene out of my remembraunce.[2]

As he wandered, four celestial shapes approached him. Mercury was the leader, who came on an errand from Jove,[3] presenting Minerva, Juno, and Venus for his judgement, as once he had done to Paris. Though Minerva offered him wisdom and Juno wealth, he gave the prize to Venus, and forthwith found himself alone with her; for Pallas and Juno incontinently vanished, and Mercury, observing with a shrug that 'al this worlde goth the same trace', shook his wings and was off. What follows marks well the difference between a purely decorative allegory and an allegorical picture of real life. Venus is ready enough to promise the youth a mistress as fair as Helen, but the youth remembers Nature's bidding sufficiently to be uncomfortable. As he explains to Venus, he is not quite his own man. He has promised Nature to travel by

[1] Ibid. 934 et seq.
[2] Ibid. 970.
[3] For the *significacio* of this—and, indeed, of the gods wherever they appear in medieval poetry—see the very important marginal gloss ibid. 1029: 'Jubiter apud poetas accipitur multis modis; aliquando pro deo vero et summo sicut hic . . . aliquando capitur pro planeta, aliquando pro celo, aliquando pro igne vel aere superiori, aliquando eciam historialiter accipitur pro rege Crete'.

the road of reason and to fly sensuality. But he would not
disoblige Venus either,

> And for that I am lothe toffende
> To you or hir by displesaunce,
> I hang as yet in ballaunce.[1]

—an admission which leaves to Venus the obvious reply
that she is Nature's most intimate friend and indispensable
ally, and that no question of divided loyalties need arise.
In the end the dreamer becomes 'her man', and the reader
begins to feel some apprehension lest once again the com-
mandments of Love are to be enumerated. But the poet
knows better. His Venus, instead of commandments, has
good news of a far country to deliver, and tells him of
the goal to which he must set out—the garden of her two
sons, Cupid and Deduit. The passage is interesting as an
interpenetration of courtly and homiletic allegory, with
the happiest results. The lover, like the Christian, be-
comes a traveller, and Love's garden, like the Celestial
City, comes at the end of his story instead of the beginning.
Before she leaves him, Venus fixes the right direction by
pointing out to him the battlemented tops of Cupid's
castle in the distance—a graphic touch not unworthy of
Bunyan.

The young man has not gone far on his journey before
he enters a large forest; a place 'wonder fair and delytable'
where the tall trees send forth a wholesome smell and
golden fruit hangs beneath their unwithering foliage. It
is the home of Diana, who at first refuses to speak to him
because he is Venus' servant, but presently relents and
warns him of the dangers of his enterprise. 'You have been
duped by that goddess', she says, 'whose very name means
venom,

> For thou hast noon experience
> Of hir large conscience![2]

The garden to which she is leading you is full of perilous
sirens, and of beds more enchanted "than was the bed of

[1] *Reson and Sensuallyte*, 2254. [2] Ibid. 3495.

Launcelot". There are trees yonder whose shadow kills a man, and wells where he can drown like Narcissus. Turn back. Enter it not,

> But abyde and make arest
> Her with me in my forest
> Which hath plentevous largesse
> Of beaute and of fairenesse;
> For shortly through my providence
> Her is noon inconvenience,
> No maner fraude, deceyt, nor wrong
> Compassyd by Sirens songe . . .
>
> And ther thou shalt no welles fynde
> But that be holsom of her kynde,
> The water of hem is so perfyte
> Who drinketh most hath most profyte.
> Eke in thys forest vertuous
> No man taketh hede of Vulcanus.'[1]

The Diana of this poet is a complex, as well as a gracious figure, of closer kin to Spenser's Belphoebe than to the abstract 'Chastity' of the pulpit. Virginity, indeed, is her profession; but she can also praise faithful loves, and it is part of her complaint against Venus that love nowadays is not as it was when Arthur reigned, when famous warriors loved gentlewomen of high degree 'nat but for trouthe and honeste', and for their sakes put life in jeopardy in 'many unkouth straunge place'.[2] Yet her Hesperean forest, in the poet's main intention, probably symbolizes the conventual life, and his hero condemns it as being, for all its beauty, too 'contemplatyfe'. If so, it is a lesson in allegory to compare this representation of 'religioun' with that of Deguileville. There we have a castle, in which we meet such characters as Lady Lesson and Wilful Poverte: here, a pagan goddess, with bow and quiver, stands in glittering attire amidst a forest out of fairyland, and discourses upon heroes of old romance. In the prosaic sense it is obvious that Deguileville's picture is very like the thing symbolized, while that in *Reason and Sensuality* is, in the same sense,

[1] Ibid. 4355 et seq. [2] Ibid. 3141-214.

not like it at all. But if we look deeper, if we attend, as in poetry we always should attend, not to the objects mentioned in the passage but to its quality and atmosphere, its immediate flavour, so to speak, upon imagination's palate, we see that Deguileville has effected nothing, where his rival has called up for us the eternal appeal of virginity, retirement, and contemplation. The one deals with a doctrine, a superficies; the other with a spiritual solid.[1]

To the speech of Diana the traveller retorts by quoting Nature's original command 'go, se the world', and will not heed the reply that he has misunderstood it. The phrase is happily chosen, for it is made clear that the young man wishes to 'see the world' in many senses. As this poet's Diana is something more than chastity, so his hero is more than an abstract lover. He is obstinate youth in all its aspects, and love, though his chief, is not his sole, preoccupation. He feels the thirst that Marlowe's heroes were to feel, and longs for

> the knowleching
> Of the heven and his meving
> And also of the salte see,
> And eke what thing it mighte be,
> Why the flood, as clerkys telle
> Folweth with his wawes felle,
> And after that the ebbes sone
> Folweth the concours of the Mone.[2]

His final rejection of Diana, when, beaten out of all his guards yet impenitent, he determines to see the garden of Deduit for himself, is expressed in terms exquisitely natural:

> Thogh yt were as mortal
> As horryble and foule also
> As is the paleys of Pluto,
> And as ful of blak derkenesse,
> Of sorwe, and of wrechchidnesse,
> Yet finaly, how ever it bee
> I shal assayen and go see . . .
> It semeth a maner destiny.[3]

[1] I owe this metaphor to Coventry Patmore.
[2] *Reson and Sensuallyte*, 4611 et seq.
[3] Ibid. 4748 et seq.

The verse (which, after all, is Lydgate's) may halt, and perhaps the images are ready made; but the psychology is excellent.

At this profession of invincible secularity, Diana 'took the thykke of the forest' and was seen no more. The hero, full of 'joy and plesaunce' continued his journey to the walls of the happy garden, where the poet pauses to praise the *Romance of the Rose* as an incomparable work of 'philosophie' and 'profounde poetrie'. The figures on the Wall, the portress, and the beauties of the garden are described, and the rest of the poem, so far as Lydgate has translated it, is occupied with an allegorical game of chess. The poem at this stage is still readable, but the inspiration of the earlier parts has disappeared. There is much satire on women here, which depends on the simple device of attributing to them all those virtues which tradition notoriously denies them; whether it is Lydgate or another who made assurance doubly sure by adding *cujus contrarium est verum* in the margin, I have not been at the pains to inquire.

This poem, in its truncated English form, is one of the most beautiful and important pieces produced between Chaucer's work and Spenser's. The historian will notice that it represents a far fuller and happier fusion of the moral and the courtly allegory than Deguileville. The author is no partisan; he gives us a balanced, even a detached, picture of the mingled yarn of human experience. The allegory, in his hands, is beginning to forget its origins in the pulpit and the courts of Love, and to feel its way towards the treatment of 'general nature'. The aesthetic critic may care nothing for tendencies and influences; but he too should remember the poem, for the unearthly freshness of Diana's forest, and for the shining and exuberant vitality of those early passages where the earth

> made him faire and fresh of hewe
> As a mayde in hir beaute
> That shal of newe wedded be,[1]

[1] Ibid. 150.

and perhaps even more for the lofty platonizings in this description of Nature's robe,

> Ther was wrought in portreyture
> The resemblaunce and the figure
> Of alle that unto God obeyes,
> And exemplarie of ydeyes
> Full longe aforn or they weren wrought
> Compassed in divine thought;
> For this Lady, freshest of hewe,
> Werketh ever and forgeth newe
> Day and night in her entent
> Weving in her garnement
> Thinges divers ful habounde,
> That she be nat naked founde.[1]

The *vis medicatrix* of Nature herself has passed into the poet's imagination. He pipes as if he would never be old, and his lines are a sovereign antidote either to Renaissance fever or modern discouragement.

In both these poems we trace the beginnings of a new kind of allegory. When I say that this impulse is continued in the work of such poets as Hawes and Douglas, I do not mean that I can prove an 'influence' or draw up a list of 'parallels'. It is not a question of a literary school, of models and imitations, but of an unconscious tendency, given no doubt in the whole state of mind at that period rather than in its literary ideals, whereof all these later allegories are in varying degree symptomatic. So in our own days, the growing popularity of the imaginative and satirical biography depends less on literary discipleship to Strachey than on a widely spread attitude of whimsical scepticism towards established reputations—an attitude whose causes are perhaps outside literature altogether.

The first of these authors with whom I shall deal is Stephen Hawes; and Hawes for our purpose means the *Pastime of Pleasure* and the *Example of Virtue*. The *Pastime* is a difficult work to judge. Read it conscientiously from cover to cover, and you will conclude that it is the

[1] *Reson and Sensuallyte*, 357 et seq.

heaviest of tasks; but then from such a reading something will cling to your memory—odd lines, odd scenes, a peculiar flavour—till you are driven back to it, to find that its faults are just as grievous as you first supposed but that its merits are greater. No poem gives us the impression of so wide a gap between its actual achievement and the thing it might have been. There is a kind of floating poetry in the author's mind but not in his grasp. He seems ever on the point of becoming much better than he actually is. Nor is it very wonderful that this should be so, for Hawes, stumblingly and half consciously is trying to write a new kind of poem. He himself believes that he is trying to revive an old kind: the praise of Lydgate is often on his lips,[1] and he deplores the direction in which poetry is moving in his own time:

> They fayne no fables pleasaunt and coverte
> But spend their tyme in vainfull vanyte
> Makynge balades of fervent amite.[2]

Like Caxton, he wishes to revive the 'floure of chyvalry which 'hath be longe decayed'.[3] But this illusion, whereby the mind posits in the past the desired thing which is really still in the future, is not unnatural, and its working explains the early history of Romanticism in the eighteenth century, when men like Walpole and Macpherson not only sought, but even invented, in the past, faint images of the poetry which was really to be written in the nineteenth century. The combination of allegory on the large scale and chivalrous romance which Hawes wants to revive, could not be revived because it had not existed. There had been some approach to it in Deguileville: but Hawes carries it much further, and we shall not find the thing in perfection till we reach *The Faerie Queene*. Hawes in the meantime moves about in worlds not realized. He has very little art and his poem is dark and tortuous, but a fitful wind of inspiration stirs in the darkness. He so

[1] *Pastime of Pleasure*, ed. W. E. Mead, E.E.T.S., 1928, 48, 1163, 1373.
[2] Ibid. 1389. Ibid. 2985.

misunderstands the original of allegory that he thinks its purpose is to hide the subject—'to blowe out a fume' are his own words;[1] but one of the reasons why he thinks so is his native and by no means unpoetic bent for the indefinite and the allusive—in a word for the romantic vague. Before his pilgrim finishes his journey and wins La Bell Pucell we have that journey so frequently predicted that all suspense is lost; but then suspense is no part of his aim, and this constant pressure of the remote and unattained—this continual hinting and casting forward (*ripae ulterioris amore*)—is of the very nature of one kind of romance.

> By the way there ly in wayte
> Gyauntes grete dyffygured of nature—
> But behonde them a grate see there is
> Beyonde which see there is a goodly lande
> Moost full of fruyte, replete with Joye and bliss—
> Of ryght fyne golde appereth all the sande.[2]

So speaks Lady Fame to the youthful Graunde Amour, and the lines are good poetry because they lead the mind on and open the doors of the imagination: and good allegory, because to be young and to look forward is, after all, very like hearing what Graunde Amour heard. And if the same journey is foretold again a couple of hundred lines later—this time the hero sees it pictured on a wall—even this has its own sense of mysterious fatality and its own truth to life. As we proceed the allegory becomes more difficult. I have not been able to find the *significacio* in the repeated partings of the hero and heroine, and perhaps there is none. Perhaps Hawes himself would have been neither able nor willing to throw much light on the deeper obscurities of his poem. He loves darkness and strangeness, 'fatall fictions, as he says, and 'clowdy fygures' for their own sake; he is a dreamer and a mutterer, dazed by the unruly content of his own imagination, a poet (in his way) as possessed as Blake. It is at once his strength and

[1] Ibid. 40. [2] Ibid. 260 et seq.

his weakness that he writes under a kind of compulsion. Hence the prolixity and frequent *longueurs* of his narrative, but hence also the memorable pictures, whether homely or fantastic, which sometimes start up and render this dreariness almost 'a visionary dreariness'.

> I sawe come rydynge in a valaye ferre
> A goodly lady envyroned aboute
> With tongues of fyre as bryght as ony sterre.[1]

> I came to a dale.
> Beholdynge Phebus declynynge low and pale,
> With my grehoundes in the fayre twylight
> I sate me downe,[2]

> And on his noddle derkely flamynge
> Was sette Saturne pale as ony leed.[3]

> Eternity in a fayre whyte vesture. . . .[4]

> We came unto a manoyr place
> Moted aboute under a wood syde.
> 'Alight', she sayd, 'For by right longe space
> In payne and wo you dyde ever abyde;
> —After an ebbe there cometh a flowynge tyde.'[5]

Indeed, all the resting places on the journey of Graunde Amour are good; and all the roadside twilights and dawns,

> Whan the lytell byrdes swetely dyde synge
> Laudes to theyr maker erly in the mornynge.[6]

Much that he describes does not interest us, but he describes nothing that he has not seen, whether with the inner or the outer eye. He has noticed the morning sky coloured like curds,[7] and the 'bypaths so full of pleasaunce,'[8] the little images of gold moved with the wind on the top of the tower of Doctryne,[9] and the sun shining, as a man wakes, in the mirror of a strange bedroom.[10] Some medieval writers have little feeling for the difference between combat with a man and combat with a monster;

[1] Ibid. 155. [2] Ibid. 326. [3] Ibid. 5618.
[4] Ibid. 5748. [5] Ibid. 4648. [6] Ibid. 4499. [7] Ibid. 62.
[8] Ibid. 116. [9] Ibid. 365. [10] Ibid. 1956.

but when the three-headed giant crosses the path of Graunde Amour

> My greyhoundes leped and my stede dyde sterte,[1]

and he is as meticulous as Spenser in telling us how many cartloads the giant's corpse measured.[2] So clear is his vision, so perfect his poetic faith in his own world, that the poem ought to be good; but his incapacity to select, his stumbling metre, and his long delay in the tower of Doctryne, have condemned him to not undeserved obscurity.

The *Pastime* is not exclusively an allegory of love, but of life as a whole, with special emphasis on love, education, and death. The educational sections in which Hawes vainly endeavours to rival the allegorico-encyclopaedic work of Martianus Capella or Jean de Meun, are the dullest part of the poem. With the possible exception of the fine passage on grammar

> (By worde the worlde was made oryginally:
> The Hye King sayde: it was made incontient).[3]

none of his presentation of the liberal arts deserves to be re-read. Much more interesting is his treatment of love. No poet whom we have considered is more homely—if you insist, more Victorian—than Hawes, in the context which he imagines for the passion. Not only does Graunde Amour look forward to marriage as the only conceivable form of success: he even hesitates over the inequality in wealth between himself and his mistress, and is reassured by *Counseyle* (who here fills the role of Frend, or Pandarus) that 'she hath ynoughe . . . for you both'.[4] The Lady, on her part, answers to his suit that she is 'sore kept under' by her 'frendes'[5] who 'wolde with me be wrothe' if they heard of his proposal.[6] This is the work-day world with a vengeance, and it might seem that we were within easy distance of the commonplace of Nevill; but then the Lady's very fear that her relatives will lead her 'to a ferre

[1] *Pastime of Pleasure*, 4312. [2] Ibid. 4433. [3] Ibid. 603.
[4] Ibid. 1857. [5] Ibid. 2203. [6] Ibid. 2368.

nacyon' (*ferre* is a key-word in Hawes) and his answering promise that he will follow

And for your sake become adventurous[1]

are essentially romantic. And if Hawes is prosaic in the context of his love, on the subjective side he is all on fire, 'wrapped,' as he says, in a 'brennynge chayne'.[2] He is far indeed from the unambiguous desire of Guillaume de Lorris, or the heroical passion of Troilus: the fire of his love is a dim fire, charged with sentiment and imagination, a thing much more ambiguous and brooding, in a word more romantic, than that of older love poetry. It is a cloudy ecstasy, love veritably in a mist, a dream or a glamour and none the less for that reason a reality; and he writes of it lines which are irreplaceable in the sense that no other poet has struck just the same note.

> She commaunded her mynstrelles ryght anone to play
> *Mamours*, the swete and the gentyll daunce.
> With La Belle Pucell, that was fayre and gaye,
> She me recommaunded with all pleasaunce
> To daunce true mesures without varyaunce.
> O Lorde God! how glad than was I
> So for to daunce with my swete lady!—
>
> For the fyre kyndled and waxed more and more,
> The dauncing blewe it with her beaute clere.
> My hert sekened and began waxe sore;
> A mynute six houres, and six houres a yere
> I thought it was.[3]

But it is Hawes' treatment of his third theme, the theme of death, which is most remarkable. Critics have been found to whom it is merely ridiculous that a narrative written in the first person should continue after the narrator is dead and thus permit him to describe his own decease. But the convention whereby the dead are allowed to speak, or the living to assume the person of the dead, is surely not a very difficult one: the Greek anthology,

[1] Ibid. 2298. [2] Ibid. 1768. [3] Ibid. 1583–1603.

and the first country churchyard you turn into, will
supply precedent. And if you object that dead men do
not really talk—and I can see no other objection—you
will be well advised to study any subject rather than
poetry, where the naïve realist can never succeed. So
much suspension of disbelief as this device demands, is
our debt to every poet; and to Hawes, for a special reason,
the debt is very easily paid. For even from the outset—
perhaps because his imagination is so earnest and his
conscious skill so weak—the good passages have had this
peculiar quality, that they seem to come from nowhere,
to be a disembodied voice, not always a perfectly articu-
late voice, coming to us out of a darkness; so that when,
at last, it comes to us admittedly from the grave, it at once
compels belief.

> O mortall folk, you may beholde and se
> How I lye here, somtyme a myghty knyght.
> The ende of Joye and all prosperite
> Is dethe at last through his course and myght;
> After the day there cometh the derke nyght,
> For though the day be never so longe
> At last the belles ryngeth to evensonge.[1]

Every one knows this stanza: but few know that it comes
at the end of a dirge sung by the Seven Deadly Sins in
which the reiteration of a single phrase ('erthe of erthe')
has all the brutal insistence of a bell heard from within the
church, and that dirge and epitaph together are merely
the starting-point for one of the most nobly conceived
passages in any allegory. For when his hero lies dead and
the poem might be expected to end, Hawes does a most
surprising thing; he rolls up curtain after curtain of his
cosmos, as the successive backcloths roll up in the trans-
formation scenes of the old pantomime, or as the planes of
time disclose themselves in Mr. Dunne's serial universe.
Remembrance has hardly finished the epitaph over the
grave of Graunde Amour when Dame Fame enters the

[1] *Pastime of Pleasure*, 5474.

temple to enroll him among the Worthies, and to conclude with her vaunt

> Infenyte I am. Nothing can me mate.[1]

and here again we suppose we are at the end: it is a familiar consolation at the funerals of great men. But no —on the heels of Fame comes another shape, the same on whose 'noddle' the dark flame of Saturn was set, and whom we quickly recognize by the horology in his left hand, and who proclaims himself,

> Shall not I, Time, dystroye bothe se and lande,
> The sonne and mone and the sterres alle?[2]

But Time is wiser than Fame and boasts less, and comes confessedly but as the usher of Eternity—Eternity who ends the poem, appearing in her white vesture and triple crown,

> Of heaven quene and hell empres.[3]

If the execution of this whole passage had been equal to the conception, it would have been among the great places of medieval poetry. It is not; but we must still say (more reasonably I hope than Goethe said of another poem) 'how nobly it was all planned'.[4]

His other allegory, *The Example of Virtue*, for some reason lacks the faint, peculiar appeal of the *Pastime*. It is a simpler and shorter poem in which Youth, after some good adventures, but also after assisting at a very dull *débat* between Nature, Fortune, Hardiness and Wisdom, changes his name to Virtue and marries Cleanness. Perhaps the most interesting character in the poem is this lady's father, the King of Love. His name prepares us for a picture of Cupid and Cupid's court: but the old Cupid could hardly have had Chastity for his daughter. And as we approach his castle and find that we are cut off from it by a swift river spanned with the traditional perilous

[1] Ibid. 5604.
[2] Ibid. 5635.
[3] Ibid. 5753.
[4] See Note on p. 296.

bridge—'not half so broad as a house ridge,[1] and that this bridge bears the legend

> No man this bridge may overgo
> But he be pure without negligence
> And stedfast in God's belief also.[2]

we begin to doubt whether he is not meant for the King of Love in a very different sense. Cleanness appears on the far side of the river encouraging the hero much after the style of *Perl*. But when at last we meet the King,

> (At the upper end of the hall above
> He sat still and did not remove,
> Girded with willows),[3]

he turns out to be very like Cupid after all—blind, winged, naked, and armed. But when he tells the wooer that none shall have his daughter's hand who does not 'scomfit the dragon with heads three',[4] (which are the World, the Flesh, and the Devil), and when the wooer arms himself for this adventure in the Pauline armour of a Christian man, then again we are thrown back on some celestial Cupid. The truth is that we have reached a point at which Hawes does almost unconsciously what Dante or Thomas Usk did by an arduous conceit; the sort of unification or ambiguity (it is not a mere critic's business to decide) on which Spenser's sixty-eighth sonnet is based, has already become natural.

Two passages in the poem are memorable. The first is the poet's shocking interview with Nature:

> Methought she was of marvellous beauty
> Till that Discretion led me behind,
> Where that I saw all the privity
> Of her work and human kind;
> And at her back I did then find
> Of cruel Death a doleful image.[5]

[1] *Example of Virtue*, printed (with modernized spelling) in Arber's *Dunbar Anthology*, London, 1901, pp. 217 et seq.

[2] Ibid., st. 179. [3] Ibid., st. 182.

[4] Ibid., st. 192. [5] Ibid., st. 71.

This is not merely a conventional exercise in late medieval gloom, for in the same passage the poet forces us to attend also to Nature's beauty and fecundity.

> a fair goddess
> All things creating by her business[1]

and working 'withouten rest or recreation.[2] Either side of the picture, alone, would be a commonplace; the synthesis of the two awakes a much deeper response. The second passage is a lovely example of the convincingness of Hawes. After a night journey in a great wilderness the traveller finds himself in a desolate place full of wild beasts. Any allegorist might have done this, but perhaps only Hawes, or only one of those far greater poets who share Hawes' matter-of-fact faith in their imaginary worlds, would have added that he knew by the sweet smell that there was a panther somewhere near.[3]

Gavin Douglas is so much of an individual, and so much more of an artist than Hawes, that I do him some wrong in citing him as the illustration of a general tendency at all. But though his allegories are distinctly his own and need no historical significance to recommend them to the lover of poetry, they have in common with their period the widened scope and the increasing imaginative liberty. Their great distinction is the artistic control, the disciplined splendour of style, the proportion and balance, in which the medieval Scottish writers so often excel the English. *King Hart*, especially, is an admirably ordered little work which ought to rejoice the heart of a French critic. Its content represents the fusion of erotic and homiletic allegory to perfection. The real theme is that of Youth and Age, and the fable tells how the Soul, long captive to beauty and pleasure, is at last awakened by age, deserted by the brisk companions of its youth, forced to return to its own long-abandoned dwelling-place, and finally defeated by death. The poem thus has an obvious affinity with the *Confessio Amantis*, and a more recondite

[1] *Example of Virtue*, st. 70. [2] Ibid., st. 72. [3] Ibid., st. 160.

and subtle affinity with *Beowulf*—which is well brought
out when the poet, describing the foul water of Corrup-
tion in the moat of King Hart's castle which is rising and
lapping upward 'gre by gre' against the walls, adds the
fact that

> thai within maid sa grit melody
> That for thair reird thay micht nocht heir the sound.[1]

It is, of course, a theme which easily becomes platitu-
dinous; but good allegory (next to the style of Johnson)
is the best way of reviving to our imaginations the grim
or delightful truths which platitude conceals, and the
whole of this poem marches impressively, in the words of a
later poet,

> To the small sound of Time's drum in the heart.

As in *Beowulf*, the end is felt from the beginning, and the
very brightness of the first stanza gives us the disquieting
sense of weather that will not last:

> So semlie was he set his folk amang
> That he no dout had of misaventure,
> —So proudly wes he polist, plane and pure
> With youthheid and his lustie levis grene,
> So fair, so freshe, so liklie to endure—[2]

The adventures of King Hart during his long sojourn in
the castle of the Lady Pleasance are good radical allegory
of love, and truer to the original *Rose* pattern than any-
thing we have met since the fourteenth century. Hart and
his companions are thrown into a dungeon with Danger
for their jailer, and there

> Full oft thai kan vpone Dame Pietie cry,
> 'Fair thing, cum doun a quhyle and with vs speik!'[3]

and it is only when Danger sleeps that Pity is able to grant
their request, and thus to make Hart in the end the master
of his captor. But the whole of this traditional passage is

[1] *King Hart*, i., st. 10. [2] Ibid., st. 1.
[3] Ibid., st. 43.

new-coloured because it is set between Hart's gay, un-suspecting youth in his own castle and the hour when Age arrives:

> Ane auld gude man befoir the yet was sene
> Apone one steid that raid full easelie.
> He rappit at the yet but courtaslie,
> Yit at the straik the grit dungeon can din[1]

The contrast between the gentle knocking (the *small* sound of Time's drum) and its appalling repercussions is a fine specimen of the complex appeal of good allegory. With-out its *significacio*, taken as a purely magical event in a romance, it is already the kind of contrast that calls to something deeply lodged in our imagination, and is always potent, whether for laughable or horrifying effects, when used on the stage. Add the *significacio*, by remembering the vast emotional disturbances which that small sound has sometimes produced in your own experience, and its potency is doubled: and then go on to remember (as poetry of this kind will force you to do) the innumerable experi-ences of quite different kinds in which the same small knocking without produces the same convulsions within, and you will find that this seemingly facile piece of alle-gory is a symbol of almost endless application, to use which is to come as near as our minds can to the concrete experi-ence of a universal. The same may be said of the scene in which Hart returns to his own deserted castle. How well the image fits the experience of coming back to a man's own interests and earliest bent of nature after the long constraint imposed by some passion! But the passion need not be love, the return need not be repentance; the symbol, consciously intended for one kind of return, fits all, and gives *in concreto* a characteristic of our life so fundamental that if you try to conceive it (instead of imagining it) it will escape you by its very abstraction. *King Hart* is not a good poem for a sick or sorry man to read, but if any one dismisses it as a frigid or conventional work he must have

[1] Ibid. ii. 2.

little feeling for reality. It strikes home where the screaming exaggerations of Blair (dare I add, of Donne?) on the same theme, go harmlessly over our heads.

The Palice of Honour is a much more elaborate, and also a more cheerful, poem. The theme, if I have understood it aright, may be expressed in Milton's words (Fame is no plant that grows on mortal soil, &c.) and the poet would set before us the mild paradox that so seemingly mundane a good as Honour can be conferred in its true form only by God and enjoyed only in eternity. The *Anagnorisis*, so to speak, of the allegory, comes at the moment when the palace of Honour, long heard of and sought for, turns out to be the dwelling-place of God; and the whole point of this passage depends, oddly enough, on the language Douglas used. When the pilgrim is allowed to peep through the keyhole of Honour's hall (like the page at the 'whummil bore' in the ballad) he sees, seated bright amidst the almost unbearable brightness of the place 'ane god omnipotent';[1] modern English, compelled to choose between the rendering *one God* and *a god*, inevitably destroys the careful equivocation, a kind of intellectual pun, on which the force of the original depends.

This conceit, though perhaps not very profound, is the nerve of the whole allegory, and it is enough to show that the *Palice*, even from the strictly allegorical point of view, is by no means contemptible. But unless the *significacio* throughout has escaped me, the poem as a whole illustrates the furthest point yet reached in the liberation of fantasy from its allegorical justification. Douglas is no dreamer like Hawes, for he is not the servant of his dream, and he writes with a clear head and a learned and practised pen; but what he describes is sheer wonderland, a phantasmagoria of dazzling lights and eldritch glooms, whose real *raison d'être* is not their allegorical meaning, but their immediate appeal to the imagination. The success of the poem depends on his poet's privilege of being awake and asleep at the same time, drawing on the dreaming mind

[1] *Palice of Honour*, iii, st. 71.

for his material without for one moment losing his power of selection or the matter-of-fact realism which compels our acceptance. In the midst of the ominous wood he tells us that 'the stichling of a mouse out of presence' would have terrified him.[1] Caught by Venus' courtiers, and mindful of other goddesses who have punished their victims by turning them into beasts, he tells us how

> Oft I wald my hand behald to se
> Gif it alterit, and oft my visage graip.[2]

The horses 'shynand for sweit as they had been anoynt,[3] the sea-nymphs 'dryand thair yallow hair',[4] and the Muses 'yonder, bissie as the beis'[5] in their garden, are admirable examples of this mixed fantasy and realism. But this liveliness is never allowed, as it sometimes is in Chaucer, to extinguish mystery and glamour. The very opening of the dream ('Out of the air come ane impressioun'[6]) is an invitation to enchantment. The howling wilderness beside the river, where the fish 'yelland as elvis shoutid',[7] into which the poet wakes in his dream, may represent the dangers and desolation of man's birth into the world of nature; or again, it may not. But who cares? To miss such a point in the *Romance of the Rose* would be to miss nearly all; but in this poem the shouting fish and the wood full of decaying trees and 'quhissilling wind' really exist in their own right. The weird energy of the description—rattling with broad Scots words of the *boisteous* style—and the careful contrast between this and the spring morning described in the Prologue, satisfy us completely. The inconsequence of the figures hithering and thithering as the narrative proceeds hits off exactly the sense of freedom combined with uneasiness which is proper to such dreams; and the sense of space, almost of infinity, which they bring, is well

[1] Ibid. i, st. 20.
[2] Ibid. i, st. 68.
[3] Ibid. ii, st. 52.
[4] Ibid. iii, st. 63.
[5] Ibid. iii, st. 87.
[6] Ibid. Prol., st. 12. The effect on the modern reader is, I take it, only partly due to our loss of *impressio* as a scientific term.
[7] Ibid. i, st. 3.

evoked by the words which Sinon and Achitophel shout over their shoulders to the poet as they pass,

> To the Palice of Honour all thay go;
> —Is situat from hence liggis ten hunder,
> Our horsis oft or we be thair will founder.
> A dew! we may na langer heir remane.[1]

The catalogues, no doubt, are an obstacle to the modern reader's enjoyment: but such obstacles will be found in all works outside our own period—slaughters in Homer, ritual in Ovid, vocal gymnastics in the old operas, which time has dulled for us. Their most profitable use is when they set us speculating which features in contemporary masterpieces are likely soonest to become similar dead-weight.

Douglas, in one sense, is not nearly so close to Spenser as Hawes is. The quality of his fancy is at once brighter and more terrifying. He is 'eldritch' where Spenser uses a solemn gloom, and full of hard light where Spenser is voluptuous. The whole difference between the air of Edinburgh and the air of Southern Ireland divides them. But if we are classifying by degrees of merit, then doubtless the *Palice* is much nearer to *The Faerie Queene* than Hawes' work is to either.

The chapter would be incomplete without some reference to a follower of Douglas, John Rolland. His *Court of Venus*, printed in 1575, is a book which has had few readers. Its 'haltand verse'[2] (which the author twice acknowledges) and its excessively dull prologue, are likely to deter any student who is not supported by some historical interest. To recover, at this time of day, the taste for its peculiarly Scottish and medieval blend of gallantry, satire, fantasy, and pedantry is all but impossible; and a full enjoyment of it presupposes that familiarity with legal technicalities which was for so long

[1] *Palice of Honour*, i, st. 15, 16.
[2] *Court of Venus*, ed. The Rev. W. Gregor, Scottish Text Society, London, 1884, Prologue 279, and iv. 740.

an essential part of Scottish culture. Our best chance of
approaching it with sympathy is to imagine how the Baron
of Bradwardine might have enjoyed it: for if the Baron,
why not Scott?—and from Scott it is no long journey
to ourselves. As an allegory it is nearer to Guillaume de
Lorris than to Machault or Chartier in so far as the core
of it is an allegorical action and not a mere complaint. It
opens indeed with a debate, such as we have learned to
dread, between Esperance and Desperance; but this only
leads up to the moment at which Esperance faints at the
arguments of his companion and thus exposes the latter
to the wrath of Venus. The goddess appears, revives her
champion, and on the advice of her 'greit advocat' Themis
instructs Nemesis to serve Desperance with a summons.[1]
The second book is occupied with Desperance's attempts
to get counsel to defend him and his final success in retain-
ing Vesta. The third and fourth give us the trial, in which
he is convicted but finally pardoned and re-converted to
the service of Venus. The allegory is coherent and reason-
able, but even this abstract is enough to show that it is
slight: and if the poem, despite its faults, has a certain
interest, this is once more because the interest lies in other
things for which the allegory is only the pretext. The first
of these is the realistic presentation, in some degree satiric,
of the contemporary legal world; and in this respect the
Court of Venus is a close parallel to the *Assembly of Ladies*.
The passage in which Nemesis presents poor Desperance
with his summons is lively and obviously true to life. He
wants a copy of it for his own use: and Nemesis would be
quite prepared to give him one *gratis* if he were not

> repugnant
> To Venus Quene and to hir court obstant.[2]

As it is, he can have one only by paying for it: and they
fail to agree on the price. The trial scene is naturally more
difficult to a layman: but all of us can relish Vesta's objec-
tions to the jury, and still more the picture of the jury

[1] Ibid. i. 641–929.　　　　[2] Ibid. i. 896.

retiring 'Richt stupefact cause the mater was hie'.[1] When
they got to their room,

> First doun they kest Moyses Pentateuchon
> With his storyis, and Paralipomenon

and so forth for twenty-five lines.

The other interest I should venture, once again, to call
that of romance, if the word were less ambiguous. The
presence of this element in Rolland is much less certain
than in Douglas and Hawes, and many readers might deny
it altogether. Perhaps fantasy or extravaganza would be a
better word. Certainly, by whatever name we call it, there
is something in Rolland's second book which brings us
near sometimes to *The Faerie Queene* and sometimes to
The Water Babies or to *Alice in Wonderland*. Here, as in
Douglas, we have a widening and deepening of the alle-
gorical *terrain*—a tendency, still faint, but recognizable,
to shift the interest from the personifications to the whole
world in which such people and such adventures are
plausible. The second book of the *Court of Venus* is, as it
were, a land with an air of its own which we remember,
and which we should recognize if we met it again in a
dream or in another book. What complicates the issue—
though it also improves the book as literature—is the fact
that in this passage the interest which I am finding it so
hard to define is inextricably mixed with the other satiric
and realistic interest. Desperance successively applies for
legal assistance to the Seven Wise Men, the Nine Muses,
the Nine Worthies, the *Ten Sibillais*, the Three Fates (or
'weird sisteris' as Rolland calls them),[2] the Three Graces,
and Vesta. The deepening despair of the unfortunate
suitor and the cold comfort with which each of these
authorities, except the last, sends him on to the next, make
a picture which every one can recognize. This is what hap-
pens when poverty or unpopularity seeks assistance against
enemies whose star is in the ascendant: every one drops
his business like a hot potato. Equally true, and more

[1] *Court of Venus*, iii. 912. [2] Ibid. ii. 679.

entertaining, is the picture of Desperance hesitating out-
side the door of the Nine Worthies—whose very aspect
terrifies him—and almost deciding to pretend that he has
come on some quite different errand:

> Best is to say I am ane chirurgiane . . .
> Best is to say that I covet service.[1]

But in one of the old allegories all these different figures
would have appeared as they were required with no more
sense of distance or wandering than we have on a chess-
board. In Rolland we are never allowed to forget the
journeys in between,

> Throw Mos and Myre and mony hie Montane,
> Half wo begone allone all solitair
> Throw wildernes in woddis and greit dangeir.[2]

We are even made to feel the passage of time and to watch
the traveller, who was in good point enough when first we
met him, becoming

> Daglit in weit—richt claggid was his weid
> In stormis fell and weder contagious,
> In frost and snaw.[3]

In the end these journeys cease to be mere connecting
links. One of them extends itself to some eighty lines, and
these lines breathe a spirit quite unknown to the old alle-
gory, and take us to the Caucasus 'most heich in Scithia'
and 'excandidate with snawis fell', where the sun is above
the horizon for twenty hours out of the twenty-four.
There the traveller lies down to sleep upon 'ane merbill
stone' and receives comfort in a dream, and wakes to
lament: but afterwards meets the sender of the dream.[4]

For the rest, Rolland is a very minor poet. He has a
command of that pungent vigour which we find in all the
Scottish writers of the Middle Ages; and the conclusion of
his poem, where he unexpectedly introduces himself at the
feast in Venus' court and identifies himself with *Eild*—

[1] Ibid. ii. 303, 309. [2] Ibid. ii. 194. [3] Ibid. ii. 566.
[4] Ibid. ii. 384-470, 778 et seq.

thus becoming one of the personifications in his own allegory—is, so far as I know, original and is certainly very effective. Nor must it be supposed, because I have here dwelt on other aspects of his work, that he is deficient in truly allegorical power. The tournament in the fourth book, when once its *significacio* has been seen, can hardly be quoted without indecorum, but it is a masterpiece: for it is a very good realistic description of a tournament, and yet at the same time a close parallel to the real subject. I do not expect to make many converts to Rolland: and I myself have not obeyed his request that the poem should be read more than once.

> For anis reading oft tyme it garris authoris
> Incur repruse be wrong Interpretouris.[1]

But authors not obviously better than he, who write in easier language and more popular forms, are daily read for pleasure and mildly praised in books of criticism. Certainly there is real poetry in the words of Desperance as he hears the song of the Muses:

> God! gif it war my fortoun, than said he,
> My fatall weird and als my destenie,
> I war convert into the may Echo
> That I micht bruik this greit quotidian joy.[2]

[1] *Court of Venus*, Prol. 285. [2] Ibid. ii. 148.

NOTE: Of *Deth*, *Fame*, *Tyme* and *Eternitee* in the conclusion of Hawes' poem, it is worth remarking that these figures appeared, and in the same order, on a *fyne paynted clothe* in the house of Sir Thomas More's father. The son's *verses over of every of those pageauntes* will be found in the *Workes* (1557). I do not know how these English examples are related to Petrarch's use of the same sequence in his *Trionfi*.

VII. *THE FAERIE QUEENE*

'The quiet fulness of ordinary nature.' GEORGE MACDONALD.

I

IN the last chapter I have endeavoured to trace the process whereby the erotic and homiletic allegories of the Middle Ages were fused together to produce something that anticipates *The Faerie Queene* more closely than either. But it must be confessed at once that this anticipation is slight. The passages in which Spenser reminds us of medieval allegory are not very numerous, and even where we are reminded we are not always sure of a real connexion. His Seven Deadly Sins certainly follow the familiar model: his House of Holinesse is not utterly unlike Deguileville's Cistercian castle; and the offence and punishment of Mirabella in the sixth book might have come in any medieval love poem. The Temple of Venus, however, in the fourth book, though it has a general similarity to the old allegories, is not really very like any one of them. The combats with allegorical monsters are like those in Hawes but not so like that they prove imitation: even the Rich Strand may be independent of its analogue in the *Pastime*.[1] If Spenser's poem had no fresh models, if an unbroken evolution led up to it from the *Romance of the Rose*, its novelty would be overwhelmingly more remarkable than its truth to the type. In fact, of course, it is the lineal descendant not of English allegory but of Italian epic.

Since this is so, it may be asked what place *The Faerie Queene* has in the present study. To this question there are two answers. In the first place, Spenser, while borrowing the form of the Italian epic, deliberately modified it by turning it into a 'continued allegory or dark conceit'. He may have been influenced in this by the allegorical interpretations which critics had fastened upon Ariosto,

[1] *F.Q.* III. iv; *Pastime of Pleasure*, 270.

and which Tasso, by an afterthought, was later to fasten on himself. But the allegory is no afterthought in Spenser's poem. When it is allegorical at all it is radically and momentously allegorical, and continues the medieval impulse whether under medieval guidance or not. The second answer is more important. I am trying to tell the history not only of the form, allegory, but also of the sentiment, courtly love: and in the latter story Spenser is not so much part of my subject as one of my masters or collaborators. The last phase of that story—the final defeat of courtly love by the romantic conception of marriage— occupies the third book of *The Faerie Queene* and much of the fourth.

Before I proceed to make good this claim I must say a word of Spenser's immediate model—the Italian epic. This vast body of poetry has in our time fallen strangely out of favour. But its products were familiar masterpieces to readers so diverse as Spenser, Milton, Dryden, Hurd, Macaulay, and Scott, and young ladies in the eighteenth century would have been ashamed to neglect what is now not infrequently neglected by scholars. Our oblivion of these poets is much to be regretted, not only because it vitiates our understanding of the Romantic Movement— a phenomenon which becomes baffling indeed if we choose to neglect the noble viaduct on which the love of chivalry and 'fine fabling' travelled straight across from the Middle Ages to the nineteenth century—but also because it robs us of a whole species of pleasures and narrows our very conception of literature. It is as if a man left out Homer, or Elizabethan drama, or the novel. For, like these, the romantic epic of Italy is one of the great trophies of the European genius: a genuine kind, not to be replaced by any other, and illustrated by an extremely copious and brilliant production. It is one of the *successes*, the un- disputed achievements.

Its subject-matter has a long history. In the eighth century the Frankish hero Hruodland dies fighting for Charlemain in a rearguard action against the Basques. By

the middle of the ninth century the story is already epic, the names of the heroes *vulgata sunt*. In the tenth and the eleventh, Christendom, hard pressed by Saracen and Viking, is still telling the tale, and now all Charlemain's enemies are paynims indiscriminately—worshippers of Tervagaunt and Mahound—the original models for the 'Saracen's Head' on our signs. Taillefer, the story tells us, rides singing the song of Roland before the Norman van at Hastings. Very early in the twelfth comes the compiler, the pseudo-Turpin, who is the Dares or Dictys or Geoffrey of this cycle: by the end of the century he is widely read and much translated. Italian versions of the story come next— an *Entrée en Espagne* in the fourteenth, a *Spagna* in verse, and another *Spagna* in prose. With the fifteenth century we reach the great poets.

As a form, the Italian epic illustrates the conversion, partly by way of parody, of a popular *genre* to literary respectability. The verse *Spagna* is said to have the character of minstrel or mendicant poetry:

> And now we've reached the end of canto Five,
> Will 't please you all in guerdon of my verses
> To put your hands, my masters, in your purses?[1]

When the 'literary' poets arrive they take up the extravagances of popular romance with a smile—a smile half of amusement and half of affection—like men returning to something that had charmed their childhood. They too will write of giants and 'orcs', of fairies and flying horses, of Saracens foaming at the mouth. They will do it with an occasional gravity, referring us to Turpin whenever the adventures are most preposterous, and it will be great fun. But they find that their pleasure is not only the pleasure of mockery. Even while you laugh at it, the old incantation works. Willy-nilly the fairies allure, the monsters alarm, the labyrinthine adventures draw you on. This blend of parody and true delight is the secret of the Italian epic, and also the thing which is so hard to explain to those who

[1] See G. Maffei, *Storia della Lett. Italiana*, II. v.

have not read the poems. There are, indeed, analogies. The French fairy-tale, as practised at the court of Louis XIV, hovers in the same way between patronage of a childish absurdity and surrender to a childlike charm; and so does Parnell's *Fairy Tale*. Pickwick changes while we watch him from a farcical puppet to a man we love. But there is no parallel on the same scale as the *Orlando Innamorato* and the *Orlando Furioso*.

Boiardo, who began his *Innamorato* about 1472, is in many ways very close to popular poetry. His cantos often begin with complimentary addresses to the audience who have gathered round to listen to him, and usually end with a reminder that there is another instalment to follow. His poem is like an endless serial—like the cycle of *Pip, Squeak, and Wilfred*. At the first glance it would seem as aimless, but this is not the case. His method is that of interlocked story. The formula is to take any number of chivalrous romances and arrange such a series of coincidences that they interrupt one another every few pages. The English reader will be apt to think of Malory or Spenser. But Malory so often leaves his separate stories unfinished or else, if he finishes them, fails to interlock them at all (so that they drop away from the rest of the book as independent organisms) and is so generally confused that he is not a good parallel. Boiardo keeps his head: we have no doubt that if he had finished the poem all the threads would have been neatly tied up. Spenser, on the other hand, has so few stories compared with the Italian (a prose abstract of *The Faerie Queene* would be a mere trifle compared with one of the *Innamorato*) and is so leisurely, that he can give no idea of Boiardo's *scherzo*. Boiardo would have told the story of Spenser's first canto in a few stanzas—the story of the whole *Faerie Queene* in a few cantos. The speed, the pell-mell of episodes, the crazy carnival jollity of Boiardo are his very essence. He invents a world in which, though love and war are almost the sole occupations, yet a major character hardly ever has time to lose a life or a maidenhead, for always, at the critical moment, a strange

knight, a swift ship, a bandersnatch or a boojum, breaks
in, and we are caught up into another story. It is extremely
enjoyable, but in a breathless way; it is rather like a ride on
a switchback. But as soon as I have said this I must
correct that impression—so paradoxical is this *genre*—by
warning the reader that a true chivalric valiancy mixes
with the hurly-burly, that serious love poetry and even
love allegory may crop up at any moment. Near the end
of the poem, when Brandiamante and Roger meet, the
poet surprises us by his power of delineating passion.[1]
Reynold's meeting with Love in the forest is a scene more
'romantic' (in the English sense of the word) and more ten-
der than anything in Ariosto.[2] The reflective passages at
the beginnings of his cantos are full of lyrical beauty. The
knight, the lover, the poet, exist in him side by side with
the manipulator of a sort of Punch and Judy show. He is
very like a boy—the best sort of boy. It is a little remark-
able that a poem of this length and a predominantly comic
poem in the Latin tradition should be so chaste.

Ariosto is admittedly the greatest of Italian poets after
Dante; but his superiority to Boiardo is not, perhaps,
immediately obvious to an Englishman. This is partly
because this superiority is, in the first place, one of style
which cannot be fully discerned except by an Italian; and
partly because he is more typically Latin than his pre-
decessor—a harder and more brilliant intelligence. He
has received his whole method, and much of his material,
ready made from Boiardo. He is much more like Boiardo
than is commonly supposed. But the differences are im-
portant. In the first place, he is far ahead of the older poet
as a delineator of character. His people are not, indeed,
what the countrymen of Shakespeare would call 'charac-
ters': they are drawn from the outside and drawn by one
who is more interested in the general nature of 'the passions'
(it is the Latin way)[3] than in idiosyncrasies. But they live.
Bradamant, with her undisguised southern jealousies and

[1] *Orl. Inn.* III. v. 38 et seq. [2] *Orl. Inn.* II. xv. 42 et seq.
[3] On this see D. E. Faulkner Jones, *The English Spirit*, 1935.

despairs, and her strange mixture of arrogance and humility, is certainly one of the great heroines. Closely connected with this delineation of character is Ariosto's command of pathos—again, not such a pathos as Englishmen like best, but very good in its way. Roland's lament over Brandimart[1] may sound to our ears but thin and rhetorical compared with Ector's lament over Launcelot— but this is our insular disability. In the third place, Ariosto's humour, at its best, is very unlike Boiardo's. Boiardo's indeed had hardly been humour, hardly more than fun, whereas Ariosto is a master of irony and of comic construction. But we must not insist too much on these differences. The power in which Ariosto excels all poets that I have read is one which he shares with Boiardo— invention. The fertility of his fancy is 'beyond expectation, beyond hope'. His actors range from archangels to horses, his scene from Cathay to the Hebrides. In every stanza there is something new: battles in all their detail, strange lands with their laws, customs, history and geography, storm and sunshine, mountains, islands, rivers, monsters, anecdotes, conversations—there seems no end to it. He tells us what his people ate; he describes the architecture of their palaces. It is 'God's plenty': you can no more exhaust it than you can exhaust nature itself. When you are tired of Ariosto, you must be tired of the world. If ever you come near to feeling that you can read no more adventures, at that very moment he begins another with something so ludicrous, so piquant, or so questionable, in its exordium, that you decide to read at least this one more. And then you are lost: you must go on till bedtime, and next morning you must begin again. The art by which this interest is kept up almost conceals itself. Part of the secret, no doubt, is Ariosto's practice of alternating stretches which are as headlong as Boiardo with resting-places where he luxuriates in description; and part is the excellence of his transitions. The *Furioso*, in its own peculiar way, is as great a masterpiece of construction as the

[1] *Orl. Fur.* XLIII.

Oedipus Rex. But nothing will finally explain, as no criticism of mine can adequately represent, the overwhelming achievement of Ariosto. There is only one English critic who could do justice to this gallant, satiric, chivalrous, farcical, flamboyant poem: Mr. Chesterton should write a book on the Italian epic.

Ariosto raises an interesting question in literary theory. A modern American critic has remarked that we have founded our taste in English poetry on 'a partial perception of the value of Shakespeare and Milton, a perception which dwells upon sublimity of theme and action'. We tend, in fact, with Arnold, to demand high seriousness of a poem before we call it great. Ariosto is the poet who of all others brings out this distinction between the English and the continental criterion—or, to speak more truly, between the Greek and English on the one hand and the Latin (should we add, the American?) tradition on the other. If you stand by Athens and London and Oxford, as I do, then of course Ariosto is not a 'great poet': but if you abandon 'high seriousness', if brilliance and harmony and sheer technical supremacy are enough, in your eyes, to constitute greatness, then *The Madness of Roland* ranks with the *Iliad* and *The Divine Comedy*.

Tasso's *Jerusalem* came too late to be more than an occasional influence on *The Faerie Queene*. It is different in kind from the work of Boiardo and Ariosto—an attempt, and a successful one, to recall the romantic epic to true epic gravity and unity of action, while retaining as much as possible of its variety, its love interests, and its romanticism. A great critic has described it as 'a sterile hybrid'— which shows how dangerous metaphors can be. If we substitute the literal statement 'It has never been successfully imitated' we shall retain the truth which this metaphor enshrined, and be rid of its depreciatory flavour. The best of all criticisms on the *Jerusalem* is that of W. P. Ker's unnamed friend, that it is 'a good story'. It can be read for the story alone from beginning to end. Its mixture of realism and fantasy is the happiest imaginable. Its

quite unforced nobility and piety set it in a class apart from other things of the same kind.

Johnson once described the ideal happiness which he would choose if he were regardless of futurity. My own choice, with the same reservation, would be to read the Italian epic—to be always convalescent from some small illness and always seated in a window that overlooked the sea, there to read these poems eight hours of each happy day.

II

'Influence' is too weak a word for the relation which exists between the Italian epic and *The Faerie Queene*. To fight in another man's armour is something more than to be influenced by his style of fighting. Spenser is not merely helped by the Italians: the very kind to which his poem belongs was invented by them, and his work is bound to theirs as closely as *Samson Agonistes* is bound to Athenian drama. But his debt by no means ends with the adoption of their form. The moralizing proems to his cantos, which sound so characteristically Spenserian, are in accordance with the regular practice of Boiardo and Ariosto. The prosaic endings of his cantos, with their promises that the story will be 'continued in our next', come from the same source. The genealogical mythus in the story of Britomart comes from the similar mythus in the story of Bradamant. The prophetic function of Merlin is the same in both. Even the reference to Merlin's betrayal by the Lady of the Lake—which so inevitably reminds an English reader of the *Morte Darthur*—has its counterpart in Ariosto.[1] The digressions on female valour are common to Spenser and his originals; and if Britomart counts the hours till Arte-gall's return, Bradamant first counted the hours till Roger's. The shield of Arthur is borrowed from the shield of Atlant, the *novello* of Phaon from that of Ariodante, Fradubio's arborification from Astulph's, Belphoebe's

[1] *F.Q.* III. iii. 10; *Orl. Fur.* iii. 10.

leechcraft from Angelica's. As Ariosto apologizes for stories that offend his female readers, so does Spenser. The terms on which Blandamour tries to fight Bragga-dochio are the same on which Marfisa had actually fought Zerbin.[1] The similarities are so numerous and patent that it would be waste labour to make a complete list. The English poet follows the Italian as closely as Virgil followed Homer, and with the same anxiety to boast, rather than to conceal, his debt.

All studies of *The Faerie Queene* which do not start from a clear recognition of this fact are really out of court, and those who pursue them end by finding obscure parallels in our earlier native literature for episodes in Spenser whose real source stares us in the face the moment we open our Ariosto. It cannot be too clearly stated that, when we reach *The Faerie Queene*, the story I am trying to tell is cut in two by the decisive appearance of a new, and foreign, model. Spenser's demonstrable debts to earlier English poetry and romance are very few. His discipleship to Chaucer exists only in profession, not in practice; and I believe it would be impossible to prove from internal evidence that he had read much of Malory. It is only after we have fully admitted this sharp discontinuity that we can safely allow ourselves to discuss his hidden affinities with English medieval poetry and to speculate on his possible debts to it—debts not in structure or style (which is out of the question) but in sentiment and outlook. Certainties must come before probabilities.

The Faerie Queene, then, is primarily an English branch of that excellent Italian *genre* the romantic epic; and on a broad view of European literature as a whole, its truth to the type would have to be emphasized at least as much as its idiosyncrasy. But when we have grasped this, we must beware of an opposite danger. Nothing is easier, or more unprofitable, than to set up Spenser and Ariosto as rivals, and to 'write down' the one in favour of the other. If your taste is for speed and gaiety you will choose Ariosto, and

[1] *F.Q.* iv. iv. 9; *Orl. Fur.* **xx.** 125.

you will find no difficulty in showing that Spenser is hopelessly inferior to his model. His loves and wars are intolerably languid compared with the briskness of the Italian. We feel at once that Mandricard or Roland would have made short work of all these slow moving, heavy-spoken fairy knights, whose allegory seems to encumber them more than their armour. As for Bradamant, inimitable Bradamant, by her side Britomart is little better than a big-boned country girl. Her speech is dull and pretentious, her love-sorrows without dignity; she carries her nurse about with her, and often suggests the *anglaise* of continental tradition. Nor will Spenser's small zoo of monsters, his reiterated single combats, his monotonous forest (relieved by no change of season), stand comparison for a moment with the inexhaustible inventions of the Italians. From this point of view *The Faerie Queene* will appear but a faint shadow of its originals. If, on the other hand, you are a romantic, if your taste is more for Wonder than for wonders, if you demand of poetry high seriousness and an admission to worlds of sensation which prose cannot enter, then you will find it just as easy to turn the tables. Dr. Richards has complained that the poetry of Rupert Brooke 'has no inside'.[1] It would be easy to say the same of Ariosto's—to show how unevocative, how merely entertaining, all his marvels are, how metallic and external his pathos. It could even be argued that the clarity of his characters is a specious clarity, and that we never know more of them than prose could tell us. The whole thing, it might be said, is hardly poetry at all in the English sense of the word.

But these two suggested views would be equally foolish, and foolish in the same way. Both are specimens of that pernicious criticism which tries to recommend one excellence by depreciating another. It is true that *The Faerie Queene* belongs to the same kind as the Italian poems; but then, as the example of Homer and Virgil shows, this does not mean that we are to expect precisely the same sort of

[1] *Coleridge on Imagination*, p. 215, London, 1934.

pleasure from it. Identity of *genre* admits diversity of imaginative quality. Virgil himself has sometimes suffered from the neglect of this principle and critics have wasted time in showing that he is a weak Homer—forgetting that Homer is a far weaker Virgil, and that neither poet could possibly console us for the loss of the other. In the same way, comparisons between Ariosto and Spenser are useful only up to a point: beyond that point we discover that the one poet is weak precisely where the other is strong. They are least alike when each is at his greatest.

Thus Spenser and the Italians are equally full of marvels, and even, in a sense, of similar marvels. In a prose abstract they would sound very alike. But in the real poems there is no common measure between them. The marvels of Boiardo and Ariosto are a literary form of one of the oldest games in the world—the 'tall story', the brag, the lie: they belong to the same world as the adventures of Baron Munchausen. The marvels of Spenser, quite apart from his explicit allegory, are always gravely imaginative. In Boiardo, the thief Brunel finds Sacripante sitting on his horse in such a study that he is oblivious of all around him. He immediately loosens the saddle, props it up with a log underneath, and leads the horse away from under the knight, who continues his meditations.[1] We have only to think of the impossibility of such an episode in *The Faerie Queene* to understand the difference between Italian and English romance. But perhaps the difference is most easily seen when the episodes are superficially alike. Orrilo in the Italians[2] is magically difficult to kill, and so is Maleger in *The Faerie Queene*. But the trouble about Orrilo is that any bit of him which you cut off immediately sticks itself on again; and in Boiardo the conflict with Orrilo leads up to the moment at which the knight has the ingenious idea of cutting off both his arms in quick succession, picking them up, and throwing them into a river. It is such a problem, and such a solution, as we should expect from

[1] *Orl. Inn.* II. v. 40.
[2] Ibid. III. iii. 12.

Mickey Mouse. We are a thousand miles away from this when we read of Maleger

of such subtile substance and unsound
That like a ghost he seem'd whose grave-clothes were unbound.[1]

The one story is fun, the other nightmare.

It is, in fact, only the surfaces of the English and Italian poems that are alike; and by 'surface' I here mean what is first presented to our gaze—interlocked stories of chivalrous adventure in a world of marvels. In calling this the surface I do not suggest that it is unimportant: it is of such importance that it attracts or repels readers in its own right, and most (not all) of those who like one of these poems will like the other two also. But it is only a surface. There are, so to speak, layers beneath, which can be discovered by scraping, and which are essentially different.

What lies immediately below the surface of the Italian epic is simply the actual—the daily life of travel, war, or gallantry in the Mediterranean world. I am not referring to those stories of the *novello* type in which the actual appears without disguise, but to the *Innamorato* and *Furioso* as a whole. Thus Agramant's war with the Franks is, on the surface, purely fantastic, and the prowess of its combatants impossible; but beneath all this we detect the familiar lineaments of a real war. There are problems of transport and lines of communication. Defeat for the invader means falling back on cities already taken. The divergent interests of allies show themselves in the councils of war. The real defeat of Agramant is plainly due not to the knightly deeds before Paris but to Astulph's blow in a different, and remote, theatre. The whole story could be plausibly re-written in headlines or generals' memoirs. When we leave the war for subordinate adventures we find the same thing. Knights may be sailing to fabulous cities of the Amazons or to the dens of ogres, but the squalls and the seamanship are those of the real Mediterranean, and so are the pirates, the brigands, the inn-

[1] *F.Q.* II. xi. 20.

keepers, the 'lousy' coloured troops (*pidocchiosi*) and all
that mass of rascality which unites the romantic epic, so
closely in places, to the picaresque novel. Even the loves
of Roger and Bradamant have a solid background of family
life and parental matchmaking: it is part of the beauty
of Bradamant's character that besides being the sternest
knight that ever struck with sword she is the dutifullest
daughter that ever cried for an ineligible lover. Thus, in
the Italians the fantastic is attached at a hundred points
to the real and even to the commonplace; nothing is in
the air. Even Astulph's cruises on the hippogryph are
controlled by continual reference to the most recent and
reliable geographers. All this lies, so to speak, an inch
below the surface. But if we scratch deeper we shall find
a third layer and another sort of actuality; we shall find
below this realism, and far below the surface fantasy, the
faint yet quite decipherable traces of the original legend—
the theme of the *chansons de geste*, the old 'world's debate'
of cross and crescent. The presence of this theme, which
the poets can suppress and revive at will, is used to supply
gravity when gravity is desired. We can always be reminded
that Roland is a senator and Charlemain the champion
of Christendom. This theme dictates that the 'machines'
of the poems should be God and His Angels instead of
classical deities; it lends a force which would otherwise be
lacking to the death of Isabella or the assault on Paris.

Such is the Italian epic: in the foreground we have
fantastic adventure, in the middle distance daily life, in
the background a venerable legend with a core of momen-
tous historical truth. There is no reason why the English poem
should not have been much more like this than it actually
is, if Spenser had chosen. Arthur's wars with the Saxons
could have been worked up just as Boiardo and Ariosto
had worked up Charlemain's wars with the Saracens. The
scene of the poem could have been laid in Britain and a real
topography (as in the Italians) could have been used at
every turn. But Spenser keeps his Arthurian lore for
occasional digressions and detaches his Prince Arthur from

Saxons, from Guinevere, Gawain, and Launcelot, even from
Sir Ector. There is no *situation* in *The Faerie Queene*,
no when nor where. Ariosto begins with a situation—
Roland's return from the East and Agramant's invasion
of France. *The Faerie Queene* begins quite differently.
A knight and a lady ride across our field of vision. We do
not know where they are, nor in what period; the poet's
whole energy is devoted to telling us what they look like.
Ariosto begins like a man telling us, very well and clearly,
a series of events which he has heard: Spenser begins like a
man in a trance, or a man looking through a window, telling
us what he sees. And however deep we dig in Spenser we
shall never get to a situation, and never find a context in
the objective world for the shapes he is going to show us.

But this does not mean that he is all surface. He, too,
has his lower levels, though they are much harder to des-
cribe than those of the Italians. In one sense, of course,
we know already what they are going to be: Spenser has
allegorized the romantic epic (that is the only formal
novelty of his work) and what lies below the surface of
his poem will therefore be something subjective and im-
material. But, for the moment, it will be better to proceed
inductively—to notice what lies beneath his poetry from
moment to moment without yet inquiring into his 'con-
tinued' allegory.

Let us return to the Knight and the Lady in the open-
ing stanzas. The knight has a red cross on a silver shield;
the lady is leading a lamb. The lamb has puzzled many
readers; but we now know[1] that it had a real function in
earlier versions of the legend of St. George, and (what is
much more important) we know that the lady was com-
monly represented leading her lamb in the pageants of
St. George and the dragon. In other words, the two
figures which meet us at the beginning of *The Faerie
Queene* were instantly recognized by Spenser's first readers,
and were clothed for them not in literary or courtly associa-

[1] See Greenlaw, Osgood, Padelford, *Works of Spenser*, vol. i, Baltimore, 1932,
p. 389.

tions, but in popular, homely, patriotic associations. They spoke immediately to what was most universal and child-like in gentle and simple alike. This at once suggests an aspect of Spenser's poetry which it will be fatal for us to neglect, and which is abundantly illustrated in the First Book. The angels who sing at Una's wedding probably come from the same pageant source as the lamb.[1] The well in which St. George is refreshed during his fight with the dragon comes from *Bevis of Southampton*.[2] The whole similarity between his allegory and that of Bunyan, which has exercised many scholars, is best explained by the fact that they have a common source—the old-fashioned ser-mon in the village church still continuing the allegorical tradition of the medieval pulpit.[3] Innumerable details come from the Bible, and specially from those books of the Bible which have meant much to Protestantism—the Pauline epistles and the Revelation. His anti-papal alle-gories strike the very note of popular, even of rustic, Protestant aversion; they can be understood and enjoyed by the modern reader (whatever his religion) only if he remembers that Roman Catholicism was in Spenser's day simply the most potent contemporary symbol for some-thing much more primitive—the sheer Bogey, who often changes his name but never wholly retires from the popu-lar mind. Foxe's *Book of Martyrs* was in every one's hands; horrible stories of the Inquisition and the galleys came from overseas; and every nervous child must have heard tales of a panel slid back at twilight in a seeming innocent manor house to reveal the pale face and thin, black body of a Jesuit. The ghosts crying from beneath the altar in Orgoglio's chapel and the mystery of iniquity beneath that other altar of Gerioneo are accurate embodiments of popular con-temporary horror at these things.[4] Gerioneo himself, who

> Laught so loud that all his teeth wide bare
> One might have seene enraungd disorderly
> Like to a rancke of piles that pitched are awry[5]

[1] Op. cit., ibid. [2] Op. cit., p. 395. [3] V. Owst, op. cit.
[4] *F.Q.* I. viii. 36, and v. xi. 19, 20. [5] Ibid., v. xi. 9.

is the genuine raw-head and bloody-bones of our remembered night nurseries. A dragon's mouth is the 'griesly mouth of hell' as in medieval drama.[1] Mammon is the gold-hoarding earthman of immemorial tradition, the gnome. The witcheries of Duessa, when she rides in Night's chariot and 'hungry wolves continually did howle',[2] or of the hag with whom Florimel guested, are almost incomparably closer to the world of real superstition than any of the Italian enchantments. We have long looked for the origins of *The Faerie Queene* in Renaissance palaces and Platonic academies, and forgotten that it has humbler origins of at least equal importance in the Lord Mayor's show, the chap-book, the bedtime story, the family Bible, and the village church. What lies next beneath the surface in Spenser's poem is the world of popular imagination: almost, a popular mythology.

And this world is not called up, as Ariosto may call up a fragment of folk lore, in order to amuse us. On the contrary, it is used for the sake of something yet deeper which it brings up with it and which is Spenser's real concern; the primitive or instinctive mind, with all its terrors and ecstasies—that part in the mind of each of us which we should never dream of showing to a man of the world like Ariosto. Archimago and Una, in their opposite ways, are true creations of that mind. When we first meet them we seem to have known them long before; and so in a sense we have, but only the poet could have clothed them for us in form and colour. The same may be said of Despair and Malengin, of Busirane's appalling house, and of the garden of Adonis. For all of these are translations into the visible of feelings else blind and inarticulate; and they are translations made with singular accuracy, with singularly little loss. The secret of this accuracy in which, to my mind, Spenser excels nearly all poets, is partly to be sought in his humble fidelity to the popular symbols which he found ready made to his hand; but much more in his profound sympathy with that which

[1] *F.Q.* I. xi. 12. [2] Ibid., I. v. 30.

makes the symbols, with the fundamental tendencies of human imagination as such. Like the writers of the New Testament (to whom, in the character of his symbolism, he is the closest of all English poets) he is endlessly pre-occupied with such ultimate antitheses as Light and Darkness or Life and Death. It has not often been noticed—and, indeed, save for a special purpose it ought not to be noticed—that Night is hardly even mentioned by Spenser without aversion. His story leads him to describe innumerable nightfalls, and his feeling about them is always the same:

> So soone as Night had with her pallid hew
> Defaste the beautie of the shyning skye,
> And refte from men the worldes desired vew—[1]

or,

> whenas chearelesse Night ycovered had
> Fayre heaven with an universall cloud,
> That every wight dismayed with darkenes sad—[2]

or, again,

> when as daies faire shinie-beame, yclowded
> With fearefull shadowes of deformed night,
> Warnd man and beast in quiet rest be shrowded—[3]

And, answering to this, in his descriptions of morning we have a never failing rapture: mere light is as sweet to Spenser as if it were a new creation. Such passages are too numerous and too widely scattered (often at unimportant places in the story) to be the result of any conscious plan: they are spontaneous and the better proof of the flawless health, the paradisal naïveté, of his imagination. They form a background, hardly noticed at a first reading, to those great passages where the conflict of light and dark becomes explicit. Such is the sleepless night of Prince Arthur in the third book, where the old description of lover's insomnia is heightened and spiritualized

[1] Ibid. III. ii. 28. [2] Ibid. xii. 1.
[3] Ibid. v. iv. 45.

into a 'statement' (as the musicians say) of one of Spenser's main themes;

> Dayes dearest children be the blessed seed
> Which darknesse shall subdue and heaven win:
> Truth is his daughter; he her first did breed
> Most sacred virgin without spot of sinne.[1]

It is no accident that Truth, or Una, should be mentioned here, for she is indeed the daughter of Light, and through the whole First Book runs the antithesis between her father as emperor of the East and Duessa as queen of the West[2]—a conception possibly borrowed from *Reason and Sensuality*—and in the Fifth canto of that book we meet Night face to face. The contrast between her 'visage deadly sad' as she comes forth from her 'darksome mew' and Duessa

> sunny bright
> Adornd with gold and jewels shining cleare,[3]

(though Duessa is but pretended, reflected light!) is, of course, a familiar example of that pictorial quality which critics have often praised in Spenser—but praised without a full understanding of those very unpictorial, unpicturable, depths from which it rises. Spenser is no dilettante, and has a low opinion of the painter's art as compared with his own.[4] He is not playing mere tricks with light and shade; and few speeches in our poetry are more serious than Night's sad sentence (the very accent of a creature *dréame bedǽled*)

> The sonnes of Day he favoureth, I see[5]

And yet it is characteristic of him that the constant pressure of this day and night antithesis on his imagination never tempts him into dualism. He is impressed, more perhaps than any other poet, with the conflict of two mighty opposites—aware that our world is dualistic for all practical purposes, dualistic in all but the very last resort: but from the final heresy he abstains, drawing back

[1] *F.Q.* III. iv. 59. [2] Ibid. I. ii. 22, vii. 43, xii. 26.
[3] Ibid. v. 21. [4] Ibid. III, Proem 2. [5] Ibid. I. v. 25.

from the verge of dualism to remind us by delicate alle-
gories that though the conflict seems ultimate yet one of
the opposites really contains, and is not contained by, the
other. Truth and falsehood are opposed; but truth is the
norm not of truth only but of falsehood also. That is why
we find that Una's father, King of the East and enemy of
the West, is yet *de jure* King of the West as well as of the
East.[1] That is why Love and Hatred, whom the poet
borrows no doubt from Empedocles, are opposites but
not, as in Empedocles, mere opposites: they are both the
sons of Concord.[2] And that, again, in the passage we were
discussing, is why Aesculapius, a creature of Night's party,
asks Night the formidable question,

> Can Night defray
> The wrath of thundring Jove that rules both night and day?[3]

The other antithesis—that of Life and Death, or, in
its inferior degrees, of Health and Sickness—enables
Spenser to avoid the insipidity of representing good as
arbitrary law and evil as spontaneity. His evils are all
dead or dying things. Each of his deadly sins has a mortal
disease.[4] Aesculapius sits in the bowels of the earth end-
lessly seeking remedies for an incurable fever.[5] Archimago
makes Guyon 'the object of his spight, and *deadly food*'.[6]
Despair is an immortal suicide,[7] Malbecco lives trans-
fixed with 'deathes eternall dart'.[8] The porter of the
garden of intemperance, the evil genius, is the *foe of life*,[9]
and so are the violent passions, red-headed and adust,
who attack Guyon in the earlier stages of his pilgrimage.[10]
Over against these mortal shapes are set forces of life
and health and fecundity. St. George, in combat with
the beast who

> was deadly made
> And al that life preserved did detest[11]

is refreshed with water from the well of life and saved by

[1] Ibid. i. 5. [2] Ibid. iv. x. 34. [3] Ibid. i. v. 42.
[4] Ibid. iv. 20, 23, 26, 29, 32, 35. [5] Ibid. v. 40.
[6] Ibid. ii. i. 3. [7] Ibid. i. ix. 54. [8] Ibid. iii. x. 59.
[9] Ibid. ii. xii. 48. [10] Ibid. vi. 1. [11] Ibid. i. xi. 49.

the shadow of the tree of life. Babies cluster at Charissa's
breasts:[1] Belphoebe's *lilly handës twaine* crush virtuous
herbs for the healing of wounds:[2] in the garden of Adonis,

> Ne needs there Gardiner to sett or sow,
> To plant or prune: for of their owne accord
> All things, as they created were, doe grow,
> And yet remember well the mighty word
> Which first was spoken by th' Almighty Lord,
> That bad them to increase and multiply[3]

—and throughout the whole garden 'franckly each para-
mor his leman knowes'.[4] The love of Britomart is enobled
by prophecies of famous offspring. The poem is full of mar-
riages. Una's face unveiled shines 'as the great eye of
heaven',[5] and Cambina carries a cup of Nepenthe.[6] The
whole shining company of Spenser's vital shapes make up
such a picture of 'life's golden tree' that it is difficult not
to fancy that our bodily, no less than our mental, health
is refreshed by reading him.

If all this is true, it will follow that we must approach
Spenser in a spirit widely different from that of the last
age in criticism. We must recognize the humility and
seriousness of his poetry, and we must be humble and
serious ourselves. A young lady whom I once had the
honour to examine advanced the view that Charissa suck-
ling her babies was a figure, in its own way, no less dis-
gusting than Error vomiting. If there is any lingering
sympathy with this attitude in us, we shall do well to
leave *The Faerie Queene* unread. It is a twofold offence
against Spenser's poem. It is a blasphemy against Life and
fertility, and it is the sin of pride, of nicety; and Spenser
will tolerate neither. He himself has nobly practised and
praised the humility which he demands of his readers.

> Entire affection hateth nicer hands—[7]
> So love does loathe disdainefull nicetee—[8]
> No service lothsome to a gentle kind[9]

[1] *F.Q.* I. x. 30. [2] Ibid. III. v. 33. [3] Ibid. vi. 34.
[4] Ibid. vi. 41. [5] Ibid. I. iii. 4. [6] Ibid. IV. iii. 43.
[7] Ibid. I. viii. 40. [8] Ibid. II. ii. 3. [9] Ibid. IV. viii. 22.

If these lines occurred in a set 'Legend of Humilitie' we might distrust them; but in fact they slip unnoticed from his pen when he is writing of other virtues. That dislike and distrust of the court and courtly life which one critic finds only in the Sixth Book is really characteristic of the poem from the beginning, as we shall presently see. And in the House of Holinesse, the name of the groom who lays us 'in easie bedd' is 'meek Obedience'.[1] In fine, as Hegel said of a very different matter, it is 'no good putting on airs' about *The Faerie Queene*.

Misconceptions about the real merit and limitation of Spenser's genius have led to his present neglect. The very phrase 'poets' poet', I believe, has done incalculable damage. The genitive of *poets'* is taken to have an intensive force and the phrase is interpreted on the analogy of *Holy of Holies*. Readers trained on such a conception open their Spenser expecting to find some quintessential 'poeticalness' in the lowest and most obvious sense of that word—something more mellifluous than Shakespeare's sonnets, more airy than Shelley, more swooningly sensuous than Keats, more dreamlike than William Morris: and then, as likely as not, what first meets their eye is something of this sort:

> But I with better reason him aviz'd,
> And shew'd him how, through error and misthought
> Of our like persons, eath to be disguiz'd,
> Or his exchange or freedom might be wrought.
> Whereto full loth was he, ne would for ought
> Consent that I, who stood all fearlesse free,
> Should wilfully be into thraldome brought,
> Till fortune did perforce it so decree:
> Yet, over-ruld at last, he did to me agree.[2]

Such a reader, at this point, excusably throws the book away. Now you may say that I have selected a specimen of Spenser at his worst; and so I have. But this 'worst' would not matter unless Spenser had a false reputation

[1] Ibid. I. x. 17. [2] Ibid. IV. viii. 58.

for sheer 'poeticalness'. The reader, unless he were a fool, would be prepared for flats in a long poem: he would not be put off by one such experience from making the acquaintance of Wordsworth or Chaucer. The real trouble is that he cannot be prepared for such a flat as this in a poem such as *The Faerie Queene* is commonly supposed to be: he has been taught not to look for vigorous thought or serious issues or even coherence and sanity in his Spenser—taught that the man's only merit is voluptuousness and day dream. And if Spenser can, in any passage, do so badly the only thing he is supposed to be able to do at all, he is naturally rejected. We tolerate bad manners in a learned, or a funny, or a good man; but how if the man admittedly has no claim on us except his reputed good breeding, and then turns out to be deficient even in that? In order to avoid such false judgements we must revise the popular opinion of Spenser. So far from being a poet whose excellent and sustained mastery of language is his only merit, he is a poet whose chief fault is the uncertainty of his style. He can be as prosaic as Wordsworth: he can be clumsy, unmusical, and flat. On this side, and on this side only, his work requires historical extenuation. He wrote in an age when English poetry had reached its stylistic nadir, the age of 'hunting the letter', of violent over-emphasis and exquisitely bad taste, the age in which that most ignoble metre, the Poulter's measure, was popular. It was an age which produced such poetry as

> Slash off his head! as though Albinius' head
> Were then so easy to be slashèd off[1]

or

> And for revenge thereof I vow and swear thereto,
> A thousand spoils I shall commit I never thought to do.
> And if to light on you my luck so good shall be
> I shall be glad to feed on that which would have fed on me[2]

[1] Greene, *Alphonsus King of Arragon.*
[2] Surrey, *Of a Lady that refused to dance with him.*

It was an age in which even Peele could make Venus speak
thus to Paris in description of Helen:

> A gallant girl, a lusty minion trull
> That can give sport to thee thy bellyful[1]

—lines of which we can but exclaim, 'No, this is not the
face that launched a thousand ships'.

Spenser himself is, of course, one of the principal agents
in the recovery which our poetry made from this clownish
period; but just as Wordsworth retains to the end many
traces of the diction he revolted against, so Spenser is
always liable to give us 'huge heaps of words uphoarded
hideously'. His excessive alliteration is a disease of the
period, and so is his tendency to abandon true poetic
presentation in favour of mere eulogistic or dyslogistic
adjectives. Such words as 'direfull', 'goodly', 'foul', 'fair',
'filthie', and the like (abdications of the poet's true office)
are far too common in his work. And even when he is at
his best the merits of his verse are not always those which
critical tradition—generalizing too hastily from the Cave
of Sleep and the Bower of Bliss—has led us to expect. Let
us dip our hands into the lucky-bag again.

> Nought under heaven so strongly doth allure
> The sence of man, and all his minde possesse,
> As beauties lovely baite that doth procure
> Great warriours oft their rigour to represse,
> And mighty hands forget their manlinesse;
> Drawn with the powre of an heart-robbing eye,
> And wrapt in fetters of a golden tresse.[2]

> And troubled blood through his pale face was seen
> To come and goe with tidings from the heart.[3]

> What time the native Belman of the night
> The bird that warned Peter of his fall—[4]

In all these there is undoubted poetry; but it is a poetry
far more nervous and masculine—a drier flavour and a
wine with more body—than the modern reader has been

[1] *Arraignement of Paris*, Act II, *ad fin.*
[2] *F.Q.* v. viii. 1. [3] Ibid. i. ix. 51. [4] Ibid. v. vi. 27.

taught to anticipate. Even more remarkable, in this context, are those passages where the pungency of the writing depends on a deliberate approximation to the prosaic, as this, of the amazon Radigund:

> For all those knights, the which by force or guile
> She doth subdue, she fowly doth entreate.
> First, she doth them of warlike armes despoile,
> And cloth in womens weedes: and then with threate
> Doth them compell to worke, to earne their meate,
> To spin, to card, to sew, to wash, to wring—[1]

A few stanzas later, the same amazon, sending her ambassadors to Arthegall, whom she hopes to conquer on the morrow and to set to washing and wringing (how admirably the verbs were chosen!), bids them

> bear with you both wine and juncates fit
> And bid him eate: henceforth he oft shall hungry sit.[2]

From this discussion I hope it has now become plain in what sense Spenser is the poets' poet. He is so called in virtue of the historical fact that most of the poets have liked him very much. And with this conclusion comes the important corollary that perhaps poets, when they read poetry, do not demand that it should be specially 'poetical'—perhaps, indeed, this demand is one of the marks of the prosaic reader who secretly suspects that poetry is at bottom nonsensical and, if he is in for a penny, would fain be in for a pound. In the same way, those who have least real sympathy with childhood become most laboriously childish when they talk to children; and no one has such high-flown notions of refinement as the temporarily converted boor. But these are generalities. For the study of Spenser himself, I think the most useful thing we can do as a preparative ('Laughing to teach the truth, what hinders?') is to draw up two lists of epithets after the manner of Rabelais. The first would run something like this:

Elfin Spenser: Renaissance Spenser: voluptuous Spenser: courtly Spenser: Italianate Spenser: decorative Spenser.

[1] *F.Q.* v. iv. 31. [2] Ibid. iv. 49.

For the second I propose—

> English Spenser: Protestant Spenser: rustic Spenser: manly
> Spenser: churchwardenly Spenser: domestic Spenser: thrifty
> Spenser: honest Spenser.

All that I have hitherto said has been directed to persuad-
ing the reader that the second of these lists is quite as
fully justified as the first—that Spenser is the master of
Milton in a far deeper sense than we had supposed. It is
the measure of his greatness that he deserves the epithets
of both lists.

III

In considering *The Faerie Queene* as a consciously alle-
gorical poem I shall neglect entirely its political allegory.
My qualifications as an historian are not such as would
enable me to unravel it; and my critical principles hardly
encourage me even to make the attempt. By his political
allegory Spenser doubtless intended to give to his poem
a certain topical attraction. Time never forgives such
concessions to 'the glistering of this present', and what
acted as a bait to unpoetic readers for some decades has
become a stumbling-block to poetic readers ever since.
The contemporary allusions in *The Faerie Queene* are
now of interest to the critic chiefly in so far as they explain
how some bad passages came to be bad; but since this does
not make them good—since to explain by causes is not to
justify by reasons—we shall not lose very much by ignoring
the matter. My concern is with the moral or philosophical
allegory.

In approaching this latter, the modern reader needs a
little encouragement. He has been told that the *signifi-
cacio* of *The Faerie Queene* is not worth looking for. Critics
have talked as if there were a fatal discrepancy between
Spenser's spiritual pretensions and the actual content of
his poetry. He has been represented as a man who preached
Protestantism while his imagination remained on the side
of Rome; or again, as a poet entirely dominated by the

senses who believed himself to be an austere moralist. These are profound misunderstandings.

The first—that of unconscious or involuntary Roman Catholicism—may be answered pretty shortly. It is quite true that Una is dressed (in her exile) like a nun, that the House of Holinesse is like a conventual house, that Penaunce dwells there with a whip, and that Contemplation, like the hermit of Book Six,[1] resembles a Catholic recluse. It is equally true that we can find similarly Catholic imagery in Bunyan; and I know a man in our own time who wrote what he intended to be a general apologetic allegory for 'all who profess and call themselves Christians', and was surprised to find it both praised and blamed as a defence of Rome. It would appear that all allegories whatever are likely to seem Catholic to the general reader, and this phenomenon is worth investigation. In part, no doubt, it is to be explained by the fact that the visible and tangible aspects of Catholicism are medieval, and therefore steeped in literary suggestion. But is this all? Do Protestant allegorists continue as in a dream to use imagery so likely to mislead their readers without noticing the danger or without better motive than laziness for incurring it? By no means. The truth is not that allegory is Catholic, but that Catholicism is allegorical. Allegory consists in giving an imagined body to the immaterial; but if, in each case, Catholicism claims already to have given it a material body, then the allegorist's symbol will naturally resemble that material body. The whip of Penaunce is an excellent example. No Christian ever doubted that repentance involved 'penaunce' and 'whips' on the spiritual plane: it is when you come to material whips—to Tartuffe's *discipline* in his closet—that the controversy begins. It is the same with the 'House' of Holinesse. No Christian doubts that those who have offered themselves to God are cut off *as if* by a wall from the World, are placed under a *regula vitae*, and 'laid in easy bed' by 'meek Obedience'; but when the wall becomes one of real bricks and mortar,

[1] *F.Q.* VI. v, vi.

and the Rule one in real ink, superintended by disciplinary
officials and reinforced (at times) by the power of the
State, then we have reached that sort of actuality which
Catholics aim at and Protestants deliberately avoid. In-
deed, this difference is the root out of which all other
differences between the two religions grow. The one sus-
pects that all spiritual gifts are falsely claimed if they
cannot be embodied in bricks and mortar, or official posi-
tions, or institutions: the other, that nothing retains its
spirituality if incarnation is pushed to that degree and in
that way. The difference about Papal infallibility is simply
a form of this. The proper corruptions of each Church
tell the same tale. When Catholicism goes bad it becomes
the world-old, world-wide *religio* of amulets and holy
places and priestcraft: Protestantism, in its corresponding
decay, becomes a vague mist of ethical platitudes. Catho-
licism is accused of being much too like all the other
religions; Protestantism of being insufficiently like a reli-
gion at all. Hence Plato, with his transcendent Forms, is
the doctor of Protestants; Aristotle, with his immanent
Forms, the doctor of Catholics. Now allegory exists, so
to speak, in that region of the mind where the bifurcation
has not yet occurred; for it occurs only when we reach
the material world. In the world of matter, Catholics and
Protestants disagree as to the kind and degree of incarna-
tion or embodiment which we can safely try to give to the
spiritual; but in the world of imagination, where allegory
exists, unlimited embodiment is equally approved by
both. Imagined buildings and institutions which have
a strong resemblance to the actual buildings and institu-
tions of the Church of Rome, will therefore appear, and
ought to appear, in any Protestant allegory. If the alle-
gorist knows his business their prevalence will rather mean
that the allegory is not Catholic than that it is. For
allegory is *idem in alio*. Only a bungler, like Deguileville,
would introduce a monastery into his poem if he were
really writing about monasticism. When Spenser writes
about Protestant sanctity he gives us something like a

convent: when he is really talking about the conventual
life he gives us Abessa and Corceca. If I might, without
irreverence, twist the words of an important (and very
relevant) Protestant article, I would say that a Catholic
interpretation of *The Faerie Queene*, 'overthroweth the
nature of an allegory'. Certainly, a Catholic reader anxious
to do justice to this great Protestant poem, would be very
ill advised to read it in that way. Here, as in more impor-
tant matters, frontier courtesies do not help; it is at their
fiery cores that the two faiths are most nearly in sympathy.

The charge of actual sensuality and theoretical austerity
cannot be answered so briefly. The spear-head of this
attack is usually directed against the Bower of Bliss, and it
is sometimes strengthened by the statement that the Gar-
den of Adonis is not sufficiently distinguished from it;
and an analysis of these two places is as good a method as
any other of beginning a study of Spenser's allegory. The
home of Acrasia is first shown to us in the fifth canto of
Book Two, when Atin finds Cymochles there asleep. The
very first words of the description are

> And over him art, striving to compare
> With nature, did an Arber greene dispred.[1]

This explicit statement that Acrasia's garden is art not
nature can be paralleled in Tasso, and would be unimpor-
tant if it stood alone. But the interesting thing is that
when the Bower of Bliss reappears seven cantos later, there
again the very first stanza of description tells us that it
was

> goodly beautifide
> With all the ornaments of Floraes pride,
> Wherewith her mother Art, as halfe in scorne
> Of niggard Nature, like a pompous bride
> Did decke her, and too lavishly adorne.[2]

In order to be perfectly fair to Spenser's hostile critics,
I am prepared to assume that this repetition of the anti-
thesis between art and nature is accidental. But I think

[1] *F.Q.* II. v. 29. [2] Ibid. xii. 50.

the hardest sceptic will hesitate when he reads, eight stanzas further,

> And that which all faire workes doth most aggrace,
> The art which all that wrought appeared in no place.[1]

And if this does not satisfy him let him read on to the sixty-first stanza where we find the imitation ivy in metal which adorns Acrasia's bathing-pool. Whether those who think that Spenser is secretly on Acrasia's side, themselves approve of metal vegetation as a garden ornament, or whether they regard this passage as a proof of Spenser's abominable bad taste, I do not know; but this is how the poet describes it,

> And over all of purest gold was spred
> A trayle of yvie in his native hew;
> For the rich metall was so coloured
> That wight who did not well avis'd it vew
> Would surely deeme it to bee yvie trew.[2]

Is it possible now to resist the conviction that Spenser's hostile critics are precisely such wights who have viewed the Bower 'not well avis'd' and therefore erroneously deemed it to be true? Let us suppose, however, that the reader is still unconvinced: let us even help him by pointing out stanza 59 where the antithesis is blurred. But we have still to deal with the garden of Adonis; and surely all suspicion that the insistence on Acrasia's artificiality is accidental must disappear if we find throughout the description of the garden of Adonis an equal insistence on its natural spontaneity. And this is just what we do find. Here, as in the description of the Bower, the very first stanza gives us the key-note: the garden of Adonis is

> So faire a place as Nature can devize.[3]

A few stanzas later, in lines which I have already quoted, we are told that it needs no Gardiner because all its plants grow 'of their owne accord' in virtue of the divine word that works within them. It even needs no water,

[1] *F.Q.* ii. xii. 58. [2] Ibid. xii. 61. [3] Ibid. iii. vi. 29.

because these plants have eternall moisture 'in them-
selves'.[1] Like the Bower, the Garden has an arbour, but
it is an arbour

<div align="center">

not by art
But of the trees owne inclination made.[2]

</div>

and the ivy in this arbour is living ivy not painted metal.
Finally, the Bower has the story of a false love depicted
by art on its gate,[3] and the Garden has faithful lovers
growing as live flowers out of its soil.[4] When these facts
have once been pointed out, only prejudice can continue
to deny the deliberate differentiation between the Bower
and the Garden. The one is artifice, sterility, death: the
other, nature, fecundity, life. The similarity between
them is just that similarity which exists between the two
gardens in Jean de Meun;[5] the similarity of the real to
the pretended and of the archetype to the imitation. *Dia-
bolus simius Dei.*

Before continuing our analysis of the Garden and the
Bower we must digress for a little to notice an important
corollary which has already emerged. Spenser, as I have
shown, distinguishes the good and evil paradises by a
skilful contrast between nature and art; and this at once
throws a flood of light upon his poetic use of the arts in
general. It has often been noticed that he is fond of
describing pictures or tapestries; but it has not been
equally noticed that he usually puts such artefacts in
places which he thinks evil. It would be rash to infer
from this that the poet disliked pictures: his practice is
probably a calculated symbolic device and not a mere
slavish obedience to temperament. But the fact is incon-
testable. There is, so far as I have noticed, only one excep-
tion, and it is very easily explained. In the House of Alma,
the cells of the brain are internally decorated with pic-

[1] *F.Q.* III. vi. 34. [2] Ibid. vi. 44.
[3] Ibid. II. xii. 44, 45. [4] Ibid. III. vi. 45.
[5] *v. supra*, p. 151. The fact that all the references to Art in the Bower are
copied from Tasso does not invalidate my argument: the opposite passages in
the Garden are not.

tures because this is the obvious, perhaps the only, way
of allegorizing the fact that the external world enters as
image into the human mind.[1] Everywhere else Spenser
uses art to suggest the artificial in its bad sense—the sham
or imitation. Thus he uses pictures to suggest luxurious
corruption in the house of Malecasta;[2] and it is deliciously
characteristic of our poet (*thrifty* Spenser) that St. George
and Britomart at first sight of the place should wonder
uneasily (like the sober English soldier and gentlewoman
they are) who is paying for it all, and how.[3] So, again,
he uses pictures to build up an unbearable silent splendour
in the House of Busirane.[4] In the Temple of Venus, on
the other hand, a place 'wall'd by nature gainst invaders
wrong',[5] we have no pictures of lovers, but the living
lovers themselves:[6] as against the pictured Cupid of Busi-
rane we have 'a flocke of little loves', all alive and fluttering
about the neck and shoulders of Venus, as birds, in another
mythology, fly about the head of Aengus.[7] The gardener's
art which had been excluded from the home of Adonis is
indeed admitted into the Temple of Venus, for a reason
which will appear later; but it is allowed only to supple-
ment Nature,[8] not to deceive or sophisticate as it does
in the Bower of Bliss. The abiding impression is that of
a place 'lavishly enricht with Natures threasure', 'by
nature made'.[9] Thus, again, Pride has a palace, Belphoebe
a pavilion in the woods, and the hill where the Graces
dance is adorned only 'by natures skill'.[10]

Truth is an unruly subject and, once admitted, comes
crowding in on us faster than we wish. I had intended
only a short digression to show the deliberate contrast
between nature and art (or reality and imitation) in all
Spenser's good and bad places, but I find that I have
stumbled on another of those great antitheses which run

[1] *F.Q.* II. ix. 50, 53. Perhaps *Mutabilitie*, vi. 8, should also be mentioned as
an exception. I do not understand this passage and suspect astronomical or
astrological meanings.

[2] Ibid. III. i. 34 et seq. [3] Ibid. i. 33. [4] Ibid. xi. 29 et seq.
[5] Ibid. IV. x. 6. [6] Ibid. 25–7. [7] Ibid. 42.
[8] Ibid. 21, 22. [9] Ibid. 23, 24. [10] Ibid. VI. x. 5.

through his whole poem. Like Life and Death, or Light and Darkness, the opposition of natural and artificial, naïve and sophisticated, genuine and spurious, meets us at every turn. He had learned from Seneca and the Stoics about the life according to Nature; and he had learned from Plato to see good and evil as the real and the apparent. Both doctrines were congenial to the rustic and humble piety of his temper—that fine flower of Anglican sanctity which meets us again in Herbert or Walton. He is not at home in the artificialities of the court, and if, as a man, he was sometimes seduced, as a poet he never was. The rotting captives in Pride's dungeon are those who 'fell from high Princes court' after long wasting their 'thriftlesse howres'.[1] Guyon, like a true Stoic, rejects Mammon's offers of wealth in favour of 'untroubled Nature', because 'at the well head the purest streames arise'.[2] Philotime's beauty is not 'her owne native hew, but wrought by art', and the description of her court ('some thought to raise themselves to high degree' &c.) is so vivid that an officer of my acquaintance thought of presenting a framed and illuminated text of that stanza to the Head Quarters Mess of the——.[3] The whole conception of the false Florimel, not to mention Braggadochio, expresses the same feeling; and at her making, Nature 'grudg'd to see the counterfet should shame the thing it selfe'.[4] True love is praised because it is 'naturall affection faultlesse',[5] whereas the false love of Paridell is an 'art' which he 'learned had of yore', and he himself 'the learned lover' equipped with 'Bransles, ballads, virelayes and verses vaine'.[6] The pictures in the House of Busirane have already been mentioned; but perhaps the simile with which they are introduced gives us more of the depth of Spenser's mind on these matters than the whole description that follows.

> Woven with gold and silke, so close and nere
> That the rich metall lurked privily

[1] *F.Q.* i. v. 51. [2] Ibid. ii. vii. 15. [3] Ibid. 45, 47.
[4] Ibid. iii. viii. 5. [5] Ibid. iv. Proem 2. [6] Ibid. iii. ix. 28, x. 6, 8.

As faining to be hid from envious eye;
Yet here, and there, and every where, unwares
It shewd it selfe and shone unwillingly;
Like a discoloured Snake, whose hidden snares
Through the greene gras his long bright burnisht back declares.[1]

Any moralist may disapprove luxury and artifice; but
Spenser alone can turn the platitude into imagery of such
sinister suggestion. It is thought completely converted
into immediate sensation. Even the innocent trappings
of the courtly life do not attract him, and he dismisses
the externals of a tournament as contemptuously as Mil-
ton himself: to describe them, he says,

Were worke fit for an Herauld, not for me.[2]

Clothes and jewellery interest him only when they adorn
his 'shining ones', and become, as a modern critic has well
pointed out, the symbol of a spiritual radiance.[3] Every-
where else the pomps and vanities of the 'World' are for
him illusions

Fashion'd to please the eies of them that pas
Which see not perfect things but in a glas,

and easily rejected by those who compare them with
'plaine Antiquitie'.[4] The Noble Savage, long before Dry-
den gives him that name, has played his part in the Sixth
Book of *The Faerie Queene*. Una's face is fairest unveiled.
'Naturals'—lions and satyrs—come to her aid. True cour-
tesy dwells among shepherds who alone have never seen
the Blatant Beast.[5]

All this is quite compatible with Spenser's horror of
something else which is also commonly called 'nature'.
As we had to remind ourselves in an earlier chapter,
Nature may be opposed not only to the artificial or the
spurious, but also to the spiritual or the civil. There is a
nature of Hobbes' painting as well as of Rousseau's. Of
nature in this second sense, nature as the brutal, the

[1] *F.Q.* III. xi. 28.　　[2] Ibid. v. iii. 3. Cf. Milton, *P.L.* ix. 33 et seq.
[3] *v.* Dr. Janet Spens, *Spenser's Faerie Queene*, p. 62, London, 1934.
[4] *F.Q.* vi. Proem 5, 4.　　[5] Ibid. vi. ix. 6, cf. Tasso *G.L.* vii.

unimproved, the inchoate, Spenser has given us notice
enough in his cannibals, brigands, and the like; and, more
philosophically, in the 'hatefull darknes' and 'deepe horrore' of the chaos whence all the fair shapes in the garden
of Adonis have taken their 'substance'.[1] This is what
moderns tend to mean by Nature—the primitive, or original, and Spenser knows what it is like. But most commonly
he understands Nature as Aristotle did—the 'nature' of
anything being its unimpeded growth from within to
perfection, neither checked by accident nor sophisticated
by art. To this 'nature' his allegiance never falters, save
perhaps in some regrettable compliments to the Queen
which accord ill with his general feeling about the court:
and when Nature personified enters his poem she turns
out to be the greatest of his shining ones. In some respects,
indeed, she symbolizes God Himself.[2]

The reader may well be excused if he has, by this,
forgotten that the whole subject of nature and art arose
out of our analysis of the Bower of Bliss and the Garden
of Adonis. But the Bower and the Garden (the very
names, I trust, have now become significant) are so important that we have still not exhausted them. We have
dealt only with their contrast of nature and art. It still
remains to consider the equally careful, and even more
important, contrast between the explicitly erotic imagery
of the one and the other. We here approach a subject on
which Spenser has been much misunderstood. He is full
of pictures of virtuous and vicious love, and they are, in
fact, exquisitely contrasted. Most readers seem to approach him with the vulgar expectation that his distinction between them is going to be a quantitative one; that
the vicious loves are going to be warmly painted and the
virtuous tepidly—the sacred draped and the profane nude.
It must be stated at once that in so far as Spenser's distinction is quantitative at all, the quantities are the other way
round. He is at the opposite pole from the scholastic
philosophers. For him, intensity of passion purifies: cold

[1] *F.Q.* III. vi. 36. [2] Ibid. *Mutabilitie*, vi. 35, vii. 15.

pleasure, such as the scholastics seem to approve, is corruption. But in reality the distinction has very little to do with degree or quantity.

The reader who wishes to understand Spenser in this matter may begin with one of his most elementary contrasts—that between the naked damsels in Acrasia's fountain and the equally naked (in fact rather more naked) damsels who dance round Colin Clout.[1] Here, I presume, no one can be confused. Acrasia's two young women (their names are obviously Cissie and Flossie) are ducking and giggling in a bathing-pool for the benefit of a passer-by: a man does not need to go to fairie land to meet them. The Graces are engaged in doing something worth doing, —namely, dancing in a ring 'in order excellent'. They are, at first, much too busy to notice Calidore's arrival, and when they do notice him they vanish. The contrast here is almost too simple to be worth mentioning; and it is only marginal to our immediate subject, for the Graces symbolize no sexual experience at all. Let us proceed to something a little less obvious and more relevant: let us compare the pictured Venus and Adonis in the house of Malecasta with the real Venus and Adonis in the Garden. We find at once that the latter (the good and real) are a picture of actual fruition. Venus, in defiance of the forces of death, the Stygian gods,

> Possesseth him and of his sweetnesse takes her fill.[2]

Nothing could be franker; a dainty reader might even object that the phrase 'takes her fill' brings us too close to other and more prosaic appetites. But daintiness will be rebuked (as Spenser is always ready to rebuke it) if any one tries to prefer the pictured Venus on Malecasta's wall. For she is not in the arms of Adonis: she is merely looking at him,

> And whilst he bath'd, with her two crafty spyes
> She secretly would search each daintie lim.[3]

[1] *F.Q.* ii. xii. 63 et seq.; vi. x. 11 et seq.
[2] Ibid. iii. vi. 46. [3] Ibid. i. 36.

The words 'crafty,' 'spies,' and 'secretly' warn us suffi-
ciently well where we have arrived. The good Venus is a
picture of fruition: the bad Venus is a picture not of 'lust
in action' but of lust suspended—lust turning into what
would now be called *skeptophilia*. The contrast is just as
clear as that in the previous example, and incalculably
more important. Thus armed, we may now return to the
Bower. The very first person we meet there is Cymochles.
He has come there for pleasure and he is surrounded by a
flock of wanton nymphs. But the wretched creature does
not approach one of them: instead, he lies in the grass
('like an Adder lurking in the weedes') and

> Sometimes he falsely faines himselfe to sleepe
> Whiles through their lids his wanton eies do peepe.[1]

The word 'peepe' is the danger signal, and once again we
know where we are. If we turn to the Garden of Adonis
we shall find a very different state of affairs. There 'all
plenty and all pleasure flowes': the garden is full of lovers
and 'Franckly each Paramor his leman knowes'.[2] And
when we have noticed this it ought to dawn upon us that
the Bower of Bliss is not a place even of healthy animal-
ism, or indeed of activity of any kind. Acrasia herself *does*
nothing: she is merely 'discovered', posed on a sofa beside
a sleeping young man, in suitably semi-transparent rai-
ment. It is hardly necessary to add that her breast is
'bare to ready spoyle of hungry eies',[3] for eyes, greedy
eyes ('which n'ote therewith be fild') are the tyrants of
that whole region. The Bower of Bliss is not a picture of
lawless, that is, unwedded, love as opposed to lawful love.
It is a picture, one of the most powerful ever painted, of
the whole sexual nature in disease. There is not a kiss or
an embrace in the island: only male prurience and female
provocation. Against it we should set not only the Gar-
den of Adonis, but the rapturous reunion of Scudamour
with Amoret,[4] or the singularly fresh and frank account

[1] *F.Q.* ii. v. 34. [2] Ibid. iii. vi. 41.
[3] Ibid. ii. xii. 78. [4] Ibid. iii. xii (First Version), 43–7.

of Arthur's meeting with Gloriana.[1] It is not to be sup-
posed of course that Spenser wrote as a scientific 'sexolo-
gist' or consciously designed his Bower of Bliss as a picture
of sexual perversion. Acrasia indeed does not represent
sexual vice in particular, but vicious pleasure in general.[2]
Spenser's conscious intention, no doubt, was merely to
produce a picture which should do justice both to the
pleasantness and to the vice. He has done this in the only
way possible—namely, by filling his Bower of Bliss with
sweetness showered upon sweetness and yet contriving
that there should be something subtly wrong throughout.
But perhaps 'contriving' is a bad word. When he wishes
to paint disease, the exquisite health of his own imagina-
tion shows him what images to exclude.

The usual charges against the skill or the sincerity of
Spenser's allegory turn out, then, to be ungrounded, and
we may begin the work of interpretation with increased
confidence. To hope for success where great critics have
failed would be rash in the writer and in the readers of
this book, if we had not one definite advantage—namely,
that we are coming to *The Faerie Queene* from the same
direction whence Spenser himself came to it, from earlier
love-poetry and earlier allegory, and from the Italian epic.
It is to be hoped, also, that most readers share with the
writer the advantage of having read that admirable third
chapter on symbolism in Dr. Janet Spens' *Spenser's Faerie
Queene*, which is perhaps the best initiation we have into
the whole subject. We have also learned by now that
allegory is not a puzzle. The worst thing we can do is to
read it with our eyes skinned for clues, as we read a detec-
tive story. If the reader has some familiarity with the
allegorical method in general and an ordinary measure
both of sensibility and adult experience, then he may be
assured that any *significacio* which does not seem natural
to him after a second reading of the poem, is erroneous.
And to this general principle we must add Spenser's own
warning in the preface, that 'many adventures are inter-

[1] *F.Q.* I. ix. 9–15. [2] Ibid. II. xii. I.

medled, rather as Accidents than intendments'. Not every-
thing in the poem is equally allegorical, or even allegorical
at all. We shall find that it is Spenser's method to have in
each book an allegorical core, surrounded by a margin of
what is called 'romance of types', and relieved by episodes
of pure fantasy. Like a true Platonist he shows us the
Form of the virtue he is studying not only in its trans-
cendental unity (which comes at the allegorical core of the
book) but also 'becoming Many in the world of pheno-
mena'. Finally, we must remind ourselves that we are
dealing with an unfinished book—a fragment, and even
a fragment so hastily sent to press that it contains an
alexandrine where it should have a decasyllable, and a
fourteener where it should have an alexandrine.[1]

The subject of the first book is Sanctification—the
restoring of the soul to her lost paradisal nature by holi-
ness. This is presented in two interlocked allegories. Una's
parents, who represent *homo*, or even, if you like, Adam
and Eve, after long exclusion from their native land (which
of course is Eden) by the Devil, are restored to it by
Holiness whom Truth brings to their aid. That is the
first allegory. In the second, we trace the genesis of
Holiness; that is, the human soul, guided by Truth, con-
tends with various powers of darkness and finally attains
sanctification and beats down Satan under her feet. Truth,
rather than Grace, is chosen as the heroine of both actions
because Spenser is writing in an age of religious doubt
and controversy when the avoidance of error is a problem
as pressing as, and in a sense prior to, the conquest of
sin: a fact which would have rendered his story uninterest-
ing in some centuries, but which should recommend it to
us. This is why forces of illusion and deception such as
Archimago and Duessa play such a part in the story; and
this is why St. George and Una so easily get separated.
Intellectual error, however, is inextricably mixed with
moral instability, and the soul's desertion of truth (or

[1] *F.Q.* III. xii. 41, line 7; xi. 42. For the many narrative inconsistencies which
tell the same tale see Spens op. cit., *passim*.

the knight's desertion of his lady) has an element of wilful rebellion as well as of illusion.

Will was his guide and griefe led him astray.[1]

The various temptations with which he contends are, for the most part, easily recognizable. The distinction between Pride and Orgoglio is the only difficulty. In the historical allegory, no doubt, Orgoglio is the dungeons of the Inquisition, but his moral signification is not so obvious. If we remember, however, that he is a blood relation to Disdain,[2] and consider (with our imagination rather than our intellect) the character of both giants, I think we shall get an inkling. Pride and Orgoglio are both pride, but the one is pride within us, the other pride attacking us from without, whether in the form of persecution, oppression, or ridicule. The one seduces us, the other browbeats us. But the utter hopelessness with which St. George, unarmed and newly roused from the fountain of sloth, staggers forward ('Disarmd, disgraste, and inwardly dismayde'),[3] to meet Orgoglio, is not very easily reconciled with this view, and it is by no means unlikely that the giant is a survival from some earlier version of the poem.[4]

This is the allegorical core of the book. Una's adventures are much less allegorical. In a very general sense the lion, the satyrs, and Satyrane represent the world of unspoiled nature, which, in the words of a modern critic 'cannot hold Una: she blesses it and passes on her way'.[5] But to go further than this—to expect that Truth parted from the soul could, or should, be allegorized as fully as the soul parted from Truth—is almost certainly a mistake. Satyrane himself is the first of many characters in the poem who are types rather than personifications. He is one of Spenser's happy pictures of the 'child of nature'. Although he is a knight, we are told that 'in vaine glorious frayes he little did delight'[6]—which is a deliberate rejection

[1] *F Q.* I. ii. 12. [2] Ibid. VI. vii. 41. [3] Ibid. I. vii. 11.
[4] *v.* Spens, op. cit., pp. 24 et seq. [5] Ibid., p. 85. [6] *F.Q.* I. vi. 20.

by Spenser of that essential element of chivalry which had most clearly survived, as the *duello*, into the courtly code of his own time. This anti-courtly character in Satyrane is emphasized by the fact that when Spenser reintroduces him twenty-four cantos later it is with the reminder that he

> in vain sheows, that wont yong knights bewitch
> And courtly services, tooke no delight.[1]

It will be noticed that I have made no mention of Prince Arthur. The regrettable truth is that in the unfinished state of the poem we cannot interpret its hero at all. We know from the preface that he personifies Magnificence and is seeking Gloriana, or Glory. But if we consider how little we should know of Britomart from the mere statement that she is Chastity, we shall see that this tells us little about Arthur. And if we consider how little we should know of Spenser's 'chastity' if we had never been to the Garden of Adonis, and how little of his 'justice' if we had never been to the Temple of Isis, or of his 'courtesy' if we had never seen its connexion with the Graces on Mount Acidale, then we must conclude that we do not know what 'Glory' would have come to mean in the completed poem. I have very little doubt that Dr. Janet Spens is right in supposing that Glory would have been spiritualized and Platonized into something very like the Form of the Good, or even the glory of God;[2] and my belief is not shaken by the fact that there is very little in the existing poem to suggest this. Spenser's whole method is such that we have a very dim perception of his characters until we meet them or their archetypes at the great allegorical centres of each book. Amoret, for example, would reveal nothing of her real nature if the Garden of Adonis and the Temple of Venus had been lost. Spenser must have intended a final book on Arthur and Gloriana which would have stood to the whole poem as such central or focal cantos stand to their

[1] *F.Q.* III. vii. 29. [2] Spens, op. cit., p. 11.

several books. If we had it we should know what the city
of Cleopolis and its tower Panthea really are; we should
have the key to the tantalizing history of Elfe and Fay;[1]
and we should be much less troubled than we now are by
the recollection of Queen Elizabeth throughout the poem.
As things are, however, Arthur is inexplicable. If he is
Aristotelian 'Magnanimity', in search of earthly glory, his
deliverance of St. George is arrant nonsense. 'Magnani-
mity', in this sense, cannot come to the rescue of Holiness;
for whatever in the pagan character of the μεγαλόψυχος is
not sin, belongs already to the Saint. And the error is
one which Spenser is the least likely of all poets to have
committed: distrust of 'the World' and worldly ambition,
even to a fault, is the essence of the man. Here, at the
very outset, we come up against an irremovable obstacle.
The poem is not finished. It is a poem of a kind that loses
more than most by being unfinished. Its centre, the seat
of its highest life, is missing.

Book II is plain sailing. As the theme of Light and
Darkness, though present throughout the poem, becomes
specially prominent in Book I, so that of Life and Death
or Health and Sickness dominates Book II. Its subject is
the defence of Health or Nature against various dangers,
and the allegoric centre of this book is to be sought in the
description, and siege, of the House of Alma—the human
soul ruling the healthy body. The dangers are of three
kinds. In the first five cantos we meet passions which are
the direct and admitted enemies of Nature and 'foes to
life'[2]—passions of Wrath and Grief. These cantos are
full of drought and heat, of 'smouldering dust', armours
that sparkle fire, blood-red horses, red hair, gnashing teeth,
and burning. They contain some of the simplest, but
also the most powerful, allegory in *The Faerie Queene*.
From these we pass on to Phaedria. Phaedria is not an
enemy to nature at all. Her charming island (in sharp
antithesis to the Bower of Bliss) is the work of 'Natures
cunning hand';[3] and if she excludes Guyon's Palmer she

[1] *F.Q.* ii. x. 71. [2] Ibid. ii. vi. i. [3] Ibid. ii. vi. 12.

excludes Atin as well.[1] She is mirth, rest, recreation—the relaxed will floating in the idle lake, secure against the arduous virtues and the arduous vices alike. Ethically she is evil *per accidens* and in a given situation: on the natural level, she is not evil at all. From the enemies and the neutral we pass on to the false friends, to the hypertrophies and diseases of natural desires, Mammon and Acrasia. Both are created by Spenser at the height of his power and are among the most obviously poetical passages in *The Faerie Queene*. But he is well aware that the virtue he here presents to us is a dull and pedestrian one to fallen man. That is why Guyon loses his horse in the second canto.[2] It is better that he should be without it, for he had found it difficult to restrain its pace to that of the Palmer and impossible to pull up in the presence of St. George.[3] But Spenser continually reminds us of the weariness of his subsequent journey on foot,[4] and the book is full of allurements to rest. Interwoven with this allegory we have the story of Mordant and Amavia, a romance of types which illustrates opposite kinds of intemperance, and things that are not allegorical at all such as the story of Braggadochio or the sonorous history of the Kings of Britain.

For the purposes of our particular study the third and fourth books of *The Faerie Queene* are by far the most important, for in them Spenser, as I promised, becomes our collaborator and tells the final stages of the history of courtly love. I do not mean, of course, that he would have understood the phrase 'history of courtly love', nor that he knew he was ending a story. But it is in his mind, none the less, that the last phase of the long process becomes conscious.

The subjects of these two books are respectively Chastity and Friendship, but we are justified in treating them as a single book on the subject of love. Chastity, in the person of Britomart, turns out to mean not virginity but

[1] *F.Q.* II. vi. 4, 19. [2] Ibid. II. ii. 11.
[3] Ibid. II. i. 7, 27. [4] Ibid. II. ii. 22, iii. 3, iv. 2, v. 3.

virtuous love: and friends are found to be merely 'another sort of lovers'[1] in the Temple of Venus. The Proem to the legend of Friendship deals entirely with 'lovers deare debate',[2] and its story is equally concerned with friendship, reconciliation and marriage. In the ninth canto Spenser explicitly classifies Eros, Storgë, and Philia as 'three kinds of love'.[3] Finally, his conception of love is enlarged so as to include even the harmonies of the inanimate world, and we have the wedding of Thames and Medway. For this all-embracing interpretation of love Spenser, of course, has precedent in ancient philosophy, and specially in the *Symposium*. His subject-matter in these two books is therefore extremely complex: and as, in these same books, the non-allegorical fringe becomes wider and more brilliant than ever, there is some excuse for the bewilderment of those critics (too quick despairers!) who suppose that Spenser has abandoned his original design. But those who have learned to look for the allegorical centres will not go astray.

A few pages ago we were considering the difference between the Bower of Bliss and the Garden of Adonis. While we did so I carefully excluded a much more interesting question—that of the difference between the Bower of Bliss and the Houses of Malecasta and Busirane. It is now time to rectify this omission. The Bower, it will be remembered, turned out to be a place not of lawless loves or even lawless lusts, but of disease and paralysis in appetite itself. It will be remembered that the Bower is the home not of vicious sexuality in particular, but of vicious Pleasure in general.[4] The poet has selected one kind of pleasure chiefly because it is the only kind that can be treated at length in serious poetry. The Bower is connected with sex at all only through the medium of Pleasure. And this is borne out by the fact—very remarkable to any one well read in previous allegory—that Cupid is never mentioned in the Bower, a clear indication that we are not yet dealing

[1] Ibid. iv. x. 26. [2] Ibid. iv, Proem. i.
[3] Ibid. iv. ix. i. [4] Ibid. ii. xii. i.

with love. The Bower is not the foe of Chastity but of
Continence—of that elementary psychic integration which
is presupposed even in unlawful loves. To find the real
foe of Chastity, the real portrait of false love, we must
turn to Malecasta and Busirane. The moment we do so,
we find that Malecasta and Busirane are nothing else than
the main subject of this study—Courtly Love; and that
Courtly Love is in Spenser's view the chief opponent of
Chastity. But Chastity for him means Britomart, married
love. The story he tells is therefore part of my story: the
final struggle between the romance of marriage and the
romance of adultery.

Malecasta lives in Castle Joyeous amid the 'courteous
and comely glee' of gracious ladies and gentle knights.[1]
Somebody must be paying for it all, but one cannot find
out who. The Venus in her tapestries entices Adonis 'as
well that art she knew':[2] we are back in the world of the
Vekke and the commandments of Love. In the rooms of
the castle there is 'dauncing and reveling both day and
night', and 'Cupid still emongst them kindles lustfull
fyres'.[3] The six knights with whom Britomart contends
at its gate (Gardante, Parlante, and the rest) might have
stepped straight out of the *Roman de la Rose*, and in the
very next stanza the simile of the rose itself occurs.[4] The
place is dangerous to spirits who would have gone through
the Bower of Bliss without noticing its existence. Brito-
mart gets a flesh wound there,[5] and Holiness himself is glad
to be helped in his fight against Malecasta's champions by
Britomart; by which the honest poet intends, no doubt,
to let us know that even a religious man need not disdain
the support which a happy marriage will give him against
fashionable gallantry. For Britomart is married love.

Malecasta clearly represents the dangerous attractions
of courtly love—the attractions that drew a Surrey or a
Sidney. Hers is the face that it shows to us at first. But
the House of Busirane is the bitter ending of it. In these

[1] *F.Q.* III. i. 31. [2] Ibid. III. i. 35. [3] Ibid. III. i. 39.
[4] Ibid. III. i. 45, 46. [5] Ibid. III. i. 65.

vast, silent rooms, dazzling with snake-like gold, and end-
lessly pictured with 'Cupid's warres and cruell battailes',[1]
scrawled over with 'a thousand monstrous formes'[2] of
false love, where Britomart awaits her hidden enemy for
a day and a night, shut in, entombed, cut off from the
dawn which comes outside 'calling men to their daily
exercize',[3] Spenser has painted for us an unforgettable
picture not of lust but of love—love as understood by the
traditional French novel or by Guillaume de Lorris—in
all its heartbreaking glitter, its sterility, its suffocating
monotony. And when at last the ominous door opens and
the Mask of Cupid comes out, what is this but a picture
of the deep human suffering which underlies such loves?

> Unquiet care and fond Unthriftyhead;
> Lewd Losse of Time, and Sorrow seeming dead,
> Inconstant Chaunge, and false Disloyalty;
> Consuming Riotise, and guilty Dread
> Of heavenly vengeaunce: faint Infirmity;
> Vile Poverty; and, lastly, Death with infamy.[4]

The Mask, in fact embodies all the sorrows of Isoud
among the lepers, and Launcelot mad in the woods, of
Guinevere at the stake or Guinevere made nun and peni-
tent, of Troilus waiting on the wall, of Petrarch writing
vergogna è 'l frutto and Sidney rejecting the love that
reaches but to dust; or of Donne writing his fierce poems
from the house of Busirane soon after Spenser had written
of it. When Britomart rescues Amoret from this place of
death she is ending some five centuries of human experi-
ence, predominantly painful. The only thing Spenser does
not know is that Britomart is the daughter of Busirane—
that his ideal of married love grew out of courtly love.

Who, then, is Amoret? She is the twin sister of Bel-
phoebe and both were begotten by the Sun,

> pure and unspotted from all loathly crime
> That is ingenerate in fleshly slime[5]

[1] Ibid. III. xi. 29. [2] Ibid. III. xi. 51. [3] Ibid. III. xii. 28.
[4] Ibid. III. xii. 25. [5] Ibid. III. vi. 3.

The meaning of which is best understood by comparison with Spenser's sonnet,

> More then most faire, full of the living fire,
> Kindled above unto the maker neare.[1]

And we know that the Sun is an image of the Good for Plato,[2] and therefore of God for Spenser. The first important event in the life of these twins was their adoption by Venus and Diana: Diana the goddess of virginity, and Venus from whose house 'all the world derives the glorious features of beautie'.[3] Now the circumstances which led up to this adoption are related in one of the most medieval passages in the whole *Faerie Queene*—a *débat* between Venus and Diana;[4] but this *débat* has two remarkable features. In the first place, the Venus who takes part in it is a Venus severed from Cupid, and Cupid, as we have already seen, is associated with courtly love. I say 'associated' because we are dealing with what was merely a feeling in Spenser's mind, not a piece of intellectual and historical knowledge, as it is to us. There is therefore no consistent and conscious identification of Cupid with courtly love, but Cupid tends to appear in one kind of context and to be absent from another kind. And when he does appear in contexts approved by our domestic poet, he usually appears with some kind of reservation. He is allowed into the Garden of Adonis on condition of his 'laying his sad dartes asyde':[5] in the Temple of Venus it is only his younger brothers who flutter round the neck of the goddess.[6] We are therefore fully justified in stressing the fact that Venus finds Amoret only because she has lost Cupid, and finally adopts Amoret *instead of* Cupid.[7] The other important novelty is that this *débat* ends with a reconciliation; Spenser is claiming to have settled the old quarrel between Venus and Diana, and that after a

[1] *Amoretti*, viii.　　　[2] *Republic*, 507 D et seq.
[3] *F.Q.* III. vi. 12.　　　[4] Ibid. III. vi. 11–25.
[5] Ibid. III. vi. 49.　　　[6] Ibid. IV. x. 42.
[7] Ibid. III. vi. 28.

singularly frank statement of the claims of each. And when the two goddesses have agreed, their young wards

> twixt them two did share
> The heritage of all celestiall grace;
> That all the rest it seemd they robbed bare,[1]

and one of them, Amoret, became

> th'ensample of true love alone
> And Lodestarre of all chaste affection.[2]

She was taken by Venus to be reared in the Garden of Adonis, guarded by Genius the lord of generation, among happy lovers and flowers (the two are here indistinguishable) whose fecundity never ceases to obey the Divine Command. This was her nursery: her school or university was the Temple of Venus. This is a region neither purely natural, like the Garden, nor artificial in the bad sense, like the Bower of Bliss: a region where,

> all that nature did omit,
> Art, playing second natures part, supplyed it.[3]

Here Amoret no longer grows like a plant, but is committed to the care of Womanhood; the innocent sensuousness of the garden is replaced by 'sober Modestie', 'comely Curtesie',

> Soft Silence and submisse Obedience,

which are gifts of God and protect His saints 'against their foes offence'.[4] Indeed the whole island is strongly protected, partly by Nature,[5] and partly by such immemorial champions of maidenhead in the Rose tradition, as Doubt, Delay, and Daunger.[6] But when the lover comes he defeats all these and plucks Amoret from her place among the modest virtues. The struggle in his own mind before he does so, his sense of 'Beauty too rich for use, for earth too dear', is a beautiful gift made by the humilities of

[1] Ibid. III. vi. 4. [2] Ibid. III. vi. 52.
[3] Ibid. IV. x. 21. [4] Ibid. IV. x. 51.
[5] Ibid. IV. x. 6. [6] Ibid. IV. x. 12, 13, 17.

medieval love poetry to Spenser at the very moment of
his victory over the medieval tradition:

> my hart gan throb
> And wade in doubt what best were to be donne;
> For sacrilege me seem'd the Church to rob,
> And folly seem'd to leave the thing undonne.[1]

Amoret, however, cannot withdraw her hand, and the
conclusion of the adventure may be given in the words
of the poet who has studied most deeply this part of
The Faerie Queene:

> she what was Honour knew,
> And with obsequious Majestie approv'd
> My pleaded reason.

The natural conclusion is marriage, but Busirane for cen-
turies has stood in the way. That is why it is from the
marriage feast that Busirane carries Amoret away,[2] to
pine for an indefinite period in his tomblike house. When
once Britomart has rescued her thence, the two lovers
become one flesh—for that is the meaning of the daring
simile of the Hermaphrodite in the original conclusion of
Book III.[3] But even after this, Amoret is in danger if she
strays from Britomart's side; she will then fall into a world
of wild beasts where she has no comfort or guide,[4] and
may even become the victim of monsters who live on the
'spoile of women'.[5]

 If it is difficult to write down in prose the *significacio*
of all this, the difficulty arises from the fact that the poetic
version has almost too much meaning for prose to over-
take. Thus, in general, it is plain that Amoret is simply
love—begotten by heaven, raised to its natural perfection
in the Garden and to its civil and spiritual perfections in
the Temple, wrongly separated from marriage by the
ideals of courtly gallantry, and at last restored to it by
Chastity—as Spenser conceives chastity. But the danger
of such analysis is that some stupid person will ask us

[1] *F.Q.* iv. x. 53. [2] Ibid. iv. i. 3. [3] Ibid. iii. xii (1st version), 46.
[4] Ibid. iv. vii. 2. [5] Ibid. iv. vii. 12.

'Who, then, is Scudamour? And if Chastity means (for Spenser) married love, and that is Britomart, then what is the difference between Britomart and Amoret?' Now, if we must, we can of course answer such questions. We can say that while Scudamour and Amoret united by Britomart are a picture of one thing—Marriage—yet Scudamour, taken by himself, is hardly a personification at all; he is the lover, the husband, any husband, or even *homo* in search of love. Or we can say that while Britomart represents Chastity attained—the triumphant union of romantic passion with Christian monogamy—Amoret, in isolation, represents the romantic passion which Chastity must so unite. We can even go on to say that whereas Amoret is the passion, Florimel is the object of the passion, The Beautiful or Loveable, and that her sufferings illustrate the miseries to which this object is exposed outside marriage: that the false Florimel is the false Loveable grasped by Courtly Love: and we might point out that the girdle which will fit only the true Florimel (and Amoret)[1] was made for Venus, but for Venus, once more, carefully dissociated from courtly love.[2] But I have no intention of following this plan. The very speed and ease with which the 'false secondary power' produces these interpretations, warns us that if once we give it its head we shall never be done. The more concrete and vital the poetry is, the more hopelessly complicated it will become in analysis: but the imagination receives it as a simple— in both senses of the word. Oddly as it may sound, I conceive that it is the chief duty of the interpreter to begin analyses and to leave them unfinished. They are not meant as substitutes for the imaginative apprehension of the poem. Their only use is to awaken, first of all, the reader's conscious knowledge of life and books in so far as it is relevant, and then to stir those less conscious elements in him which alone can fully respond to the poem. And perhaps I have already done too much. Perhaps all we need to know is that the twins Amoret and

[1] Ibid. IV. v. 19. [2] Ibid. IV. v. 3–6.

Belphoebe represent Spenser's view that there are two kinds of chastity, both heaven-born.

The less allegorical parts group themselves easily enough round this core. The swashbucklers—the Paridells and Blandamours—are an almost literal picture of court life. In Book IV they are the enemies of true friendship; they are the young men, described by Aristotle, who change their friends several times in the same day.[1] In Book III, Paridell wooing Hellenore, is a picture of courtly love in action: he is the *learned* lover and knows all the Ovidian tricks.[2] That is why the one constant element in him is his hatred of Scudamour.[3] Marinell is a sort of pendant to Belphoebe: she represents virginity as an ideal, while he avoids love on prudential grounds, which Spenser disapproves. His marriage with Florimel probably expresses no allegorical relation; it comes in, like the wedding of the rivers, or Arthur's reconciliation of Poeana and Amyas, to illustrate the general theme of the book, which is Reconciliation rather than what we should call Friendship. Concord is for Spenser the resolution of discord: her two sons are Hate and Love, and Hate is the elder.[4] That is why we meet Ate, and her works, long before we meet Concord, and also why the titular heroes of the book are friends who were once foes; and the same theme of reconciliation connects Arthur's activities with the main subject.

In addition to such merely typical adventures, we have, as usual, passages that are quite free from allegory. Such are the beautiful 'episode' of Timias and Belphoebe, and the prophecies of Merlin. We also have, so to speak, 'islands' of pure allegory such as that of Malbecco or the House of Care, which are not closely connected with the central allegorical action. The two books, taken together, are a kind of central *massif* in *The Faerie Queene*, in which the poet's originality is at its highest and his command (for his own purposes) of the Italian art of interweaving

[1] *Ethics*, 1156 B. [2] *F.Q.* iii. ix. 28, 29, 30: x. 6, 7, 8.
[3] Ibid. iv. i. 39. [4] Ibid iv. x. 32.

is most perfect. It is very unfortunate that they also contain some of his worst writing; but this must not be taken as proof that he is tiring of his design. It comes mainly from the very simple cause, that in these books Spenser is facing the necessity, incumbent on a professed disciple of Ariosto, of giving us some big, set battle-pieces, and Spenser, like all the Elizabethans, does this kind of thing very badly. It is idle to seek deep spiritual causes for literary phenomena which mere incompetence can explain. If a man who cannot draw horses is illustrating a book, the pictures that involve horses will be the bad pictures, let his spiritual condition be what it may.

The fifth book is the least popular in *The Faerie Queene*. This is partly the poet's fault, for he has included in it some flat and uninspired passages; but in part it results from the differences between his conception of justice and ours. The modern reader is apt to start from an egalitarian conception; to assume, in fact, that the fair way of dividing a cake between two people is to cut it into two equal pieces. But to this Aristotle, and the most reputable political thinkers between Aristotle's time and Spenser's, would have replied at once 'It all depends who the two people are. If A is twice as good a man as B, then obviously justice means giving A twice as much cake as B. For justice is not equality *simpliciter* but proportional equality.' When this principle is applied to things more important than cakes, justice becomes the art of allotting carefully graded shares of honour, power, liberty and the like to the various ranks of a fixed social hierarchy, and when justice succeeds, she produces a harmony of differences very like the Concord of Book IV. The poet describes this harmony in the following lines:

> The hils doe not the lowly dales disdaine,
> The dales doe not the lofty hils envy.
> He maketh Kings to sit in soverainty;
> He maketh subjects to their powre obey.[1]

[1] Ibid. v. ii. 41.

Justice, in fact, is 'the grand principle of Subordination'. The priests of Isis abstain from wine because wine comes from the blood of the old rebellious giants, who are the very type of insubordination, and to drink their blood

> Mote in them stirre up old rebellious thought
> To make new warre against the Gods againe.[1]

The egalitarian giant in Canto II offends against subordination by believing in equality *simpliciter*. The amazon Radigund, who enslaves men and sets them to female tasks, represents another form of insubordination—the 'monstrous regiment of women'. Apart from its political allusions, this allegory is an attack on uxoriousness—a vice to which the way is easily left open when once we have directed the whole force of romantic passion into marriage, and which is, for Spenser, a form of injustice—a disturbance of the hierarchy of things. For we must not conceal the fact that Spenser, for all his chivalry, is in complete agreement with Milton about the right relations of the sexes, and his picture of Radigund is a good commentary on the fact that Amoret had learned 'soft silence and submisse obedience' in the Temple of Venus. The doctrine is not very congenial to modern sentiment; but perhaps Spenser's delineation of the cruelty of Radigund (So hard it is to be a woman's slave),[2] if seasoned with our recollections of Mrs. Proudie or of the Simla memsahibs in Kipling's early work, will go down palatably and profitably enough.

But these considerations do not alter the fact that Artegall is one of the most disagreeable characters in the whole poem. He alienates us from the very beginning by his vindictive ill temper at being defeated in a perfectly fair tournament,[3] and continues to alienate us by his cruelty. And when we reflect on the judicial methods of the time, the statement that his iron page Talus 'could reveale all hidden crimes'[4] becomes abominable, for it means that Talus is the rack as well as the axe. In all

[1] *F.Q.* v. vii. 11.
[2] Ibid. v. 23.
[3] Ibid. iv. v. 9, vi. 5 et seq.
[4] Ibid. v. xii. 26.

this there is something I shall not attempt to excuse. Spenser was the instrument of a detestable policy in Ireland, and in his fifth book the wickedness he had shared begins to corrupt his imagination. But while it would be absurd to suggest that Spenser saw Artegall with our eyes, he has none the less made it clear that Artegall is not intended to be perfect. His motto *Salvagesse sans Finesse*[1] warns us that, if he is Justice, he is not meant to be more than a rough justice, and when we reach the Temple of Isis this is explained. The doors of that temple, it will be remembered, do not admit Talus,[2] and inside the temple we find that the true goddess is Equity or 'clemence',[3] and that Artegall is symbolized by the crocodile

> That under Isis feete doth sleepe for ever,
> To shew that clemence oft, in things amis
> Restraines those sterne behests and cruell doomes of his.[4]

Artegall, in fact, is to the whole virtue much as Talus is to Artegall. This fruitful idea ought to have found its full expression in the canto on Mercilla, but Spenser has allowed himself to be carried away by flattery and historical allegory (his 'fatal Cleopatra') and that canto is his one great failure in this kind—a failure which paralyzes the whole book because that canto should have been its heart. The actual behaviour of his Mercilla vies with that of Tertullian's *patientia* for the palm of absurdity:

> So did this mightie Ladie, when she saw
> Those two strange knights such homage to her make,
> Bate somewhat of that Majestie and awe
> That whylome wont to doe so many quake.[5]

An exquisite Mercy this, that can just velvet her claws for a moment if you gorge her with cream!

The rest of the book needs little comment. It is not, and ought not to be, a favourite, but it contains some

[1] Ibid. IV. iv. 39. [2] Ibid. v. vii. 3. [3] Ibid. v. vii. 3.
[4] Ibid. v. vii. 22. [5] Ibid. v. ix. 35.

excellent passages, such as the vanishing of false Florimel, the fight with Gerioneo, and, above all, the weird scene of Malengin's capture among the mountains.

From this stony plateau—for the fifth book would have been severe even if it had been successful—the sixth leads us down into the gracious valley of Humiliation. Spenser himself seems to pause at the brow of the barren country and look down with relief at this delightful land, spacious and wide, and sprinkled with such sweet variety.[1] The greatest mistake that can be made about this book is to suppose that Callidore's long delay among the shepherds is a pastoral truancy of Spenser's from his moral intention. On the contrary, the shepherd's country and Mount Acidale in the midst of it are the core of the book, and the key to Spenser's whole conception of Courtesy. As any one who has read *The Faerie Queene* carefully will expect, Courtesy, for the poet, has very little connexion with court. It grows 'on a lowly stalke';[2] and though the present age seems fruitful of it, yet a glance at 'plaine Antiquitie' will convince us that this is all 'fayned showes'.[3] I have already pointed out how the whole tenor of the book bears this out; and it is only necessary here to remind the reader that the great opposite of courtesy, the Blatant Beast, has ravaged all the world except the shepherds.[4] If we add to this that courtesy's other enemy—the enemy defeated by Arthur—is Disdaine,[5] we shall have made some progress towards understanding Spenser's conception. Since the virtue, as Spenser saw it, is one that does not exist in the modern scheme of values at all, we have to represent it by combining those virtues we do know. We may say for the moment that it is a combination of charity and humility, in so far as these are social, not theological, virtues. But there is another important aspect of it to be noticed. According to Spenser, courtesy, in its perfect form, comes by nature; moral effort may produce a decent

[1] *F.Q.* vi, Proem. 1. [2] Ibid. vi, Proem. 4.
[3] Ibid. [4] Ibid. vi. ix. 3–6.
[5] Ibid. vi. viii.

substitute for everyday use, which deserves praise, but it will never rival the real courtesy of those who

> so goodly gracious are by kind,
> That every action doth them much commend,
> And in the eyes of men great liking find,
> Which others that have greater skill in mind,
> Though they enforce themselves cannot attaine:
> For everie thing to which one is enclin'd
> Doth best become and greatest grace doth gaine.[1]

And this doctrine is confirmed by the allegory of the Graces in Canto X. The important thing about these beautiful dancers is that they vanish if disturbed, and then

> being gone, none can them bring in place
> But whom they of themselves list so to grace.[2]

The meaning of the Graces, in their relation to Colin Clout, is perfectly clear: they are 'inspiration', the fugitive thing that enables a man to write one day and leaves him dry as a stone the next, the mysterious source of beauty. But not, Spenser holds, of literary beauty alone. There is a similar inspiration that comes and goes in all human activities—and by its coming adds the last unpurchasable beauty—and specially in our social activities. There it produces 'comely carriage', 'sweete semblaunt', 'friendly offices', right behaviour whether among our friends or our enemies, and all that is collectively called 'Civility'.[3] To Spenser, in fact, as to Shelley or Plato, there is no essential difference between poetic beauty and the beauty of characters, institutions, and behaviour, and all alike come from the 'daughters of sky-ruling Jove'.[4] Writers such as Elyot and Castiglione, who combine high flights of philosophy with the *minutiae* of etiquette and see nothing absurd in so doing, would here have understood Spenser much more easily than we. But enough has been said to give us an inkling of what is meant. We are to conceive of courtesy as the poetry of conduct, an 'unbought

[1] *F.Q.* vi. ii. 2. [2] Ibid. vi. x. 20.
[3] Ibid. vi. x. 23. [4] Ibid. vi. x. 22.

grace of life' which makes its possessor immediately love-
able to all who meet him, and which is the bloom (as
Aristotle would say)—the supervenient perfection—on the
virtues of charity and humility.

Around this central conception we find the usual variety
of allegories, romance of types, and pure fiction. The
episode of Disdaine and Mirabella is remarkable for its
close approximation to the oldest models. Turpine and
Blandina are Aristotelian—the boor and the flatterer,[1]
representing the defect and excess which lie on either side
of the virtue. The courtly life which Meliboe condemns,
and the brutal life of Serena's or Pastorella's captors, are
arranged according to the same scheme—the one being
a sophistication of nature, in whose humilities true cour-
tesy dwells, and the other being a lapse below nature, as
nature was defined by Aristotle. The noble savage I have
already referred to. He and the Hermit are in a sense
opposites: one emphasizes the natural aspect of courtesy,
the other its spiritual aspect—its affinity with the sterner
or more awful forms of the good. The wise old man, full
of true courtesy without 'forged shows' such as 'fitter
beene for courting fools',[2] happy as 'carelesse bird in
cage',[3] and gently teaching his penitents that the Blatant
Beast cannot do you much permanent injury unless some-
thing is wrong within, is one of the loveliest of Spenser's
religious figures. The whole book is full of sweet images
of humility; Calidore and Priscilla carrying the wounded
knight, Calepine looking after the baby, the Salvage man
fumblingly doing his best with the harness of Serena's
horse. Some readers cannot enjoy the shepherds because
they know (or they say they know) that real country people
are not more happy or more virtuous than any one else;
but it would be tedious here to explain to them the many
causes (reasons too) that have led humanity to symbolize
by rural scenes and occupations a region in the mind which
does exist and which should be visited often. If they know
the region, let them try to people it with tram conductors

[1] *F.Q.* vi. vi. 42. [2] Ibid. vi. v. 38. [3] Ibid. vi. vi. 4.

or policemen, and I shall applaud any success they may have; if not, who can help them?

The sixth book is distinguished from its predecessors by distinct traces of the influence of Malory (a welcome novelty) and by the high proportion of unallegorical, or faintly allegorical, scenes. This last feature easily gives rise to the impression that Spenser is losing grip on the original conception of his poem; and it suggests a grave structural fault in *The Faerie Queene* in so far as the poem begins with its loftiest and most solemn book and thence, after a gradual descent, sinks away into its loosest and most idyllic. But this criticism overlooks the fact that the poem is unfinished. The proportion of allegoric core to typical, or purely fictional, fringe has varied all along from book to book; and the loose texture of the sixth is a suitable relief after the very high proportion of pure allegory in the fifth. The only fragment of any succeeding book which we have proves that the poem was to rise from the valley of humiliation into allegory as vast and august as that of the first book.

In the poem as a whole our understanding is limited by the absence of the allegorical centre, the union of Arthur and Gloriana. In the Mutabilitie cantos the opposite difficulty occurs—we have there the core of a book without the fringe. The fact that this should be so is interesting because it suggests (what is likely enough *a priori*) that Spenser was in the habit of writing his 'cores' first and then draping the rest round them. But we lose much by not seeing the theme of change and permanence played out on the lower levels of chivalrous adventure. It is obvious, of course, that the adventures would have illustrated the theme of constancy and inconstancy, and that the mighty opposites would have appeared in the form of Mutabilitie and the Gods only at the central allegorical gable of the book—which is the bit we have. It is obvious too, that the Titaness, despite her beauty, is an evil force. Her very name 'bold Alteration',[1] and the fact that she

[1] *F.Q. Mut.* vii, Argument. On the influence of Giordano Bruno, see B. E. C. Davis, *Edmund Spenser*, pp. 232 et seq.

rises against the gods, put her at once among the enemies for any reader who understands Spenser's conceptions of health, concord, and subordination. The state of affairs which she would fain upset in heaven and has already upset in earth, is precisely that state which Spenser (or Aristotle) would have described as just and harmonious,

> all which Nature had establisht first
> In good estate, and in meet order ranged
> She did pervert.[1]

She is, in fact, Corruption, and since corruption, 'subjecting the creature to vanity', came in with the Fall, Spenser practically identifies his Titaness with sin, or makes her the force behind the sin of Adam. She it is who

> Wrong of right, and bad of good did make
> And death for life exchanged foolishly:
> Since which all living wights have learn'd to die,
> And all the world is woxen daily worse.
> O pittious worke of Mutability,
> By which we all are subject to that curse,
> And death, instead of life, have sucked from our Nurse![2]

The full impact of that last line can be felt only when we have read the whole *Faerie Queene*. The enemies of Mutability are, first, the gods, and then *Nature*. Taken together they represent the Divine order in the universe— the concord, the health, the justice, the harmony, the Life, which, under many names, is the real heroine of the whole poem. If we take them apart, however, then the gods represent precisely what we should call 'nature', the laws of the phenomenal universe. That is why the Titaness so far prevails with them—they are that world over which, even in the highest regions, she asserts some claim. But *Nature*, taken apart, is the ground of the phenomenal world. The reverence with which Spenser approaches this symbol contrasts favourably with the hardier attempts of Tasso and Milton to bring God, undisguised, upon the stage—and indeed it would be a pleasant task, if this

[1] *F.Q. Mut.* vii, vi. 5. [2] Ibid. *Mut.* vi. 6.

chapter were not already too long, to show how much more religious a poem *The Faerie Queene* is than the *Paradise Lost*. Mutability's appeal, it should be noticed, is not in the first instance to Nature at all, but

> to the highest him, that is behight
> Father of Gods and men of equall might,
> To weete the God of Nature.[1]

Yet when this appeal is answered it is the goddess *Natura* who appears, as in Claudian, Bernardus, Alanus, and Jean de Meun,

> This great Grandmother of all creatures bred,
> Great Nature, ever young, yet full of eld;
> Still mooving, yet unmoved from her sted,
> Unseene of any, yet of all beheld.[2]

The woody pavilion (unlike those fashioned by the 'idle skill' of craftsmen)[3] which rises up to receive her, the 'flowers that voluntary grow' beneath her feet, and the homage of the river-god, are all in the same tradition. Yet at the same time Spenser can compare her garments to those of Our Lord on the mount of Transfiguration, and even put into the mouth of Mutability words that separate *Nature* by a great gulf from the mere gods:

> Sith heaven and earth are both alike to thee,
> And gods no more then men thou doest esteeme;
> For even the gods to thee, as men to gods, do seeme.[4]

The modern reader is tempted to inquire whether Spenser, then, equates God with Nature: to which the answer is, 'Of course not. He was a Christian, not a pantheist'. His procedure in this passage would have been well understood by all his contemporaries: the practice of using mythological forms to hint theological truths was well established and lasted as late as the composition of *Comus*. It is, for most poets and in most poems, by far the best method of writing poetry which is religious without being

[1] Ibid. *Mut.* vi. 35. [3] Ibid. *Mut.* vii. 8.
[2] Ibid. *Mut.* vii. 13. [4] Ibid. *Mut.* vii. 15.

devotional—that is, without being an act of worship to
the reader. In the medieval allegories and the renaissance
masks, God, if we may say so without irreverence, appears
frequently, but always *incognito*. Every one understood
what was happening, but the occasion remained an imagi-
native, not a devotional, one. The poet thus retains
liberties which would be denied him if he removed the
veil. For even Spenser, daring though he is in such mat-
ters, could hardly have descended so suddenly and delight-
fully as he does from the high court of the universe to the
grotesque antimask of Faunus ('A foolish Faune indeed'),[1]
if he had placed the Almighty undisguised instead of
'Nature' on the bench of that high court; though in the
long run this intermeddling of the high and low—the
poet's eye glancing not only from earth to heaven but
from the shapeless, funny gambollings of instinct to the
heights of contemplation—is as grave, perhaps even as
religious, as the decorum that would, in a different con-
vention, have forbidden it.

I find the significance of the whole *débat* hard to deter-
mine with precision because of the deep obscurity of the
lines in which Nature gives her sentence; but the general
outlines of the meaning I think I have grasped. It is a
magnificent instance of Spenser's last-moment withdrawal
from dualism. The universe is a battlefield in which
Change and Permanence contend. And these are evil and
good—the gods, the divine order, stand for Permanence;
Change is rebellion and corruption. But behind this end-
less contention arises the deeper truth—that Change is
but the mode in which Permanence expresses itself, that
Reality (like Adonis) 'is eterne in mutabilitie',[2] and that
the more Mutability succeeds the more she fails, even here
and now—not to speak of her more ultimate ruin when we
reach the

> rest of all things, firmely stayd
> Upon the pillars of Eternity.[3]

[1] *F.Q. Mut.* vi. 46. [2] Ibid. iii. vi. 47. [3] Ibid. *Mut.* viii. 2.

To praise this fragment seems almost an impertinence. In it all the powers of the poet are more happily united than ever before; the sublime and the ridiculous, the rarified beauties of august mythology and the homely glimpses of daily life in the procession of the months, combine to give us an unsurpassed impression of the harmonious complexity of the world. And in these cantos Spenser seems to have soared above all the usual infirmities of his style. His verse has never been more musical, his language never so strong and so sweet. Such poetry, coming at the very end of the six books, serves to remind us that the existing *Faerie Queene* is unfinished, and that the poet broke off, perhaps, with many of his greatest triumphs still ahead. Our loss is incalculable; at least as great as that we sustained by the early death of Keats.

If this chapter is not radically erroneous, then the history of Spenserian criticism, with one or perhaps two honourable exceptions, is a history of gross under-estimation. I have not tried to conceal his faults; on some of them I have spoken more severely than most of his professed admirers. His prosaic, and even prosy, tendencies I almost claim to have set for the first time in their true light. I have exposed, without extenuation, those unpleasing passages where he becomes a bad poet because he is, in certain respects, a bad man. But they must be set beside the barbarity of Homer, the hatreds of Dante, the pride of Milton—and perhaps we may add, Shakespeare's apparently contented acquiescence in the ethical tomfoolery of honour and revenge. I do not mention these things with the absurd intention of exalting Spenser by depreciating others. I wish merely to indicate the level on which Spenser stands, the poets with whom he is to be compared.

My claim for Spenser may take the form of the old eulogy—*totam vitae imaginem expressit*; but perhaps my meaning will be clearer if we omit the word *totam*, if we say simply *vitae imaginem*. Certainly this will help to clear up a common misunderstanding. People find a

'likeness' or 'truth' to life in Shakespeare because the persons, passions and events which we meet in his plays are like those which we meet in our own lives: he excels, in fact, in what the old critics called 'nature', or the probable. When they find nothing of the sort in Spenser, they are apt to conclude that he has nothing to do with 'life'—that he writes that poetry of escape or recreation which (for some reason or other) is so intensely hated at present. But they do not notice that *The Faerie Queene* is 'like life' in a different sense, in a much more literal sense. When I say that it is like life, I do not mean that the places and people in it are like those which life produces. I mean precisely what I say—that it is like life itself, not like the products of life. It is an image of the *natura naturans*, not of the *natura naturata*. The things we read about in it are not like life, but the experience of reading it is like living. The clashing antitheses which meet and resolve themselves into higher unities, the lights streaming out from the great allegorical *foci* to turn into a hundred different colours as they reach the lower levels of complex adventure, the adventures gathering themselves together and revealing their true nature as we draw near the *foci*, the constant re-appearance of certain basic ideas, which transform themselves without end and yet ever remain the same (eterne in mutability), the unwearied variety and seamless continuity of the whole —all this is Spenser's true likeness to life. It is this which gives us, while we read him, a sensation akin to that which Hegelians are said to get from Hegel—a feeling that we have before us not so much an image as a sublime instance of the universal process—that this is not so much a poet writing about the fundamental forms of life as those forms themselves spontaneously displaying their activities to us through the imagination of a poet. The invocation of the Muse hardly seems to be a convention in Spenser. We feel that his poetry has really tapped sources not easily accessible to discursive thought. He makes imaginable inner realities so vast and simple that they ordinarily escape us as the largely printed names of continents escape

us on the map—too big for our notice, too visible for sight. Milton has well selected wisdom as his peculiar excellence—wisdom of that kind which rarely penetrates into literature because it exists most often in inarticulate people. It is this that has kept children and poets true to him for three centuries, while the intellectuals (on whom the office of criticism naturally devolves) have been baffled even to irritation by a spell which they could not explain. To our own troubled and inquiring age this wisdom will perhaps show its most welcome aspect in the complete integration, the harmony, of Spenser's mind. His work is one, like a growing thing, a tree; like the world-ash-tree itself, with branches reaching to heaven and roots to hell. It reaches up to the songs of angels or the vision of the New Jerusalem and admits among its shining ones the veiled image of God Himself: it reaches down to the horror of fertile chaos beneath the Garden of Adonis and to the grotesque satyrs who protect Una or debauch Hellenore with equal truth to their nature. And between these two extremes comes all the multiplicity of human life, transmuted but not falsified by the conventions of chivalrous romance. The 'great golden chain of Concord' has united the whole of his world. What he feels on one level, he feels on all. When the good and fair appear to him, the whole man responds; the satyrs gambol, the lances splinter, the shining ones rise up. There is a place for everything and everything is in its place. Nothing is repressed; nothing is insubordinate. To read him is to grow in mental health.

With Spenser my story comes to an end. His chivalrous and allegorical poem was already a little out of date when it first appeared, as great poems not infrequently are. Its literary influence is much more important for the student of Milton and the Romantics than for the student of the Elizabethans. There is a history of great literature which has a slower rhythm than that of literature in general, and which goes on in a higher region. The biggest things do not work quickly. It is only after centuries that Spenser's position becomes apparent; and then he appears as the

great mediator between the Middle Ages and the modern poets, the man who saved us from the catastrophe of too thorough a renaissance. To Hurd and the Wartons and Scott he appeared chiefly as a medieval poet, to Keats and Shelley as the poet of the marvellous. What the romantics learned from him was something different from allegory; but perhaps he could not have taught it unless he had been an allegorist. In the history of sentiment he is the greatest among the founders of that romantic conception of marriage which is the basis of all our love literature from Shakespeare to Meredith. The synthesis which he helped to effect was so successful that this aspect of his work escaped notice in the last century: all that Britomart stands for was platitude to our fathers. It is platitude no longer. The whole conception is now being attacked. Feminism in politics, reviving asceticism in religion, animalism in imaginative literature, and, above all, the discoveries of the psycho-analysts, have undermined that monogamic idealism about sex which served us for three centuries. Whether society will gain or lose by the revolution, I need not try to predict; but Spenser ought to gain. What once was platitude should now have for some the brave appeal of a cause nearly lost, and for others the interest of a highly specialized historical phenomenon— the peculiar flower of a peculiar civilization, important whether for good or ill and well worth our understanding.

APPENDIX I
GENIUS AND GENIUS

THE significance of the being called Genius in ancient, medieval, and renaissance literature easily escapes a modern reader. The best way of understanding him is to begin with St. Augustine's statement:

> Quid est genius? 'Deus' inquit (sc. Varro) 'qui praepositus est ac vim habet omnium rerum gignendarum' . . . et alio loco dicit esse uniuscuiusque animum rationalem et ideo esse singulos singulorum. (*De Civ. Dei*, vii. 13.)

We have here a pretty clear distinction between what may be called Genius A (the universal god of generation) and Genius B (the δαίμων, tutelary spirit, or 'external soul', of an individual man); and it is plain, as Augustine points out, that while there is but one Genius A, there are as many Genii BB as there are men. It is with these latter that the modern reader is familiar; they are brothers to the δαίμων of Socrates, ancestors of the Guardian Angels in Christian pneumatology, and have dwindled by a natural metaphor into the 'genius' of a modern novelist or painter. But it is Genius A who dominates medieval poetry: an obscure figure at first, but ever clearer and more dominant as we proceed.

In the *Cebetis Tabula* we find outside the περίβολος or park of life (the origin, probably, of Spenser's Garden of Adonis)—

> ὁ γέρων ὁ ἄνω ἑστηκώς, ἔχων χάρτην τινὰ ἐν τῇ χειρί, καὶ τῇ ἑτέρᾳ ὥσπερ Δεικνύων τι, οὗτος Δαίμων καλεῖται· προστάττει Δὲ τοῖς εἰσπορευομένοις, τί Δεῖ αὐτοὺς ποιεῖν ὡς ἂν εἰσέλθωσιν εἰς τὸν βίον. (iv.)

Here the name and the function are perfectly clear. Much vaguer, but not unrecognizable, is the figure who sits in Claudian's cave:

> Ante fores Natura sedet, cunctisque volantes
> Dependent membris animae. Mansura verendus
> Scribit iura senex, numeros qui dividit astris
> Et cursus stabilesque moras, *quibus omnia vivunt*
> *Ac pereunt fixis cum legibus.*
> (*De Cons. Stilichonis*, ii. 432 et seq.)

Here the name is not given and the Senex has other concerns besides generation. His secretarial duties, and the words which I have italicized, however, are sufficient to identify him.

Martianus Capella, while ignoring the reproductive functions of Genius, stresses the singleness of Genius A as against the multitude of Genii BB. He is speaking of the duties performed by the sub-solar gods to their superiors:

> Sed quoniam uni cuique superiorum deorum singuli quique deserviunt, ex illorum arbitrio istorumque comitatu et generalis omnium praesul et specialis singulis mortalibus genius admovetur, quem etiam Praestitem quod praesit gerundis omnibus voca-verunt. (*De Nupt.* ii. 38 g.)

Isidore, a good witness to the accepted usage of a word, explains Genius in sense A exclusively:

> Genium dicunt quod quasi vim habeat omnium rerum gignen-darum seu a gignendis liberis: unde et geniales lecti dicebantur a gentibus qui novo marito sternebantur. (*Etymol.* viii. xi. 88.)

In Bernardus Sylvestris, on reaching the *aplanon* or sphere of the fixed stars, we have the following:

> Illic Oyarses quidem erat et genius in artem et officium pictoris et figurantis addictus. In subteriacente enim mundo rerum facies universa caelum sequitur sumptisque de caelo proprietatibus ad imaginem quam conversio contulit figuratur. Namque impossibile est formam unam quamque alteri simillimam nasci horarum et climatum distantibus punctis. Oyarses igitur . . . formas rebus omnibus et associat et ascribit. (I *Pros.* iii ad fin.)

This is the fullest description I have yet quoted of Genius A, and the second part of it is a comment (some centuries belated) on the scroll held by Δαίμων in the *Cebetis Tabula*. The name *Oyarses*, as Professor C. C. J. Webb has pointed out to me, must be a corrup-tion of οὐσιάρχης; and he has kindly drawn my attention to Pseudo-Apuleius *Asclepius* (xix), where the ousiarch of the fixed stars is certainly Genius A (though not so named) 'qui diversis speciebus diversas formas facit'.

The Genius A of Bernardus sufficiently explains the Genius in the *De Planctu Naturae*, who is the enemy of unnatural vice because he is the patron of generation and therefore of heterosexuality. From him the Genius of Jean de Meun and of Gower directly descends.

The troublesome person in this story is Spenser. The Genius at the gate of the Garden of Adonis (*F.Q.* iii. vi) is unmistakably Genius A, about whom the unborn attend to get their 'fleshly weeds'. Spenser probably got him from the *Cebetis Tabula*, which

was a popular Renaissance school-book (see Milton, *On Education, Prose Wks.*, ed. Bohn, vol. iii, p. 468) and which supplied him with other details—perhaps even with personified Acrasia. Now the Genius in the Bower of Bliss (*F.Q.* ii. xii), is equally certainly the *evil* genius of the individual soul; for, though none of our authors has drawn attention to it, we must now remember that in some systems each man has two genii of the B type, a good genius (b) and an evil (β). We all remember the good and evil angels in *Dr. Faustus*; and Spenser would have read of their like, if nowhere else, at any rate in Natalis Comes:

> Crediderunt singulos homines statim atque nati fuissent dae-mones duos habere, alterum malum, alterum bonum. (*Mythologiae*, iv. iii.)

The appearance of such an evil genius in Acrasia's home would present no difficulties, and all would harmonize with the whole story of Genius A and Genii BB (both bb and ββ), if it were not for Spenser's baffling forty-seventh stanza. This stanza begins, indeed, as we should expect:

> They in that place did genius him call:
> Not that celestiall power, to whom the care
> Of life, and generation of all
> That lives, perteines in charge particulare.

If this were all it would be a plain statement that the genius in Acrasia's bower is not Genius A. Unhappily Spenser proceeds:

> Who wondrous things concerning our welfare
> And straunge phantomes doth lett us ofte foresee,
> And ofte of secret ills bids us beware:
> That is our Selfe, &c.

This amounts to a complete identification of Genius A with the *good* individual genius (B b): and this composite, and strictly un-imaginable, being is contrasted in the following stanza with the evil individual genius (B β). Elsewhere (*R.E.S.*, xii, 46, April 1936) I have suggested a textual operation which would remove the confusion: but it remains very likely that Spenser was, in fact, confused.

NOTE: I had not thought of identifying the figure in Claudian with Genius until this was suggested to me by E. C. Knowlton's 'The Allegorical Figure Genius' (*Classical Philology*, xv, 1920), which the reader should consult, along with the same scholar's 'Genius as an Allegorical Figure' (*Modern Language Notes*, xxxix). I might also add that the mysterious *Schreiber* in Novalis' *Heinrich von Ofter-dingen* (cap. ix) may have some connexion with Claudian's Genius; but I think that Novalis symbolizes by him the Understanding.

APPENDIX II
DANGER

THE primitive meaning of *dominiarium* and *daunger* is certainly lordship or dominion. Thus:

> *Ancren Riwle* (see *O.E.D.* s.v. 'Danger') Þolieð ofte daunger of swuche oðerwhule þet muhte beon ower þrel.
>
> *Rom. de la Rose* 1033 (of Richece). Toz li monz iert en son dangier.

From this root, so to speak, two trunks of semantic development seem to grow according as we consider the lord's power to act (and therefore to hurt) or his power to give (and therefore to withhold). From A (power to hurt) we get:

1. (Undefined) power or influence over:

 > Chaucer, *Prol.* 663. In daunger hadde he at his owne gyse
 > The yonge girles of the diocyse.

2. Legal power over, specially the power of creditor over debtor:

 > Shakespeare, *Merch.* IV. i. 180. You stand within his danger, do you not?

3. Power of offensive weapons within a certain area:

 > Berners' *Froissart*, clxii. The archers shot so wholly together that none durst come in their dangers.

4. Hence peril, 'danger' in the modern sense.

From B (power to withhold) we get:

1. Churlishness or niggardliness:

 > Chrétien, *Yvain*, 5304. Del pain avons a grant dangier.
 > *Rom. de la Rose*, 478. Car li lieus d'oisiaus herbergier
 > N'estoit ne dangereus ne chiches.

2. Refusal, or difficult granting, of love:

 > *Rom. de la Rose*, 9091 (The jealous husband, to his wife).
 > Car quant je vous vueil embracier
 > Pour vous baisier et soulacier . . .
 > Tant soupirez, tant vous plaigniez
 > E faites si le dangereus.

Chaucer (W. of Bath) D. 513.

> I trowe I loved him beste for that he
> Was of his love daungerous to me.

3. Obstinacy, insubordination, lack of humility in an inferior:

Rom. de la Rose, 1889. Il est fos qui moine dangier
> Vers celui qu'il doit losengier.

4. The harsh or 'difficult', as opposed to the affable and obliging:

Rom. de la Rose, 4017. Se Jalosie est vers vos dure
> E vos fait enui et laidure,
> Faites li engrestié encontre;
> E dou dangier qu'ele vos montre
> Vos vengiez . . .

> Bruce, v. 280. and can him pray
> That he wald cum all anerly . . .
> And he but danger till him gais.

The A senses hardly concern us. Of the B senses it will be seen that only sense 2 gives any countenance to the theory that 'danger' means *pudor*; and even in sense 2 'danger' is connected with *pudor* only as an effect with a possible cause. *Pudor* is one of the things that may make a woman display danger; but it will be noticed that there is no question of modesty as the ground of refusal in either of the two quotations. In the first quotation the lady is 'dangerous' because she is sulking; in the second the man may be 'dangerous' for almost any reason except *pudor*. Senses 3 and 4 are closely connected with the idea of pride, distance, and excessive or formidable dignity, and thus fall in with the meaning I give to 'danger' in the *Roman*. Sense 1 seems at first far removed from this, and I should hesitate to plead that the modern uses of *difficult* and *difficile* as a social term provide a kind of bridge, if it were not for one remarkable fact. The Manuscripts of the *Roman* at l. 479 vary between *dangereus* and *desdeigneus*: which I take to be probable, though not certain, evidence that scribe or poet felt the two words to be neighbours in meaning as well as in form.

It must always be remembered (and here again I refer the reader to Barfield's *Poetic Diction*) that the various senses we take out of an ancient word by analysis existed in it as a unity. There is therefore no question of deciding in which of the senses given above the word *danger* is used on each occasion: it is like asking a modern Frenchman to choose between English 'like' and English 'love' every time

he uses the verb *aimer*. There are times when he could so decide; but on most occasions the question simply does not exist in the meaning-system of his language. Thus, the admirable description of 'danger' given in Skelton's *Bouge of Court* (stanzas 10 et seq.) is not a picture of Danger in any *one* of our B senses more than another, but of Danger *simpliciter*. What is even more remarkable is that Spenser seems conscious of no inconsistency in giving us the A sense in *F.Q.* III. xii. 11 and the B sense in IV. x. 17 et seq.

INDEX

(All references are to pages)

RR. = *Roman de la Rose*; FQ. = *The Faerie Queene*; Psf. = personified.

3 B